Trauma, Media, Art

Trauma, Media, Art:
New Perspectives

Edited by

Mick Broderick and Antonio Traverso

CAMBRIDGE
SCHOLARS

PUBLISHING

Trauma, Media, Art: New Perspectives,
Edited by Mick Broderick and Antonio Traverso

This book first published 2010

Cambridge Scholars Publishing

12 Back Chapman Street, Newcastle upon Tyne, NE6 2XX, UK

British Library Cataloguing in Publication Data
A catalogue record for this book is available from the British Library

ISBN (10): 1-4438-2283-3, ISBN (13): 978-1-4438-2283-1

TABLE OF CONTENTS

ACKNOWLEDGEMENTS

The essays in this Cambridge Scholars Publishing anthology were developed from papers presented at the *Interrogating Trauma: Arts & Media Responses to Collective Suffering* international conference convened by the editors and held at Murdoch and Curtin universities (Perth, Australia) in December 2008. This collection would not have been possible without the assistance provided to the conference and we would like to thank our sponsors, who generously granted financial and in-kind support. From Murdoch University: the School of Media Communication and Culture; the Faculty of Creative Technology and Media; the National Academy of Screen and Sound (NASS); the Kulbardi Aboriginal Centre; and the Institute for Sustainable Societies Education and Politics. From Curtin University: the Centre for Advanced Studies in Australia, Asia and the Pacific (CASAAP); the Faculty of Humanities; the School of Media, Culture and Creative Arts; the Centre for Aboriginal Studies; and the Sustainability Policy Institute. Thanks are also due to our conference co-convener Dr Miyume Tanji of Curtin University. The conference and the present collection would have been impossible without the stimulating contributions from the authors assembled here, and many others whose works have been collected in another two publications: Mick Broderick and Antonio Traverso, eds. (2010) *Interrogating Trauma: Collective Suffering in Global Arts and Media*, London: Routledge; and Mick Broderick and Antonio Traverso, eds. (2010) 'Arts and Media Responses to The Traumatic Effects of War on Japan', Special Issue, *Intersections: Gender and Sexuality in Asia and the Pacific*, No. 24, June. Finally, our thanks go to the Cambridge Scholars Publishing editors for soliciting, commissioning and producing the present volume.

—M.B. and A.T.

NEW PERSPECTIVES ON INTERNATIONAL TRAUMA CULTURE: AN INTRODUCTION

MICK BRODERICK AND ANTONIO TRAVERSO

During the past one hundred years or so the depiction of traumatic historical events and experiences has been a recurrent theme in the work of artists and media professionals, including those in literature, theatre, visual art, architecture, cinema, and television, among other forms of cultural expression and social communication. The sustained attention given to disaster by writers, directors, artists, architects and journalists has at the same time attracted the interest of critics and academics and, as a result, a substantial mass of theories, ideas and debates on the topic has accumulated across diverse disciplines. However, the analysis and discussion have tended to focus on representation of European and US historical catastrophes and relatively scarce critical interest has been committed to media and artistic depictions of third-world disasters, in spite of the fact that the latter often flood global contemporary media and art.

The essays collected in this book follow a contemporary critical trend in the field of trauma studies that seeks to redress this Euro-American imbalance by reflecting on artistic and media representations of traumatic histories and experiences from countries around the world. Focusing on a diversity of art and media forms—including memorials, literature, visual and installation art, music, video, film, and journalism—they apply dominant theories of trauma, yet also explore the former's limitations while bearing in mind other possible methodologies. Therefore, the essays in *Trauma, Media, Art: New Perspectives* are purposely preoccupied with the ways in which *concepts* of trauma are used to analyse artistic and media depictions of traumatic events and experiences. One of the outcomes of this theoretical concern is the promise of a critical trauma studies, a field that reinvigorates itself in the 21st century through its

constant reassessment of the relationship between theory, representation, and ongoing histories of global violence and suffering.

Thus, the fifteen essays that follow have been arranged thematically in order to reflect not only the vast disciplinary groupings through which the research and debates regarding trauma's representation in the arts and the media is currently undertaken but also the diverse epistemological and methodological approaches informing the field today.

Memorials, Trauma and the Nation

Public memorials are sites of collective remembrance usually devoted to experiences of great human suffering, loss and sacrifice. Their use as mediums of public memory, whether spontaneous or institutionalised, is widespread. In fact, it is not hard nowadays to find in most towns and cities gardens, commemorative structures, and spaces memorialising traumatic events in the community's local history, such as battles, atrocities or natural disasters. Yet memorials are neither formally homogenous nor simple, passive receptacles of truthful records of history. Rather they come in all sizes and shapes: from monuments and ruins to evocative parks and landscapes in which the regenerative capacity of nature has concealed all visible signs of the past. The critical study of memorials continues to occupy the attention of scholars working across the boundaries of trauma studies, memory studies, history, and visual culture studies. Following work in the 1990s on memorials that commemorate experiences from the twentieth century's two world wars— principally, James Young (1993), Raphael Samuel (1994) and Jay Winter (1995)—new and diverse scholarship has emerged in the past decade, such as Chris Pearson's incisive discussion (2008) of the function of the natural landscape both in war and the memorialisation of war traumas, and the highly influential study by Maria Tumarkin of sites marked by violence and tragedy, which she calls "traumascapes" (2005).

As Winter argues in relation to war memorials, while these have often been discussed as expressions of architectural or visual art forms, as well as in terms of the politically charged debates concerning their historical meanings, they are also important in facilitating and encouraging "rituals, rhetoric, and ceremonies of bereavement" (1993: 79). Thus, the first two essays of this collection focus precisely on the dense, multilayered, and polyvalent nature of memorials. In the first essay, 'Collective Suffering and Cyber-memorialisation in Post-genocide Rwanda', Giorgia Doná

explores the aesthetic response to collective suffering in virtual reality, and its relation to performative politics in post-genocide Rwanda. Indeed, the use of interactive digital technologies such as the internet, as the loci for the construction of public memorials, is becoming an increasingly common occurrence. As Doná's essay attests, the virtual memorialisation of Rwanda's genocide is in this sense no longer an exception.[1] Officially more than a million Rwandans (the vast majority identified as Tutsi) were killed during one hundred days of sustained slaughter as the West and the rest of the world, forewarned of the approaching butchery, withdrew international peacekeepers and denied genocide was occurring. More than fifteen years on, Rwandan society grapples with rebuilding the nation and narrating its own history to both citizens and the outside world via traditional static memorials in situ and new sites accessible online.[2]

Doná's rich analysis provides a critique of trauma that "essentialises socio-political suffering in contexts of violence", where it is "appropriated to promote national agendas in transnational spaces". The virtual memorialisation online at the 'Kigali Genocide Memorial' site, according to Doná, clearly illustrates a dialogical tension between "corporeal and a-corporeal representations of collective trauma". This Rwandan site also exhibits both apolitical and political strategies for representing societal suffering as well as national and transnational agendas. For Doná, conventional memorialisation relies on the "physicality of buildings, corpses, and bones to express embodied traumas of the past". Yet these constructions serve to "deny the existence of contested and contestable spaces". Virtual memorialisation in Rwanda, she asserts, "denies the socio-political suffering of the nation as a whole". In this way "reductionist appropriations of trauma representations" serve to "de-politicise socio-political suffering and to silence alternative contested traumatic memories", especially when aligned with "western humanitarianist sentiments with the politics of nation-building" that avoid capturing "the suffering of the social fabric of society".

[1] Other important examples of virtual versions of genocide memorials include the website of Villa Grimaldi, an ex-torture house of General Pinochet's regime, now a peace park and memorial in Chile, www.villagrimaldi.cl; and the website of the Armenian Genocide Institute, which includes an Armenian Genocide Memorial virtual tour, www.genocide-museum.am/eng/index.php (also see Torchin 2007).
[2] For informed accounts of the historical, social and political antecedents of the Rwandan genocide, see Dallaire 2003 and Melvern 2004; on the role of media in the context of the genocide and after see Thompson 2007 and Broderick 2009.

Jennifer Harris' essay 'Memorials and Trauma: Pinjarra, 1834' suggests that memorials frequently reflect traumatic experiences by insisting on the historic, lived quality of the events while paradoxically attempting to reflect the events in a manner which "transcends politics". Memorials are, she suggests, "rich sites of semiotic contradiction". Harris examines aspects of the memorial experience at Pinjarra in Western Australia, the site of a contested "event" which occurred in October 1834 between British colonisers and the Indigenous Binjareb people. For the British it was the place at which south-western Aboriginal resistance to colonisation was overcome in what has been referred to most often as a "battle", a word which many still insist is the correct description. For the descendants of the 1834 Binjareb, and their supporters, it is a place known through oral history as a "massacre" site in which a number of people estimated between 15 and 80, mostly women, children and the old, died in an ambush by white settlers, an event that deeply marking yet not destroying their society has carried intergenerational trauma.

Like Doná, Harris recongnises the "performative quality of memorials", implicit in their narratives, but often suppressed due to a contradictory insistence that historical events are "beyond debate". Accordingly, Harris asserts that memorials must be reconceptualised as cultural resources that could "open up the act of narrativising trauma", and as highly effective spaces for confronting traumatic history. Harris proposes a reconceptualisation of the role of memorials, one diverging from places of assumed harmonious memory that are fixed in the landscape. Instead, she proposes that memorials be seen as "process sites" that could activate debate with the intention of easing trauma. Memorials "used actively", she proposes, could result in apologies for historic events, re-narrativisation and some social control of trauma.

The Holocaust, Trauma and the Arts

Contemporary scholarship on the artistic engagement with the Holocaust is vast.[3] One of the most traumatic event of the past century, its impact and legacy remain ubiquitous. Yet, while the field of Holocaust studies appears well established, new research, interpretation and insight is not only abundant and ongoing but is reinvigorated by a new critical impetus that

[3] Only in terms of Holocaust cinema sources the list is generous. Key examples include: Hirsch 2004, Hornstein & Jacobowitz 2003, Vice 2003, Walker 2003, Zelizer 1998 and 2001, and Insdorf 1989.

seeks to revise the theoretical and methodological foundations of the study of this key event of the twentieth century. The next two essays illustrate these fresh energies. Magdalena Zolkos' contribution 'The Weight of the Other: Jean Laplanche and Cultural Trauma Studies' explores the thematics of trauma in Imre Kertész's book *Fateless*, which narrates the incarceration in (and survival of) a Nazi extermination camp by a Jewish-Hungarian schoolboy, Gyuri Köves. Zolkos studies the metaphoric relation that *Fateless* delineates between trauma, spectrality and a community "haunted" by past violence. Her close reading of *Fateless* is divided into four segments: on communal violence towards trauma subjects and community as being-with the other; on the continuity of the catastrophic; on the strangeness of the other's love; and on writing-as-witnessing. Drawing on the alternative theory of trauma found in the works of Jean Laplanche, Zolkos offers a psychoanalytic reading of *Fateless*, arguing that the novel makes a contribution into two debates relevant to contemporary trauma studies. Firstly, the author points out that this narrative work concerns "the extraneous and subjective workings of trauma, and the distinction and relation between the psychic experience of trauma and a catastrophic event, which is external to and affects the psychic". Secondly, and most importantly, Zolkos explores the novel's enacting of "the individual-collective and intrapsychic-intersubjective working of trauma".[4]

In a deeply personal reflection, Stephen Goddard's contribution, 'Video Testimony: The Generation and Transmission of Trauma', appraises his mother's experience of the Second World War when she was traumatically displaced and separated from her family.[5] Goddard recounts how in 1997, more than five decades after the events, his mother narrated on video her individualised testimony ("once again, separated from her family") as part of the Shoah Foundation Visual History series. Goddard's essay scrutinises the methodologies of this video testimony in relation to two important and related questions, which are relevant to anyone conducting research in the field. The author asks provocatively: "[W]as my mother traumatized or re-traumatized by the process of providing her testimony?" and "by narrating and recording her video testimony, did she, unwittingly, 'transmit' her traumas, and those of her generation to my generation?" The significance of such unsettling questions for Holocaust and trauma studies

[4] For a robust use of Laplanche's theory of trauma in the context of film analysis, see Radstone 2011.
[5] For another insightful discussion into the use of video testimony in Holocaust remembrance and research, see Brown 2011.

today is great, as they emphasise the way in which new Holocaust scholarship appears to be redefining the long accepted parameters of this field of study.

History, Trauma and the Arts: Experimental Visual Arts, Literature and Opera

Representing the social and subjective aftermath of traumatic experiences has been a key concern to artists from across the globe and the growing scholarship on the topic demonstrates its importance.[6] The intersection between theoretical insights and the critical impulse to apprehend and convey trauma to audiences remains a profound intellectual and praxiological challenge. In 'Dancing Out of Trauma: From Charcot's Hysteria to Haitian Voudoun', Dirk de Bruyn references the "classic and foundation work" of American avant-garde cinema and situates Maya Deren's 1943 experimental short film *Meshes of the Afternoon* as having lasting relevance due to the filmmaker's use of a "cyclical, repetitive narrative structure" that would pre-date Lev Manovich's "new media concerns with database and narrative fusion". According to de Bruyn, Deren's process of editing was a conscious strategy for examining "issues of amnesia and dissociation". Expanding E. Ann Kaplan's analysis of *Meshes of the Afternoon*, de Bruyn suggests that Deren's "self-theorised strategies of horizontal and vertical editing open the film up to multiple readings not only in terms of the film's content, but also around contestations of authorship and critical debate as to whether the film should be interpreted through psychoanalysis and surrealism or through Deren's stated preference for psychopathology and Imagist poetry." The author traces Deren's anthropological work on Haitian Voudoun, contrasting sharply with Charcot's (and later Freud's) clinical containment and framing of hysteria in the late 1800s. As a "parallel phenomena", both the 'disciplined' Haitian Voudoun dances of possession and the dominant western pathology of hysteria would have led Deren to proclaim that it was the "cultural context" in which hysteria occurred that made it "aberrant or dysfunctional in western culture".

In a similar vein, Lee-Von Kim's 'Rethinking Visual Representations of Trauma in the Work of Kara Walker' investigates the representation of historical trauma in relation to the work of another controversial avant-

[6] Two often cited sources on trauma and contemporary visual arts are Bennet 2005 and Guerin & Hallas 2007.

garde visual artist, in this case the silhouette tableaux of African-American artist Kara Walker. In her essay Kim explores the way in which Walker's artistry grapples with the representation of the trauma wrought by slavery in order to consider how the work "engenders new ways of theorising trauma in visual productions". Walker's black paper silhouettes, the author maintains, can be read as a series of incisions "which bring to mind the notion of physical wounding". Kim proposes that Walker's *Slavery! Slavery!* constitutes a rich and productive space for the discussion of visual representations of trauma, since trauma is "doubly encoded in the text, both in its form and subject matter". Walker's silhouettes not only engage with the historical traumas wrought by slavery, but their very production would also "[enact] a kind of physical trauma".[7]

Just as the history of slavery informs contemporary art practice, Sarah Leggott finds a "tremendous upsurge of interest" in the remembrance of Spain's twentieth-century traumatic history, in particular the years of the Spanish Civil War (1936-1939), the Franco dictatorship (1939-1975) and the transition to democracy in the immediate post-Franco period. In 'Representing Spain's 20th Century Trauma in Fiction: Memories of War and Dictatorship in Contemporary Novels by Women' Leggott considers the lingering social and political debates over "how best to deal with the country's recent repressive past". As contemporary legal battles and political contestations around the legacies of this nation's traumatic twentieth-century history intensify, the phenomenon has been increasingly reflected in contemporary cultural production, in particular, narrative fiction. Drawing on the literary works of Dulce Chacón and Rosa Regàs, Leggott examines these novelists' presentation of "the complex relationship between remembering and forgetting in a society in which the articulation of the past has been forbidden". By examining the recent novels by Spanish women writers who "open up for debate important questions about the on-going process of remembrance in Spanish society and the impact of past wounds on the present", Leggott evaluates the extent to which "traces of traumatic experience might be meaningfully represented in fiction".

Additionally, in 'Trauma, Memory and Forgetting in Post-War Cyprus: The Case of *Manoli...!*' Anna Papaeti discusses the representation of the legacies of historical trauma in an artform seldom given critical attention

[7] For further examples in the growing literature on the work of Kara Walker, see Fryd 2011 and Shaw 2006.

in the field: opera. Papaeti identifies a "distinct change in opera" regarding its subject matter and aesthetics for over a century, with "earlier notions of redemption increasingly replaced with issues [of] loss, trauma and anxiety". It is from this new operatic tradition that post-1945 political opera emerged, "depicting the silences, horrors and traumas of war and political instability". The author views the horrors of World War II as "an historical caesura that impose new problems on artists and composers". Vassos Argyridis's chamber opera *Manoli...!*, commissioned by and performed at Pfalztheater Kaiserslautern in 1991, deals with traumatic events in recent Cypriot history, and "specifically with the absence of catharsis and justice after the Greek coup d'état that led to the Turkish Invasion". Based on a play and the libretto by George Neophytou, the opera tells the story of a Cypriot mother who was an eye-witness to her son's murder during the Greek coup in Cyprus in 1974. Papaeti's essay explores the manner in which the opera *Manoli...!* recounts the trauma and anxiety of contemporary Greek-Cypriot society in relation to the events of July 1974. By focusing on the opera's reception in the Greek-Cypriot press, she examines the "mechanisms of memory and forgetting" in post-1974 Cyprus in the context of a "tenuously restored national unity".

Journalism, Trauma and Mental Health

As Alan Thompson's collection *The Media and Rwanda* (2007) attests, the implications of reporting trauma, and its transmission to journalists and readers alike, warrants investigation. Sue Joseph's essay 'Narrating the Silence of Trauma' foregrounds how silence is a "ubiquitous by-product of traumatic crime". She relates that when the subjects of such crime finally decide to speak, "the interview process itself can be a traumatising experience". Furthermore, Joseph argues, the use of such material by journalists, particularly in the format of extended narratives, is integral to that traumatic experience. Contextualising these narratives within the genre of literary journalism, Joseph explores the ethics of professional practice when dealing with the traumatic memory of interviewed subjects. Her essay draws from interviews relating to traumatic experiences, particularly sexual assault kept undisclosed for a very long time (including racist pack rape, war time rape, and child sexual abuse), which form part of her creative, non-fiction manuscript, entitled *Speaking Secrets*. Joseph argues for a greater academic discussion of empathy "as a tool of journalism", rather than empathy being regarded by most as "anathema to the industry". Instead, she suggests that "empathy must and should be

taught and embraced within journalism education", particularly within long-form literary journalism.

Traumatic silence of a different nature informs Deb Waterhouse-Watson's contribution to this collection: 'Silencing or Validating Traumatic Testimony: Footballers' Narrative Immunity Against Allegations of Sexual Assault'. The essay explores several sets of sexual assault allegations made against professional footballers in Australia throughout 2004. According to Waterhouse-Watson, these public allegations sparked an "intense media debate around the culture of the leagues and the nature of relations between elite footballers and women". Her analysis examines the role of narrative and grammar in different commentators' engagements with the complainants' traumatic testimony. By comparing "different narrative constructions of the same events", Waterhouse-Watson demonstrates that even when commentators engage with a complainant's account, the techniques used to narrate it can evoke cultural narratives that "blame the complainant and discount her testimony". In this way, the author maintains, narrative and grammar are used in public commentary to perform a *de facto* adjudication of the cases, "deflecting blame away from footballers" and providing them with a "narrative immunity" against complaints of sexual assault.

Just as issues of empathy and ethics increasingly pervade media professions, Katrina Clifford's "confessional" reflection on her own research into discursive representations of fatal mental health crisis interventions demonstrates the limitations of traditional trauma theory, which, according to the author, has "conventionally insisted on a model of spectatorship that remains passive". In 'Mental Health Trauma Narratives and Misplaced Assumptions: Towards an Ethics of Self-care among (Humanities-based) Trauma Researchers', Clifford draws from a key case study involving the fatal shooting by police of a mentally ill man, and the graphic media coverage that ensued. She demonstrates how a shared negotiation of meaning "extends beyond research participants with lived experience of trauma to (humanities-based) trauma researchers themselves" who are typically exposed to a 'vicarious trauma' from secondary source documents including "often distressing media materials that can shape and complicate such trauma narratives". Clifford's essay challenges the "strongly paternalistic ethical frameworks of a psycho-medico tradition", which she asserts has largely failed to acknowledge the importance of maintaining an obligation to self among trauma researchers, in addition to the ethical responsibility required towards their research participants.

Refugees, Trauma, Gender and Racism

As with the observations of Joseph, Waterhouse-Watson and Clifford, the reportage of mass human suffering and traumatic upheaval due to voluntary or enforced migration away from natural disasters and human atrocity (war, genocide, ethnic cleansing) is the subject of Pauline Diamond and Sallyanne Duncan's 'Professional and Ethical Issues in Reporting the Traumatic Testimony of Women Asylum Seekers'. In particular, this essay examines "the professional considerations and dilemmas" of reporting the personal testimony of women asylum-seekers. According to Diamond and Duncan, "women asylum-seekers often have different reasons for seeking refuge than men", such as "gender-based persecution, which is not recognised in the UN Convention on Refugees". Sourced from interviews conducted with both women asylum-seekers and journalists in Scotland, Diamond and Duncan explore "issues of truth, trust, empathy, exploitation and intrusion in the mediation of others' experiences of trauma, torture and atrocity", while reconstructing these intimate stories as representations of catastrophic events.

Similarly, Anne Harris's essay 'Too Dark, Too Tall, Too Something: New Racism in Australian Schools' considers the re-traumatisation of young Sudanese-Australian women in Australian schools via "both subtle and overt racism", insufficient school support, and competing home and school demands on these former refugees. Harris' experience working with this cohort suggests that "arts-based educational tools might be best suited to assist former refugee students", and that critical pedagogy offers a theoretical framework for more successfully assisting integration with input from the students themselves, through film and other arts methodologies.

Trauma, Cinema and the Mass Media

The concepts of 'empty empathy' and 'vicarious trauma' appear latent in much conventional western mass mediation of human suffering. Lindsay Hallam's essay "Genre Cinema as Trauma Cinema: Post 9/11 Trauma and the Rise of 'Torture Porn' in Recent Horror Films" seeks to comprehend how trauma theory can be usefully applied to a maligned film genre in order to 'work through' the collective sense of "culpability in the use of violence and torture as a form of retaliation and revenge" by

the US military.[8] For Hallam, one of the most shocking revelations post-9/11 was the awareness that outside of their own borders Americans "were hated". For decades US audiences had bought into the myth "continually perpetuated by Hollywood" that "the American way" was held internationally as "a beacon of truth and justice". The impact of 9/11 changed that, Hallam suggests, adding that it is this "newfound vulnerability and insecurity, and the trauma resulting from this realisation" that is expressed in these recent 'torture porn' horror films. Despite this fear and vulnerability being masked by a veneer of self-conscious "ignorance and arrogance", Hallam concurs with "the long held notion that horror can have a cathartic effect". Having grown up "in a nation that is traumatised and in a state of constant fear", the author proposes, young audiences in the US are using torture porn as a form of release by 'acting out' trauma.[9]

Problems with identification and empathy also inform Glen Donnar's final contribution to this volume: 'Levinas and the Face: Helping News Consumers Witness, Recognise and Recover Trauma Victims'. Adopting a Levinasian philosophical approach[10] to 'the face' Donnar reminds us that we often ignore the mediated suffering and trauma of (distant) others and effortlessly "accept their effacement". Accordingly, one way for news consumers "to bear witness and establish a social connection with (often anonymous) victims" is through a consideration of images of terror and trauma, rather than refusing to look. For the author, "witnessing is essential if we are to 'recover' victims as individuals". Following Levinas, Donnar suggests that in the "encounter with the Other—unique and irreducible—'the face' discloses itself *to me*. It exceeds and transcends both death *and* mediation." In addition, for Donnar empathy and transmission are unavoidable: "the Other's regard of me provokes recognition, commands my respect and elicits my responsibility". Donnar concludes that in mass media representation "the effacement of victims in death or mediation cannot be reversed", but in our response and recognition "it can be exceeded, transcended and then, ultimately, recovered".

[8] See Lowenstein 2005 for a broad discussion of the engagement with historical trauma in horror films from countries around the globe.
[9] In relation to the problem of acting-out and working-through in trauma cinema, see Walker 2005, Collins 2011, and Traverso 2011.
[10] For an encompassing anthology of discussions and applications of philosophical theories of trauma, see Sharpe et al 2007.

Film Program and Art Exhibition

Trauma, Media, Art: New Perspectives concludes with two appendices. The first presents the *Interrogating Trauma* conference's Film Program, held at the Film and Television Institute in Fremantle, Western Australia, in December 2008. This program, curated by this volume's editors, included film and video productions from Argentina, Australia, Canada, Chile, Japan, Northern Ireland, Sri Lanka, Rwanda, the UK and USA. The second appendix lists the conference's Art Exhibition, also curated by the editors, which was held at the Kidogo Art House in Fremantle simultaneously. The exhibition featured multimedia installation works, sculpture, experimental video, painting, sketches and photography by artists from Australia, Ireland, Germany, and the USA.

Works cited

Bennett, Jill. 2005. *Empathic Vision: Affect, Trauma, and Contemporary Art*. Stanford, California: Stanford University Press.

Broderick, Mick. 2009. 'Mediating genocide: Producing digital survivor testimony in Rwanda'. In Janet Walker and Bhaskar Sarkar, eds. *Documentary Testimonies: Global Archives of Suffering*. London and New York: Routledge, pp. 215-44.

Brown, Adam. 2011. 'Confronting "choiceless choices" in Holocaust video testimonies: Judgement, "privileged" Jews, and the role of the interviewer'. In Mick Broderick and Antonio Traverso, eds. *Interrogating Trauma: Collective Suffering in Global Arts and Media*. London and New York: Routledge, pp. 79-90.

Collins, Felicity. 2011. 'After the Apology: Re-framing violence and suffering in *First Australians*, *Australia*, and *Samson and Delilah*'. In Mick Broderick and Antonio Traverso, eds. *Interrogating Trauma: Collective Suffering in Global Arts and Media*. London and New York: Routledge, pp. 65-77.

Dallaire, Roméo. 2003. *Shake Hands with the Devil*. Canada: Random House.

Fryd, Vivien. 2011. 'Bearing witness to the trauma of slavery in Kara Walker's videos: *Testimony*, *Eight possible beginnings*, and *I was transported*'. In Mick Broderick and Antonio Traverso, eds. *Interrogating Trauma: Collective Suffering in Global Arts and Media*. London and New York: Routledge, pp. 145-159.

Guerin, Frances and Roger Hallas, eds. 2007. *The Image and the Witness: Trauma, Memory and Visual Culture*. London and New York: Wallflower Press.

Hirsch, Joshua. 2004. *After Image: Film, Trauma and the Holocaust*. Philadelphia: Temple University Press.

Hornstein, Shelley & Florence Jacobowitz, eds. 2003. *Image and Remembrance: Representation and the Holocaust*. Bloomington and Indianapolis: Indiana University Press.

Insdorf, Annette. 1989. *Indelible Shadows: Film and the Holocaust*, 2nd ed. New York: Cambridge University Press.

Lowenstein, Adam. 2005. *Shocking Representation: Historical Trauma, National Cinema, and the Modern Horror Film*. New York: Columbia University Press.

Melvern, Linda. 2004. *Conspiracy to Murder: The Rwanda Genocide*. London and New York: Verso.

Pearson, Chris. 2008. *Scarred Landscapes: War and Nature in Vichy France*. UK: Palgrave Macmillan.

Radstone, Susannah. 2011. '*Caché*: Or what the past hides'. In Mick Broderick and Antonio Traverso, eds. *Interrogating Trauma: Collective Suffering in Global Arts and Media*. London: Routledge and New York, pp. 17-29.

Samuel, Raphael. 1994. *Theatres of Memory. Volume 1: Past and Present in Contemporary Culture*. London and New York: Verso.

Sharpe, Matthew, Murray Noonan and Jason Freddi, eds. 2007. *Trauma, History, Philosophy*, Newcastle, UK: Cambridge Scholars Publishing, pp. 1-7.

Shaw, Gwendolyn. 2006. 'The "rememory" of slavery: Kara Walker's *The End of Uncle Tom and the Grand Allegorical Tableau of Eva in Heaven*. In Lisa Saltzman and Eric Rosenberg, eds. *Trauma and Visuality in Modernity*. Hanover, New Hampshire: Dartmouth College Press, pp. 158-186.

Thompson, Alan. 2007. *The Media and Rwanda*. London: Pluto.

Torchin, Leshu. 2007. 'Since we forgot: Remembrance and recognition of the Armenian genocide in virtual archives'. In Frances Guerin and Roger Hallas, eds. *The Image and the Witness: Trauma, Memory and Visual Culture*. London and New York: Wallflower Press.

Traverso, Antonio. 2011. 'Dictatorship memories: Working through trauma in Chilean post-dictatorship documentary'. In Mick Broderick and Antonio Traverso, eds. *Interrogating Trauma: Collective Suffering in Global Arts and Media*. London and New York: Routledge, pp. 179-191.

Tumarkin, Maria. 2005. *Traumascapes: The Power and Fate of Places Transformed by Tragedy.* Carlton, Vic.: Melbourne University Publishing.

Vice, Sue, ed. 2003. *Representing the Holocaust.* London and Portland: Vallentine Mitchell.

Walker, Janet. 2005. *Trauma Cinema: Documenting Incest and the Holocaust.* Berkeley: University of California Press.

Winter, Jay. 1995. *Sites of Memory, Sites of Mourning: The Great War in European Cultural History.* Cambridge: Cambridge University Press.

Young, James E. 1993. *The Texture of Memory: Holocaust Memorials and Meaning.* New Haven and London: Yale University Press.

Zelizer, Barbie. 1998. *Remembering to Forget: Holocaust Memory Through the Camera's Eye.* Chicago and London: The University of Chicago Press.

Zelizer, Barbie, ed. 2001. *Visual Culture and the Holocaust.* New Brunswick, New Jersey: Rutgers University Press.

MEMORIALS, TRAUMA AND THE NATION

COLLECTIVE SUFFERING AND CYBER-MEMORIALISATION IN POST-GENOCIDE RWANDA

GIORGIA DONÁ

Introduction

The year 2009 marks the 15th anniversary of the Rwandan genocide, an event which has entered our collective imagination as a marker of 20th century violence, and one that has profoundly shaped Rwanda's recent socio-political landscape. Following the shooting down of the plane that carried Rwandan President Habyarimana on April 6th 1994, Hutu militias, soldiers and civilians initiated a systematic slaughter of approximately one million Tutsi and moderate Hutus over three and a half months of widespread violence. In July 1994, the Rwandan Patriotic Army (RPA), composed mostly of Tutsi refugees living in the Eastern African region, gained control of the capital and ended the killings. The RPA advance led to the mass exodus of two million Hutus into neighboring states.

If visible violence ended in July 1994, physical and emotional scars are the ongoing signs of the 'traumatic' historic rapture the country endured. The legacy of the genocide shaped the political agenda of reconstruction and national unity of the post-genocide Rwandan Government, and it is embedded in various initiatives like justice, assistance, reconciliation, and international relations.

The memory of the genocide is kept alive through acts of memorialisation that include the preservation of memorial sites and yearly commemorations. Across the country, there is awareness that trauma and memory are connected; for instance, the 'commemoration programme' of the 15th anniversary of the genocide includes trainings on 'psycho-social trauma' for understanding and managing 'the psychological trauma phenomena that are frequent in our community so that they may be helpful within the

national mourning period' (GAERG Commemoration Program - Rwandan 15th Commemoration of Tutsis Genocide.htm).

Caruth (1995, 1996) writes that trauma is expressed, processed and integrated in the act of remembering. There is a curative aspect to memory whereby collective memories can act as a response to trauma (Brown 2004), constructed in transmissible form through the performative practice of memorialisation. In the Rwandan context, the act of remembering has the potential to help survivors to deal with the traumatic events of the past through an acknowledgement of their experiences and the offering of public support (IRDP 2006).

Corporeal forms of memory embody an active process of remembering (Kuhn 2000) and recycling of meaning (Nora 1989). Revisiting the past through memorialisation fulfils helpful functions but the active process of remembering may lead to the resurgence, reoccurrence or re-elaboration of past traumas. In Rwanda, the National Commission to Fight Genocide against Tutsi, aware of the link between memorialisation and re-traumatisation and in preparation for the 15th anniversary commemorations of the genocide, set up a unit within the Commission itself to address the ongoing psychological side effects that memorialisation may trigger.

Private and public memorialisation fulfils different roles. Nora (1989) writes that a monument constructed in marble or erected in public places performs different memorial functions than a personal object. By acting as material matter, as lieux de mémoire (Nora 1989), these public projects of shared memory mark bonds, connect individuals, and place them within ideological and political spheres. State leaders regularly deploy lieux de mémoire and memorialisation of traumatic events to promote identities or ideologies, and to prescribe action. Through the recalling of the violent past and the affect affirmation of grief, fear and anger associated with loss, mourning may be directed to instrumental ends that include nationalism, political transition, modernization, revolution, capitalism, institutionalised justice, human rights, and national projects (Saunders and Aghaie 2005).

Memorialisation becomes an activity through which a mythical truth is conveyed to construct a new identity (Gillis 1994). A key aspect of this reconstruction is what is not done. Memorialisation is about not forgetting and yet by choosing what to tell, stories and traumas are either forgotten or become unspeakable. In rethinking 'After Auschwitz', Mandel (2001) writes that the unspeakable can be what is part of an agenda or what

cannot be physically spoken or pronounced, like an infinite word or a scream. The unspeakable is echoed in taboos or injunctions against certain speech acts by the community, and in these instances the unspeakable takes the form of trauma, not merely for the individual survivors but for a collective post-Holocaust culture, which is perceived to be traumatized by the presence of the Holocaust in its past.

The remembered, the forgotten and the unspeakable coexist. Trauma politics and aesthetics go hand in hand. Memorialisation of a traumatic past is subjected to political manipulations because the choice of specific representations of suffering leads to the exclusion of counter-narratives of forgotten or unspeakable traumas. Memorial sites and other types of corporeal memory play pivotal roles in the aesthetics of trauma and its appropriation for political purposes. Memorials 'invite us to remember, but they are far from neutral and universal; they are influenced by their locations, constructed from various subjects' positions, and embody the ideals of those who erect them (Ngwarsungu 2008, p 83). In other words, they inhabit a performative model of politics (Chakrabarty 2002).

In this essay I want to explore the aesthetic response to collective suffering in virtual reality, and its relation to performative models of politics. I will use the 'Kigali Genocide Memorial' virtual site as a case study of memorialisation, and I will compare its narrative with 'real' memorialisation in the country where I conducted fieldwork in 2009. Through this analysis I want to expose the dialogical tension between corporeal and a-corporeal representations of collective trauma; a–political and political strategies for representing societal suffering; and national and transnational agendas. The essay offers a critique of trauma to capture socio-political suffering; it warns against the dangers of its appropriation for political purposes; and it advocates a move 'beyond trauma' towards a re-politicisation and re-contextualisation of collective suffering.

Memorialisation in Rwanda

Memory and trauma coexist both temporally and spatially in Rwanda. Immediately after the genocide, the newly established Government of National Unity announced the suppression of Easter as a public holiday to be replaced by a week of 'mourning'—the week of the 7th of April—the day the killings began. No music is allowed in public spaces; marriages, naming ceremonies and other festivities are halted; and offices remain closed during the week of mourning. April is the unofficial month of

mourning, during which the trauma of the one hundred days is re-counted by survivors in public ceremonies that keep the memory alive. Bodies continue to be exhumed and transferred to communal sites, officials preside commemorations in the capital and replicate them at 'cellule' level (the second smallest administrative unit of local government), and public testimonies are heard across the country.

Internationally, the genocide is commemorated by Rwandans living abroad and by Friends of Rwanda. The United Nations Security Council responded to the call to internationalise national memorialisation by declaring April the 7th an international genocide day. In preparation for the 2009 commemorations, Rwandan diplomatic corps across the world were recalled to Kigali to attend a meeting with the National Commission to Fight Genocide against Tutsi in March. The aim of the meeting was to discuss the role that the diplomatic corps can play in making the commemoration of the 1994 Rwandan genocide an international one, and for commemorations to be carried out internationally. A representative of the National Commission reported that commemoration had been held at national level but "this time around it should be done at international one" (Rwandan Television news, 12th of March 2009).

These initiatives map national memorialisation onto the international arena, and diplomatic relations are played out through memorialisation. The international community is invited to participate to the Rwandan nation-building project in which the memory of the genocide plays a central role, by participating in collective mourning, validating survivors' stories, and acknowledging that it did not intervene to stop the genocide.

If annual commemorations of the genocide are the main reminders of the traumatic past, its legacy is embedded in the social, cultural and political life of the country through other lieux de mémoire, including public executions of those accused of involvement in the genocide, the establishment of gacaca courts to promote justice and reconciliation at grass-root level, and the release of detainees from prisons. These public acts are ongoing reminders of the genocide that trigger traumatic memories.

The flourishing of various types of literature on the subject and the undertaking of cinematic and arts projects testify to the continuing resonance of the genocide internationally. The wish to comprehend and remember is visible in the increasing number of artistic and cinematic projects like Hotel Rwanda, novels like A Sunday by the Pool by Gil Countenance, and

documentaries like the Gacaca trilogy by Ghion. This last one comprises the documentary My Neighbour My Enemy, in which the viewer is shown how gacaca, grass-level justice, is performed and its impact on the life of survivors. The viewer hears survivors making constant references to the embodied pains of their "hearts" through metaphors like the "broken heart" or the "empty heart" that poignantly convey their past and present sense of loss, emptiness, and suffering.

Localities where massacres took place were converted into sites of memory to show the extent to which cruel suffering was inflicted (Caplan 2007). Upon entering these sites, estimated to be approximately 200 across Rwanda, the visitor is exposed to the stark view of 'bare bones'. The remains of the dead and their possessions are neatly arranged on benches, shelves and boxes. Bones and skulls are exposed in open air; there are no glass cabinets to protect them from the passing of time, and no strings to delimit the space that separates the viewer from the dead. Their physical proximity makes them almost touchable, were it not for a sense of respect and awe. Stains of blood can still be seen on the altar's tablecloth at Nyamata Memorial site and the writings of the children who died during the genocide can be seen in their exercise books piled up in a cask at Ntarama Memorial site.

In 2004, on the occasion of the 10th anniversary of the genocide, a new purpose-built Kigali Genocide Memorial centre (KGM) was officially inaugurated in the capital Kigali. The undertaking is a partnership between the Rwandan Government and Aegis, a UK Non-governmental organisation, highlighting the relationship between national and international memorialisation agendas. The installations for the Kigali Genocide Memorial are artistic responses to suffering made by national and international artists. The Rwandan sculpturer Laurent Hategekimana created three pieces to represent the pre, during and post-genocide periods while the artist Ardyn Halter, the son of a survivor of the Auschwitz camp, made the Windows of Hope. Part-cemetery, part-museum and part-education centre, the Kigali Genocide Memorial fulfils various functions, ranging from the recording of history to mourning the victims and educating the young.

Inside the building there are three main exhibitions: the Rwandan genocide, a children's memorial, and an exhibition on the history of genocidal violence around the world. The Rwandan genocide exhibition introduces the viewer to a brief history of Rwanda and the causes of the

genocide. Path to Genocide is followed by The 100 Days Genocide with pictures of the massacres and their victims, and concludes with The Aftermath, a brief description of life in the years following the genocide.

The internationalisation of memory can be seen in the modern features of the memorial centre and the choice of its exhibits. The KGM is one of few memorials to include other genocides across the world to remind us that genocide is not a brutal tribal affair but a crime against humanity, adopting the language of the human rights discourse. A stereotype of Africa as a place of natural violence and tribal bloodshed is replaced by a view of genocide as historical norm and colonial legacy.

The children's memorial is personal to create a rapport with the dead child. It shows pictures of children, and underneath each picture there is a caption that describes the child's behaviours, their hobbies, favourite people, and how they were killed. Suffering is conveyed in personal and affective modes that echo western preoccupations of children as innocent victims.

A virtual site called 'Kigali Genocide Memorial' brings together preserved and purpose built memorial sites in cyberspace. The virtual site transcends the physicality of memorial sites to generate a distinct performative narrative of suffering, one that I argue is complementary yet distinct from 'real' memorialisation. If memorialisation represents the embodiment of memory, what happens when this is performed in disembodied cyberspaces?

Memorialisation in cyberspace: Embodied and virtual memories

As social activity, memory is the product of ongoing interactions among recollections of the mediated past. It generates narratives about specific times, places, persons, and events that are laden with affective meanings. Memory websites fulfil the social functions of commemorative sites: memory is socially and culturally shaped—but differently from conventional memorial sites, these are "alive" through the possibility of ongoing contributions and additions (Douglas 2006). Virtual memorial sites offer support to those who bereave their lost ones: personal involvement in the creation and development of web memorials engages family and friends in active mourning and memorialisation while the creation of support group websites offers spaces for informal bereavement and for group support to take place (Roberts 2004).

In Rwanda, memory narratives fulfil various functions. Remembering the genocide is a way to pay collective tribute to the deceased, and an action that makes survivors feel supported by society and that strengthens "individual and group therapy" (IRDP 2006, p. 145). Preserving the memory of the genocide has educational functions because it teaches future generations of Rwandans and non-Rwandans the lessons of the past and acts as a warning sign that genocide should happen "never again". Memory helps to bring facts to light, and can be the basis for cohabitation (IRDP 2006).

Cyber-memorialisation transfers the narrative of the genocide from the space of nation-state into the transitory space of global and diasporic dwellings. In the context of Rwanda, cyber-memorialisation contributes to internationalise memorialisation, to promote the Rwandan nation-building project transnationally, and to target the diasporic and international community for financial contributions.

In the following section, I describe my 'virtual' visit to the Kigali Genocide Memorial site, as I explore the aesthetics of memory and trauma and their relation to performative models of politics. The virtual Kigali Genocide Memorial reproduces memorialisation in cyberspace, opening possibilities for ongoing revisiting of the past and for transnational participation in the national project of memorialisation. Upon entering the virtual Kigali Genocide Memorial (KGM)[1], the visitor is confronted with the possibility of exploring a number of sites: Rwanda, the genocide, survivors' testimonies, documentation, and fundraising. The clicking of one heading opens possibilities for further exploration. Under the Genocide heading, the visitor can explore its history, or she can view memorial sites across the country, or the Kigali Genocide museum.

The site on Memorials contains pictures and captions of physical buildings scattered across the country, reproduced in a standardised manner. Each of the sites shows a picture of the preserved memorial, formerly a church or school. The similarity in the aesthetic representation minimises the existence of local history, local dynamics, and local spaces where life pre- and post- genocide unfolds. The physicality of the buildings is altered not only by the virtual modality of representation but also by the absence of landscapes in which these buildings are situated. Through another click it

[1] www.kigaligenocidememorial.org.

is possible to read a short history of each site though the standardised summary that speaks of their similarities rather than their particularities.

Through another click the visitor accesses images of the contents inside the memorial building. Preceded by the warning that some of the pictures may be disturbing, the visitor is exposed to powerful images of skulls and bones that powerfully evoke embodied traumas. As Véronique Tadjo observed in *The Shadow of Imana*, these corpses "bear witness, and will have no burial. They are nothing but bones ... But these dead are screaming still... This is not a memorial but death laid bare, exposed in its rawness." (2002, p. 12).

Why is death, the extreme form of suffering exposed through 'bare bones'? Those who visited Rwanda immediately after the genocide remarked that most shocking and noticeable were the chaos and smells that reigned everywhere. These have disappeared in the pictures of tightly arranged bones in immaculately clean spaces that recall the sanitised order of hospitals or mortuary cells rather than the liveliness of schools or churches. At Ntarama Memorial Centre, the past and present, the sacred and non-sacred are kept physically separated: an open-air construction was built in the garden so that those who want to pray can do so outside and not inside what formerly was the church.

By clicking the heading 'Kigali Genocide Memorial' the visitor is presented with a starkly different architectural picture of a modern building surrounded by a garden and a fountain. Few more clicks of the mouse allow the virtual visitor to explore additional physical spaces such as collective graves where 250,000 bodies recovered from the area were re-buried, the Wall of Names, the Memorial Garden, or the Education and Documentation Centre. All images contribute to create a modern atmosphere.

The KGM site is reliant on pictures of physical spaces, makes references to global geographies, and is aesthetically embellished by artistic productions. Virtual reality is to a great extent reliant on physical representations to communicate the past, but these are *neutral* spaces with minimal extraneous information that deploy abstraction to facilitate a "politics of the sensible" (Mirzoeff 2005).

The virtual KGM adds a 'live' dimension to memorialisation with the introduction of survivors' testimonies arranged in alphabetical order. By

clicking a letter of the alphabet, the name and picture of a survivor appears. These standardised pictures of isolated individuals, captured standing and looking at the photographer, are abstracted from their surroundings. The photos are accompanied by survivor's testimonies recounting life before, during and after genocide, echoing the chronological reference of the sculptures of Hategekimana and the genocide exhibit. Here too, figurative reproductions are central to the construction of the virtual site and yet they are abstracted from their localities and particularities to generate a collective representation of 'standardised' individual trauma and recovery.

Virtual memorialisation is not simply an aggregate reproduction of memories of buildings and stories of the past; it rather creates a distinct narrative in which temporal and spatial dimensions are re-positioned to be simultaneously accessible through interactivity. While commemorations mark the passing of time and rekindle the memory of the past, virtual reality engages the viewer with changeable temporal perspectives where preserved sites, newly built museums, and survivors' testimonies interact in ways that are not possible in reality. The past and present cohabit the virtual space, where the bones of the dead and the stories of the survivors enter in virtual dialogue. The juxtaposition of rural and urban landscapes of memory, machetes on the one hand and aesthetic artefacts on the other, colonial and post-colonial symbols of power, contribute to generate representations of suffering that contain references to tradition, modernity, and post-modernity.

Visits to physical memorial sites usually guide the imagination of the visitor back into the past and the memory of the dead. Virtual memorialisation presents the visitor with the possibility of engaging in live memorialisation (Douglas 2006), where memories of the reconstructed past are complemented by present post-genocide testimonies, and projected into the future. Although existing as a disembodied modality, virtual memorialisation is strongly reliant on embodied representations of suffering in the past, present and future. And yet, these embodied representations are de-contextualised from the physicality of localities, the hills and villages where Rwandans lived prior, during and after the genocide, their lived experiences conspicuously absent. Similarly to the way in which Eastern Congo was represented as an uninhabited space occupied by Rwandan refugees (Ngwarsungu 2008), the virtual KGM represents Rwanda as an uninhabited space occupied by corpses of the dead and the few remaining survivors.

Collective trauma in cyberspace

Saunders and Aghaie (2005) write that from its original denotation of bodily injury, with Charcot, Janet, Breuer and Freud, trauma came to bear a psychological meaning and to refer to internal states rather than embodied realities. Fanon's clinical work in Algeria, the authors continue, repositioned trauma away from the individual psyche to social situations, from relations within the family unit to relations between families and the national unit, and from the singularity of the traumatogenic event to the pervasive and diffuse inhumanity of racism and colonialism. Similarly, Martin-Baró (1988), noting the effects of violence on society, coined the term 'psychosocial trauma' to draw attention to the fact that the whole nation's social fabric was injured by oppression. The effects of State terrorism, he writes, are best described within a social relational framework that emphasises the shattering of social relations and inter-group polarization, one that challenges State guided definitions of what counts as normal and acceptable behaviour (Martin-Baró 1996).

Fanon's contribution to trauma studies is significant for reintroducing the material meaning of trauma into a term that had largely become psychologised, and for situating individuals within a social context. Martin-Baró's contribution to trauma studies goes further to advocate not a simple shifting from the individual to the collective but the existence of embedded traumas through which inter-personal relations, structures and societies themselves are viewed as traumatised by violence.

In contexts of collective suffering, individualised and psychologicised interpretations of trauma become reductionist. Eastmond (1998) for instance is critical of trauma's reliance on medical rather than religious or moral frameworks that position individuals as clients in need of therapy rather than citizens. Papadopoulos (2002) argues that to confuse the moral disgust of cruel actions or the socio-political analysis of political oppression with clinical positions reliant on trauma pathologises the very persons who survived them, and constrains individuals into the roles of victims rather than those of social actors. Bracken et al. (1997) critique those who choose to interpret experiences of socio-political violence through the reductionist lens of trauma that essentialises political experiences into medical symptoms, victimising rather than empowering the individual and transforming collective experiences of violence into individual stories.

In pre-genocide Rwanda, the term "trauma" was unknown to the ordinary Rwandan. Like in other African societies, the articulation of suffering was expressed with reference to imbalances among the worlds of the living, nature and the dead, and suffering was an embodied experience caused by imbalances of bodily fluids or the weakening of organs (Bagilishya 2000; Hagengimana et al. 2003; Honwana 1999; Taylor 1989).

The arrival of international donor agencies and humanitarian organisations soon after the genocide was significant to the introduction of trauma into Rwanda. Central to this process were two Unicef initiatives: a nationwide study on the effects of the genocide on children, which concluded that the majority of Rwandan children were "traumatised" (Gupta 1996), and the Unicef funded Trauma Centre, later renamed Psycho-social Centre, which mapped trauma onto the socio-political landscape of post-genocide Rwanda. More than a decade after the genocide, trauma has become a familiar term for ordinary Rwandans (Kaninba 2007; Schaal and Elbert 2006), who learn to recognise its symptoms and identify its causes on television and radio programmes and who encounter trauma counsellors in health centres, non-governmental organisations, and government bodies across the country.

Eyerman (2001) insists that "there is a difference between the trauma as it affects individuals and as cultural process" where "as cultural process, trauma is mediated through various forms of representation and linked to the reformation of collective identity" (p. 1). Similarly, Alexander (2004) points to the representational qualities of collective trauma: cultural trauma occurs "when members of a collectivity feel they have been subjected to a horrendous event that leaves indelible marks upon their group consciousness, marking their memories forever and changing their future identity in fundamental and irrevocable ways" (p. 10).

In the virtual space of the Kigali Genocide Memorial collective trauma is carefully arranged and displayed. The virtual visitor, prior to confronting bare bones, is warned of the potential vicarious traumatic nature that the images may provoke by the warning "these images can be shocking". The exhibited human remains are clean, neatly arranged in rows of skulls or long bones with small bones not in sight[2]. The skulls are voiceless, and yet their pain objectified by their wounds and cracked skulls, narrates their

[2] When the author visited the physical memorial sites, she was shown the small bones placed inside coffins.

ordeal. The laborious and painful task of cleaning, sanitising and re-arranging them can be seen as an attempt to re-construct memory through embodied ordering and also to the need to cope with the chaos and enormity of the tragedy. To order and re-arrange bones symbolises the collective attempt to order and contain the anarchy and intensity of the pain. To keep the memory alive, burials have been indefinitely postponed and these unburied corpses have been sacrificed for the sake of memorialisation. The State has appropriated them and foregone personal rights to burial in dignity. The impossibility of mourning and achieving some sort of closure, which burial rituals provide (Erny 2005) is foregone so that the visitor can experience the brutality of the tragedy. The remains are arranged separately, with skulls orderly positioned one beside the other on the same shelf and long bones together, marking the difficulty of integrating the tragedy[3], almost to indicate that suffering can be controlled in pieces but not integrated or brought to a complete closure.

As the virtual visitor looks hesitantly at the skulls and mass graves, she is struck by their anonymity and uniformity. No names are to be seen beside the dead as if their individual identities did not matter in the face of collective suffering. These skulls could belong to any place, any period, anybody as an echo of the timeless suffering of humanity rather than the specific suffering of Rwandans. Viewed through what Karnik (1998) describes as "an existentialist lens wherein suffering exists as a universal archetype" (p. 36), the Rwandan genocide becomes a prototype of universal suffering. The anonymous and medical arrangement of death for the gaze of the visitor constructs physical and social identities that deny rather than affirm the Rwandan citizen.

Survivors' testimonies are stories of open wounds, of negotiations with the memory of the past that is still alive, and the visitor empathises with them, trying to imagine what it must be like to have survived the tragedy. Survivors are portrayed as victims with whom we identify. Edkins (2003) comments that the State searches for a normalisation or medicalisation of the survivor and offers sympathy and pity in return for the surrender of a

[3] On a visit to the Nyamata Memorial centre, the guide was clearly preoccupied and emotionally concerned by the deterioration of the bones, openly exposed to the environment. He showed a worried expression while pointing to details of bones that had been eroded or eaten away by insects. He said that most of his family had been massacred at the site, and he repeated many times that it was difficult for survivors to manage. The sight of deteriorating bones (could they be those of his relatives?) acted as a daily reminded of the emotional erosion of the ongoing pain.

political voice through the construction of victimhood. Here too, the State is constructing its survivors as traumatised by the events or in need of help rather than as political actors in the nation-building project.

Overall, a similar organisation underlies the aesthetic representation of suffering in virtual space: standardisation is favoured over diversity, and individuality over collectivity. Social suffering is represented in its essence, deprived of localities and people, and conspicuously absent is the narration of the psycho-social trauma of Rwandan social fabric (Martin Baró 1988).

In KGM, the memory of the genocide and the suffering of the survivors are central to narratives of nation building. Through memorialisation the suffering of a section of Rwandan society—the Tutsi—comes to symbolise the suffering of the nation. Virtual memorialisation, similarly to 'real' memorialisation, fulfils political functions and acts as a vehicle for the consolidation of national projects. The politics of trauma and the aesthetics of the nation-building project are played out in contested spaces, in what is represented and also in what is unspoken and unspeakable, where the unspeakable can take the form of trauma, not merely for the individual survivor but for a collective post-genocide culture (Mandel 2001).

There are conspicuous absences and organised amnesia (Saunders and Aghaie 2005) in the KGM virtual site. Tadjo (2002) ponders about the unspoken pain of the Hutus who died during the genocide: "How many bones of moderate Hutus, those men and women who rejected genocide are mingled with those of the others?" (p. 17). Their death is silenced within the "national Tutsi genocide narrative" (Ngwarsungu 2008, p. 83). "Unspeakable" is the loss of life of those Hutus who died in the massacres committed by the Rwandan Patriotic Army (RPA) as it advanced towards the capital during the genocide (Des Forges 1999), who have no place in national memorialisation because they challenge the heroic image of the RPA as the saviour and victorious army that ended the genocide. The Hutu bones scattered throughout Congolese forest too have no national memorial for they are génocidaires and hence fail to elicit the empathetic identification of the international community. Hutus' open wounds fail to narrate their stories of pain because politics and ideology shape and enable the production of only some narratives (Ngwarsungu 2008).

National and transnational subjectivities in cyberspace

The Rwandan genocide elicited artistic productions of key images that have become the defining yet dehistoricised moments of the genocide for global audiences. Rwandan collective trauma has acquired symbolic potency as a prototype of human suffering amidst the increasing tendency to construct non-western suffering for the western gaze. Härting's (2008) examines the spectacle of the suffering African body to show that Western narratives rely on and produce what might be called *necropoeia*, an infusion of social, political, or physical death that negates rather than constructs the African subject (p. 64).

Representations of the genocide appropriate and repeat a modern and imperial discourse of authenticity, of the archaic and animalistic, and of sexual and savage intimacy to talk about Africa, thus expropriating and totalising African subjectivity to build Western communities of *humanitarianist* sentiment (Härting 2008). The author uses the term *humanitarianist* to refer to the cultural and narrative production of affect as a form of global capital, and argues that humanitarianism is a presentist political and moral strategy of intervention that fosters dehistoricised humanitarian sensibilities, and thus, necessitates a cultural inquiry into its modes of representation (p. 63).

Cyber-memorialisation transfers the narrative of the genocide from the space of the nation-state into the transnational space of global and diasporic dwellings. The virtual project is transnational both in authorship and audience. The collaboration between the Rwandan Government and Aegis, a UK based charity, makes the convergence of national and transnational agendas transferable and exportable. The humanistic agenda of the western non-governmental organisation contributes to frame the spectacle of the suffering Rwandan corpse as universal, humanistic, and thus neutralises political suffering. But setting up reality as a spectacle of suffering, Susan Sontag insists, "is a breathtaking provincialism. It universalises the viewing habits of a small, educated population living in the rich part of the world" (p. 110). Collines (in Härting 2008) makes an even stronger criticism when she claims that these images are a form of "new racism"—a transnational phenomenon dependent on media technology.

The Kigali Genocide Memorial virtual site offers the opportunity to enter a different spectacle, in which the main 'author' is a non-western entity—a

national African Government. The repositioned gaze challenges existing critiques framed within discourses of western subjectivities constructing African non-subjectivities. The Rwandan Government subjectivity is evident in the similarity of the messages that are created and disseminated in real and virtual memorialisation that use parallel constructions of the suffering Rwandan body to give meaning to the mediated past in relation to the present national project. Through virtual memorialisation, the State engages with a new imagined community that is transnational, computer literate, urban, and English reading. This imagined community excludes those inhabitants of rural Rwanda, including survivors and ordinary citizens, who are not computer literate, do not have access to technology, and speak Kinyarwanda or French. Memorial sites and commemorations mark bonds among individuals, and cyber-memorialisation revisits the boundaries of national remembrance through a process of exclusion and inclusion.

 Western technologies and western modalities of representation are then appropriated by the State to communicate the nation-building project transnationally and to win over international audiences to the validity of this project. The choice of cyberspace as a vehicle for memorialisation defines the non-western State as modern and technological, an image that the Rwandan Government is keen to promote through its development agenda that includes considerable investments in information, communication and technology.

The Rwandan Government inhabits and actively engages with the space of global and diasporic dwellings, and the choice of framing the genocide through the lens of *necropoeia* is not unintentional, I would argue. The representation of Tutsi suffering at the hand of extremist Hutus constructs the memory of the past through the lens of the victim-perpetrator dichotomy, which positions the Rwandan Patriotic Army as the outside heroic saviour who stopped the genocide of the Tutsi victims at the hand of the Hutu perpetrators while the international community stood by without intervening. The presentist tone of the narrative contributes to give legitimacy to the post-genocide political party in power since the end of the genocide, the Rwandan Patriotic Front (RPF), which is the political successor of the RPA. State subjectivity is played out through an authoritative moral voice that continues to remind the world that it also shares responsibility for the suffering of Rwandans. The virtual visitor encounters signs of admonishment like "never again" or 'the genocide happened as the world watched'. Therefore the viewer's empathy for the

suffering of Rwandans is accompanied by the feeling of guilt due to the inaction of the international community.

Necropoeia superimposes the suffering of the Tutsi during the genocide to the suffering of the Rwandan nation. In doing so, it de-legitimises the suffering of other Rwandans who perished in massacres. They are expelled from the genocide narrative of the suffering African body, and relegated to an invisible space through a process of organised amnesia. Counter-narratives of war, ethnicity, and local histories are silenced to become unspoken and unspeakable. The viewer is asked to condemn violence while ignoring a critique of the racialised political construction of ethnicities as an essentially modernist feature in Rwanda's postcolonial and post independence history of nation formation (Härting 2008).

Finally, cyber-memorialisation dramatises the Rwandan suffering corpse to enlist participation through financial contributions. The virtual KGM invites the viewer to become a Friend of Rwanda by donating a rose for the Memorial Garden or by sponsoring a name for the Wall of Names. The invitation to become a Friend of Rwanda is a call to become an active participant in the nation-building project of remembrance and to sponsor it not only as a viewer but as a participant. Therefore *necropoeia* allows the Rwandan State to reclaim its subjectivity and to appropriate *humanitarianist* sentiments for its own nation-building agenda.

Conclusion

In this essay I explored the aesthetic response to collective suffering in virtual reality and its relation to performative models of politics. Real and virtual memorialisation are related yet distinct forms of memorialisation where the latter does not simply reproduce the former in a different media but creates a parallel and complementary narrative of collective trauma to be consumed beyond the borders of the national community. Generally speaking, memorialisation has moved beyond merely being a rite and ritual for the victims/witnesses and their community to become a compulsively practiced politicised rite and ritual for the "international society" (Steele 2006), and cyber memorialisation is ideally positioned to achieve this transformation.

If old media and speech acts (Schabas 2000) were instrumental in the ideation and implementation of the genocide in Rwanda, new media is functional to the transnational diffusion of a new moral order in post-

genocide Rwanda. By appropriating western humanistic representations of trauma to represent genocide victims, a non-western Government positions itself within the space of humanitarianist sentiment, and uses it to strengthen the legitimacy of its nation-building project.

Non-corporeal memorialisation is reliant on the physicality of buildings, corpses, and bones to express embodied traumas of the past. However, these constructions are abstracted from 'lived' localities, and they deny the existence of contested and contestable spaces. In virtual memorialisation, post-colonial narratives of the abject African corpse are appropriated by those in power to refer to the dead and survivors. *Necropoeia*, the denied subjectivity of the dead, is instrumental to the reclaimed subjectivity of the post-genocide Government.

Virtual memorialisation then does not aim to heal and make trauma expressible or integrated but rather to promote medicalised and individualised representations of collective trauma that deny the socio-political suffering of the nation as a whole. Trauma is central to the genocide memory discourse because it allows to de-politicise socio-political suffering and to silence alternative contested traumatic memories. I therefore conclude with the observations that in contexts of violence and post-violence, reductionist appropriations of trauma representations that do not capture the suffering of the social fabric of society are problematic, and that the confluence of western humanitarianist sentiments with the politics of nation-building in virtual reality needs to be examined and critiqued.

Works cited

Agamben, G. 1998. *Homo Sacer Sovereign Power and Bare Life*. Stanford: Stanford University Press.
Alexander, J. C. 2004. 'Toward a theory of cultural trauma'. In J. C. Alexander, ed. *Cultural Trauma and Collective Identity*. Los Angeles: University of California Press, pp. 1-30.
Bagilishya, D. 2000. 'Mourning and recovery from trauma: In Rwanda, tears flow within', *Transcultural Psychiatry*, 37(3), pp. 337-353.
Bracken, P., J. E. Giller and D. Summerfield. 1997. 'Rethinking mental health work with survivors of wartime violence and refugees', *Journal of Refugee Studies*, 10(4), pp. 431-442.
Brown, T. P. 2004. 'Trauma, museums and the future of pedagogy', *Third Text*, 18(4), pp. 247-259.

Caplan, P. 2007. "'Never again': Genocide memorials in Rwanda', *Anthropology Today*, 23(1), pp. 20-22.

Caruth, C. ed. 1995. *Trauma: Explorations in Memory*. Baltimore: Johns Hopkins University Press.

Caruth, C. 1996. *Unclaimed Experience: Trauma, Narrative, and History*. Baltimore: Johns Hopkins University Press.

Chakrabarty, D. 2002. 'Museums in late democracies', *Humanities Research* IX(1), pp. 5-12.

Des Forges, A. 1999. *Leave None to Tell the Story: Genocide in Rwanda*. New York: Human Rights Watch.

Douglas, K. 2006. 'Cyber-commemoration: Life writing, trauma and memorialisation', unpublished paper, Life Writing Symposium, www.dspace.flinders.edu.au

Eastmond, M. 1998. 'National discourses and the construction of difference: Bosnian Muslim refugees in Sweden', *Journal of Refugee Studies*, 11(2), pp. 161-181.

Erny, P. 2005. *L'Éducation au Rwanda au Temps des Rois*. Paris: L'Harmattan.

Edkins, J. 2003. *Trauma and the Memory of Politics*. Cambridge: Cambridge University Press.

Eyerman, R. 2001. *Slavery and the Formation of African American Identity*. Cambridge: Cambridge University Press.

Gillis, J. R. 1994. *Commemorations: The Politics of National Identity*. New Jersey: Princeton University Press.

Gupta, L. 1996. *Exposure to War Related Violence among Rwandan Children and Adolescents*. Kigali, Rwanda: Unicef.

Hagengimana, A., D. Hilton, B. Bird, M. Pollack and R. K. Pitman. 2003. 'Somatic-panic attack equivalents in a community sample of Rwandan widows who survived the 1994 genocide', *Psychiatry Research*, 117(1), pp. 1-9.

Härting, H. 2008. 'Global humanitarianism, race, and the spectacle of the African corpse in current western representations of the Rwandan genocide', *Contemporary Studies of South Asia, Africa and the Middle East*, 18(1), pp. 61-77.

Honwana, A. 1999. 'Non-western concepts of mental health'. In M. Loughry and A. Ager, eds. *The Refugee Experience*. Oxford: Refugee Studies Programme.

IRDP (Institut de Recherche et de Dialogue pour la Paix). 2006. *Rwandan Tutsi Genocide: Causes, Implementation and Memory*. Kigali: IRDP and Interpeace.

Kaninba, M. C. 2007. 'Keeping alive the memory: genocide and trauma in Rwanda', *Gradhiva*, 5, pp. 62-75.

Kigali Memorial Center. 2004. 'Kigali Memorial Center', http://www.kigalimemorialcentre.org/.

Kuhn, A. 2000. 'A journey through memory'. In S. Radstone, ed. *Memory and Methodology*, Oxford: Berg, pp. 179-196.

Mandel, N. 2001. 'Rethinking "After Auschwitz": Against a rhetoric of the unspeakable in Holocaust writing', *Boundary* 28(2), pp. 203-228.

Martin-Baró, I. 1988. 'Political violence and war as causes of psychosocial trauma in El Salvador', *Revista de Psicologia de El Salvador* 7, pp. 123-141.

—. 1996. *Writings for a Liberation Psychology*. Cambridge, MA: Harvard University Press.

Mirzoeff, N. 2005. 'Invisible again. Rwanda and representation after genocide', *African Arts* 38(3), pp. 36-39.

Ngwarsungu, C. 2008. 'When wounds and corpses fail to speak: Narratives of violence and rape in Congo (DRC)', *Comparative Studies of South Asia, Africa and the Middle East* 28(1), pp. 78-92.

Karnik, N. S. 1998. 'The photographers, his editor, her audience, their humanitarians: How Rwanda's pictures travel through the American psyche', *Association of Concerned Africa Scholars Bulletin* 50, pp. 35-42.

Nora, P. 1989. 'Between memory and history: Les lieux de mémoire', *Representations* 26, pp. 7-25.

Papadopoulos, R. K. 2002. 'Refugees, home and trauma'. In R. K. Papadopoulos, ed. *Therapeutic Care for Refugees: No Place like Home*, London: Karnac, pp. 9-39.

Roberts, P. 2004. 'Here today and in cyberspace tomorrow: Memorials and bereavement support on the web', *Generations* 28(2), pp. 41-46.

Sontag, S. 2003. *Regarding the Pain of Others*, New York: Farrar, Straus, and Giroux.

Saunders, R. and K. Aghaie. 2005. 'Mourning and memory', *Comparative Studies of South Asia, Africa and the Middle East* 25(1), pp. 16-30.

Schaal, S. and T. Elbert. 2006. 'Ten years after the genocide: Trauma confrontation and posttraumatic stress in Rwandan adolescents', *Journal of Traumatic Stress* 19(1), pp. 95-105.

Schabas, W. A. 2000. 'Hate speech in Rwanda: The road to genocide', *McGill Law Journal* 46, pp. 141-171.

Steele, S. L. 2006. *Memorialisation and the Land of the Eternal Spring: Performative Practices of Memory on the Rwandan Genocide.* www.law.unimelb.edu.au/cmcl

Taylor, C. C. 1989. 'The concept of flow in Rwandan popular medicine',
Social Science and Medicine 27(12), pp. 1343-1348.
Tadjo, V. 2002. *The Shadow of Imana*, trans Véronique Wakerly.
Portsmouth, NH: Heineman.

MEMORIALS AND TRAUMA: PINJARRA 1834

JENNIFER HARRIS

Introduction

Memorial spaces so often appear to sit quietly in the landscape, as Huyssen (1995: 258) notes, the usual critique is that they appear to bury memory and to ossify the past. Many memorials, however, are spaces of almost overwhelming semiotic contradiction. They often seem to be frozen places of outdated memories about events that seem to have no impact on us but, if dissent is voiced, the historic and contemporary importance of the events is often revived. Memorials usually declare the past in a way that seems beyond interpretation by making a transcendent statement which appears to escape moulding by politics and time. Analysis reveals, however, that they are grounded in narratives—at minimum there are two narratives: a narrative of the original events and a narrative of the time in which they were memorialised. Memorials suppress their narrative aspects by insisting through sacred and solemn connotations that the events they recall are beyond debate and that they represent truths. Memorials are, therefore, places of intense semiotic conflict even if it is not apparent day by day. In this conflict reside latent performative qualities as viewers are positioned as audience and players.

The paradoxical character of memorials is the first place to start when thinking about their role in performative aspects of trauma. This paper emerges from my thinking about attempts to deal justly with sites of historic conflict between coloniser and colonised in Australia. Tunbridge and Ashworth argued as long ago as 1996 that a process was needed to deal with contested heritage. Heritage work, therefore, ought to move on from simply identifying points of conflict, to finding ways of responding to memory problems. De Jong and Rowlands (2008: 133) have high ideals for heritage saying that it can be a "technology of healing", similarly, Meskell and Scheermeyer (2008: 156) argue that it can be a therapy. These

ideals are far removed from most heritage achievements which simply record or preserve a memory in a place. This paper argues that memorials are always sites of narrative and performance, even if sometimes muted and that now is the time for that latent quality to be identified and pushed to the foreground of memorial work. Moral obligations to Reconciliation in Australia demand that the performative aspect of memorials be developed with great sophistication and in full awareness of the textual elements which compose them. This paper analyses the textual components of types of memorials which mark contested heritage. It does so with the belief that heritage work needs to practice problem solving and that the performative aspects of heritage offer scope for interactive healing.

Attempts to memorialise the 28 October 1834 events at Pinjarra, a small town about an hour's drive south of Perth in the Shire of Murray, offer an opportunity for Australia to begin to deal justly with some aspects of the past which are disputed fiercely. Along the banks of the Murray River, only five years after British settlement of the Swan River Colony, an event occurred which resulted in the deaths of 15 to 80 Binjareb people and one British participant. For the British, it was the place at which south-western Indigenous resistance to colonisation was overcome (Contos and Kearing, 1998; Richards, 1993: 8) in what has been referred to most often as a "battle", a word which many insist today is the correct description. For the descendants of the 1834 Binjareb people and their supporters, the event could not be further from a battle. It is a place known through oral history as an infamous "massacre" site in which, in the historically-debated absence of the young Binjareb warriors (Statham, 2003), mostly women, children and the old died in a disgraceful ambush which all but destroyed their society and has carried intergenerational trauma (Contos and Kearing, 1998; Contos, 2002).

A memorial has been erected, but it bears no words. The local council, Shire of Murray, supports development of the site to tell the story, but an impasse has been reached about what to call that event. The Council insists through a formal resolution that the word "battle" is accurate while Indigenous people and their supporters insist on "massacre". Desire to mark the 175th anniversary in 2009 put pressure on both sides to begin to deal with the naming of this event. This paper is used to think through the blockage in Pinjarra by exploring the enormous emotional, political and textual challenges that are encountered when attempts are made to memorialise events which are so bitterly contested. The first half of the

paper consists of an extended analysis of two other conflictual events and attempts to memorialse them. It then looks at the potential of the Pinjarra case to develop performative qualities which would enable a contested site to remain rich in meaning, bear the legacy of the interpretation conflicts and contribute to Reconciliation.

Challenging memorials

Early memorials to colonial conflict were statements by the coloniser about Indigenous "treachery" or European "bravery" in the face of Indigenous "aggression". These memorials are dotted about the Australian landscape, but it was not until very late last century that responses emerged that insisted on counter-narratives.

The *Explorers' Monument* on the Esplanade in Fremantle illustrates a provocative response. The memorial's 1913 words:

> This monument was erected by CJ Brockman as a fellow bush wanderer's tribute to the memories of Painter, Harding and Goldwyer. Earliest explorers after Grey and Gregory of this "terra incognita". Attacked at night by the treacherous natives they were murdered at Boola Boola near La Grange Bay on the 13th November 1864. Also as an appreciative token of remembrance of Maitland Brown one of the pioneer pastoralists and a premier politician of this state. Intrepid leader of the government search and punitive party. His remains together with the sad relics of the ill fated three recovered with great risk and danger from lone wilds repose under a public monument in the East Perth Cemetery. "Lest We Forget"

In 1994 an opposing text was juxtaposed to the original. The new text is a counter-narrative.

> This plaque was erected by people who found the monument before you offensive. The monument describes the events at La Grange from one perspective only, the view point of the white 'settlers'. No mention is made of the right of Aboriginal people to defend their land or of the history of provocation which led to the explorers' deaths. The 'punitive party' mentioned here ended in the deaths of somewhere around twenty Aboriginal people. The whites were well-armed and equipped. Lest We Forget Mapa Jarriya Nyalaku

The memorial has become a powerful place for several reasons. First, because it alerts us to the fact that the original words on the memorial construct a narrative, although they purport not to do so, as they seem simply to record facts. Secondly, the 1913 words link implicitly the actions of the punitive expedition to the bigger story of the development of

pastoralism and good government in WA. This story claws back the story of European-Australian progress and harmony from the story of violence. This story of progress underlies most memorials and offers narrative closure to otherwise unresolvable events. The implicit narrative of harmony and progress, belief in the ultimate good of the society, is one of the key factors which produces an often numb look at memorials because it is a static and repetitive story. The increasing difficulty, however, of stating the repeated narrative closure in a period of historic revisionism opens up textual possibilities for alternatives. Thirdly, the memorial itself is now both a narrative and a counter-narrative against itself. Fourthly, the continuing controversy over the two narratives and frequent theft of the 1994 counter-narrative plaque mean that this place is a place of high drama as visitors can see the two sides play out a conflicting drama of interpretation.

It is certainly a raw place in which conflicting views of the La Grange events co-exist in continuing historical and political tension. The site thus offers a dramatic performance because a singular vision of the past is demonstrated as impossible; the viewer sees performed the conflicting narratives. The memorial has the effect of encouraging performance from its viewers—or vandalism—as the newer plaque is often stolen; on one occasion the head of Maitland Brown disappeared from the top of the monument. It is not, therefore an ossified memorial, or a place where nothing happens. This is a vivid and active place in which the conflicting versions of history are played out in the middle of the town's most popular park.

It is evident that this kind of lived-out drama at a memorial site is not liked by everyone, maybe because it is aesthetically untidy to attach a counter-narrative after the construction of a memorial. More likely, however, is the discomfort aroused by a memorial of conflict in the heart of the City of Fremantle—a city, after all, with a highly developed sense of identity and social pride. There are signs, therefore, that there is now some re-thinking of monuments of conflicting histories so that they will include oppositionality from inception.[1] The desire to represent oppositionality in

[1] Tunbridge and Ashworth (1996: 219) describe a similar approach in the "inclusivist" approach of settler societies with the example of Canada: "the incorporation of all perspectives into a patchwork quilt called Canadian heritage". This desire to construct an inclusive society is achieved through subordination of diversity.

the same memorial results in what I call a "twinned memorial".[2] An example of this thinking is found in an interpretation plan for Bootenal Spring on the Greenough River 400 kilometres north of Perth and 18 kilometres south of Geraldton.

> Bootenal Spring was the site at which a violent incident occurred in July 1854. The local Indigenous people, called Naaguja, have an oral history version of the event which includes the slaying of many Indigenous people. The written European version, however, refers to driving out Aborigines, but not to their killing. (Latitude Creative Services, 2007: 5-6)

The Plan suggests that a memorial that states both opposing histories would be advantageous to Indigenous and non-Indigenous Australians today.

> The contradictory accounts of events at Bootenal Spring site provide a valuable opportunity to acknowledge and provide meaningful interpretation in a unique and significant landscape setting, of the conflicting histories and fatal consequences for Indigenous and settler communities on the mid-west Western Australia frontier. (Latitude Creative Services, 2007: 6)

The plan recommends that:

> The Bootenal Spring site should be supported with thought provoking interpretation to acknowledge the violent climate and conflicting versions of Indigenous and non-Indigenous history of the Greenough district. (Latitude Creative Services, 2007: 7)

This highly sympathetic response to the tragic events of colonial expansion is evidence of growing resistance to the triumphant, imperialist history of the settlement of Australia, but it offers only "thought provoking interpretation to acknowledge" the various versions of events. Although the plan emphasises the importance of engaging local Indigenous people to play a key role in developing tourism and the creation of a monument at Bootenal Spring, it does not move beyond saying that there are two conflicting histories. The plan thus proposes implicitly to harness and control the drama by making conflicting statements central to its conception. This has the effect of attempting to deny the performative quality of the possible drama because it *contains* the conflict. If the aim of

[2] I differentiate this type of opposition-bearing memorial from the twinned memorial style of Oxford and the Nazi death camp, Belzec—a piece of English ground marked out in the dimensions of the camp, 300 metres square, for one week in January 2010. (www.twinned.org/parks/index.htm)

the finished monument is to state the two histories, it thus poses conceptual and political problems. Certainly, visitors would be alerted to the atrocity—and probably shocked—this clearly would be a good outcome. But, by containing the two accounts of the events neatly in the one space, it is unlikely that the memorial would push visitors to think of the legacy of the events today.

A model of the western democratic nation with its idealised balanced system of government and opposition, suggests that transferring this model to a memorial might be a productive idea for dealing with historic conflicts that continue to be lived out in various ways in contemporary society. Setting out to construct a memorial with the intention of embedding oppositionality in the construction right from the start, by stating the two histories, could seem like a rational and just way to treat memorials to contested anguish. Memorials, however, are not rational spaces because in many cases they are about trauma and any attempt to make them conform to the neat framework offered by the institutionalisation of two opposed statements is an unrealistic attempt to narrate trauma. Controlled statements of traumatic memories are most unlikely to produce a result which expresses adequately the trauma of the experience especially if there are opposing sides because such statements imply a radical equality of interpretation of the past. Two centuries of European control of history has clearly not delivered a just society to Indigenous people.

To re-tell the history of dispossession and violence now, by elevating the fact of the historic moral achievement of acknowledging conflicting histories, is to avoid implicitly making moral judgements about the continuing lived effects of these atrocities. I argue this despite noting that the Interpretation Plan says that it draws on historiographical concepts encouraged by the Council for Aboriginal Reconciliation, such as the pursuit of

> a shared sense of history between Indigenous and non-Indigenous Australians. To share history involves changing the way Australian history is constructed and represented. It involves non-Indigenous Australians identifying with aspects of Indigenous Australians' cultures and histories. It also involves Indigenous Australians sharing their knowledge of history in this country. (Latitude Creative Services, paraphrasing Clark (1994), 2007: 9)

I argue that such is the strength of the underlying narrative of progress and order at memorials, that it insists on asserting itself endlessly even in a

political climate which is favourable to Reconciliation. It is conceptually difficult to adhere to the spirit of Reconciliation while maintaining the very old narrative about social progress which underpinned so much colonial expansion and dispossession of Indigenous people. It is evident that the desire to juxtapose contrary statements is a genuine act of good faith with the aim to state opposed positions and to move towards resolution and a more peaceful future. The implicit insistence on the radical equality of statements, experience and outcome, however, can appear as an unintended act of imperialism; it cannot express the trauma and certainly does not resolve it. Why?

Textual elements of memorials that try
to represent opposing sides

A key reason for the failure of balanced, opposed statements to express trauma is the textual difficulty of having someone adopt the speaking position of the one who chooses the statements for the memorial. If a "super voice", a form of omniscient narrator, speaks the opposing narratives, it follows that both the Aboriginal and the European stories risk being subordinated to another superior and hegemonic story from which the twinning emanates. Conservative Europeans in Australia have always held the position of protagonist in their massively dominant versions of colonisation and, therefore, are at only slight risk of being objectified as they have been the ones controlling the extension of the protagonist and antagonist positions to others. For Indigenous Australians, however, twinned memorials could result in a double denial of their status as protagonists. They were denied, first, in the preceding two centuries of history telling and then are denied again through the twining process that subordinates their history to a larger history of European progress—an inevitable trajectory of memorials noted above and discussed further below.

It is more than ten years ago that Jacobs (1997: 203) described the impact of revisionist historiographies as celebrating "those moments when Aborigines broke out of the subordinate positioning conferred upon them by the colonial order and entered onto the historical stage as protagonists". The reconstructions of the histories of resistance (see for example Macintyre and Clark (2003) and Reynolds (1981; 1998)) have, step-by-step, written new histories and rewritten or challenged existing versions. It is now accepted by many historians that an Aboriginal version of colonial clashes ought morally to be documented. Thus the history of Australia is

being transformed both in terms of content and construction as the narrating of those stories is ideally heard through Aboriginal voices.

The problem of twinning lies in the effect it has of incorporating the opposed narratives into a single seemingly coherent and harmonious text even if this is not the intention. This occurs unwittingly through the aesthetics of the site which do not permit a secondary voice to disrupt the memorial, hence there is rarely any intention to allow in the physical construction for other and future stories to be written. By comparison, the *Explorers' Monument* has an additional plaque which disrupts the aesthetics and the story of the original.

Incorporation occurs also because of the detached voice of the expert, that is, the constructing voice of the memorial, which produces a new, unarticulated narrative. This narrative emerges from the two opposed narratives and it says "the new, superior narrative is that our society can embrace and nullify the oppositionality of historical narratives; this new narrative is about social cohesion". This implied hegemonic narrative is spoken by a disconnected and disembodied omniscient narrator. The twinned memorial, therefore, risks losing the raw pain activated by the rubbing up against each other of the two narratives because it unwittingly erases them with another story. To do this, it assumes a visitor who feels safe in the exercise of social justice of his or her European-based society.

The appearance of the super narrative is a problem also because it jumps over the necessity of an apology. Daye (2004) argues from South African apartheid history that the moment of apology is an essential step in a forgiveness and healing plan and that forgiveness starts with memory and moral judgement (Daye, 2004: 20). It is not possible to replace trauma with a hegemonic story because such a story does not resolve trauma, to the contrary, it functions to mask it. Daye argues that the first step is for injustice to be named; "the second essential act is an apology or confession in which the guilty party admits to the wrong done and acknowledges its moral indebtedness to the party it has harmed. Very often at this stage the guilty party offers excuses or explanations along with the admission of guilt" (Daye, 2004: 7-8).

Plans for twinned memorials could be understood as a partial attempt at apology and are certainly effective for alerting visitors to the existence of hidden histories and in this they should be applauded. The revelation of the twin narratives, so often about violent events of celebrated nation

building, could be a moment of productive shock for the visitor. The soothing, hegemonic narrative, however, would undermine the memorial's positive aspects with the calming statement that the current society is good, especially so for the act you see before you, that is, for acknowledging this acrimonious past event. Further, the super narrative in a twinned narrative memorial could end up stating implicitly and with unwitting irony that the new society was not connected to the violent, former society and proof of the disconnection resides in the very fact of the memorial's existence which is a sign of the contemporary moral courage needed to state the shameful past.

Nora's (1989) analysis of the arrival of formal history being the moment when real, lived, organic memory fades is important in understanding the impact of the super narrative. The super narrative not only replaces other narratives, but it also directs us how to read the past, that is, as a series of events which are finally resolved and dissolved into an agreed-upon story. When that super voice narrates the bigger story it removes subjects from their stories as they are no longer the ones who are permitted to speak. This is a serious textual problem as it removes participants and descendants of participants from their own story and works against the story having any power today.

The fact that the emergence of the super narrative is virtually naturalised in heritage activity is illustrated vividly by the speech made in 2008 by Heritage Minister, Peter Garrett on the occasion of the inclusion of Myall Creek on the National Heritage List. Mr Garrett attended a memorial service to mark the 170th anniversary of the murder of approximately 30 Aboriginal people by local stockmen. The atrocity is distinguished in Australian history because "It was the first and last time the Colonial Administration intervened to ensure the laws of the colony were applied equally to Aboriginal people and settlers involved in frontier killings" (Garrett, 2008). The execution of the murderers was greeted with anger by the coloniser community and such justice was not meted out again.

Garrett's remarks move from setting out historic details of the conflict and early responses to it to broader, super narrative statements about the success of contemporary society.

> The conflict of 170 years ago has given way to a new understanding of Aboriginal people's attachment to the land. Recognition of this attachment and the sometimes brutal ways in which Aboriginal people were dispossessed are important in the journey of Reconciliation. The Myall

Creek Memorial was established in 2000. The fact that the descendants of some of the people massacred on that horrific day in 1838 and the descendants of those charged with the crime come together in their own peaceful and personal reconciliation gives me great hope for our country and makes me very proud to be an Australian. (Garrett, 2008)

There is no doubt that national heritage recognition of the horror of the events at Myall Creek is a goodwill landmark in colonial and heritage history. The ease, however, with which the Minister moved from the conflict to the super narrative of the achievements of Australian society demonstrates the political, philosophic and textual effortlessness with which the retelling of the tragic event was so swiftly subsumed into the dominant narrative of national progress. Naturalising of the super narrative has the effect of nullifying the continuing effects of violent colonial relationships and contributes to disregard for Aboriginal versions of the past. A memorial that contains oppositionality thus can virtually erase troubled dissonant histories by replacing them. By contrast, a memorial containing a counter-narrative added after the memorial was constructed, does not produce a super, erasing narrative and is more likely to represent bitter dissent. The counter-narrative memorial achieves this by permitting the telling of a counter-narrative in defiance of the first narrative and without resolution. The two narratives are not muted by the appearance of a dominant voice which calms their histories and produces a restabilised historical position. The 1986 *Monument Against Fascism* by Jochen and Esther Gerz is a good example of productive clashing of stories. It was constructed in Hamburg, Germany with the intention of gradually being lowered into the ground and finally disappearing. On a pillar encased in soft lead, visitors were invited to perform by writing, and many did so, even supporters of fascism with new messages of hate added to those of heartfelt sadness. A memorial was produced, therefore, which over time came to bear the drama of its own opposition. Young says:

[I]ts aim is not to console but to provoke; not to remain fixed but to change; not to be everlasting but to disappear; not to be ignored by passersby but to demand interaction; not to remain pristine but to invite its own violation and desanctification; not to accept graciously the burden of memory but to throw it back at the town's feet. (Young, 1993: 30)

In this monument, performance was activated in such a confronting way that it could almost have been considered dangerous and a risk to public safety. Conflicting stories were permitted to be told even though the intention of the memorial, as understood from its title, was to speak against fascism. In allowing more stories than that single narrative to be

spoken—but crucially refusing to control them—the monument became exceptionally strong. It did this by laying bare violently clashing stories, refusing to resolve them and asking visitors to perform.

This kind of memory work is active and fluid, refusing to fix meaning and even risking exposure to the pain caused necessarily by colliding in the same space with an opposition. The brutal juxtaposing of such terrible feelings and memories is one of the most powerful ways of encouraging visitors to engage with some aspects of history. By contrast, a memorial that denies its opposition or attempts to subordinate it to a hegemonic story of social success loses this extraordinary opportunity to allow the monument actually to perform some of the reality of the original violent encounters. The rarity of counter-monuments highlights the continuance of the overwhelming desire to produce neat thematic histories that subordinate discontinuous and abrupt events to linear and controlled versions of the past. Foucault argues for the necessity of practicing genealogy rather than this kind of controlling history; genealogy allows for "the singularity of events outside of any monotonous finality" (Foucault, 1977: 139) so that the twists and turns of discontinuous stories are retold through multiple, inconsistent versions. The duty of genealogy "is not to demonstrate that the past actively exists in the present... to follow the complex course of events in their proper dispersion is to identify the accidents" (Foucault, 1977: 146).

As the particular events associated with most Australian memorials are subordinated to bigger stories, it is politically and emotionally confronting to have iconic stories challenged. In the case of Pinjarra, one of the most difficult aspects is the fact that the expedition against the Binjareb was led by no less a person than the governor himself, Governor James Stirling, a person who elsewhere is associated with many apparently honourable actions in founding the Swan River Colony. If Foucault's genealogy is practised, then Stirling's participation in the killing of Binjareb people, including children, needs to be told as part of the wider history of the state.

Related to genealogy is the concept of trauma time and linear time developed by Edkins (2003). It is derived from an analysis of the way that memory is used in politics and offers insights into why the two types of memorials discussed above are textually so different. Linear time is the time with which we are most familiar in the west and complements the process of most narratives with their sequential structure. Edkins argues that it is used by the nation state, it is the "time of the standard political

processes... with the continuance of the nation state... we know almost in advance that such events have a place in the narrative" (Edkins, 2003: xiv). By contrast, trauma time concerns disruption.

> It doesn't fit the story that we already have, but demands that we invent a new account... until this new story is produced we quite literally do not know what has happened: we cannot say what it was, it doesn't fit the script - we only know that 'something happened' (Edkins 2003, xiv).

Therefore, a twinned memorial re-tells opposing narratives as if they were equalised works in linear time, because the disruption caused by the opposition of the stories is smoothed over by the super, harmonious narrative of the state. A memorial bearing a counter-narrative, such as the *Explorers' Monument*, however, works in trauma time as the disruption is never resolved and the impossibility of its resolution is one of the main messages of the memorial. Trauma time is very difficult to live in and heritage responses to the 1834 events at Pinjarra illustrate the great tension that is generated by living in this time with its lack of a big, comforting narrative.

Productive trauma in Pinjarra

The exact location of the events at Pinjarra is not fixed, but accounts state that it took place along the edge of the Murray River. Despite the absence of a verified site, the general vicinity is tense with conflicting views of the events and the generalised site has shown great resistance to a heritage resolution, a situation which exasperates Indigenous and non-Indigenous alike. In the non-resolution, however, there is a rich and productive dramatic tension which has been instigated by neither party, but results in a site of strange historic power. The history of the events which occurred five years after the commencement of settlement of the Swan River Colony can be grasped by being guided by Foucault's (1977) insistence on genealogy as a more truthful approach to past events than a history which tries to produce a coherent thematic whole.

The events have a range of interpretations. Richards (1993: 8) quotes a frightening eyewitness account of the slaughter; George Winjan said: "They rush camp: they shoot-em man, shoot-em gins, shoot-em picaninnies and they shoot-em dogs too". Given the savagery described in this quote, Richards summation is particularly callous and even dismissive of the event: "The upshot of the affair was the spirit of the tribe was broken and settlement could, and did, proceed at a fairly rapid pace soon

afterwards... Although several "depredations" occurred and soldiers were at times despatched... the trouble decreased" (Richards, 1993: 8). In contrast, Mulvaney (1989: 170) says that an Aboriginal oral tradition which was recorded in 1973 suggested that the deaths could be as high as 750 thus illustrating the trauma felt by Indigenous people. Contos and Kearing (1998) are outraged by the incident and the European history telling that followed. It took until the 1970s and the rise of Aboriginal social justice activism for the site to be memorialised in any way by which time the use of the word "battle" to describe the events was entrenched. First accounts, however, describe the events differently and include "rencontre", "salutary example" "skirmish", encounter", "affray", "affair" and "chastisement" (Contos and Kearing, 1998: 64). Despite such an array of choices the word "battle" seems to have become the usual title from quite early after the events (Contos and Kearing, 1998: 64). Noteworthy is Fletcher's (1984: 1) observation that the event was not an isolated incident as there had been many violent encounters in the previous five years and yet this is the one chosen for remembrance and history telling.

Contos and Kearing (1998) record attempts to memorialise the site. From 1975 to 1978 a plaque commemorating the event was attached to a tree by the river, but it disappeared inexplicably. In the 1980s the Murray Districts Aboriginal Association (MDAA) worked towards establishing a memorial in Pinjarra with support from Bicentennial funding, but the Murray Shire would not accept proposals for a memorial. The MDAA then campaigned for ten years for acceptance of the idea of erection of a memorial. In 1991 the first "Back to Pinjarra Day" was held to mark the anniversary of the 1834 events and has been held several times since. In 1992 the area was entered on to the Register of the National Estate with both names recorded: "Pinjarra Battle Memorial Area" and "Pinjarra Massacre Site" (Contos, 2002: 126). On 28 October 2001 a memorial was dedicated by WA Governor, John Sanderson. It consists of a large boulder of adult head height erected on the edge of thick brush by the river's edge. It is surrounded by a circular paved area in which are inset four mosaic medallions depicting black and white figures in the landscape, but it has no plaque to explain to the visitor what this place means because no agreement could be reached on the description, "battle" or "massacre". The visitor can see, however, four screw holes on the memorial stone where a plaque was attached briefly before being removed.

In many ways, this event could be compared to Myall Creek where a representative of the government was accepted by Indigenous people as an

appropriate person to unveil a memorial to a great tragedy. Similarly, the place is listed as a place of national importance. The absence of an explanatory sign, however, makes the site mysterious and incomplete. In its present unkempt state, the visitor comes across it while walking in a narrow clearing between the river and McLarty Road. Its apparent silence raises questions - what is this place about? Why does it have no sign?

The answer lies in the fact that this is a place of double trauma. First, it is obvious trauma for the Indigenous people who have insisted on the correctness of their oral history against almost two centuries of insistence on a European version. Secondly, it is a site of trauma for parts of the European population which are caught in the awful situation of having to contemplate the revision of their history and all of the values associated with it, especially fairness and justice. Humphrey (2002) and Daye (2004) argue that nightmarish details of the past must be confronted by the whole society as part of a healing strategy. "The rationale is to prevent the past returning by producing a stored public memory of atrocity and terror" (Humphrey, 2002: 105). Daye (2004) goes further arguing that for political forgiveness to occur on a nation wide level it is necessary to revise

> The very myths and narratives that tell a people who they are and who their friends and enemies are... for movement towards political forgiveness to occur, charismatic actors and creative thinkers will have to bend these symbol systems away from enmity and toward affinity. (Daye, 2004: 11)

So very far are some parts of the Pinjarra population from confronting the past that in December 1998 the Shire of Murray took the extraordinary step of voting on a motion which was carried eight to two stating that the Council does not recognise the word "massacre" and that the area must be known as "Battle of Pinjarra Memorial Area". Despite protests, the Council has not rescinded the resolution and continues to assert its view of history. In 2007 the Council placed a plaque on the memorial. It disappeared but not before the Heritage Council of Western Australia had objected to the wording saying that it was not consistent with the statement of significance for the site (*Mandurah Coastal Times*, 22 August 2007). Acting CEO, Peter Black told me on 8 October 2008 that the Shire wants to recognise the area.

> It is part of the history here and should be properly recognised. The only issue has been the same one right from the beginning: local Indigenous community interests call it "massacre", and Council, by resolution, says

> that it is a "battle", this is the only issue. Most Councillors have been on
> Council for a considerable time - the issue has come up many times, it has
> always been the difference between "massacre" and "battle".... The issue
> is just sitting at the moment waiting for someone to pick it up and run with
> it.

Unfortunately, for the potential political and social power of a united
Indigenous voice, there is no single "local Indigenous community", it is
split into opposing factions, but this is not the reason why the Council has
difficulties with the memorial.

Why is the Council intransigent? First, the standard answer is that the
word "battle" suggests dignity which Contos and Kearing (1998: 64)
reject. They restate accepted definitions to show that the two words
describe different things. "The New Oxford Illustrated Dictionary gives
the following definitions of the terms: battle: *n.* combat, especially
between large organised forces... massacre: *n.* the indiscriminate killing,
especially of unresisting persons... (65). There was no "battle" they
argue, but an ambush which resulted in a massacre of people who were not
expecting to fight and whose warriors were away at the time. The
Council's insistence on the word "battle", therefore, seems to be a
desperate moral assertion that the event was fair by combat standards and
has nothing immoral or disgraceful associated with it. Statham (2003)
refutes much of the argument of Contos and Kearing (1998) arguing that
Stirling acted in a moral way by the standards of the day. She says that he
tried to have Indigenous matters dealt with by civilian rather than military
institutions; that he tried to lessen the impact of invasion on the Nyongars;
that he had not planned a "major onslaught" (190) and that Binjareb
warriors were certainly present rather than mostly women and children
(191). Secondly, battles for Europeans, especially in the nineteenth
century, are often associated with nation building and national defence and
are often constructed as glorious events. Hence, battles such as Trafalgar
and Waterloo, not so distant in 1834, are part of the myth of English
heroism. From the late nineteenth century, Australia was engaged in
intermittent international combat and, certainly from the time of Gallipoli
in 1915, battles were used to construct Australian national identity.
Consequently, the word "battle" is clung to fiercely, even in the twenty-
first century. It would be socially, culturally, historically and emotionally
dangerous to lose the word because so much identity is built around it, but
as Daye (2004) argued it is imperative that the myth that created that
identity is exposed and challenged.

For Contos and Kearing (1998) the site has enormous power.

> That the Pinjarra Massacre occurred is indisputable... it therefore stands as
> testimony to the treatment of Aboriginal people by the European invaders.
> It also stands as proof of the powerful resistance that was mounted by
> Aboriginal people against the invasion. So successful was the resistance of
> the Binjareb Nyungars that the head of the Swan River Colony saw the
> only "solution" being to "wipe them out". (Contos and Kearing, 1998: 63)

The current situation is one which perpetuates the 1834 trauma, becoming
ever more complicated. In an interview on 17 October 2008, Karrie-Anne
Kearing, the daughter of Theo Kearing who co-authored with Natalie
Contos (1998), reflected on the frustrations of memorialising the site from
the Aboriginal perspective, an impasse made all the more frustrating and
ironic given that much of the information about the events are drawn from
European accounts.

> A plaque was put up, but it lasted about a month, it said "here a battle
> happened" - just crap, it did not mention women and children... We tell
> them what we know from European diaries which say 21 deaths. They
> should put it down and get over it, it is listed as a massacre, it is their
> people who wrote it down. They are not going to suffer today, we are not
> going to take their homes, we just want respect and acknowledgement.
> They've got memorials in other people's countries like the Kokoda Track,
> in places they invaded. They invaded this mob's country.

It is noteworthy that Karrie-Anne Kearing says that Europeans should "get
over it" thus implying that she recognises that it is traumatic for Europeans
to have to admit to an atrocity.

In an interview on 6 October 2008, Lisa Gardiner, manager of Community
Services in the Shire showed her frustration with both the Council and the
split Indigenous community:

> I use the word "massacre" but I get chastised by Council, I must take the
> Council stance. The difficulty is that there is a disconnected Indigenous
> community, two distinct factions, it is awkward and uncomfortable, we
> give offence if we talk to one before the other, we can't please anyone, it
> is bogged down.

She sees possibilities for the town if the interpretation of the site could be
agreed upon:

It would make a wonderful entry statement, many interpretative possibilities… no matter what we do it gets trashed, we don't know who does it, now we simply mow… it is a poison chalice.

The "poison chalice" concept reflects the current trauma. Trauma as an open-ended crisis is dealt with extensively in trauma literature - the trauma cannot be expressed nor resolved. The metaphor of the wound that cannot heal is used by Kaplan (2005: 135) in her analysis of Tracey Moffat's *Night Cries*. Kaplan identifies the potential of this expression of trauma in her discussion of on-going mourning—mourning with no resolution. The most productive use of the Pinjarra site, therefore, at this moment of Australia's post-colonial history might be in its power as a place of no healing. If the site is conceptualised as a festering wound it can be seen to be in a state of on-going injury which elicits attempts by Indigenous people and their supporters to heal, again and again. It is thus a place of continuous intergenerational trauma. The site has emerged as an incomplete memorial place with strong performative qualities continuously provoking action. Ironically, it is an unkempt looking place where some people with little local knowledge set up camp, while for others, it is a sacred place which lacks proper signage.

Two forces are clear: Europeans who cling to the word "battle" are trying to control the meaning of the site. For Aboriginal people, however, the place is implicitly a performance zone. I cannot say whether this is their long term vision for the site, but it is how it functions at the moment. Its performative aspects include the drama of the Indigenous refusal of a plaque which bore the word "battle"; their refusal ensured the issue of interpretation continues to be debated. The 18 year history of "Back to Pinjarra Day" is one of the activities around the site with a strong tradition of gathering to mark the day. On 28 October 2008 local Indigenous people arranged a basketball game for under 18 year olds from Perth and the Pinjarra area. Following the game, the wider group gathered at the rock memorial for a barbeque and to listen to speeches. Information boards were erected to give background details to visitors. The Vietnam Wall site in Washington DC is alive with visitors who leave personal mementoes to mark the loss of men in the war, so too the Pinjarra memorial is a site of activity and the performance of everyday life as commemoration. Despite the success of many previous memorial days, plans for the bigger175[th] anniversary in 2009 did not proceed smoothly. Although the Council staff said that they wanted to assist, Karrie-Anne Kearing felt rebutted.

> I wanted to hold a concert, but was told that the music would be too loud
> for the old people's home near by and the environment manager says that
> trees could fall on people; I am looking for another place. I might run a
> film festival through Fairbridge, but I really want it at the site... I feel that
> I am getting nowhere with the Council, old farmies (farmers) run it they
> think that we are going to take their land. (Karrie-Anne Kearing, interview
> 17 October 2008)

The idea of the co-existence of everyday performance and memory
emerged strongly from Kearing's plans. They were in the spirit of the
1990s plans for the memorial which were explicit in the intention not to be
divisive but to be a positive force for the wider community.

> MDAA intend to involve the local community, both Indigenous and non-
> Indigenous, in developing the memorial area dedicated to the people who
> died in the Massacre. A series of community workshops will invite input
> from different sectors of the community, including schools... it is intended
> that this will facilitate a sense of pride and ownership amongst the local
> community. (Contos and Kearing, 1998: 114)

Despite disagreements, the 175th anniversary on 28 October 2009 was
commemorated and attended by a few hundred people on a cold, wet,
windy day. Both opposing Indigenous sides erected marquees and
arranged performances and speeches. The popular commemorative
basketball match was played again. Members of the local shire staff
attended both sides of the commemoration, but as audience not as
participants.

Indigenous actions are clearly aimed at keeping the site vibrant and
performative, but those who resist are ironically contributing also to its
performative aspects. The sign at the entrance to the town reads: "Pinjarra
Historic Town 1834", it seems most ironic if the arriving visitor knows
about the violence of the same year because the idea of the sign connotes
the opposite—a town of harmony, clearly an assertion of the super
narrative. Historic markers along a different town section of the river
record other events which have not achieved the fame of the 1834
massacre but are given precedence in the landscape. For the visitor who is
informed about the long running dispute and the history of the violence the
town seems to handle its history in an unintentionally ironic manner which
has the effect of highlighting the unresolved trauma of 1834.

Conclusion

The Pinjarra site is a place of drama/trauma. Memory of the past is used as the centre for other events which could function quite well without a link to the past, but act powerfully to connect the everyday to the past thus keeping memory alive. Basketball matches, concerts and theatrical performances are examples of taking ordinary events and endowing them with special commemorative meaning by linking them to past events. Sadly, at Pinjarra these events are occurring because of the lack of resolution about the massacre; unwittingly and ironically they have the effect of enhancing the site and calling our attention to past and present injustices in a strong way.

Stirring memorials such as the Vietnam Wall inspire interaction, they do not sit idly in the landscape but have become the focus for activity and vigorous memory (Edkins, 2003). Likewise, Pinjarra is a site of active memory which offers learning possibilities as some of us try to develop performative aspects of memorials seeing in the idea of the everydayness of performance around memorials, a textual possibility offered by the reality of many existing memorials. It is a powerful and productive place if we understand it as a memorial in transition and do not ask it to produce a permanent Australian answer to how to build memorials to traumatic events. It is better to understand it, therefore, as a place-in-process that could be extended to be the focus for debates, lectures, film screenings, theatre and also celebratory events such as barbecues.

The everyday activities that the local Indigenous people use to keep the place alive should be encouraged to continue after the memorial wording is resolved. Further, the history of the memorial debate should be inscribed in any new wording so that almost two centuries of conflict over its meaning would be recorded.

I propose a role for memorials that departs from the old ideal of a place of silent respect to one that exists to activate debate. It is possible that the extraordinary apparent permanence of memorials works against them being more performative. If they were more transitory, or transitional for some fixed time, such as the *Monument Against Fascism* discussed above, then more daring intellectual interaction might take place around them. The *Explorer's Monument* activates performance, but in such a way that bitterness lingers. It is unfortunate that the Pinjarra memorial does so also because it is such a traumatic place; it is not the intention of this paper to

suggest that the activation of on-going trauma is a good outcome of a memorial. The aim of a good memorial ought to be to resolve trauma, but if the meaning of a place is finally resolved there is no reason why it should not continue to be the focus for deliberately planned memory events.

Public programmes that activate debates related to historic sites would push memorials into very active roles. It should be insisted that events considered significant enough to be placed in memorial form in the landscape should be made to do some on-going intellectual work. If memorials could be reconceptualised as places of foregrounded memory work then we would all become aware of our parts in social and historic dramas; we would all be protagonists, listening to and telling stories.[3]

Works cited

Black, Peter. 2008. Acting CEO, Shire of Murray. Interview 8 October.
Contos, Natalie. 2002. *A Quest for Justice: The Binjareb Nyungar Story*, unpublished PhD thesis, Curtin University of Technology.
Contos, Natalie and Kearing, Theo in conjunction with the Murray District Aboriginal Association and Len Collard and David Palmer. 1998. *Pinjarra Massacre Site Research and Development Project*.
Daye, Russell. 2004. *Political Forgiveness: Lessons from South Africa*. Maryknoll, New York: Robis Books.
De Jong, Ferdinand and Michael Rowlands. 2008. 'Postconflict heritage', *Journal of Material Culture*, 13(2), pp. 131-134.
Edkins, Jenny. 2003. *Trauma and the Memory of Politics*. Cambridge: Cambridge University Press.

[3] Shortly before this book was published, agreement on memorial wording at the Pinjarra site was reached by the Shire of Murray and the Indigenous group represented by Karrie-Anne Kearing. The words are those of Governor, Lieutenant-General, John Sanders in 2001 when he unveiled the boulder memorial: "In memory of the men, women and children of the Bindjareb Noongar people and a Colonial officer who died here on the 29th October 1834 as part of confrontation in the early days of the Swan River Colony. Remembering the spirit of the traditional owners of this land, we go forward together in peace, building a united nation for future generations" (*Mandurah Coastal Times,* 30 June 2010, p6). After decades of acrimony, the brutal history of the event is reduced to "confrontation" and neither the word "battle" nor "massacre" is used. Instead, the words invoke the familiar, soothing super narrative of Australian progress.

Fletcher, Christine. 2007. 'The battle for Pinjarra: A revisionist view', *Studies in Western Australian History*, VIII, pp. 1-6.
Foucault, Michel. 1977. *Language, Counter-Memory, Practice: Selected Essays and Interviews*, D.F. Bouchard, ed. Oxford: Basil Blackwell.
Gardiner, Lisa. 2008. Manager Community Services, Shire of Murray. Interview 6 October.
Garrett, Peter. 2008. 'Myall Creek massacre recognised 170 years on', media release, Minister for the Environment, Heritage and the Arts, Australian Government, June 7.
Humphrey, Michael. 2002. *The Politics of Atrocity and Reconciliation: From Terror to Trauma*. London and New York: Routledge.
Huyssen, Andreas. 1995. *Twilight Memories: Marking Time in a Culture of Amnesia*. London and New York: Routledge.
Jacobs, Jane. 1997. 'Resisting Reconciliation: The secret geographies of (post) colonial Australia'. In Steve Pile and Michael Keith, eds. *Geographies of Resistance*. London and New York: Routledge.
Kaplan, E. Ann. 2005. *Trauma Culture: The Politics of Terror and Loss in Media and Literature*. New Brunswick: Rutgers University Press.
Kearing, Karrie-Anne. 2008. Interview 17 October.
Latitude Creative Services. 2007. *Interpretation Plan: Bootenal Spring*.
Macintyre, Stuart and Anna Clark. 2003. *The History Wars*. Melbourne: Melbourne University Press.
Mandurah Coastal Times. 2007. 'Battle of words leads to conflict', 22 August, p. 3.
Mandurah Coastal Times. 2010. 'Wise words to live on', 30 June, p. 6.
Meskell, Lynn and Colette Scheermeyer. 2008. 'Heritage as therapy', *Journal of Material Culture*, 13(2), pp. 153-174.
Mulvaney, John. 1989. *Encounters in Place: Outsiders and Aboriginal Australians, 1606-1985*. St Lucia: University of Queensland Press.
Nora, Pierre. 1989. 'Between memory and history: Les lieux de memoire', *Representations*, 26, pp. 7-25.
Reynolds, Henry. 1982. *The Other Side of the Frontier*, Ringwood, Vic: Penguin Books.
—. 1998. *This Whispering in Our Hearts*. St Leonards, NSW: Allen and Unwin.
Richards, Ronald. 1993. *A Sequel History of the Old Murray District of Western Australia*, Shire of Murray and City of Mandurah.
Scholze, Marko. 2008. 'The politics of inscription into the UNESCO World Heritage List: The case of Agadez in Niger', *Journal of Material Culture*, 13(2), pp. 215-232.

Statham, Pamela. 2003. 'James Stirling and Pinjarra: A battle in more ways than one', *Studies in Western Australian History*, 23, pp. 167-194.

Tunbridge, J.E. and G.J. Ashworth. 1996. *Dissonant Heritage: The Management of the Past as a Resource in Conflict*. Chichester, UK: John Wiley.

Young, James. 1993. *The Texture of Memory, Holocaust Memorials and Meaning*. New Haven and London: Yale University Press.

THE HOLOCAUST, TRAUMA AND THE ARTS

THE WEIGHT OF THE OTHER: JEAN LAPLANCHE AND CULTURAL TRAUMA THEORY

MAGDALENA ZOLKOS

Introduction

The French post-Lacanian theorist of psychoanalysis, Jean Laplanche, has acquired an influential position within the so-called "trauma turn" in cultural studies and humanities.[1] This is, partly, because his work has put at the heart of the psychoanalytic theory of trauma figures of otherness and alterity. Laplanche has namely re-emphasized the exogenous dynamics in the traumatic formations of subjectivity, and in the unconscious. This has been articulated in the course of his theoretical-interpretative attempts of bridging the 'early' and 'late' Freudian writings. Laplanche has further undermined those interpretations of the Freudian thought that have positioned Freud's post-1920 writings, i.e. with publication of *Beyond the Pleasure Principle,* as "psychoanalysis proper". More specifically, Laplanche's contribution has centred on retrieving the Freudian seduction theory, which, in Laplanche's view, has been largely forgotten and underplayed in the classical psychoanalytic tradition, even by Freud himself.

In this essay I argue that the significance of Laplanche's contribution to the contemporary debates on trauma in cultural studies and humanities lies not just in his careful negotiation between exogenous and endogenous components of trauma, but, more specifically, in his insistence that constitutive of the subject's traumatic formation is the presence, actions and the unconscious of the Other. The consequence of that theorization is that Laplanche's post-Freudian subject emerges as one that remains in a

[1] For cultural studies of trauma that use Laplanche's approach, see for example Jacobus 1999; Punter and Bronfen 2001; Radstone 2010.

relation of radical dependence on the Other—a relation that is modelled
upon the infantile condition of being in the need of others for subsistence.
In this essay I further connect this intersubjective and relational theory of
trauma with two other themes, which have acquired central place in
Laplanche's writing: (a) the complex diphasic temporal structure of
trauma; and (b) the question about the possibility of working through and
expressing ('translating') psychic trauma.

This theoretical and interpretative exposition of Laplanche's theory of
trauma is accompanied here by examples taken from literary texts by a
Jewish-Hungarian post-Holocaust writer, Imre Kertész. The purpose of
weaving these literary references into theoretical explorations is not
simply illustrative, but, rather, is to further complicate the ideas of inter-
subjectivity, alterity, and the traumatic scene. Kertész's writing about the
Holocaust is, in other words, taken to represent what Laplanche labels as
the work of "translation" of trauma. It is animated by the subject's
conflicting and ambiguous desires of *overcoming* and being, in turn,
overcome by traumatic memories. These memories are, for the subject,
catastrophic and precious—destructive and formative—at the same time.

The metaphoric and metonymic figures of trauma

Laplanche has argued that with the abandonment of the seduction theory
in 1897 and the move towards endogenous theorizing of infantile
sexuality, Freud had subverted the effect of decentering the human subject
that he attributed to psychoanalysis. For Laplanche (1999: 135), Freud'
Copernican revolution—a kind of "narcissistic wound" to the ego that is
no longer "master in its own house" (Punter and Bronfen 2001: 8)—had
been brought to a halt by his subsequent epistemological investment in the
category of the subconscious, which "dwells at the centre of the
individual, [and] whom it governs in its own way, even if it has dethroned
the ego." Laplanche (1999: 52-83) sees the classical psychoanalytic theory
as a back-and-forth movement between what he calls "Copernican" and
"Ptolemic" moments, or, in other words, between the idea of an
autocentred subject and an allogenic subject (where the primary stimulus
for psychic formation comes from outside). Laplanche's project can be
thus defined as an attempt to retrieve these allogenic dimensions in the
Freudian thought—elusive and hidden as they might be—and to articulate
a metapsychology of "what is irreducible to autocentrism" (1999: 136).

The influence of Laplanche's work for the contemporary cultural theory of trauma, while no doubt irreducible to his critique of psychoanalytic autocentrism, pivots thereby upon the opening he creates to think, in parallel, about (a) trauma as a particular structure of psychic experience and (b) trauma as a "shock coming from the exterior" (1999: 199). Karyn Ball (2009) has shown how the tension between endogenous and exogenous ideas of trauma, often aporetic in its different manifestations, has become not only a contentious issue in the contemporary trauma studies, but also a constitutive one. Famously, LaCapra (1999; 2001) has expressed it in terms of the distinction between trauma as a "structural disorder" and as a "historical event." The identification of a complex interplay of the emblematic and the exceptional in trauma theory calls for elaboration of the relationship between the reality of the "individual's phantasy life" and the "historical reality of violence" (Caruth 1995: 8).

In accordance with Laplanche's account (1976: 129-131), the conceptual history of trauma has developed along two distinct trajectories in psychoanalytic theory. The first trajectory is *metaphoric* (in the structural linguistic sense advanced by Roman Jakobson). For Jakobson, metaphor has indicated a mode of communication in which one rhetorical element is substituted for another based on the relationship of resemblance. Accordingly, the psychoanalytic concept of trauma is derived from the medical and surgical use of trauma, signifying corporeal incision, or effraction—the effect of piercing the bodily surface. The psychoanalytic meaning of trauma established along the metaphoric trajectory has further aspects that testify to its link to a physical act, in which the 'sealed' surface of the skin, or the bound of the body, is broken. These are, according to Laplanche (1976: 129), (a) trauma's a violent exogenous impact; (b) "a breaking into the organism [...] a rupture or opening of a protective envelope," and (c) the resultant "repercussion on the whole of the organism, resulting in a more or less unadapted, disproportionate and catastrophic global reaction on the part of that organism." Modelled upon the traumatic corporal incision is the psychic "protective shield" or a "layer" that allow for "only tolerable quantities of excitation" (Laplanche and Pontalis 1973: 466). The metaphoric conceptual trajectory is reflected in the very etymology of trauma, from the Greek work "wound," which is in turn derived from the active verb *tro-* or *trau-*, "to pierce" (Laplanche and Pontalis 1973: 465). The image of wounding—piercing or penetrating—suggests thus "a spatial model [of trauma], in which the reality of trauma originates 'outside' an organism which is violently imposed upon" (Caruth 2002: 107).

The second conceptual trajectory is *metonymic*. As part of the structural linguistic vernacular, metonymy signifies a mode of communication in which one rhetorical element is substituted for another, based on the relationship of proximity, or contiguity. Laplanche and Pontalis (1973: 465-469) have sought to establish a close link between Freud's interest in trauma and the study of hysteria by one of Freud's teacher, the French neurologist Jean-Martin Charcot. In 1880s Charcot described clinical cases of "traumatic hysteria," in which he emphasized the occurrence of paralysis following a traumagenic and life-threatening event. A significant commonality across the cases was that the paralysis never followed the event directly, but came only after some temporal delay; a period of "incubation."

Through this metonymic relation to Charcot's "traumatic hysteria," the psychoanalytic concept of trauma has become inscribed in a specific temporal pattern of a "deferred action." This has further fuelled a claim that the structure of trauma depends upon incomplete psychic assimilability of a catastrophic event (Laplanche and Pontalis 1973: 112):

> It is not lived experience in general that undergoes a deferred revision but, specifically, whatever it has been impossible in the first instance to incorporate fully into a meaningful context. *The traumatic event is the epitome of such unassimilated experience.*[2]

The complex metaphoric-metonymic conceptual trajectories of the psychoanalytic notion of trauma explain, at least partly, the motley intellectual territory that trauma has carved out today. Among others, Ragland (2001) maps this diverse, if not eclectic, field of signification as "testimony of an accident," "breaking of a frame of the seemingly normal," "the catastrophic qualities of a literal event," "temporal delay," "insistence of certain images," "secrecy and silence." Within that cluster of characteristics, the metaphoric and metonymic trajectories translate into (complementary) topographic dimension (the image of the wound as infringed surface) and temporal dimension (the delayed workings of trauma), (Fletcher 1999: 16-7). The latter is also connected to the theme of *repetition* in trauma.[3]

[2] Emphasis added.
[3] On traumatic repetition and hermeneutics, see Belau 2002. The repetitive temporality in trauma has been linked to the theme of *spectrality* in trauma; hence the phantom-like quality of the re-appearance of traumatic memories. Caruth (1995: 4 and 6) writes in this context that trauma event takes in "repeated

Traumatic deferrals

Laplanche (1999: 260-265; in Stanton 1992: 15-16; in Caruth 2002: 104-105) is credited with invention of an English neologism "afterwardsness," which describes the complex temporal modalities of trauma. "Afterwardsness" is also a more recent translation of the Freudian term *Nachträglichkeit* (the earlier term "deferred action" was proposed by James Strachey).[4] "Afterwardsness" has a dual signification of (a) the structure of the initial non-assimilation of the traumatic experience in the human psyche; and (b) its revising only after a period of latency.

The notion of "afterwardsness" implies that there is a dual directionality at play in the hermeneutics of trauma; progressive and retrogressive (Laplanche 1999: 235-236; cf. Perelberg 2006). Accordingly, trauma's temporality not only begs the question about how the past catastrophic event affects the subject in the present, but also problematizes the on-going work of investing that event with meaning and cathexis. The point in that retrogressive dynamic is that "consciousness constitutes its own past, constantly subjecting its meaning to revision in conformity with its 'project'" (Laplanche & Pontalis 1973: 112).

In her philosophic study of trauma, Polish theorist Bielik-Robson (2004: 24-27) has, perhaps provocatively, situated the trauma temporality in opposition to some of the contemporary Kantian projects of narrative identity formation, formulated by, among others, Paul Ricoeur and Charles Taylor. The trauma perspective breaks a continuous and linear self-narration of a subject, and points to something unassimilable and unexplainable that is encountered *within* the domain of catastrophic subjective experience. For Bielik-Robson, the subjective perspective of trauma reveals the fictional character of any formulation of a self-contained and internally coherent subject position. She suggests instead

possession [...] the one who experiences it." Thus, "to be traumatized is to be possessed by an image or event. [...] The scene is not a possessed knowledge, but [it] itself possesses."
[4] The French translation of *Nachträglichkeit* has been "*après-coup.*" Laplanche (1999: 235) notes that Freud "plucked [the adjectival form *Nachträglich*] from everyday language, [and] transformed it into a noun (*Nachträglichkeit*) at a precise moment in the letters to Fliess, and valorised [it] as a technical term." Laplanche (1999: 260) also credits Jacques Lacan with the "discovery" of *Nachträglichkeit* in his 1953-1954 seminars, while also noting limitations of the Lacanian approach to this concept.

that the cultural notion of trauma situates the subject momentarily in a complicated and, perhaps, antagonistic relation to one's own psychic constitution and one's memories of the past. Bielik-Robson (2004: 25) writes, rather poignantly, that it is in "the very nature of trauma that it always happens 'too early', and that its understanding always comes 'too late'." In trauma, the "Self exists in the state of de-synchronization; in the condition of belatedness; where nothing happens 'in time'." The literary texts by Imre Kertész often adopt such "de-synchronized" narrative perspective in respect to the temporal situation of his protagonists. For instance, the narration in *Fateless* (2006) adopts a mediative position between, on the one hand, 'documenting' the catastrophic and formative experiences of a Hungarian Jewish adolescent in a Nazi death camp (its deposits "will only be reactivated later, [they] will only become active in a 'second time'"), and, on the other hand, a perspective of "retrospective attribution," or a "retrospective fantasy" (Laplanche 1999: 262).

The interplay of progressive and retrogressive directions in traumatic operation, including its breaking of the linear temporal narrativity, is an important aspect of Laplanche's interpretation of *Nachträglichkeit*.[5] Laplanche's primary contribution to psychoanalytic theorizing of trauma and temporality lies in his insistence on the primacy of the Other in the existential and hermeneutic workings of trauma (see e.g. Laplanche and Pontalis 1968). Famously, Laplanche elaborates his idea of "time and the Other" in reference to Freud's anecdote about a young man, "a great admirer of feminine beauty." In his adult life the man met a woman, who used to be his wet-nurse, and he remarked: "'I am sorry [...] that I didn't make a better use of my opportunity'" (Freud quoted in Laplanche 1999: 263-264). Freud gives this anecdote to illustrate the two-directional dynamics in the formation of human sexuality: the child's sexuality is *deferred* into adulthood and/or the experience of milk-sucking is *retrospectively* sexualised.

[5] In fact, if Laplanche's contribution was reducible to the combination of (a) the progressive perspective on the formative effects of trauma and (b) its retroactive hermeneutics, his contribution would be that of mediating between Freud's and Jung's theorizing of temporality. In other words, while the Freudian notion of *Nachträglichkeit* could indicate the deferred effect of the past event (the "delayed onset" of trauma), one finds only rudimentary reflections on the retroactive hermeneutics of trauma in Freud's work, primarily in his letters to Wilhelm Fliess. It is Jung's theorizing of active imagination that assumes the importance of retrospective meaning-formation as "retrospective fantasizing."

For Freud, trauma unfolds within a similar structure of deferral. It thus requires at least two events, or "scenes." In the first scene, as Laplanche and Pontalis (1973: 467) suggest, "the child is the object of sexual advances from the adult which fail to arouse any sexual excitement in him." That first scene is labelled "the scene of seduction." The second scene takes place *after* puberty and "evokes the first one through some association." It is thus "the memory of the first scene that occasions an influx of sexual stimuli which overwhelm the ego's defences." The signification of the first scene as traumatic is only "ascribed to it after the fact (*nachträglich*); or [...] it is only *as a memory* that the first scene becomes pathogenic by deferred action, in so far as it sparks off an influx of internal excitation."

In this context John Fletcher (2007: 18) suggests that the traumatic temporal structure is further complicated by the assumption that "the initial traumatic scene is supplemented by a series of later auxiliary scenes that orchestrate the production of symptoms." In his analysis of the traumatic texture of *Oedipus the King*, Fletcher (2007: 19) suggests further that traumatic temporality is composed of (at least) two scenes and the temporal distance that separates (or, perhaps, *joins*) them. Contrary to some popular uses of the term, from a psychoanalytic perspective trauma cannot be regarded as connotative, simply, of "the overwhelming impact of a single event." Therefore, "[w]hat had been inscribed or deposited as excessive and unassimilable in the first scene is either traumatically repeated, or repressed and symbolically symbolized, or revived and translated into the terms of a new scene and stage of development."

It is at this point of his theoretical exposition of that Laplanche comes to articulate what is perhaps his most acute critical point about the classical psychoanalytic view on trauma. For Laplanche, Freud, in his anecdote about the young man, *overlooks the figure of the woman*. It is not an innocent negligence, but, rather, a highly significant failure to see the Other.[6] Laplanche uses here a term that psychoanalysis has borrowed from

[6] It is my choice to capitalize the expression "the Other" consistently throughout the text, since Laplanche uses both capitalized and non-capitalized versions. Importantly, he does insist that his understanding of alterity points specifically to adult-infant relation, and is unrelated to Levinas's idea of the Other (which Laplanche regards as overly abstract and transcendence-oriented to engage in a dialogue with it; cf. 1999: 225). While I do not intend to formulate any strong links between Laplanche and the post-structuralist theorists of alterity (Levinas, Derrida, and others), my own project is hugely indebted to the latter, and I am aware that

ocular pathology, "scotomization," and which means "a spot in the visual field in which vision is deficient or absent." René Laforgue, who first adopted this term for psychoanalysis in 1927, writes of a "mental 'blind spot'" of the subject—an impairment of mental acuity—and "a process of psychic depreciation, by means of which the individual attempts to deny everything that conflicts with his ego." Interviewed by Caruth (2002: 106), Laplanche argues thus that "[i]f you don't take into account the wet nurse herself, and what she contributes when she gives the breast to the child—if you don't have in mind the external person, [...] the stranger, and the strangeness of the other—you cannot grasp both directions implicit in afterwardsness."

It is at the point of recognizing the primacy of the Other in the unconscious formation that, for Laplanche, the Freudian "Copernican revolution" of the human subject can avoid the obstacle created by Freud himself when he moved away from the exogenous to endogenous understanding of psychic processes. It is also in Laplanche's figuration of the Other that the topographic and the temporal aspects of trauma are brought together. In as far as topography (or spatiality) of trauma comes to be synonymous to "the outside" (Laplanche in Caruth 2002: 107), or to what is external to the body, it becomes also irreducible to the biological understanding as the organism's "envelope" and as a homeostatic inside-outside relationship. Rather, Laplanche explains (in Caruth 2002: 107 and 108), "I am speaking of something very much more 'outside' that this ['envelope'], that extraniety, or strangeness, which [...] is not a question of the outside world. [In] the topographical model [of trauma], [...] the very constitution of this topography of the psychic apparatus is bound up with the fact that the small human being has to cope with this strangeness."[7]

The primary passivity and helplessness of the subject

The central place of the Other in Laplanche's theory of psychic formation means further that he posits the primacy of passive and receptive subjective condition (prior to any forms of activity). He has further revised

my abstraction of Laplanche's "Other" from the adult-infant relation does some violence to his ideas.
[7] Laplanche coins another neologism, in French, to refer to that radical "strangeness" of others, *étrangèreté*, which has been translated into English as "alien-ness." See 1999: 134 (n.3).

the classical psychoanalytic vernacular that describes processes of subjective engagement with the object (the world), such as introjection, incorporation, identification, etc. (1999: 133-134). Their psychoanalytic significance notwithstanding, these terms share a grammatical and substantive characteristic of affirming the agency of the subject in psychic processes and in defence mechanisms (1999: 134). In other words, these are all autocentred descriptors. It is always, Laplanche writes (1999: 135, *emphasis in original*), "*I* project, *I* disavow, *I* foreclose."

In contrast, Laplanche (1999: 135-136) advances allogenic terminology of "implantation" and "intromission," which attests to primacy of the Other in the psychic life (and in traumatic formation) of the subject. Etymologically, the verb "to implant" has the connotations of infixing, inserting, or engrafting upon the body or the psyche of the subject. In turn, the verb "to intromit" signifies an analogous, though also more forceful, action; it means to introduce, or send, into, but with the association of (bodily or psychic) interposition or interference. Thus, Laplanche elaborates (1999: 136-137):

> By [implantation] I wish to indicate that the signifiers brought by the adult [the Other] are fixed, as onto a surface, in the psychophysiological "skin" of a subject in which the unconscious agency is not yet differentiated. [...] Beside [implantation], as its violent variant, a place must be given to *intromission* [...]. [Just like it has traditionally been with the autocentric processes, the allogenic ones] take as their model well-known *bodily processes*, bringing into play the volume of the body, its skin-envelope and its orifices. Intromission relates principally to anality and orality. Implantation refers, rather, to the surface of the body as a whole, its perceptive periphery.[8]

The perspective of these allogenic processes is potentially very useful in interpreting cultural trauma in so far as implantation shares with trauma the idea of interrupted bodily and psychic surface. In turn, intromission connotes penetration by something that cannot be accommodated within, or metabolised. In other words, in Laplanche's project of de-centring the subject in trauma theory, there is no dismissal of psychic interiority as such, but, rather, that interiority is being further complicated by the exogenous presence and communication of the Other.

Importantly, Laplanche models the self-Other relation upon the early developmental infant-adult relation. In the Freudian ideas about infantile

[8] Emphasis in the original.

precariousness Laplanche finds a concept that allows him to theorize further the subject's primary passivity and receptivity vis-à-vis the Other. In relation with the Other the infantile subject is in position of "helplessness" (*Hilflösigkeit*). In the seminar "The Freud Museum," organized at the University of Kent and Canterbury in May 1990, Laplanche elaborated on his French translation of Freud's *Hilflösigkeit* as *désaide,* rather than the more commonly used word *impuissance,* and which connotes "weakness," "powerlessness," or "impotence." It was because he sought to avoid the autocentric ambiguity of *impuissance.* Laplanche (1992, 50) has further elaborated that:

> *Hilflösigkeit* is an objective state for Freud, much more than a subjective one. In the ordinary German *Hilflösigkeit* means distress and tears, whereas in Freud it does not have the pathos [...]. [Y]ou cannot translate [*Hilflösigkeit*] from the text of 1926 (*Inhibitions, Symptoms and Anxiety*) alone, you must go back to the *Project* of 1896, where he uses it for the first time. Here he talks about *fremde Hilfe,* foreign help, for the first exchanges between the child and the parents. The child needs foreign help. That is why, translating *Hilfe* into French by *aide,* we said it is impossible to have a French word for helplessness that would not have the root *aide* in it. That's why we created *désaide* [...]. If we had used *détresse,* we would lose the continuity between the *Project,* where Freud talks of *Hilfe/aide* and the texts where he talks of the absence of *aide* that is *désaide.*[9]

For Laplanche, the infantile subject is precarious because she/he is primarily, and potentially, exposed to the situation of "*désaide,*"—that is of being "without the help" of the Other. It thus describes the infant's "incapacity to help itself" (1999, 75). Importantly, this situation of the infantile precariousness and dependence is both traumatic and constitutive of the subject as it contributes to the formation to the unconscious. The "helpless human infant [...] must depend on an external, alien other to get its survival needs met," and, consequently, she/he "must struggle—and fail—to interpret the gestures performed and words uttered by that alien other" (Stack 2005, 64). The infant's relationship with the Other is *radically* asymmetrical as she/he remains "passive and open to the actions, gestures and words of the other" (Fletcher 1999: 11). Laplanche and Pontalis (1973: 189-190; see also Pontalis 1981) declare that *Hilflösigkeit* is "prototypical" of any subsequent trauma experience. It has also led Freud to theorizing satisfaction "the hallucinatory wish fulfilment," and to

[9] Emphasis in the original.

articulating the infant's radical dependence on the care-taker as "the mother's omnipotence" (Perelberg 2007: 1483).[10]

I have elaborated elsewhere that Kertész's novels can be interpreted as penetrating studies of the Other's intransparency, alien-ness or strangeness in a catastrophic situation—and of the subject's helplessness vis-à-vis the Other (Zolkos 2010). The perhaps provocative, but also insightful, aspect of Kertész's writing about the experience of Nazi death camp is that the trauma of his protagonists cannot be understood as a result, or a function, of that cataclysmic experience *per se*, but as always triggered by an encounter with the Other.

The perspective of *Hilflösigkeit* gives insight into Kertész's textual preoccupation with the inscrutable *strangeness* of the Other, or, to put it in terms of Levinasian vernacular, with the Other's ethical irreducibility to the self. The perspective of *Hilflösigkeit* illuminates Kertész's numerous literary constructions of precarious subjects. On the basis of Laplanche's ideas about the centrality of the Other in trauma experience—a situation modelled upon the infantile *Hilflösigkeit*—I have thus come to interpret Kertész's notion of "fatelessness" as *homologous* to the subjective condition of being "without the help of another."

I will illustrate this with reference to a scene from *Kaddish for a Child Not Born* (1997: 33), whose protagonist B. survived the death camp because of a giving (and, for him, also irrational and inscrutable) gesture of another inmate. In an inter-camp transport the protagonist and an inmate known only by the nickname "Professor" were given a daily bread portion to share. In the disorder of the transport, Professor, who was carrying their combined bread allotment, was separated from B. by a crowd of inmates. Lying on the ground, malnourished, ill, and overpowered by fatigue (literally "helpless"), B. was not able to stand up to pursue the man who was carrying his bread. However, rather than cease the opportunity and appropriate the double portion of food, and thus substantially increase his chances for survival, Professor returned:

> Shouting and his eyes restlessly searching, the "Professor" was unsteadily heading for me, carrying a single portion of the cold food allotment, and when he caught sight of me on the stretcher, he quickly put the food [on] my stomach; I wanted to say something, and it seems that my total surprise

[10] Perelberg (2007: 1483) suggests that the prototypical situation of *Hilflösigkeit* indicates its formation of anxiety of loss and separation.

screamed unabashedly from my face, because as he quickly headed back—if they didn't find him in his place they'd kill him—he replied with recognizable disgust on his moribund face: "Well, what did you expect...?" […] And this here is the question, this is what I'd like you to answer if you can: why did he do it?

Professor's return and his gesture of sharing the bread with B. subsequently become for the protagonist an unsolved puzzle, an obsession, and a haunting and incessantly returning image.

[D]id not do what he had to do, what, in other words, he should have done according to the rational demands of hunger, the instinct for survival, and the madness and the governing rules of the blood pact of hunger, survival instinct, and madness. […] He didn't do what he had to do but did something else in spite of everything, something that he didn't have to do and what no one in his right mind expected him to do. […] And even though the "Professor's" deed was one performed in totalitarianism, forced by totalitarianism, and as such, in the final analysis, a deed of totalitarianism, that is to say, senselessness, yet the deed itself was still a deed of total victory over total senselessness because it was precisely there in the world of total eradication and destruction that the indestructibility of that concept living in "the Professor," or idée fixe, if you will, could actually become a *revelation*.

It is perhaps surprising that for B. this "act of inexplicable kindness" of the Other is traumagenic. This literary trauma event acquires meanings that extend beyond the specifics of its occurrence. As a "foreign body," it almost violently penetrates the subject's psychic life, and remains un-assimilated and un-metabolised within it. It is not the catastrophic experience of death camp *per se* that exceeds the subject's understanding, but the manifestation of "the good," that which is "out of the ordinary" and "has no logic to it" (Evans 2006). The event becomes *implanted* within the subject. It by the virtue of its traumatic quality, that the memory of Professor's deed haunts, torments and, gradually, overpowers the subject. Professor's life-giving gesture makes upon B.'s post-war life a powerful ethical claim as it coagulates into the questions about the meaning and implications of surviving, and about bearing witness to the catastrophe of the camp. In consequence, B. remains *indebted* to the Other as for him *to survive* and to live *after the catastrophe* means *to owe life* to the Other.

Writing – metabolising – translating trauma

Laplanche conceptualises the trauma-prototypical situation of *Hilflösigkeit* not solely in existential terms, but also (and primarily) in communicative

terms. This implies that in the infantile *Hilflösigkeit* the message of the Other (the caring adult) is for the subject *enigmatic,* "not only in the usual meaning of [being] puzzling or interrogative, [or] rich in meaning, but also [...] in the precise sense that *the meaning remains hidden*" (1992: 23).[11] For Laplanche (1999: 173), what is therefore significantly absent in both Freudian and Lacanian psychoanalysis is "consideration of the enigmatic dimension, otherness, on the part of the child's adult protagonist."

In the infantile situation of *Hilflösigkeit,* the self-Other relation is communicatively asymmetrical, which means that while the infant attempts "to metabolize, assimilate—or read—the various gestures and utterances of [her/his] caretakers, there will always be an excess, something that *exceeds* this helpless creature's limited capacity to assimilate" (Stack 2005: 65, *emphasis in original*). The enigmatic quality of the message is not reducible to communicative impairment (for instance, an utterance in an unknown language), a "riddle," or a "mystery" (Laplanche 1999: 255). Rather, "[t]he enigma leads back [...] to the otherness of the other, [...] the other implanted in me, the metabolised product of the other in me: forever an 'internal foreign body'" (Laplanche 1999: 256). For Punter and Bronfen (2001: 18), "the enigmatic dimension [as] the real traumatizing otherness of the child's protagonists" means that the child's world "does not consist of neatly interlocking parts, or of messages and meanings which can be clearly assigned." Rather, it includes "impossibilities, of incomprehensible messages, of matters half-heard, glimpsed, barely understood, of conversations in distant corridors, shapes that have already disappeared in the instant of apprehension."

Importantly, the enigma is *hidden* not only from the receiving subject, but from the communicating Other as well. The message is itself unconscious and, as such, correlative to the Freudian "scene of seduction." In the communicating presence of the adult, the infant encounters the unconscious content of the sexuality of the Other, "transmitted in the form of enigmatic signifiers, messages in verbal or non-verbal form, that are implanted through ordinary ministrations of childcare and nurture" (Fletcher 2007: 20). In this encounter with "the enigmatic desire" of the Other—the prototypical or primary scene of trauma—the subject is being, at the same time, *wounded* and *seduced*. At the same time, however, as Punter and Bronfen argue (2001: 9), "the child does not watch the primal scene by accident; s/he watches it as an effect of the parents

[11] Emphasis added.

[subconsciously] letting it be seen." The question is thus what it is that "the parents want by making [the child] a witness."

Judith Butler (2005: 86-100) discusses Laplanche's "enigma of the Other" in order to theorize the Other's address as a formative and constitutive interpellation of the subject. For Butler, the subject's "impingement by the Other" is both traumatic and creative. Butler's distinctive contribution is to take the thesis of the primal passivity of the subject vis-à-vis the Other's address in the direction of ethical theory of self-narration (or what she calls "giving account of oneself"). Following the Other's address, the subject responds by explaining, justifying and/or elucidating the self. It is an idea of narrativity that subscribes to Laplanche's (1997) "primal Copernicanism," where the subject "from the start focuses on and gravitates around the other."

When the subject is affected by the traumagenic workings of the enigmatic and strange Other, another socio-psychic process is initiated (though never successfully completed), which is *metabolization* of the Other's message, or what Laplanche (1997) calls "translation" of that message. For the subject it is a "Ptolomaic movement [...] of self-appropriation." Necessarily inadequate or flawed, translation connotes here subjective work through trauma, where she/he seeks to "re-establish a condition of control, or pseudo-control."[12] However, the event and mechanics of trauma, understood communicatively as the message of the Other, cannot be fully contained or accommodated, or "explained away." Its excess is thus correlative to the *falling through* of its translation. The enigmatic signifier "always leaves something untranslated; there is always a remainder, [...] *à traduire*, the yet-to-be-translated" (Fletcher 1999: 16). It is a "dynamic of a self-presencing that is always [...] incomplete" which is, also, the "coming to presence of an unconscious" (Benjamin 1992: 146 and 149).

This brings to mind the notion of (politics or democracy) *à venir*, "to-come," in Jacques Derrida's deconstructive project (see e.g. 1992). While drawing a connection between the Laplanchian *à traduire* (of the message of the Other) and the Derridean *à venir* (of democracy) requires a more careful and detailed conceptual-interpretative engagement, it suffices here to emphasize the grammatical homology of the two terms. Positioned in

[12] On the connection between translation and repression see Laplanche 1997 and 1999: 93-98.

structural proximity to Derrida's democratic ideas, Laplanche's notion of translation as being (always) "to-come" appears not simply futural but also, and more importantly, promissory. The translation remains unfinished, infinitely deferred, animated by a promise of its coming. As such, it is manifest "in the form of the provisional, minimal, and internally differentiated moments of an incomplete, fragile identity" (Fritsch 2002: 576).

The significance of that point for cultural trauma studies is that it illuminates literary, cinematic, and other engagements with subjective experiences of trauma as *traumatic translations*. What is so interesting about these engagements with trauma is how they recognize and approach their own representational and testimonial aporias, or impossibilities. And, also, whether and how they work within the promissory structure of trauma as a code for the *yet-to-be-translated*; the textuality that is always *to-come*.

The theme of the impossibility to narrate trauma has resonated, and been explored, among others, by Shoshana Felman (1995; 2002) in her vocabulary of trauma as anti-story; by Giorgio Agamben (2002) in his book on the impossibility of the human to bear witness to the Holocaust; or by Veena Das (2003) in her prioritizing of the gestural over the narrative in attesting to catastrophic subjective experiences. However, the reference to trauma writing as Laplanche's *à traduire* does not simply reiterate the focus of the contemporary trauma and testimony literature on trauma's apophasis. It also suggests productive trajectories of interpretation. This perspective gestures towards the epistemological, as well as political and ethical complexity of Kertész's work, as hinted at in his enigmatic claim (2002) that, in his writing, "the traumatic impact of Auschwitz" inspires reflection "not on the past but on the future."

In his Nobel Lecture (2002) Kertész makes a rather moving confession. He says that he can identify precisely the moment when he decided to become a literary author: it was the moment in which he realized that his memory of concentration camp had started to desert him. Kertész (2002, *emphasis mine*) admits, "[t]o my horror, I realized that ten years after I had returned from the Nazi concentration camp, and halfway still under the awful spell of Stalinist terror, all that remained of the whole experience were a few muddled impressions, a few anecdotes. *Like it did not even happen to me* [...]." In these words, the traumatic experience acquires a furtive, even spectral, quality. It does not guarantee any sense of subjective grounding or

belonging. In other words, for Kertész, the trauma scene does not create stable ontological or epistemological subject position. While it appears to have a "life of its own," independent of and uncontrolled by the subject, its working does not testify to the omnipresence of traumatic memory, or to the traumatic overpowering of the subject, but rather to the possibility of its disappearance. There is a sense of abandonment in Kertész's words, and a sense that with the disappearance of the traumatic memory something at once terrible and precious is being lost. What is so provocative about this insight is that the subject appears to be in mourning not for what he was deprived or dispossessed of in the camp experience, but for the loss of trauma. Writing (translating) becomes for Kertész a strategy of conjuring the traumatic memory: *naming it* and thus *making it stay*.

Kertész's writing about the Holocaust is directed against the anxiety that the, at the same time, *wounding* and *seductive* trauma of the catastrophe of the Holocaust will prove to be transient and evanescent to the point of forgetting. "What I have gained from [writing]," says Kertész (2002), "was not my art, [...] but my life, which I had almost lost."[13] His literary vision indicates then "something real that assumes a supernatural guise—the sudden, almost violent eruption of a lowly ripening thought within [the subject]."

Kertész makes one of his heroines, Judit in *Liquidation* (2007: 110-119), engage with the anxiety about the disappearance of traumatic memory. Judit goes for a trip to Auschwitz in hope to revisit and connect to her parents' experience (and, thus, to be liberated from it), but, to her terror, she makes a discovery that Auschwitz "does not exist." The site of the mass extermination and industrialized killing has become a site of meretricious and kitchy tourist attraction. She says (2007: 123), "I was there. I saw. Auschwitz does not exist."

Thus, when in his Nobel Lecture Kertész (2002) speaks of "Eureka," he means, literally, "getting hold" or "having a grip" of what has appeared to him as fugitive and elusive. The writing of trauma is not fuelled by any objectives of appropriation as if, Kertész (2001: 267) mocks, anyone could possess the "great and unique secret of Auschwitz." Rather, writing of trauma becomes an act of *conjuration* of the *spectrality* of catastrophic experience. Furthermore, Kertész's writing of trauma, animated by the

[13] See Spiró (2001) on Kertész's difficulties with survivor identity.

promise that the "translation" of its enigmas is *to-come*, works therefore within a dual temporal-hermeneutic paradigm (progressive and retrogressive).

Conclusion

In his autobiography, *Love of Beginnings*, J.-B. Pontalis defines writing as analogous to the work of mourning, which "transforms the lost object, incorporates and idealizes it, takes it to pieces and puts it together again" (1993: xviii). Writing isn't thus only "working," but also "dreaming." To write is "to be animated by a mad desire to possess things through language, and to experience with each page, sometimes with each word, that this is never it!" Writing produces not "truth, but the illusion of an endless beginning" (1993: xix).

For Kertész the *translation* of traumatic encounter with the Other is impossible because "the Holocaust doesn't and cannot have its own language" (2002). Kertész confesses (2002), "I like to write in Hungarian because, this way, I am more acutely aware of the impossibility of writing [...] about the Holocaust." The author of Holocaust writing "*chooses to continue living* knows only one real problem, that of [...] exile [...] from his true home, which never existed. For if it did exist, it would not be possible to write about the Holocaust" (2002, *emphasis mine*). The task of mourning is undertaken from an exiled subject position; it is also a position of traumatic displacement from any language appropriation. The "consciousness of the Holocaust" has to remain "homeless" and interstitial, just as no language "can claim to include the essence of the Holocaust, its dominant Self, its language" (2002). And if its catastrophic trauma indeed *had* its own language—its own translation—"wouldn't this language have to be so terrifying, so lugubrious, that it would destroy those who speak it?"

Works cited

Agamben, Giorgio. 2002. *Remnants of Auschwitz: The Witness and the Archive*. New York: Zone Books.

Ball, Karyn. 2009. *Disciplining the Holocaust*. New York: SUNY Press.

Benjamin, Andrew. 1992. 'The unconscious: Structuring as translation'. In John Fletcher and Martin Stanton, eds. *Jean Laplanche: Seduction, Translation and the Drives*. London: Institute of Contemporary Arts, pp. 137-160.

Bielik-Robson, Agata. 2004. 'Słowo i trauma: Czas, narracja, to samość', *Teksty drugie* 89(5), pp. 23-34.

Butler, Judith. 2005. *Giving an Account of Oneself.* New York: Fordham University Press.

Caruth, Cathy 1996. *Unclaimed Experience: Trauma, Narrative, and History.* Baltimore: Johns Hopkins University Press.

—. 2002. 'An interview with Jean Laplanche'. In Linda Belau and Petar Ramadanovic, eds. *Topologies of Trauma: Essays on the Limit of Knowledge and Memory,* New York: Other Press, pp. 101-125.

Das, Veena. 2003. 'Trauma and testimony: Implications for political community', *Anthropological Theory* 3, pp. 293-307.

Derrida, Jacques. 1992. *The Other Heading: Reflections on Today's Europe.* Bloomington: Indiana University Press.

Felman, Shoshana. 1995. 'Education and crisis, or the vicissitudes of teaching'. In Cathy Caruth, ed. *Trauma: Explorations in Memory.* Baltimore: Johns Hopkins University Press, pp. 13-60.

—. 2002. *The Juridical Unconscious: Trials and Traumas in the Twentieth Century.* Cambridge: Harvard University Press.

Fletcher, John. 1999. 'Psychoanalysis and the question of the Other'. In Jean Laplanche, *Essays on Otherness.* London: Routledge, pp. 1-51.

—. 2007. 'The scenography of trauma: A "Copernican" reading of Sophocles' *Oedipus the King', Textual Practice* 21(1), pp. 17-41.

Fritsch, Matthias. 2002. 'Derrida's democracy to come', *Constellations* 9(4), pp. 574-597.

Jacobus, Mary. 1999. *Psychoanalysis and the Scene of Reading.* Oxford: Oxford University Press.

Kertész, Imre. 1997. *Kaddish for a Child not Born,* Evanston: Northwestern University Press.

—. 2001. 'Sworn Statement', *The Hungarian Quarterly* 42, pp. 45-58.

—. 2002. 'Heureka!' Nobel Lecture, Stockholm, The Nobel Foundation, http://nobelprize.org/nobel_prizes/literature/laureates/2002/kertesz-lecture-e.html.

—. 2006. *Fateless.* New York: Vintage International.

—. 2007. *Liquidation.* London: Vintage Books.

LaCapra, Dominick. 1999. 'Trauma, Absence, Loss,' *Critical Inquiry* 25, pp. 696-727.

—. 2001. *Writing History, Writing Trauma.* Baltimore: Johns Hopkins University Press.

Laplanche, Jean. 1976. *Life and Death in Psychoanalysis.* Baltimore: Johns Hopkins University Press.

—. 1992. 'The Freud Museum seminar'. In John Fletcher and Martin Stanton, eds. *Jean Laplanche: Seduction, Translation and the Drives.* London: Institute of Contemporary Arts, pp. 41-64.

—. 1997. 'Aims of the psychoanalytic process', *Journal of European Psychoanalysis* 5, www.psychomedia.it/jep/number5/laplanche.htm.

—. 1999. *Essays on Otherness*. London: Routledge.

Laplanche, Jean and J.-B. Pontalis. 1976. *The Language of Psychoanalysis*. London: Karnac and the Institute of Psycho-Analysis.

Perelberg, Rosine Jozef. 2006. 'The controversial discussions and après-coup', *International Journal of Psychoanalysis* 87, pp. 1199-1220.

—. 2007. 'Space and time in psychoanalytic listening', *International Journal of Psychoanalysis* 88, pp. 1473-1490.

Pontalis, J.-B. 1993. *Love of Beginnings*. London: Free Association Books.

Punter, David and Elisabeth Bronfen. 2001. 'Gothic: Violence, trauma, and the ethical'. In Fred Botting, ed. *The Gothic*. New York: Boydell & Brewer, pp. 7-22.

Radstone, Susannah. 2010. '*Caché*: Or What the Past Hides,' *Continuum: Journal of Media and Cultural Studies* 24.1, pp. 17-29.

Ragland, Ellie. 2001. 'The psychical nature of trauma: Freud's Dora, the young homosexual, and the Fort! Da! paradigm', *Postmodern Culture* 11(2), pp. 75-100.

Spiró, György. 2001. 'In art only the radical exists', *The Hungarian Quarterly* 42, pp. 29-37.

Stack, Allyson. 2005. 'Culture, cognition and Jean Laplanche's enigmatic signifier', *Theory, Culture and Society* 22(3), pp. 63-80.

Stanton, Martin. 1992. 'Jean Laplanche talks to Martin Stanton'. In John Fletcher and Martin Stanton, eds. *Jean Laplanche: Seduction, Translation and the Drives*. London: Institute of Contemporary Arts, pp. 3-20.

Zolkos, Magdalena. 2010. *Reconciling Community and Subjective Life. Trauma Testimony as Political Theorizing in the Work of Jean Améry*, New York: Continuum.

VIDEO TESTIMONY:
THE GENERATION AND TRANSMISSION
OF TRAUMA

STEPHEN GODDARD

Introduction

My mother experienced the final part of the Second World War displaced and separated from her family and particularly her husband. (His name was on Oscar Schindler's List; her name was, and then wasn't). This dislocation from her husband was one trauma within a larger set of daily traumas. In 1997, as part of the Shoah Foundation Visual History series, my mother narrated her individualized video testimony, once again, separated from her family. This paper examines the methodologies of this video testimony in relation to two connected questions: was my mother re-traumatized by the process of providing her testimony, and by narrating and recording her video testimony, did she, unwittingly, 'transmit' her traumas, and those of her generation to my generation?

Context

"Shoah" is a Hebrew word for calamity or catastrophe, and is often used with reference to the Jewish "Holocaust" during the Second World War. "Holocaust" is a word based on the Greek concept of 'completely burnt'. In 1983, Claude Lanzmann completed the 9 and a half hour film *Shoah*. Instead of the usual use of re-enactments and historical footage it is based mostly on interviews and testimonies. This film was a mediated response to the Holocaust in which personal traumatic experiences were encased within a socially experienced set of collective traumas.

Ten years later, in 1993, the Shoah Foundation was established to record the testimonies of survivors from the Second World War. This was a

media (and mediated) response to the collective suffering of those who experienced trauma during the Second World War. Since 27 October 2005 the videotaped testimonies are now part of the University of Southern California Shoah Foundation Institute for Visual History and Education (University of Southern California, *Index*, 2007).

Discussion

This paper examines the Shoah Foundation methodologies, using my mother's testimony as a case study. As a defence for the value of using case studies, Cathy Caruth concludes that, "we may thus ultimately have to struggle with the particularity of each individual story in order to learn anew, each time, what it means for a memory to be true" (Caruth, 1995, p. ix). The Shoah Foundation performative testimonies 'bear witness' and provide both an individualized and collective account: their witnessing is based not only on their *eye*witness testimony, but on the experience of their whole embodied, situated body—as an individual (body) and as a collective body. My mother's stories are part of a larger collective traumatic experience. Her specific testimony is (now) a stone, in the graveyard of stories from the Second World War; it remains alongside others, as part of the geology of a continuing and generative story.

Originary experiences and re-enacted memory

The aim of the original Shoah Visual History Foundation was "to document the experiences of survivors and other witnesses of the Holocaust" (University of Southern California, *Index,* 2007). What we see and hear in these audio-visual histories, are the testimonies rather than the actual experiences of the participants. I am interested in the relationships between the initial traumatic experiences and the memory of those experiences at the time of the testimonial. There's many a slip between the originary experiences and the reported testimony. There is also the difference between the trauma of *trying* to recall, and the trauma of *actually* recalling the initial events.

During her video testimony, my mother's own capacity to recall, and at the same time interpret the initial events, was influenced as much by the fragmentary character of her memory as the complexities surrounding the events. There was also her own memory of her previous (non-recorded) attempts at narrating her half-remembered stories. As my mother would say: "I remember things differently". As ever, this had at least four

possible meanings: she remembered things differently to others, she remember different things to what others remembered, to the way she previously remembered, and in relation with whom she was remembering.

The idea that we all remember different things differently is part of the larger enigmatic questions associated with memory and narration. How do we remember and how do we tell our stories? Is it in relation to who we are with, who we trust, where we are, our abilities to recall, our abilities to narrate with a sense of coherence, and at the same time, our desire (or need) to forget? For the moment, I am interested in whether the recording methodology adopted by the Shoah Foundation produced a series of shifts, by which a witnessed testimony became a guided interview, and then a form of traumatic interrogation.

Re-traumatization

My mother was initially reticent about agreeing to provide her video testimony for the Shoah Foundation Visual History series, and only agreed after some peer pressure. Was she traumatized (and re-traumatized) by the process of providing her testimony? As evidenced from the following, during the testimonial narration there seemed to be a sense of re-experiencing and a feeling of travelling through a darkened past. In this excerpt (from the longer 170-minute video testimony) a number of issues were raised relating to remembering, forgetting and re-experiencing.

> We knew that the war was ending, but whether we would survive or whether they would finish ... [or] take us with them, we didn't know. [Big breath.] So, some time, in the middle of January, we were walking, all night to Auschwitz ... and we saw that famous ... entrance: Arbeit macht ... something ... what is it? ... and a group of women were coming out. It was early in the morning, and the women were going out to work: it was still dark, January, it's Winter. So they started to call: "Who are you? Who are you?" We said: "We're coming from Plaszów." They said: "Don't worry, they don't burn anymore. The crematorium is not working anymore. Don't worry." So, we went in, and went to that bath. We still didn't know whether it was true or not. We had the bath, and they didn't kill us. We stayed a very short time: not in Auschwitz, but in a place called Brezinka, and then we were rounded up again, and we were going ... We went from morning to late, late evening, and there were cattle trains waiting for us. We were loaded very, very tightly. In that wagon, where I was with my mother and the rest of my family ... [springs to life and leans forward] because I found my mother there. I forgot to tell you. As we were walking, masses of walking, towards something, we didn't know what, I

saw a girl who worked with my mother, in the sewing place, in the tailor's place. She said: "Did you see your mother?" I didn't know she was alive. So people were walking one way and I turned the other way to find my mother, and I really did find my mother [beaming]. You can imagine the joy. I said: "Where is Lucy?" She said: "Lucy [the eldest sister] was taken somewhere, before…" (Godard, Felice. Testimony for the Shoah Visual History Foundation, 1997).

My mother did seem to be 'transported' (again) into the nightmares of her past. She did seem to be 'there', re-living and re-experiencing things. Notably, in the midst of her performative testimony, my mother could not remember the missing final word from the infamous (Arbeit macht frei) sign over the gates at Auschwitz. Beyond the mere word "frei" (free), she later mentions that her life after liberation was a continuous search for freedom.

In this excerpt from her testimony, my mother almost forgot to tell the story of how she found her own mother. In the middle of a sentence, a word or an image reminds her of what she had often referred to as one of the most poignant moments of her life. However, in her testimony, her narration situates this story, briefly, amidst all of the other minute-by-minute traumas. During her testimony, she seems almost relieved to have remembered this important story, and, in a way, re-found her lost mother (again). The way the story arises, seemingly from nowhere, as another story on the road to nowhere, also inflects the testimony with a haunted tone. Just after this excerpt, my mother tells the story of how she saw her mother for the final time. Within the context of daily trauma, it seemed like the most ordinary thing to find and lose your mother.

My generation is often reminded of its inability to really know or understand the traumas associated with World War II. This research, therefore, forms part of a larger project attempting to re-trace and re-consider the experiences of my parents, their relatives, and the wider community of souls.

When family members were asked to leave before the recording of my mother's video testimony commenced, this ritual separation re-enacted three all-too-familiar traumatic movements: separation, trespass and liberation. During her video testimony, each of these movements also contributed to a degree of performance anxiety.

Separation anxieties

My parents experienced much of the Second World War in different locations—only re-united after many months. For their Shoah Foundation video testimonies, they were interviewed separately (once again) with a distance of many months between. Their testimonies were recorded separately, in accordance with the Shoah Foundation interviewing guidelines, which state:

> Interviews are conducted individually, e.g. only one interviewee is videotaped per interview.

> The only people who will be allowed in the room during the interview are the interviewee, the interviewer, the camera operator, and the camera assistant (University of Southern California, *Interviewer Guidelines*, 2007, p. 5).

It was assumed that this methodological strategy would empower the storyteller to narrate without interruption, and, perhaps, more importantly, without the *fear* of interruption or possible contradiction. However, the effect of this was that before my mother's testimony was to be recorded, my father and I were asked to leave the family home. (Another exodus.)

What happens when you have spent more than 50 years telling stories together, and then you are, once again, separated? After a lifetime of living and narrating in collaboration, this methodology left her (and the other 52,000 Shoah Foundation narrators) with the prospect of performing a form of unrehearsed autobiographical monologue. There are issues and questions here, as to what is remembered in relation to who is present and who is absent. Was she, as a testifying narrator re-traumatised by being prompted to re-count her stories and re-live her pasts as separate and individualized?

Oral storytelling usually occurs in the presence of others – others who are also authoring and telling their stories. The removal of family members meant that the remembering and the narration occurred without the usual familial context or the dynamism of interactive storytelling. Although I understand the desire to protect the storyteller by only allowing one interviewee to testify at each recording session, I also believe that some storytellers prefer to remember and narrate within the context of a social setting. With a single camera, it is easier and customary to record a single

interviewee rather than two or more interviewees. I hope that the Shoah Foundation decision to feature a single 'talking head' was not based on convenience. It may be difficult for cameras and microphones to record a multitude or even a multiplicity of sounds and images, but that is often the way in which we tell our most important stories of remembrance in a family setting.

By writing these words, I am attempting to re-enter the family living room and the space from which I was asked to leave when my mother provided her testimony. In attempting to communicate with her again, I'm also trying to remember her, and remember what she remembered. By remembering with her, I'm co-memorating.

Trespass

In the same way that it is possible to question the methodology of separation, it is possible to wonder whether the decision to conduct the interviews in the survivor's own house and living room may well have re-enacted a form of trespass into a space that was once familiar and secure.

Videographers were reminded to be sensitive to the interviewee's living environment:

> In most cases you will be shooting the video in the survivor's home. Please be sensitive to the fact that he or she may not be accustomed to having strangers come into his/her living rooms with camera and lighting equipment. Remember to ask permission before moving furniture or any other items (University of Southern California, *Videographer Guidelines*, 2007, p. 4).

However, each living room necessarily underwent either a subtle or radical re-design in order to provide space for the camera, camera operator and lights. Although there was no on-screen evidence, before the recording of my mother's video testimony, the living room was altered in order to provide an image of aesthetic design and domestic order. She provided her testimony whilst sitting in a chair and in a part of the living room that was unfamiliar to her. Knowing how important the design and familiarity of a living room is for those who live with/in them, the recording process re-enacted the disruption of strangers entering and altering a space that is usually so untouched and untouchable. Moving a sofa, or even, sitting in someone else's favourite chair, can trigger memories of wartime trespass and dispossession.

Interviewer and videographer guidelines

The Shoah Foundation guidelines also meant that the remembering and the storytelling occurred more in response to the presence of unfamiliar participants, unfamiliar techniques, and unfamiliar technologies. The recording methodology used for these testimonies was based on the guidelines provided to the videographers. For example: "Always choose a location that allows for depth, with a glimpse of the survivor's home in the background. NEVER position a survivor against a flat wall." (University of Southern California, *Videographer Guidelines*, 2007, p. 5). This meant moving chairs and re-arranging heavy pieces of furniture, in order to provide the shot with a three-dimensional sense of depth. The guidelines also recommend a preference for a fixed, stable medium close up shot, in order to de-emphasize independent, editorializing or distracting camera moves: "Once the close shot has been established, do not zoom in or out. Such camera moves would add editorial comment to the testimony, thereby compromising its historical validity (University of Southern California, *Videographer Guidelines*, 2007, p. 7)." Understandably, these guidelines were a way of empowering the interviewee, and in order to give precedence to the performative elements of the testimony. However, with a single light and unblinking camera, the setting also re-enacted an interrogatory structure that foregrounded the mediating influence of the camera, the videographer, and especially the promptings of the interviewer. In addition, the interviewee eventually had to contend with the anxiety of narrating traumatic stories from the Second World War based on half-remembered memories, to an unknown (usually unprofessional) interviewer and camera operator, in what once was a familial living room. Under these circumstances, was the storyteller able to testify and tell her stories in the way she wanted to?

Performance anxieties

The strangeness and unfamiliarity of the recording situation, and the separation anxieties prompted by the recording methodology of excluding other family members, meant that there were performance anxieties associated with trying to summarize a whole life in one sitting, and get the stories "right" in "one take". Like the living room, the living stories may well have undergone a certain amount of re-arranging and improvisation in order to provide a single-take attempt at recording an autobiographical testimony.

There were, of course, untold stories lurking behind and around my mother's testimony. Because she was not prepared to share all of her stories in public, some of the most important stories remain in the private domain of the family. These remain as part of her unrecorded and un-recordable private memoirs. This raises questions to do with the differences between family narratives produced in private and in public domains. When she told these stories in a private family setting, they were anecdotes and part of our family history. When recorded by the Shoah Foundation they became transformed into public testimonies.

There were also the added pressures of wanting to only tell certain parts of her story, and of not wanting to remember, or more significantly, not *needing* to remember other parts of her life story. As she said in her testimony:

> I forgot so much (about the old world); I didn't *need* to remember.
> I wanted to start being normal.
> I loved Australia; I loved my freedom.
> (At last) I wasn't afraid of anyone... (Felice Goddard, Testimony for the Shoah Visual History Foundation, 1997).

Liberation

My mother's testimony is also characterised by stories of liberation. Not merely liberation by and from others, but a sense of self-liberation and empowerment through testimony and storytelling. Hers is a story of starting again and re-writing herself—back into the book of life. In this respect, providing and performing her testimony was as (re-) traumatizing as it was (re-) liberating. She often mentioned that the time after her Second World War liberation was the time of highest hopes: hopes of surviving and hopes of starting again. Providing her testimony also re-enacted a form of liberation for her. Whilst narrating her story, she was also hearing herself telling her story: it was a reminder (to herself) that she had attempted to start again by re-building her life—with a son born directly after the war in Europe, and another son born in Australia.

My mother's testimony documents how different narrators can (and do) generate different stories from differing ways of remembering and a variety of narrative perspectives. It also suggests that within each version, each story generates a series of narrative possibilities, in which associations could lead to further narrative detours and reveries. (For example: the stories of my mother finding her mother and immediately

worrying about the whereabouts of her elder sister. In her testimony, the generational continuity of the family is represented by narrative continuities. Whether they were memories from her individual perspective, or whether she was sharing recollections derived from other family members, these narratives transformed towards a form of confessional.

Video confessional

As an autobiographical narration, my mother's video testimony provided an opportunity for self-representation and self-critique. Perhaps, beyond her individual intentions, she also enacted, what Jean Rouch has referred to as, a "very strange kind of confession in front of the camera...." (Eaton, 1979, p. 51). Michel Foucault observes:

> [T]he confession is a ritual of discourse in which the speaking subject is also the subject of the statement; it is also a ritual that unfolds within a power relationship, for one does not confess without the presence (or virtual presence) of a partner who is not simply the interlocutor but the authority who requires the confession, prescribes and appreciates it, and intervenes in order to judge, punish, forgive, console (Foucault, 1980, p. 60).

Foucault has also indicated, that confession is a ritual "in which the expression alone, independently of its external consequences, produces intrinsic modifications in the person who articulates it: it exonerates, redeems, and purifies him; it unburdens him of his wrongs, liberates him, and promises salvation" (Foucault, 1980, pp. 61-62). I do not believe that my mother's testimony was either seeking forgiveness or appealing for absolution. Nor was she seeking permission and attempting to solicit a response. Throughout her testimony, her disclosures were initially revelations *of* the self, and revelations *to* herself. However, she also knew that she was performing to future audiences.

Audiences

Through the process of providing her testimony, my mother developed a performative subjectivity in the presence of the camera and the virtual presence of an eventual audience. In storytelling, audiences are present and absent, addressed directly and delayed. There are at least five audiences or addressees for my mother's Shoah testimony. The first audience was the individual narrator, herself: able to hear herself narrating, and a spectator to her own performance. The second audience was the

interviewer, who functioned as an off-screen addressee, mediator and proxy for the off-screen audience. As a surrogate for the audience, the interviewer was also a reminder of the need for the narrator to translate private stories and languages into a more public sphere. The interviewer was placed as close as possible to the camera operator, in a traditional semi-confrontational interviewer position, in order to present as much of the interviewee's face as possible: "The interviewer should sit as close to the lens as possible, at eye level with the camera." (University of Southern California, *Videographer Guidelines*, 2007, p.7) This positioning of the interviewer also enabled a shot-reverse-shot fragmentation of perspective. However, there are no reverse angles or edits in the Shoah Foundation testimonies. As such, it would have been possible for at least two people to present their testimonials side-by side. As the third audience, the camera and microphone also function as much as a mediating technology as an enabling surrogate presence, for a public audience and future addressees. The fourth, and other known audience, at the time of production, was the family that would eventually watch and hear the testimony when the tapes were returned to the testifier, as a VHS compilation of the recordings. These could be screened either in the not too distant future by the current generation, or in the distant future by subsequent generations. The fifth audience is the wider community who can access these and other testimonies in libraries or online via the University of Southern California.

Camera as mediating presence

In audio-visual recorded interviews, the camera is both an observer and participant. In both respects it is also a catalyst – producing change without itself undergoing change. However, human intermediaries are never mere catalysts. All participants undergo both minute and substantial changes during their performative roles. In an interview in 1964, Jean Rouch provided a telling response to the 'fly on the wall' ideology of supposed non-intervention and effacement, which was espoused by the exponents of Direct Cinema:

> You know very well that when you have a microphone – such as the one you are now holding, and when you have a camera aimed at people, there is, all of a sudden a phenomenon that takes place because people are being recorded: they behave very differently than they would if they were not being recorded: but what has always seemed strange to me is that, contrary to what one might think, when people are being recorded, the reactions that they have are always infinitely more *sincere* than those they have

when they are not being recorded. The fact of being recorded gives these people a public (Macdonald and Cousins, 1996, pp. 268-269).

Perhaps in filmic or video space we can see ourselves more clearly, or using Rouch's formulation, perform more sincerely. We may well *try* to be on our "best behaviour" during the recording of a video testimony or other autobiographical performances, but as Rouch suggests, perhaps the special qualities associated with "being recorded" (and going on record) produce a special kind of sincerity—a sincerity and an authenticity beyond intention and beyond the traumatic. I will return to this attempt to move 'beyond trauma' after considering the issue of the generational transmission of trauma.

Generational transmission

Whilst these testimonies enact a form of traumatic re-experiencing and a poignant reminder of the separation, trespass, and performance anxieties that accrue with the originary events, debates continue to circulate around the inter-generational and trans-generational transmission of traumatic experiences through family members (Halasz, 2002; Hirsch, 2008).

There are, at least, two uses of the concept of 'generation' at work here. It is an indication of a class or a grouping: in this case, it refers to second-generation children of Holocaust survivors. There is also the implication that the (trans-generational) transmission of trauma is an activity that generates a continuing legacy.

The concept of generational transmission or inherited memory remains controversial. According to Marianne Hirsch, postmemory "describes the relationship of the second generation to powerful, often traumatic experiences that precede their births but that are nevertheless transmitted to them so deeply as to seem to constitute memories in their own right" (Hirsch, 2008, p. 103). Whilst Hirsch admits that she is not referring to the literal memories of others, there are still many unresolved issues associated with the ways in which memories "seem to" be transmitted. Perhaps, what is of more significance is the way in which Hirsch movingly reminds us that these traumatic memories, and the context of these stories, can usefully "*reactivate* and *reembody*" a wider community of participants, beyond family members of survivors (Hirsch, 2008, p. 111). There is a sense that the memory and the memories of the Holocaust have been bequeathed to all of us—not only the children of Holocaust survivors, but to all post Second World War generations.

An eye-witness testimony generates a distinct form of traumatic re-experiencing for the storyteller. Through their testimonies, the Shoah testimonies produce a storyteller who bequeaths their stories to family members, who, as carriers, pass their genetic and cultural inheritance on to others. As the stories are transmitted from one community to another, these stories and their traumatic aura permeate the everyday and ever-present heritage we seek to understand.

As a participant-observer, I am still in the process of considering and trying to understand these difficult matters associated with the transmission of trauma. In the process of recording their video testimonies, and under the guise of being asked to disclose and reveal hitherto private parts of themselves, were Holocaust survivors being asked to (metaphorically) undress and reveal too much of themselves before the camera? Are Holocaust testimonies a form of traumatic re-enactment, transmitted to current and future generations, who, in turn, become traumatized by seeing their parents attempting (once again) to tell their complex stories in a single sitting to an unknown interrogator?

My specific interest is in whether my mother 'transmitted' her traumas, and those of her generation to me and to my generation. To be precise, my mother's traumas, my father's traumas and the traumas of a community of souls, were *not* my traumas. I did not experience them directly. And in many ways, their testimonies remind me of how my history is separate (and has been separated) from theirs. Of course, at the same time, my histories are also strongly connected. It is in this tension between connection and separation where we negotiate the seemingly simple and eternally enigmatic questions of who we are, where we come from, and how the generations are connected.

An audience can hear and empathize with another person's memories, but cannot actually recall another person's memory. It only seems to be possible. We can, at best, merely quote another person's memories. In much the same way, one person's actual memory cannot be 'transmitted' to another: memories, and their cast of emotions and imagery, tend to arrive through sensory communication and narrative packages. Moreover, is not a simple matter of claiming that trauma can be transmitted. The process of transmission is never clear or direct: there are all manner of loses, interruptions, confused signals and mis-readings that impede the direct movement of signals and meanings.

As previous generations had before us, my generation were the inheritors of previous collective sufferings. Within a general soup of cultural contagion, stories spread from one community to another. What was also bequeathed, were the humble and dignified stories that situate the survival strategies of our smaller and larger family. I do not believe that my mother (or father) tried to contaminate or inculcate me with their stories. And even beyond their intentions, I do not believe I have been infected. What I believe I have inherited is the belief in the possibility of starting again, of re-writing, and of re-interpreting the impact of trauma. My mother also bequeathed to me her survival instinct and her stories of resilience and re-birth. I quoted her incantation in my own autobiographical video memoir, as I re-enacted my walk to a seaside hospital after an adolescent surfing accident: "...just keep walking..." (Felice Goddard, Testimony for the Shoah Visual History Foundation, 1997) My mother utilized the performative process of video testimony to re-write herself, because although she wanted to forget some things, and perhaps needed to forget others. She also wanted to keep walking ... towards the future.

Beyond trauma

Whilst we need to continue listening to the continuing global stories of traumatic distress, Cathy Caruth has advised, there is also a need to consider traumatic stories "beyond the painful repetitions of traumatic suffering" (Caruth, 1995, p. viii). In the final chapter of *Empathic Vision,* Jill Bennett is concerned that Trauma Culture is becoming passé. Like others, she searches for interdisciplinary strategies for moving 'beyond' trauma and beyond 'post' trauma (Bennett, 2005, p. 149). This echoes my mother's desire to create a life beyond the trauma of the Holocaust she experienced. I believe she did so, by re-writing her past and re-inventing herself through storytelling. Her video testimony was one of the important ways in which she re-inventing herself. It was a way in which she motivated herself to remember, perform and record her telling stories. It was also her own mediated response to the traumatic suffering that she, and her collective community of wandering souls, had endured and remembered.

My mother was both (re-) traumatized and liberated by the experience of remembering and narrating her testimony. Through witnessed, confessional testimony and performative, autobiographical narrativity she moved beyond the role of traumatized wartime survivor. Was she ever redeemed or even reconciled through the interaction of memory and testimony? On

one hand, the performance and recording of her confessional video testimony meant that she knew that she had bequeathed an important legacy. On the other hand, she is part of a generation, still wandering, and waiting for the world to progress towards social justice.

It is neither possible nor useful to assert that we are now 'post trauma' and 'beyond trauma', as if it has been explained and resolved. There is still, for example, the need to develop strategies to connect the different genres of trauma research. In particular, trauma studies can benefit from the continuing effort to examine the techniques, methodologies, uses and impact of video testimony on current generations.

Conclusion

Testimonies are life stories with a pedagogical underpinning. The story that the Shoah Foundation testimonials seek to teach is the story of how it is possible to link one holocaust and genocide with others. It is not only possible; it is necessary to make these connections.

As my mother linked her history to the struggle against other social injustices, the new Shoah Foundation Institute has connected with the University of Southern California, to move beyond the monolithic concept of 'the' Holocaust and to work against collective and continuing global injustices. This shift in focus is reflected in their new manifesto.

> The change of name and location to the USC Shoah Foundation Institute for Visual History and Education reflects the broadened mission of the Institute: to overcome prejudice, intolerance, and bigotry–and the suffering they cause–through the educational use of the Institute's visual history testimonies. Today the Institute reaches educators, students, researchers, and scholars on every continent, and supports efforts to collect testimony from the survivors and witnesses of other genocides (University of Southern California, *History*, 2007).

The Shoah Foundation testimonies can now be considered in conjunction with other testimonies and in relation to other atrocities and other genocides. These survivor testimonies will continue to illuminate and educate as long as they are considered as members of our collective family tree. The aim of these testimonies is, at the same time, to move beyond the symptoms of trauma and the desire to merely elicit empathy, and to connect stories (and storytellers) from the recent past with current injustices and current intolerances.

This is the responsibility and that my mother and other testifiers have bequeathed to current and future generations. Rather than wondering whether we have merely inherited a catalogue of incomprehensible traumas, the effort can be directed towards working against the very tangible and continuing traumas associated with individual and collective injustice.

Works cited

Bennett, Jill. 2005. *Empathic Vision: Affect, Trauma, and Contemporary Art*. Stanford: Stanford University Press.

Caruth, Cathy. 1995. *Trauma: Explorations in Memory*. Baltimore: Johns Hopkins University Press.

Eaton, Mick. 1979. 'The production of cinematic reality'. In Mick Eaton, ed. *Anthropology-Reality-Cinema: The Films of Jean Rouch*. London: British Film Institute, pp. 40 - 53.

Foucault, Michel. 1980. *The History of Sexuality: Vol. 1, An Introduction*. Trans. Robert Hurley. New York: Vintage Books.

Goddard, Felice. 1997. *Testimony for the Shoah Visual History Foundation*, Videotape. Survivors of the Shoah Visual History Foundation.

Halasz, George. 2002. 'Children of child survivors of the Holocaust: Can trauma be transmitted across the generations?', *If Not Now eJournal* 3, http://www.baycrest.org/If_Not_Now/Volume_3_Fall_2002/default_7 117.asp.

Hirsch, Marianne. 2008. 'The generation of postmemory', *Poetics Today* 29(1), http://poeticstoday.dukejournals.org/cgi/content/abstract/29/1/103.

Macdonald, Kevin and Mark Cousins, eds. 1996. *Imagining Reality: The Faber Book of Documentary*. London: Faber and Faber.

University of Southern California. 2007. Shoah Foundation Institute for Visual History and Education. *History*, http://www.college.usc.edu/vhi/history.php.

—. 2007. *Index*. http://college.usc.edu/vhi/pr/FAUI2_Aug2007/index.php.

—. 2007. *Interviewer Guidelines*, http://college.usc.edu/vhi/download/Interviewer_GuidelinesAugust10.pdf.

—. 2007. *Videographer Guidelines*. http://college.usc.edu/vhi/download/Videographer_GuidelinesAugust1 0.pdf.

HISTORY, TRAUMA AND THE ARTS: EXPERIMENTAL VISUAL ARTS, LITERATURE AND OPERA

DANCING OUT OF TRAUMA:
FROM CHARCOT'S HYSTERIA
TO HAITIAN VOUDOUN

DIRK DE BRUYN

Introduction

Meshes of the Afternoon (dir. Maya Deren, 1943, USA, 15 min) is a classic and foundational work in avant-garde cinema. Part of its contemporary relevance relates to both its cyclical, repetitive narrative structure that pre-dates Manovich's New Media concerns with database and narrative fusion (2001) and to Deren's conceptualisation of vertical and horizontal editing as a method for examining issues of amnesia and dissociation. E. Ann Kaplan has argued that Maya Deren's *Meshes in the Afternoon* "produces a visual correlative to the subjective, emotional and visual experience of trauma" (2005: 125) It is argued here that Deren's self-theorised strategies of horizontal and vertical editing open the film up to multiple readings not only in terms of the film's content, but also around contestations of authorship and critical debate as to whether the film should be interpreted through psychoanalysis and surrealism or through Deren's stated preference for psychopathology and Imagist poetry. The indeterminacy of this contested space is contrasted to Charcot's clinical containment and framing of Hysteria in the late 1800s through his photographs and the weekly hysterical public demonstration-performances that he conducted at Paris's Salpêtrière Hospital. Deren's later anthropological work on Haitian voodoun is presented as a counter response to Charcot (and later Freud) within the social. It is outlined how Deren's theorising about 'disciplined' Haitian voodoun dances of possession and Charcot and Freud's western Hysteria as 'parallel phenomena' brought her to the assertion that it was the cultural context in which hysteria occurred that made it aberrant or dysfunctional in western culture.

Meshes of the Afternoon depicts a young woman entering and exploring a small apartment. Through deft editing and surreal like trick-effects she witnesses herself entering the flat from a second floor window. This next split persona enters the flat and finds her 'other' sleeping on the couch, floats through the room, turns off a record player and then witnesses a third split clone of herself chasing a hooded figure in the street below through that same window, eventually repeating the action of the previous iteration. Deren (she plays herself) then, like the 'other' clones before enters the flat (again). A fourth clone then is seen chasing the hooded figure and enters the flat to be confronted by the other three. They interact. A man (played by Hammid) then enters the flat to eventually, in the last shot, find a single Deren on the couch, with her throat apparently slit. Is this a suicide shot? What is the film about? A number of interpretations are possible. Has she committed suicide? Is it a hysterical dream?

Vertical-horizontal

Deren has referred to this structure with the story unfolding through its repeated chain of events as an interplay between a vertical and a horizontal axis. The story plays out on the horizontal axis, and the vertical axis peals away multiple layers or views of these events. Deren has theorised in her writings about these horizontal and vertical axes in terms of amnesia and memory.

> What I called horizontal development is more or less of a narrative development, such as occurs in drama from action to action, and that a vertical development such as occurs in poetry is a plunging down. (Sitney, 1970: 183).

Vertical development also has an affinity with the performative, and its direct impact evidence of a Cinema of Attractions. "An attraction aggressively subjects the spectator to 'sensual or psychological impact'" (Gunning, 1990 :59). It is in this pre-reflective realm that the invisible and unspeakable of trauma can be articulated. For Deren the poetic, with its multiple meanings, its all at once impact on our thinking, can address this realm.

> The poetic construct arises from the fact, if you will, that it is a "vertical" investigation of a situation, in that it probes the ramification of a moment, and is concerned with its qualities and its depth, so that you have poetry concerned, in a sense, not with what is occurring with what it feels like or what it means. A poem, to my mind, creates visible or auditory forms for

something that is invisible, which is the feeling, or the emotion, or the metaphysical content of the movement. (Sitney, 1970: 173-4)

The interplay between the horizontal and vertical narrative paths creates what Le Grice refers to as a circular or spiral trajectory within the film. "At each repetition small changes expand the spectator's imaginary construction of the symbolic space rather like a spiral through a matrix of action images." (Le Grice, 2001: 318) Each scan or iteration of the situation adds depth and complexity and builds on the reading enabled so far to end on an image that Kaplan refers to as a "traumatic hallucination". (Kaplan, 2005: 129) Deren herself has said that

This film is concerned with the interior experiences of an individual. It does not record an event that could be witnessed by other persons. Rather, it produces the way in which the subconscious of an individual will develop, interpret and elaborate an apparently simple and casual incident into a critical emotional experience. (Deren, 1965: 1)

Contested space

Meshes of the Afternoon can be considered a contested space not only in terms of vertical and horizontal narrative interplay or because of differences of opinion of the events depicted but also because of the contention of authorship between Hammid and Deren and in terms of the reflective thinking and theorising used to frame and contain the work.

Three main clusters of often overlapping contention around *Meshes of the Afternoon* are considered. The first centres on authorship. There has always been a degree of contention about the balance and nature of the Deren-Hammid collaboration in Deren's first film. The second area of contention is in part a feminist response to this questioning of authorship and moves into an argument about autobiography and psychoanalysis in support of Deren's claim. A third area is concerned with the tools used to read the film itself for or against Deren's own wishes as Deren herself pointedly dismissed Freudian and Surrealist readings of her work. This feminist position is thus of particularly interest given its support of Deren's ownership on the one hand often coupled to a counter-reading of the work against her own wishes on the other.

Sitney, who saw this film as central to his argument about visionary film, marks it as surrealist and as co-authored, as a collaboration between Deren and her then husband Hammid. As far as he is concerned the framing, look

and trick effects come from Hammid. Jonas Mekas also makes the link between surrealism and Hammid's claim to the film through trick effects and their surrealistic impact: "surrealism was imposed upon Maya by Sasha" (Mekas, 1998: 131).

The issue of Hammid's authorship and influence seems to have run a course through the pages of Film Culture and its contributors (Mekas, Sitney, Brakhage). Film Culture nurtured that generation of film artists and writers that directly followed Deren's lead into cultural activity, exhibition, analysis and production but who also, it can be argued, had a need to set themselves apart from her initiating work. It is within such a context that the argument for Hammid's surrealist influence is first inspected and played out.

Hammid himself remained mute in terms of cultural activity and critical analysis, reinforcing his perceived role as technician. Certainly Deren's developed public profile and committed screening activity reinforced her claim on the film, inserting herself emphatically inside the dialogue between audience and film, between the viewer and the viewed.

Deren's work has garnered its most substantial critical attention from feminist commentators since her untimely death in 1961, as a response to a cultural profile erected at a time when such activity was clearly male dominated. This commentary on her work often questions the gender prejudices of Deren's contemporaries and makes the case for autobiographic readings of *Meshes of the Afternoon* often through the prism of psychoanalysis.

Geller, for example, responds to Mekas's assessment of Deren as an 'adolescent film poet' (Mekas, 1970: 23) and her 'artificial' depth (1970: 25) as "symptomatic of gender prejudices". Geller identifies Sitney's "unproblematized" reading as exhibiting "an implicit discomfort with the film's critical engagement with gender relations" (Geller: 149).

Kaplan (2005: 128) enlists Deren's own words to support "autobiography" by identifying correspondence that prefigures the record player sequence in *Meshes of the Afternoon's* second iteration. This account involves terrifying moments of "possession" triggered in Deren while dancing alone in her apartment. "I ran to the phonograph and lifted the needle and grabbed my head with both my hands to stop it. I felt terribly exhausted and sank into a chair" (Clark Hodson and Neiman, 1988: 472).

While Sitney and others have interpreted this film as an apprenticeship to Hammid into the technical aspects of filmmaking, there has been no such stated concern as to the impact of Deren's poetry on the film. Clearly her poem "Death by Amnesia" (Clark Hodson and Neiman, 1988: 65) can be seen as a rehearsal text that influences the film's structure.

Geller further argues persuasively for a central role for Deren in any feminist revision of film history and remarks on the discounting by feminist scholars such as Rabinovitz who see Deren as having "constructed a position of resistance within traditional roles" (Rabinovitz, 1991: 5) without having fully understood the impact of cultural institutions on her. More importantly Geller identifies Mulvey's (1996: 213) assignment of Deren to dance and avant-garde pioneer rather than as a "legitimate founder of feminist film practice" (Geller, 2006: 154) as a move that benefits Mulvey directly, as it enables "Mulvey to emerge from this void—along with her European counterparts Yvonne Rainer and Chantal Ackerman—as the necessary integrators of avant-garde film praxis and feminist polemics" (Geller, 2006: 154). This is a critical area and moment which is identified by Mulvey as a "meeting between the melodramatic tradition and psycho-analysis" (Mulvey, 1996: 213) a meeting that for Geller is clearly evident in *Meshes of the Afternoon.*

Perceptively, Mellencamp inside her effective critique of Sitney's discounting of Deren offers that "Meshes is about the female subjectivity divided against itself, held in the violent and domestic contradictions of sexual difference" (Mellencamp, 1990: 33), yet marks Deren as "knowledgeable about psychoanalysis" (: 34) to support her argument when clearly Deren has rejected what she calls "Freudians". In this way Mellencamp embraces in turn that same accusation of opportunity that she herself levels at Sitney, in her pointing out that "Deren's death silences her opposition. (Mellencamp, 1990: 35)

Clark's (Clark Hodson and Neiman, 1984, Clark Hodson and Neiman, 1988) research indicates that Deren herself was more interested in a meeting between melodrama and Vorticism (or Imagism) than psychoanalysis as this related to her thesis work at Smith College, being more interested in perceptual and visceral effect than psychoanalytic symptom. (Holl, 2001: 160) This is certainly the view that Millsapps (1986) pursues. Deren's own notes to organisers of film screenings of her work state that "Under no conditions are these films to be announced or

publicized as surrealist or Freudian" (quoted in: Millsapps, 1986: 26) and emphatically states in a lecture at the Cleveland Museum of Art in 1951 that the "work must not be dismembered with some system as Freudian" (quoted in: Millsapps, 1986: 26).

Deren herself places her work in the realm of Imagist poetry and research into perceptual processes and mental activity that she saw uniquely enabled by cinema. It was not about symbolic representation "When you see a bird or tree in my films it represents a bird or a tree, not something else altogether" (Patterson, 1951: 6).

She pursued a neuropsychological tradition, which she inherited from her father, in preference to and even against psychoanalyis. Her contemporary Anais Nin, identified as "writing in the tradition of psycho-analysis" by Holl (Holl, 2001: 173) in questioning that Deren's "obsession was to employ symbolic acts but to deny that they had symbolic significance" (Nin, 1973: 135) marks that line and clearly identifies a resistance in Deren's method attitude.

Charcot

Not only are contested readings of its situation or events played out inside *Meshes of the Afternoon* itself through its iterations and points of view, but as has been discussed there are also contestations as to authorship and debates and counter-readings about the film's historical and critical currency. It is as if this maelstrom of contestations itself reflects the film's own internal layered psychic dance at some 'meta' level (or perhaps as evident of some slippery fractal like structure)

There is an indeterminacy here that has enabled these layers of contestation, and that is also evident inside the performative nature of Charcot's hysteria. It is in the weekly scientific enactments of hysteria with his female patients from Paris's Salpêtrière Mental Hospital in the late 1800's and it registers in the clinically assembled series of photographs of these same hysterics.

Such performances orchestrated by Charcot can be read as a kind of framed theatre of cruelty (Artaud) and as precursor to later Fluxus art events. The photographic series can be identified as an early formulation of the database and the "technical image" (Flusser) currently so central to an understanding of new media or digital art. In fact Charcot's hysteria

gains a certain resilience and mobility through its multi-platform delivery as authoritative clinical invention, public performance and conceptually arranged field of photographic images, a record of hysterical gesture.

Charcot had proposed that the "symptoms of his hysterical patients had their origins in histories of trauma" (Van der Kolk, 1996: 52). Yet Charcot's hysteria has eventually become identified as problematic and/though many of its checklist of symptoms have migrated into contemporary conceptions of trauma and PTSD. Apignanesi states this hysteria is "described a sexualised madness full of contradictions, one which could play all feminine parts and take on a dizzying variety of symptoms, though none had any real, detectable base in the body" (Apignanesi, 2008: 126). For Apignanesi hysterics also embodied a desire for sexual freedom "both for herself and for the fascinated men who watch and help to invent her" (2008: 126). The contestations about authorship and ownership evident in the previous discussion about *Meshes of the Afternoon* resurface here and again play themselves out along gender lines but this time with a different outcome. At the very least in Deren's case *Meshes* problematic authorship is publicly recognised and registered as hers. With Charcot, he takes ownership, with the female body caged within a clinical construct arrived at through a relentless male gaze.

And Charcot's scrutiny was relentless as Freud attests in his obituary to Charcot:

> he was, as he himself said, a 'visuel', a man who sees...He used to look again and again at the things he did not understand, to deepen his impression of them day by day, till suddenly an understanding of them dawned on him'. Quoted in (Apignanesi, 2008: 128).

This gaze, one could say, finds it technological equivalent in the camera, and the "new nosological pictures" (Apignanesi, 2008: 128) that emerged find their equivalent representation in the field of symptomatically arranged 'technical' images that Charcot's team constructed.

Didi-Hubermans levels an accusation of slippery-ness at Charcot's reading of hysteria and stresses hysteria's un-containability, naming Charcot's causes of hysteria as "a chaotic ragbag of causes, again. A dissemination of causality: circulus vitiosus. But is not this the very same causality, specific and strategic, as it were of hysterical causality?" (2003 [1982]: 72) It is as if the elusive checklist of Charcot's hysteria is itself hysterically un-nameable. Didi-Huberman had also noted that:

time is stubborn in the cryptology of the symptom: it always bends a little,
ravelling and unravelling, but, in a certain sense, it remains stubborn- very
stubborn in hysteria (2003 [1982]: 26)

Furthermore, Didi-Huberman laments that "if only hysteria could have
been found, somewhere. But nothing was; because hysterics are everything
at once" (2003 [1982]: 72) This *everything at once* reminding us of the all
at once Imagist vortex harnessed by Deren at the end of her film and her
commitment to poetry's plunging down. In this sense the hysterical could
be said to reside inside Deren's 'vertical', inside the poetic and outside
time.

In terms of this famous photographic record assembled at Salpêtrière,
whether coached or of their own volition, Charcot's hysterics, "like the
early silent film stars, who may well have imitated their impressions, went
through the dramatic paces of their condition for the camera" (Apignanesi,
2008: 129).

Three historical traces converge here in this pre-cinematic database of
transportable images. We have a technology historically poised to usher in
moving images and a core database of gesture and emotion to invigorate
cinematic melodrama as it arrives, and critically, we also have a clinician
at the heart of its directorship whose mentoring work inspires Freud's
"The Aetiology of Hysteria" (1896) (Freud, 1962), and spawns psycho-
analysis itself. This is a core gestation point, a convergent moment set to
belatedly (in Caruth's sense of the word) remind us of Mulvey's earlier
quoted remark about the encounter between melodrama and psychoanalysis
in the development of feminist film theory in the 1970's to say nothing of
the scopophilic male gaze itself so heavily and articulately theorised by
Mulvey herself in her critical historical text: Visual Pleasures and
Narrative Cinema.

There is an essential core in the dialogues between Charcot and his
patients, as Didi-Hubermans intimates, which speaks to this tussle between
the un-speakability and un-containability of trauma. In its mirroring
dialogue between Charcot and 'Hysteria', it is as if science in its pulling
apart and dissecting, its opening up of the toy to see how it works, is in co-
dependant accord with that state of hysteria, itself a pulled apart and
dissected or fragmented psychic state. Could it be a way of being in the
social, one that continually reflects back to others (including Charcot) their
own point of view, like a broken record, amplifying any scrutiny in a kind
of biofeedback loop back to the scrutineer?

This question may also be part of the continued fascination of *Meshes*, its continued ability to reflect back to successive generations essential elements of their own being-in-the-world and the political imperatives this throws out. Such a question may also open up to Sobchack's phenomenological argument expressed in *Address of the Eye* (Sobchack, 1992) that the action is not in the film but in the dynamic to and fro between the "viewer and the viewed" a dynamic that she argues is neglected within psychoanalytic film criticism. Certainly it is within the social that Deren eventually frames her own response to this dynamic between viewer and viewed, into her study of Haitian voodoun as 'culturally disciplined states of possession'. (Clark Hodson and Neiman, 1988: 108)

Haiti

Through the public success of *Meshes* Deren gained the opportunity to go offshore to Haiti to investigate and document her long-standing interest in voodoun dance and ritual. A short trip there extended to eighteen months. What does such work bring to Deren's practice and a traumatic reading of her work? There are three areas that will be commented on. One is her relationship to the mountain of film material shot during her eighteen month stay in Haiti, the second is her embrace of voodoun practice on her return to New York and finally her critical writing which contextualizes voodoun with western interpretations of possession.

Firstly Deren brought back with her from Haiti film documentation of Haitian rituals and over another two and a half years of returns shot even more material but she encountered great difficulty giving the material a form she was happy with. "She sat on what was finally twenty-five or thirty thousand feet of color film of voodoun ritual and never could bring herself to edit that footage into a final form. It overwhelmed her" (Brakhage, 1989: 100).

This film material froze Deren. Her editing and her foraging for a structure to impose on the material, the continual going over and re-organizing through ten years of treatments, scripts and storyboards never came to a resolution. In that process she was caught in the kind of re-iterative loop reminiscent of the one presented as *Meshes*' narrative, which through it representations also can be interpreted as ending in the 'defeat' of suicide. Brakhage observed that "she did not believe that the film had captured

what really was involved in the mystical experience of this religion" (Brakhage, 1989: 112).

A second impact of Deren going offshore was that after she returned from Haiti "Maya became the priestess in a Voodoun cult in the city" (Brakhage, 1989: 100). Brakhage's sketch of an event he witnessed gives some indication as to the level of Deren's involvement in such practices. Brakhage describes an event in which Deren became "possessed" after her preparations for an important Haitian New Yorker's wedding were marginalized. After throwing a fridge around the kitchen,

> a group of Haitians formed a ring around her and said not to call the police, that they would handle this themselves. And so they began to calm her down according to the rituals of the religion. She left the room still growling and was taken upstairs. As it was explained to me, she was possessed by Papa-Loco, the Haitian god of ritual, tradition and artists. (Brakhage, 1989: 105)

As Brakhage observes "After that experience, I wasn't inclined to doubt the power of Voodoun, or Maya's status in it" (Brakhage, 1989: 105). Here is described a very non-western community operating 'inside' of New York—a self-contained cell of social 'other' operating like a dissociated fragment within the wider social environment. This community performs as a fragment inside New York but also as a displaced cell of culture split off from Haiti. It is suspended in between.

Such an 'underground' community has its affinities in structure and cultural position with the underground film scene Deren helped congeal and 'surface' and also connects with Herman's reading of the study of trauma as a relentless underground history, to say nothing of the cultural and political position of the migrant or of women in a male dominated oeuvre. As always such a position runs the risk of being defined and contained by the larger community within which it 'struggles': "The possessed person in Western cultures is considered sick, because the disease is not traced back to the social context that caused it" (Holl, 2001: 159).

Possession in such a Haitian oriented community is not constructed to address individual conflicts but group or social ones. It is a rule that one must not use the magic accessible during possession for personal reasons. Brakhage suggests that Deren at times transgressed this principle, "It is

said that Maya had gotten into the practice of putting Voodoun curses on people who displeased her" (Brakhage, 1989: 107).

A third impact or product of this interaction with Haiti surfaces within Deren's critical writing. Her book on Haitian Voodoun, 'Divine Horseman' assured her critical authority in the area in a way that would have pleased her father. Her views on the relationship between possession and hysteria were here clearly conceptualised within the critical language of the 'west'. "For Deren repression or disavowal is not a matter of personal neurosis but of social conventions and communication systems" (Holl, 2001: 174). These are rules she herself has been accused of transgressing in New York with her Voodoun curses.

Such a focus emphasises a counter view to that arising out of the clinical investigations initiated by Charcot. As Holl states:

> In examining possession, suggestibility and affectivity of the nerves, she returns to the roots of European medical discourse and thus to the favourite fields of Charcot- and consequently of Bechterev and Freud. (Holl, 2001: 158)

Deren identifies an audience, and a witnessing as vital to the performance of both hysteria and possession, emphasising the social context of such phenomena. "One of the similarities is that hysteria, as possession also, occurs only within a social context, when there are one or more witnesses to the scene" (Clark Hodson and Neiman, 1984: 489).

Giesen has pointed out that body-centred or what he describes as "corporeal experiences" (as which hysteria can be categorised) are often incorporated into the social through ritual and also recalled through such ceremony. 'Those who are present and participate are mirrored in the body of others, they experience immediately a corporeal similarity, they are merged in a collective identity' (Giesen, 2004: 35).

Conclusion

Deren's theorising about 'disciplined' Haitian Voodoun dances of possession and western Hysteria as 'parallel phenomena' brought her to the assertion that it was the cultural context in which hysteria occurred that made it aberrant or dysfunctional in western culture. "The hysteria of an individual in our culture is pathological because it is induced by personal conflicts. In the African or Haitian cultures the conflicts are the conflicts

of a community, and the system of ideas which is emancipated is organised entirely in terms of their cultural tradition" (Clark Hodson and Neiman, 1984: 490).

Given this "hysterical" trajectory embedded in Deren's performance, film making and scholarship that terminates in a more empowering reading of its symptom cluster as possession within Voodoun dance and ritual, it becomes possible to read *Meshes* as a signpost along such a road to Deren's designated "normalcy" and "belonging" that she identified within Haitian culture but was unable to fully implement in her own life and failed to demonstrate visually through the unfinalised editing of the Haitian documentary footage. This is a trajectory that delivers the hysteric female body out of the clutches of the originating diagnostic moments of Charcot's photographs and the weekly hysterical public demonstration-performances at Salpêtrière's hospital in Paris that he conducted, to dance all the way into the centre of Haitian and African cultural and political life as an empowering ritual. In this way Deren's *Meshes of the Afternoon* can be read as a pre-feminist performative response to Charcot's clinical caging of the female body.

Works cited

Apignanesi, Lisa. 2008. *Mad, Bad and Sad: A History of Women and the Mind Doctors from 1800 to the Present*. London: Virago.

Brakhage, Stan. 1989. *Film at Wit's End*. Kingston, New York: Documentext.

Clark, Veve A., Millicent Hodson and Katrina Neiman. 1984. *The Legend of Maya Deren: Signatures (1917-42)*. New York: Anthology Film Archive.

Clark, Veve A., Millicent Hodson and Katrina Neiman. 1988. *The Legend of Maya Deren: Chambers (1942-47)*. New York: Anthology Film Archive.

Deren, Maya. 1965. 'Notes, essays, letters', *Film Culture* 39, pp. 1-70.

Freud, Sigmund. [1896] 1962. 'The aetiology of hysteria'. In J. Strachey, ed. *Standard Edition of the Complete Psychological Works of Sigmund Freud* vol. 3. London: Hogarth Press, pp. 89-221.

Geller, Theresa L. 2006. 'The personal cinema of Maya Deren', *Biography* 29, pp. 140-158.

Giesen, B. 2004. 'Noncontemporaneity, asynchronicity and divided memories', *Time & Society* 13, pp. 27-40.

Gunning, Tom. 1990. 'The cinema of attractions: Early film, its spectator and the avant-garde'. In Thomas Elsaesser, ed. *Early Cinema: Space Frame Narrative*. London: BFI Publishing.

Holl, Ute. 2001. 'Moving the dancers' souls'. In Bill Nichols, ed. *Maya Deren and the American Avant-Garde*. Berkeley: University of California Press.

Kaplan, E. Ann. 2005. *Trauma Culture: The Politics Of Terror And Loss In Media And Literature*. New Brunswick: Rutgers University Press.

Le Grice, Malcolm. 2001. *Experimental Cinema in the Digital Age*. London: British Film Institute.

Manovich, Lev. 2001. *The Language of New Media*. Cambridge: MIT Press.

Mekas, Jonas. 1970. 'The experimental film in America'. In P. Adams Sitney, ed. *Film Culture Reader*. New York: Praeger.

—. 1998. 'A few notes on Maya Deren'. In Shelley Rice, ed. *Inverted Odysseys*. Cambridge: MIT Press.

Mellencamp, Patricia. 1990. *Indiscretions: Avant-garde Film Video and Feminism*. Indianapolis: Indiana University Press.

Millsapps, Jan L. 1986. 'Maya Deren, imagist', *Literature/Film Quarterly* 14(1), pp. 22-31.

Mulvey, Laura. 1996. 'Film, feminism and the avant-garde'. In Michael O'Pray, ed. *Anthology of Writings*. Luton: University of Luton Press, pp. 211-221.

Nin, Anais. 1973. *The Diary of Anais Nin, Summer 1946* vol. 4. New York: Harvest Books.

Patterson, George. 1951. 'Maya Deren comes to town', *Canadian Film News*, pp 5-7.

Rabinovitz, Lauren. 1991. *Points of Resistance: Women, Power and Politics in the New York Avant-Garde Cinema 1943-171*. Urbana: University of Illinois.

Sitney, P. Adams, ed. 1970. *Film Culture Reader,* New York: Praeger Publishing.

Sobchack, Vivian. 1992. *The Address of the Eye*. New Jersey: Princeton University Press.

Van Der Kolk, B. A. 1996. 'History of trauma in psychiatry'. In B. A. Van Der Kolk, A. Mcfarlane and L. Weisaeth, eds. *Traumatic Stress: The Effects of Overwhelming Experience on Mind, Body, and Society*. New York: Guilford Press.

RETHINKING VISUAL REPRESENTATIONS OF TRAUMA IN THE WORK OF KARA WALKER

LEE-VON KIM

Introduction

This article is interested in rethinking how we engage with and theorise visual representations of trauma. In particular, I want to reconsider how trauma theory has been marshalled in readings of traumatic experience in visual texts and interrogate some of the assumptions that underpin these readings. Focusing on African-American artist Kara Walker, I will critically discuss how Walker's work grapples with the representation of the trauma wrought by slavery and consider how it engenders new ways of theorising trauma in visual productions. Walker's large-scale silhouettes have generated controversy due to their reappropriation of black racial stereotypes in their reconstruction of antebellum historical narratives. While much of the existing critical scholarship has focused on her reappropriation of racial stereotypes, in this article I wish to shift the focus to how representations of trauma, and their specific visuality, are complicated in Walker's work.

In particular, I will focus on Walker's large-scale silhouette installation *Slavery! Slavery! Presenting a GRAND and LIFELIKE Panoramic Journey into Picturesque Southern Slavery or "Life at 'Ol' Virginny's Hole' (sketches from Plantation Life)" See the Peculiar Institution as never before! All cut from black paper by the able hand of Kara Elizabeth Walker, an Emancipated Negress and leader in her Cause* (1997), which depicts a reimagined narrative of pre-Civil War Southern plantation life. As Yasmil Raymond and Rachel Hooper note in the exhibition programme that accompanied Walker's mid-career retrospective "Kara Walker: My Complement, My Enemy, My Oppressor, My Love," *Slavery! Slavery!* explicitly references Eastman Johnson's well-known oil painting *Old-Kentucky Home-Life in the South (Negro Life in the South)* (1859), which represents a bucolic scene of slave-master relations in the South (10-11).

Slavery! Slavery! is a large-scale black paper silhouette tableau that spans across a semi-circular installation space. It is intended to evoke the now-obsolete cyclorama, and Walker herself has noted that its form intentionally references a much larger cyclorama in Atlanta that depicts a scene from the Civil War (English, *How to See a Work of Art in Total Darkness*, 92). Its semi-circular layout and near-lifesize figures serve to induct the viewer into the representational space of the piece. Entering the room through a narrow doorway, the viewer is almost overwhelmed by the scale of this installation, which measures 3.7 x 25.9 metres. Walker's tableau depicts a number of different vignettes from antebellum plantation life. There are no clear demarcations between the different scenarios, and it is difficult to determine where one begins and another ends. At first glance, the characters (there are more than 30 in total) and scenarios that are represented in this reimagined narrative of plantation life seem all too familiar. Yet on closer inspection, it becomes evident that Walker's reconstructions of Southern plantation life differ substantially from the familiar narratives that have circulated in American popular culture. *Slavery! Slavery!* references both the nostalgic representations of the antebellum South from the first half of the nineteenth century and the brutal depictions of plantation life from anti-slavery narratives (including those written by former slaves) that began to appear during the eighteenth century. While her installation is clearly indebted to both, its reimagining of plantation life in the antebellum South is something entirely different. *Slavery! Slavery!* is replete with sexual and scatological imagery, and confronts the viewer with graphic scenes of exploitation, conflict and violence. The familiarity of the characters (black slaves, white slavemasters) is disrupted by the unfamiliar and fantastical situations that Walker depicts in *Slavery! Slavery!*

Walker's work recognises the difficulties inherent in attempting to negotiate the ethical dilemmas that are necessarily wedded to any engagement with the representations of the overwhelming historical trauma of slavery. In speaking of trauma in relation to Walker's silhouette installations, I am conscious of the potential dangers of claiming that her work is "about" the historical legacies wrought by slavery. While there is no doubt that her large-scale silhouette tableaux, such as *Slavery! Slavery!*, narrativise antebellum plantation life, they do not abide by the conventions of "objective" historical accounts. These silhouette installations are as much "about" the antebellum period as they are "about" contemporary understandings of the legacies of slavery. While Walker's silhouette tableaux have been criticised for its fantastic reimaginings of slave-master

relations in the pre-Civil War period, I would argue that these criticisms often fail to address the non-realist register in which her work operates. By choosing to revisit the traumatic experience of slavery through the lens of fantasy and imagination, Walker recognises that there is more than one way to deal with the legacies of historical traumas. As Darby English writes in "This is not about the past: silhouettes in the work of Kara Walker," Walker's work "takes note of 'dead and gone' violences in order to better comprehend the multiply reshaped and redirected forms they take today" (167). In bringing together trauma theory with *Slavery! Slavery!*, I will demonstrate how this text speaks back to certain underlying assumptions of trauma theory and in turn calls out to us to rethink how we engage with visual representations of trauma.

In recent years, the field of trauma studies has generated increasing scholarly interest from those working across a wide range of disciplines from the humanities. In particular, there seems to be a burgeoning interest in trauma theory within literary and cultural studies within Western academy. This hardly seems surprising, given the global social and political catastrophes that have taken place in the past two decades. While trauma studies appears to have firmly established its place within the humanities, it seems apposite at this particular moment to reflect upon its genesis and its interests as well as its limitations. The far-ranging reach of trauma theory, and its seemingly unabated popularity within literary and cultural studies, demands closer scrutiny, I would argue, especially given the apparent canonization of trauma theory within the humanities.[1]

The publication of Cathy Caruth's edited collection *Trauma: Explorations in Memory* (1995) and her monograph *Unclaimed Experience: Trauma, Narrative and History* (1996) and Shoshana Felman and Dori Laub's *Testimony: Crises of Witnessing in Literature, Psychoanalysis and History* (1992) signalled the emergence of trauma theory as a distinct field of study within the humanities. Caruth's monograph *Unclaimed Experience: Trauma, Narrative, and History* marked a seminal moment in trauma studies. Caruth's book tentatively elaborates a theory of trauma that focuses on the interrelations between reference and representation. As Caruth points out, "trauma describes an overwhelming experience of sudden or catastrophic events in which the response to the event occurs in the often delayed, uncontrolled repetitive appearance of hallucinations and

[1] For a discussion of trauma theory and its place within the humanities, see Radstone 2007.

other intrusive phenomena" (11). Caruth focuses on a number of scholarly and literary texts, most notably Freud's *Moses and Monotheism* and *Beyond the Pleasure Principle* and Alain Resnais and Marguerite Duras' *Hiroshima mon amour*, in her exploration of "the complex ways that knowing and not knowing are entangled in the language of trauma and in the stories associated with it" (4). She argues that each of these texts "ask what it means to transmit and to theorize around a crisis that is marked, not by a simple knowledge, but by the ways it simultaneously defies and demands our witness" (5).

The traumatic event is accorded a privileged position in Caruth's work, and she proposes that "The crisis at the core of many traumatic narratives... often emerges, indeed, as an urgent question: Is the trauma the encounter with death, or the ongoing experience of having survived it" (7). One of the key ideas that emerges from Caruth's book is that of belatedness, in which the effects of the traumatic event might be delayed: "What returns to haunt the victim... is not only the reality of the violent event but also the reality of the way that its violence has not yet been fully known" (6). Caruth argues that "Through the notion of trauma... we can understand that a rethinking of reference is aimed not at eliminating history but at resituating it in our understanding, that is, at precisely permitting *history* to arise where *immediate understanding* may not" (11, emphasis in the original).

In *Testimony: Crises of Witnessing in Literature, Psychoanalysis, and History* (1992), Shoshana Felman and Dori Laub turn their attention to the ethical and political implications of witnessing. The book is a collaborative work between Felman, a literary studies scholar, and Laub, a psychoanalyst, and their work explores the juncture of literary, pedagogical and clinical studies in relation to trauma. Felman and Laub focus on how testimony to a traumatic event comes into being through witnessing. Felman's writing on testimony focuses on trauma within the contexts of pedagogy and literary studies. In the first chapter "Education and Crisis, Or the Vicissitudes of Teaching," Felman asks "*Why has testimony in effect become at once so central and so omnipresent in our recent cultural accounts of ourselves?*" (6, emphasis in the original). In the second chapter "Bearing Witness or the Vicissitudes of Listening," Laub examines the privileged position of the listener to the testimony of trauma. Drawing upon his work with survivors of the Holocaust, Laub proposes articulates the relations between the trauma subject and the listener to this subject's testimony (57). In Laub's theorising of bearing witness to the

testimony of the trauma subject, the listener is not figured as a passive actor; rather, the listener takes on an active role in the emergence of the trauma narrative (57-58).

One of the key points that emerges from any discussion of Caruth, Felman and Laub is that trauma theory has drawn heavily on Western intellectual traditions of psychoanalysis and post-structuralism. It is also evident that the Holocaust, as the most extreme example of individual and collective catastrophe from the twentieth century, holds a privileged position in trauma studies. Trauma theory's provenance has also ensured that written expressive forms, such as literature and biography, have been privileged in the field. Trauma theory has in turn come to be dominated by interpretative approaches that have often assumed that trauma is something private that emerges from within the individual subject. As Jill Bennett notes in *Empathic Vision: Affect, Trauma, and Contemporary Art*, "We are accustomed by various individualizing discourses to think of pain as something private that emerges from within, and that must be *worked through* if one is to return to a normal life" (48). Yet Bennett continues by questioning the orientation of such approaches, and evokes Veena Das's idea that the pain of the other seeks a home in both language and the body on pain and language as an alternative to such individualizing discourses (48).

In thinking about how visual texts, such as Walker's *Slavery! Slavery!*, represent traumatic experience, I am especially wary of uncritically applying a clinical, one-on-one patient/therapist model to the reading of cultural texts. Indeed, it seems that this transference neglects the possible shortcomings of such a model when engaging with visual representations of trauma such as Walker's *Slavery! Slavery!*. However, I want to emphasise that this uneasiness is directed not so much at existing trauma theory, or its origins in psychoanalysis, as it is towards its *application* in readings of visual representations of trauma. I would argue that the clinical or therapeutic models of trauma that have come to dominate trauma theory cannot be unproblematically transferred to analyses of visual cultural productions. While trauma studies has tended to focus on written (especially literary) expressive forms, the burgeoning interest in visual representations of trauma demands, I would argue, a theoretical engagement that attends to specificities of the *visual*. What I am proposing here is the negotiation of a different kind of engagement with visual representations of trauma, one that takes its cue such representations themselves, from

their formal and historical specificities, rather than mapping existing interpretative frameworks onto these texts.

In proposing that *Slavery! Slavery!* acts as a call to us to reconsider our viewing position vis-à-vis visual representations of trauma, I want to take seriously the idea of calling out and suggest that Walker's work be read as operating within an antiphonic framework of call and response. In so doing, *Slavery! Slavery!* acts as a kind of call to us, in the present, to take another look at slavery and its continuing legacies in the present-day. Furthermore, it compels us to reconsider how *visual* representations of trauma might generate different forms of engagement that attend to their specific visuality and do not assume or privilege literary modes of expression.

Bennett convincingly argues that trauma can be conceptualised as a kind of presence or force, "not simply as an interior condition but as a transformative process that impacts on the world as much as on bodies" (12). To conceive of trauma as a presence or force seems apposite when considering Walker's reimagined narratives of antebellum plantation life. In Walker's silhouettes, the contours of the traumatic legacies of slavery are not always explicitly represented, nor easy to identify, but their presence can nevertheless be felt.

By re-orienting the focus on how trauma is registered within a broader social context, we can negotiate a way of conceptualising the representation of trauma in art that moves beyond the psychoanalytic discourses that have come to dominate trauma theory. What I find especially compelling about Bennett's analysis is the fact that she places the emphasis on how trauma exists within a "nexus of social relationships" which can be "conceived of as a 'call' is bound up with a response, which, in turn, implies a kind of antiphonic structure. ... the lived experience of pain is shaped by the language – and also the silences – that surround it" (48). In emphasising the importance of sociality in my critique of how trauma theory has been marshalled in textual analysis, I am not suggesting that psychoanalytic models of trauma theory are necessarily asocial or ahistorical; rather, I seek to negotiate a theoretical position that foregrounds the intricate social networks in which trauma exists.

The conceptualising of trauma not as something private and individual but as something that must always be located within a broader social network is a crucial starting point for any theorising of trauma that attempts to

move beyond the familiar psychoanalytic theories of trauma. This also allows us to reconsider the commonly-made assumption that visual representations of trauma "offer us a privileged view of the inner subject" (Bennett, 12). By recognising that visual representations of traumatic events and legacies do not necessarily claim to have "insider" knowledge of the subject of trauma means that such representations can at least attempt to negotiate a position which is not about "claiming" or, indeed, "colonising" another person's trauma.

Walker's *Slavery! Slavery!* is a productive intervention in the existing scholarship on trauma theory and its engagement with visual representational practices. It seems apposite to focus on *Slavery! Slavery!* as it is a visual text that inscribes trauma on multiple levels. Walker's silhouette figures can be read as a series of incisions, which bring to mind the idea of wounding or trauma. Thus, trauma is doubly inscribed in Walker's silhouettes, in form and content: not only do they engage with the historical traumas wrought by slavery, but their very production enacts a kind of physical trauma too. The X-Acto knife that is often used to cut the black card from which the silhouettes are made is echoed in the works themselves. As Yasmil Raymond notes in "Maladies of Power: A Kara Walker Lexicon," knives, axes and razor blades often feature in Walker's tableaux (351-354).

In *Slavery! Slavery!*, the idea of physical trauma can be seen quite literally in the headless figure holding the severed head of a bird (whose headless body stands to the right of him). Further to the right of the headless boy, a woman dances with a young child, but somewhat menacingly clasps a knife behind her back. This is also vividly illustrated in one of her single-image silhouettes entitled *Cut* (1998). This work depicts a slave woman, an "emancipated negress" perhaps, who has slit both of her wrists with a razor blade, which she still holds in one of her hands. Blood gushes out from both wrists in an exaggerated manner, and there are two small pools of blood that lie to the left of her feet. While this scene ostensibly represents an act of suicide, the female figure is represented in a strangely exuberant manner. The woman is depicted jumping into the air, her full skirt ballooning as if she were to be carried up and away. Her arms are outstretched over her head, further emphasising the blood that pours forth from her self-inflicted wounds and suggesting that this act should be read as one of defiance and liberation. The dual violences that are at play in Walker's silhouettes suggest that violence cannot simply be read as destructive: the act of cutting the black cardboard is integral to the creative

process, and yet the violence that is represented in her work is often destructive. In Walker's reimagined narrative of plantation life, violence and its effects are often visible on the black figures. Bodies are violated, brutalised, wounded, and Walker does not shy away from explicit (and often disturbing) sexual and scatological references. In her work, pain and violence are not internalised: they are highly visible and occur on the edges (not the interior) of the figures. This focuses our attention as viewers on the outside, on the social, rather than on the interior subject of the individual.

Walker's silhouette figures offer a reorientation of the critique of the dominant individualising discourses of trauma, which conceive of trauma as something private that emerges from within an individual subject towards the outside world. Walker's flat two-dimensional figures, cut from black card, do not invite viewers to focus on the interior subject of the figures: their interiors are "empty spaces" that do not facilitate such readings of trauma as emanating from within an interior subject. The figures themselves are rarely given names or faces; rather, they are stock types whose distinguishing features are read on their edges rather than what lies inside. Walker's installations are peopled with racist stock characters drawn from the vast repertory of American popular culture: mammies, sambos, pickaninnies, white Southern belles. Walker has developed a lexicon using particular motifs, such as hair and clothing, that require us to call upon our prior knowledge of visual references and symbols in order to "read" the characters. For example, the hoop skirt, worn by a number of the female figures in the piece, is the quintessential symbol of white Southern femininity from the antebellum era and serves to clearly mark its wearer as a white Southern woman.

Yet Walker also complicates the ease with which we "read" the racialised and gendered identities of these figures through their exterior contours. The "facelessness" of the figures seems to suggest that Walker is not interested in representing "actual" people in her silhouettes. In so doing, Walker does not invite us to look for the inner subject within the silhouette figures. She refuses to indulge our desire to know, and thereby claim, the trauma of the subject. I would argue that this could also be read as an acknowledgment of the limitations of "outsider" knowledge and the realisation that we can only know (and represent) so much, that our understanding can only ever be partial.

Walker also encourages us to turn away from the individual subject by grouping together the figures, thus emphasising the social interconnectedness of the different characters. Furthermore, in the case of her large-scale silhouette tableaux, multiple figures are often cut from a single piece of card, reinforcing the reading that these figures are not meant to be read as individuals, nor their trauma as residing with an individual subject.

In the far right side of the tableau there are two figures walking very closely together. The first appears to be a white slavemaster (judging by his sturdy knee-high boots and hat), whose left leg is raised off the ground. In front of him is a black male slave, whose ankles are bound with leg chains (it is interesting to note that these chains are three-dimensional in the installation: they are made from interlocking paper rings which actually protrude from the flat white surface of the gallery wall). While it is only the black male slave's legs that are bound together, the way that the two men are depicted (the raised foot of the white man, which appears between the legs of the black slave) implies that the two are bound together as well within master/slave relationship. In so doing, Walker emphasises the complex social network in which the historical trauma of slavery occurred, even if this "shared" experience of trauma took place under vastly inequitable conditions between white slaveholders and black slaves.

Much has been written on the limits of representation in relation to traumatic events. What I find so compelling about Walker's silhouettes are their ability to take the familiar cultural scripts of American slavery (its narratives, actors, tropes) and transform it into something strange and unfamiliar. Formally, this defamiliarisation is set into motion by Walker's marshalling of the silhouette, a formal practice that is often associated with eighteenth- and nineteenth-century profile portraits of white middle-class domesticity. Here, Walker uses it instead to represent graphic scenes of violence and sexuality between black slaves and white slaveholders. In so doing, she encourages us to take another look at slavery and its present-day legacies, and to question what we know (or at least think we know) about, as English puts it, the "dead and gone" ("This is not about the past," 167).

Even though Walker's reconstructed antebellum plantation narratives might not be historically accurate, I would argue that they might still serve a kind of testimonial function. While these reimagined narratives might

not, strictly speaking, abide by the conventions of historical accuracy, it is not to say that they are inherently false or untrue. They testify to the continuing currency of the racial and sexual stereotypes that are central to narratives of America's antebellum period. In that sense, one could even argue that Walker, unlike some of her critics, chooses to recognise the lingering power and prevalence in contemporary American popular culture that such stereotypes continue to possess.

In conclusion, I would like to propose that Walker's work offers a way out of existing trauma theory in its evocation of an antiphonic structure. Antiphony is often defined as a responsive singing structure but it can also be considered more broadly to be a responsive or reciprocal interchange. The idea of call and response is central to Walker's tableau: from its title (which itself evokes popular nineteenth-century advertisements), Walker calls out to us to take another look at slavery's taken-for-granted narratives and its enduring legacies. Once we enter the exhibition space, we are confronted with this "un-lifelike" (contrary to what the title suggests) fantasy of antebellum plantation life. I would like to propose that this antiphonic structure, especially the manner in which it reorients our focus on the sociality of traumatic experience (by asking us to consider how traumatic experience changes the social world, not just the traumatised subject/survivor of trauma), has much to offer trauma theory. It encourages us to see representations of trauma in visual culture as calling out to us, the viewer, to re-engage with slavery and its enduring legacies. In *Picture Theory: Essays on Verbal and Visual Representation*, W. J. T. Mitchell cites Hortense Spillers, who argues that slavery has become a kind of "knowledge industry": "I was cautioned not so long ago that 'we already know about slavery,' which amounts to saying that we can look forward to repeating what everybody 'knows'" (183). In asking us to take another look at slavery and what we know about it (or at least, what we think we know), Walker's *Slavery! Slavery!* also offers us another look trauma theory and asks us to reconsider how we engage with visual representations of trauma.

Works cited

Bennett, Jill. 2005. *Empathic Vision: Affect, Trauma, and Contemporary Art*. Stanford: Stanford University Press.
Caruth, Cathy, ed. 1995. *Trauma: Explorations in Memory*. Baltimore and London: The Johns Hopkins University Press.

Caruth, Cathy. 1996. *Unclaimed Experience: Trauma, Narrative, and History*. Baltimore and London: Johns Hopkins University Press.

English, Darby. 2003. 'This is not about the past: Silhouettes in the work of Kara Walker'. In Ian Berry, Darby English, Vivian Patterson and Mark Reinhardt, eds. *Kara Walker: Narratives of a Negress*. Cambridge, Mass.: MIT Press, pp. 140-167.

—. 2007. *How to See a Work of Art in Total Darkness*. Cambridge, Mass.: MIT Press.

Felman, Shoshana and Dori Laub. 1992. *Testimony: Crises of Witnessing in Literature, Psychoanalysis, and History*. New York and London: Routledge.

Mitchell, W. J. T. 1994. *Picture Theory: Essays on Verbal and Visual Representation*. Chicago: University of Chicago Press.

Radstone, Susannah. 2007. 'Trauma theory: Contexts, politics, ethics', *Paragraph* 30(1), pp. 9-29.

Raymond, Yasmil. 2007. 'Maladies of power: A Kara Walker lexicon'. In Philippe Vergne, ed. *Kara Walker: My Complement, My Enemy, My Oppressor, My Love*. Minneapolis: Walker Art Center, pp. 347-369.

Raymond, Yasmil and Rachel Hooper. 2007. 'Kara Walker: My Complement, My Enemy, My Oppressor, My Love'. In *Kara Walker Exhibition Catalogue, March 2-June 8 2008*. Los Angeles: Regents of the University of California.

Walker, Kara. 1998. *Cut*. Private collection.

—. 1997. *Slavery! Slavery! Presenting a GRAND and LIFELIKE Panoramic Journey into Picturesque Southern Slavery or "Life at 'Ol' Virginny's Hole' (sketches from Plantation Life)" See the Peculiar Institution as never before! All cut from black paper by the able hand of Kara Elizabeth Walker, an Emancipated Negress and leader in her Cause*. Private collection.

REPRESENTING SPAIN'S 20TH-CENTURY TRAUMA IN FICTION: MEMORIES OF WAR AND DICTATORSHIP IN CONTEMPORARY NOVELS BY WOMEN

SARAH LEGGOTT

Introduction

In recent years the topic of recovering the memory of Spain's twentieth-century past has emerged as an issue of fundamental importance in Spanish society, generating intense media attention and sparking vociferous debate in the public sphere about problematic elements of the national past. The events in question, namely the Spanish Civil War (1936-1939) and the ensuing repressive dictatorship of General Francisco Franco (1939-1975), are omnipresent in the cultural memory of Spain, despite attempts by various governments to gloss over and silence aspects of the nation's history.[1] As is well known, Spain's transition to democracy following Franco's death in 1975 was characterised by the silencing of the more painful and polemical aspects of the preceding decades in the interests of national reconciliation. As Paloma Aguilar Fernández explains: "[B]ajo la apelación emocional a la 'reconciliación nacional' se corrió un tupido velo sobre el pasado y se aceptó que aquellos actos de violencia institucional cometidos a lo largo de la dictadura quedaran impunes" [Under the emotional call for "national reconciliation" a thick veil was drawn over the past and it was accepted that those institutional acts of violence committed throughout the dictatorship would remain unpunished] (2001, 8). This impunity for past offences was enshrined in the 1977 Amnesty Law, which

[1] Such moves occurred not only during the years of the Franco regime, under which "[t]he historiographic enterprise . . . became an overt political act bound up with the Catholic/Falangist conception of truth" (Herzberger 20), but also during the post-Franco transition to democracy, as is discussed below.

both pardoned individuals charged with political crimes against the Franco regime, and guaranteed that those involved in the regime's unlawful activities would not be brought to account for their past actions.[2] There was, therefore, no judicial enquiry, nor any explicit peace accord, for fear of jeopardising the new democracy, meaning that the stories of Republican families that could not be told during the years of Francoism continued to be silenced in democratic Spain.

This element of the transition has been the cause of much criticism, with critics arguing that "political amnesty" became confused with "historical amnesia" during the years of the transition and that the effect of this on Spanish society was extremely negative (Sartorius and Alfaya 11).[3] Others called for the resulting lack of collective memory to be urgently redressed (Morán, Subirats), referring to the silencing of stories about the past during the transition as a "pacto de silencio" [pact of silence] or "pacto de olvido" [pact of oblivion], terms that became quite common although their accuracy has been questioned in recent studies, with some critics arguing that discussion about the past was deferred, rather than forgotten.[4]

However, there is certainly no question that since the late 1990s any such "pact" of silence or oblivion in Spain has been displaced, to the extent that we can no longer say that there is no collective memory of the Civil War or that memory is denied.[5] There has, in fact, been an outpouring of memory about the recent past—dubbed the "memory boom"—which has manifested itself in diverse ways, from television documentaries to special newspaper supplements, from feature-length films to well-documented historical studies. In addition, the campaigns by civil pressure groups for recognition and compensation for victims of the regime's repression and their demands for the opening of the mass graves which contain the remains of thousands of unidentified Republicans have heightened public awareness of the ongoing significance of this contested past, as did the passing in late 2007 of the Socialist government's controversial Historical

[2] For further details, see Graham.
[3] For further discussion of the negative effects of the transition, see Aguilar Fernández.
[4] See Juliá; Blakeley.
[5] This is not to say, of course, that the task of confronting the past is over and that there is no further work to be done in this regard.

Memory Law.[6] The recent dictatorial past continues, therefore, to hold deep significance in contemporary Spain.

This focus on the national past has also led to a proliferation of films and fictional narratives about the Spanish Civil War and its aftermath, as numerous writers and directors, both from the generation that experienced the harshest years of Francoism and those who have no active memory of it, engage with recent history in their works. My discussion in this essay explores responses in contemporary fiction to the collective suffering of the trauma of the Spanish Civil War and Franco dictatorship, by examining recent novels by Spanish women writers that focus on this period and reflect wider concerns about recovering the past. I will focus here on two such novels: Rosa Regàs's *Luna lunera* [Moony Moon] (1999)[7] and Dulce Chacón's *La voz dormida* [The Sleeping Voice] (2002),[8] exploring their presentation of the complex relationship between remembering and forgetting in a society in which the articulation of the past has been forbidden, and considering the extent to which traces of traumatic experience might be meaningfully represented in fiction.

Regàs's work recounts the story of four children who were born to Republican parents in the early 1930s and who, after spending the years of the Civil War outside Spain, are returned to Barcelona in 1939 under the custody of their Nationalist paternal grandfather, who denies them contact with their parents. They go on to experience a childhood marked by an absence of parental love and dominated by episodes of extreme physical and psychological cruelty in a domestic environment characterised by brutal authoritarianism, mirroring the repressive regime that controls

[6] The law includes a condemation of Francoism, as well as clauses relating to compensation payments and pensions for relatives of victims, both of the Civil War and of Francoist repression, and the removal of plaques and symbols commemorating the war and dictatorship from public buildings. It also requires local authorities to provide support for the exhumation of mass graves. While many on the right opposed the new law and groups on the left felt that it failed to fully address their concerns, its introduction nevertheless constituted an important and promising step in the on-going process of dealing with the past in Spain, although it remains to be seen if, in the longer term, the new measures will be successful implemented in practice.

[7] The phrase "luna lunera" comes from a well-known Spanish lullaby, and is also the title of a bolero song that the children in the novel hear their neighbour sing every morning.

[8] An English translation of *La voz dormida* was published in 2006 under the title *The Sleeping Voice*.

postwar society outside their grandfather's house. Furthermore, the children's grandfather manipulates both family and national history, removing photographs of their mother from family albums and deeming many topics to be "unspeakable" in the household. As a result, the children become determined to reconstruct their family history from fragments of information that they gather from various sources, in an attempt to recover the memory that they have been denied, offering a clear parallel with the wider movement to recover historical memory in Spain. Emphasising the importance of speaking out about Spain's recent past, Regàs explicitly places her work within the framework of current efforts to recover historical memory of the Civil War and its aftermath: "[Y]o sí creo en la memoria como compromiso intelectual. La memoria como recuperación histórica, sobre todo en un país en el que ha sido tan brutalmente falsificada, y que sigue siéndolo" [I believe in memory as a form of intellectual commitment, in memory for historical recovery, especially in a country in which it has been so terribly falsified, and continues to be so] (Ávila López 2004, 224).

While specific historical or political events are not outlined in any detail in the novel, *Luna lunera* tells us much about the realities of postwar society and is explicitly aware of the national historical context. The children's experiences serve as a microcosm of the situation for those oppressed and persecuted by the regime in the early postwar years, a situation described by Michael Richards as one of "physical, psychological, geographic and political internment" (88). Moreover, different characters in the novel are invested with allegorical significance, representing aspects of the political situation and thus becoming symbolic of different elements of the national story. There are clear parallels to be drawn here between the Spanish state under Franco and the ideologically divided family depicted in the novel, a family unit splintered by the events of the war and the ensuing repression.

The account of *Luna lunera's* young protagonists' difficult childhood is recounted in the novel from the children's perspective, primarily by the youngest girl, Anna. Although there is a marked collective element to her descriptions of the siblings' shared past, it is with Anna whom the reader comes to identify most strongly and from whose perspective we view the events that she describes. The narrative present of the novel is 1965, when the four siblings, aged in their thirties, return to the house in which they grew up when their grandfather's death is imminent. Most of the novel, however, focuses on the protagonists' experiences as children during the earlier years of the Franco dictatorship, and the future is also anticipated

via references to the early post-Franco years, signalling that Anna is remembering the past once democracy has been established in Spain. The narrative in *Luna lunera* is thus produced by the adult who remembers this childhood trauma.

The difficult process of coming to terms with such a traumatic past is illustrated in the novel, as Anna acknowledges that many years after leaving their grandfather's house, she and her siblings have been unable to overcome the psychological effects of their experiences: "Moriremos deseando lo que deseamos de niños y llorando por lo que lloramos entonces, y perderemos la vida entera buscando el amor no concedido en la infancia, un vacío que nunca nadie ni nada podrá llenar" [We will die wishing for what we wished for as children and crying for what we cried for then, and we will waste our whole lives looking for the love that we lacked in childhood, a void that nothing nor nobody will ever be able to fill] (331). The four have come back to Barcelona not to mourn their grandfather but to seek closure on their past, in the hope that this will allow them to construct for themselves a sense of identity that they still lack, pointing to the unremitting consequences of the years of repression that they suffered as children. In this way, their experiences epitomise those of the generation that film scholar Marsha Kinder designates "the children of Franco" who, she affirms, "were led to see themselves as emotionally and politically stunted children who were no longer young; who, because of the imposed role as 'silent witness' to a tragic war that had divided country, family and self, had never been innocent and who . . . were obsessed with the past and might never be ready to take responsibility for changing the future" (58).[9]

The protagonists in Regás's novel continue to be fixated on the events of the past, tending to relive their painful memories rather than being able to work through them. In working through, according to LaCapra, "the person tries to gain critical distance on a problem and to distinguish between past, present and future" (143-44). This is the challenge facing Anna and her siblings at the end of the novel, when they determinedly leave the Barcelona house, finally ready, the text suggests, to face the future with confidence.

[9] Kinder uses the term "children of Franco" in reference to the directors of the so-called Nuevo Cine Español [New Spanish Cinema] of the 1960s, especially Carlos Saura (1932 -) and Victor Erice (1940 -), who form part of the generation that grew up in the period immediately following the Civil War.

In contrast to *Luna lunera*, Dulce Chacón's *La voz dormida* presents a more positive portrayal of the generation that will one day fight for political and cultural change in Spain. Chacón's novel tells the stories of women involved in the clandestine resistance movement in the early postwar years and also depicts women's experiences in the infamous Las Ventas prison. Central to Chacón's work are the stories of Hortensia, a prisoner who is condemned to death and gives birth to a daughter shortly before being shot by firing squad in March 1941, and her sister Pepita, who goes on to raise the child, named Tensi. The women's partners are comrades in the Communist guerrilla resistance movement. Felipe, Hortensia's partner and the father of Tensi, is killed in an ambush following a guerrilla raid on a nearby town, while Pepita's fiancé Paulino spends many years in prison, until he is finally granted conditional freedom as the novel closes in 1963.

Tensi's childhood and adolescence are thus inevitably marked by her awareness of the violent deaths of her parents, who were both killed for their political ideals, as well as by the climate of fear and hostility that pervades the postwar society in which she grows up. Tensi is, however, well prepared for the future, as her aunt, Pepita, passes on to her the stories about the past. This transgenerational transmission is facilitated by the notebooks which Hortensia wrote from prison and left to her daughter and which Pepita reads to the child as she is growing up. As a result of hearing the stories about her parents' political commitment and ideals, Tensi decides to take up their cause, becoming involved in the clandestine activities of the illegal Spanish Communist Party when she is eighteen years old, despite Pepita's attempts to dissuade her from doing so. Thus in this novel, unlike in *Luna lunera* where silence dominates, Republican stories are kept alive, at least within the private sphere, and transmitted to the next generation, embodied here by Tensi.

However, while this process of transgenerational transmission is an important means of commemorating and preserving the past, it simultaneously runs the risk of placing an immense burden on the children of the next generation by investing them with the hopes and memories of their relatives. In the case of Tensi, her very name is a mode of commemoration, a shortened version of the name of her mother who passes it on to the child knowing that her own death is imminent. It is, moreover, the name that her father Felipe called her mother as a term of endearment. There is, therefore, a risk that Tensi will become what Dina Wardi has referred to as a "memorial candle," a term that she uses to refer

to the children of Holocaust survivors on whom the burden of the past is placed. As Wardi affirms, such children are "given the special mission of serving as the link which on the one hand preserves the past and on the other joins it to the present and the future. This role is generated out of the need to fill the enormous vacuum left behind by the Holocaust" (6). Tensi may be considered in this light, as she is depicted in the novel as being haunted by the histories of her parents which in large part define her own identity. Their convictions, but also their trauma, are passed down across the generations.

However, despite the undeniable burden that is placed on Tensi, *La voz dormida* nevertheless offers an optimistic vision for the future, suggesting that despite the traumatic events of the past, a positive future can be created. In contrast again to *Luna lunera's* Anna and her siblings who, many years on, continue to struggle with the legacy of the past, Tensi, the novel suggests, is able to move on. Her ability to look towards a new future is shown to be largely due to Pepita's role in mediating the transmission of memories to the second generation. Her decision not to pass on to Tensi the fragment of the dress in which her mother died nor Hortensia's death sentence is key in this regard, allowing Tensi to put the past behind her and engage with a new future.[10]

As is the case with many of the recent films and literary works that deal with the subject of the Spanish Civil War and the ensuing dictatorship, Chacón's *La voz dormida* seeks to present a realistic account of the conflict and its consequences. The stories told in the novel are recounted in the narrative present through the voices of the various protagonists, thereby offering multiple perspectives: no single protagonist's story is privileged over others, creating the sense of a "community of witnesses" to the past. The deployment of this realist style to communicate the suffering caused by the war and the Francoist repression is similarly found in contemporary writing and films that deal with the Holocaust, many of which are also characterised by a quest for verisimilitude in order to communicate to readers and viewers the full extent of its horror.

However, the assumption that realism is the most effective means of constructing a meaningful representation of the past is debated by critics, some of whom remind us of the impossibility of re-creating a traumatic

[10] See Portela for further discussion of transgenerational transmission in *La voz dormida*.

past for the reader or viewer that might allow them to experience such events as they were experienced at the time. Geoffrey Hartman, for example, has argued that graphic portrayals of violence often "desensitize rather than shock" (64), suggesting that works which avoid detailed depictions of violence are ultimately more effective in creating public awareness and discussion, as well as in retaining a sense of the continued relevance of the past for the present. With regard to works that deal with Spain's repressive past, Hispanist Jo Labanyi has similarly argued that films and works of fiction that represent Spain's violent past indirectly, deploying what she refers to as a "trope of haunting" (103), are ultimately more effective in communicating the wartime and postwar repression than are realist narratives that seek to create a detailed reconstruction of the past for the viewer or reader. Labanyi makes reference to Chacón's *La voz dormida* in her discussion, a novel which, as we have already seen, closes with a relatively happy ending that suggests the start of a new life for the remaining protagonists. This ending, while offering hope for a positive future, suggests that the Civil War and its consequences can now be relegated to the past, rather than acknowledging what Labanyi terms the "unfinished business" (113) that inevitably remains, as the survivors and their descendants seek to come to terms with their painful past and engage with its legacy. In contrast, Regàs's *Luna lunera* does communicate the on-going impact of the past on the present and the complexities inherent in the process of working through a traumatic past.

Of relevance here is the question of the generational difference between these two writers, an element that may impact on their approach to dealing with their country's repressive past in their works. Born in 1933, Regás forms part of a group of writers who bring to their narratives their own experience of the Civil War and the Franco dictatorship, and whose works are thus influenced, to different degrees, by their memories of those years. Their novels are thus to some extent testimonial, set in their respective places of origin and reflecting their lived experiences and the sociopolitical context which shaped their own lives. The story recounted by Regàs's protagonist Anna in *Luna lunera* is based on the author's own childhood, as she herself spent the war years in France and in 1939 was returned to Spain and was placed, together with her siblings, in the custody of her Nationalist paternal grandparents. Regàs's father was a Republican lawyer who worked for the Generalitat (Catalan government) and who, like the children's father Manuel in the novel, lost everything as a result of the

Spanish Civil War, including the right to retain custody of his children.[11] Regàs has confirmed this parallel between this novel and her personal experience, describing *Luna lunera* as "mi obra más personal al basarse en una parte importante de mi propia y 'dickensiana' infancia" [my most personal work as it is based on an important part of my own "Dickensian" childhood] ("El juego").[12] For Regàs then, as for other writers of her generation, the desire to write about the war and postwar years may respond to a need to voice their personal experiences or those of their contemporaries.

Regàs also seeks to counter the historical amnesia of democratic Spain in *Luna lunera*, with the author affirming herself to be "absolutamente partidaria del rescate de dicha memoria [histórica] . . . porque . . . se nos ha prohibido hablar de ella" [totally in support of the recovery of our historical memory because we have been forbidden to talk about it] ("El juego"). The death of Franco and the transition to democracy in Spain, while occurring subsequent to the narrative present of the novel, are alluded to in Anna's retrospective remembering of the past. Recalling her father's determined optimism regarding the eventual reinstatement of the Republic in his country, firstly in the 1940s with the victory of the Allied forces in the Second World War and again in the mid-1970s with Franco's death, Anna recalls his ultimate disillusionment in the early 1980s: "[S]e dio cuenta de que la República a la que tanto había dado había quedado en una vía muerta y los nuevos aires democráticos estaban en manos de gran parte de los hijos y de los nietos de los que habían ganado la guerra civil y que así sería por muchos años" [He realised that the Republic to which he had given so much had come to a dead end and that the new democratic currents were in the hands of many of the children and grandchildren of those who had won the civil war and that it would be that way for many years] (256). Regàs thus effectively points here to the continuity of Francoist legacies during the transition period and beyond, a characteristic of the political and social structures of democratic Spain that has been the

[11] Detailed biographical information about Regàs is included in Ávila López (2007).

[12] Despite this, it should be noted that Regàs also emphatically asserts in the same interview that *Luna lunera* remains a work of fiction: "[U]na novela no es una autobiografía, unas memorias; la concepción de un mundo literario es algo que trasciende lo real aunque se base en ello, como ocurre en este caso" [A novel is not an autobiography, nor memoirs; the creation of a literary world is something that transcends reality although it might be based on it, as is the case here] ("El juego").

focus of a number of recent texts.[13] In *Luna lunera*, Manuel, who lost everything as a result of the war and saw important aspects of his family's history silenced or rewritten, now finds that in the new democracy, reflection about the past continues to be discouraged, a characteristic of the transition that Regàs denounces.

In contrast to Regàs, Chacón (1954-2003) was born during the later years of the Franco period and began writing after the restoration of democracy in Spain, and thus did not personally experience either the trauma of the Civil War or the earliest and harshest years of postwar repression. Her decision to engage with her country's difficult past in her fictional narrative is representative of a broader trend, as many such recent works have been produced by writers who have no active memory of the Civil War nor, in some cases, of the dictatorship. Chacón was nevertheless profoundly affected by the stories of Republican suffering and, like Regàs, by the on-going silencing of those stories in democratic Spain. Chacón described the project of rescuing the silenced Republican history as a responsibility of her generation,[14] thereby evoking Graham's affirmation that "the return of Republican memory is necessary . . . for all living Spaniards of whatever generation" (326).

This is borne out by the fact that in contemporary Spain, it is the children and grandchildren of the victims or survivors of the Civil War who are now confronting their country's past and seeking to deal with the stories of violence and repression. The distance between this generation and the political trauma of the war and dictatorship facilitates their engagement with the past; as Marianne Hirsch has affirmed, "[p]erhaps it is *only* in subsequent generations that trauma can be witnessed and worked through, by those who were not there to live it but who received its effects, belatedly, through the narratives, actions and symptoms of the previous generation" (2001, 12, italics in original).[15] For Chacón and other writers of her generation, the events that she depicts in her work are "postmemory," a term used by Hirsch (1997) to refer to the experiences of the children of Holocaust survivors whose life experiences are profoundly influenced by traumatic events that they did not personally experience.

[13] See, for example, Jáuregui and Menéndez (1995); and Merino and Song (2005).
[14] Valenzuela 2002.
[15] Jelin similarly emphasises the importance of generational distance in her work on the collective memory of Argentina's dictatorial past (64-66).

The process of remembering the nation's twentieth-century history of war and dictatorship has revealed in Spain the need of individuals and groups to remember and articulate elements of the past that have long been silenced in the name of national reconciliation. As part of the manifestation of this memory boom in the cultural sphere, both Regás's *Luna lunera* and Chacón's *La voz dormida* engage with the on-going process of dealing with the traumatic implications of the Civil War and the Franco years in contemporary Spain, and pose questions about the ways in which a painful and divisive past might be effectively represented in fiction. Furthermore, as part of a broader trend in contemporary Spanish narrative in which the national past is a primary concern, these two novels may also be understood as part of the on-going development of a culture of memory in contemporary Spain.

Works cited

Aguilar Fernández, Paloma. 1996. *Memoria y olvido de la guerra civil española.* Madrid: Alianza.

Ávila López, Enrique. 2004. 'Conversando con Rosa Regàs, una figura polifacética de la cultura catalana: Miembro de la gauche divine, traductora y escritora. Madrid, 28 septiembre 1999 y 27 marzo 2000. Santander, 16 agosto 2001.' *Tesserae: Journal of Iberian and Latin American Studies* 10(2), pp. 213-36.

—. 2007. *Imaginación, memoria, compromiso. La obra de Rosa Regàs: Un ámbito de voces.* USA: Asociación de Literatura y Cultura Femenina Hispánica.

Blakeley, Georgina. 2005. 'Digging up Spain's past: Consequences of truth and reconciliation', *Democratization* 12(1), pp. 44-59.

Chacón, Dulce. 2006. *La voz dormida.* Madrid: Punto de Lectura.

—. 2006. *The Sleeping Voice.* Trans. Nick Caistor. New York: Harvill Secker.

—. 2002. *La voz dormida.* Madrid: Santillana.

Domínguez, Antonio José. 2003. 'Entrevista con Dulce Chacón', *Rebelión: Periódico Electrónico de Información Alternativa* 23 March. http://www.rebelion.org/cultura/dulce230303.htm.

Graham, Helen. 2004. 'The Spanish civil war, 1936-2003: The return of republican memory', *Science and Society* 68(3), pp. 313-328.

Hartman, Geoffrey. 1997. 'The cinema animal'. In Yosefa Loshitzky, ed. *Spielberg's Holocaust: Critical Perspectives on Schindler's List.* Bloomington: Indiana University Press, pp. 61-76.

Herzberger, David K. 1995. *Narrating the Past: Fiction and Historiography in Postwar Spain*. Durham: Duke University Press.

Hirsch, Marianne. 1997. *Family Frames: Photography, Narrative and Postmemory*. Cambridge: Harvard University Press.

—. 2001. 'Surviving images: Holocaust photographs and the work of postmemory', *The Yale Journal of Criticism* 14, pp. 5-37.

Jáuregui, Fernando and Manuel Angel Menéndez. 1995. *Lo que nos queda de Franco: Símbolos, personajes, leyes y costumbres, veinte años después*. Madrid: Temas de Hoy.

Jelin, Elizabeth. 2003. *State Repression and the Labors of Memory*, trans Judy Rein and Marcial Godoy-Anativia. Minneapolis: University of Minnesota Press.

Juliá, Santos, ed. 1999. *Víctimas de la guerra civil*. Madrid: Temas de Hoy.

Kinder, Marsha. 1983. 'The children of Franco', *Quarterly Review of Film Studies* 8(2), pp. 57-76.

Labanyi, Jo. 2007. 'Memory and modernity in democratic Spain: The difficulty of coming to terms with the Spanish civil war', *Poetics Today* 28(1), pp. 89-116.

LaCapra, Dominick. 2001. *Writing History, Writing Trauma*. Baltimore: Johns Hopkins University Press.

Merino, Eloy E. and H. Rosi Song, eds. 2005. *Traces of Contamination: Unearthing the Francoist Legacy in Contemporary Spanish Discourse*. Lewisburg: Bucknell University Press.

Morán, Gregorio. 1991. *El precio de la transición*. Barcelona: Planeta.

Preciado, Nativel. 1996. *El sentir de las mujeres*. Madrid: Temas de Hoy.

Regás, Rosa. 1999. *Luna lunera*. Barcelona: Plaza y Janés.

—. 1999. 'El juego de la memoria: *Luna lunera*', *El Correo Digital: Aula de Cultura Virtual*. http://servicios.elcorreodigital.com.

Richards, Michael. 1998. *A Time of Silence: Civil War and the Culture of Repression in Franco's Spain, 1936-1945*. Cambridge: Cambridge University Press.

Sartorius, Nicolás, and Javier Alfaya. 2002. *La memoria insumisa: Sobre la dictadura de Franco*. Barcelona: Crítica.

Subirats, Eduardo. 1993. *Después de la lluvia: Sobre la ambigua modernidad española*. Madrid: Temas de Hoy.

Valenzuela, Javier. 2002. 'El despertar tras la amnesia', *Babelia* 2 November. www.el pais.es/suple/babelia.

Wardi, Dina. 1992. *Memorial Candles: Children of the Holocaust*, trans Naomi Goldblum. London: Routledge.

TRAUMA, MEMORY AND FORGETTING IN POST-WAR CYPRUS: THE CASE OF *MANOLI...!*

ANNA PAPAETI

Introduction

As early as the beginning of the twentieth century there has been a distinct change in opera in terms of its subject matter and aesthetics. Moving away from the nineteenth-century notion of redemption, opera increasingly dealt with such issues as loss, trauma and anxiety. Theodor W. Adorno was one of the first scholars to address this radical change in terms of musical aesthetics in his book *Philosophy of Modern Music*, pointing out how modern opera expressed the anxiety of modernity, alienation, and suffering. It is within this new operatic tradition that post-1945 political opera emerged, depicting the silences, horrors and traumas of war and political instability. The horrors of World War II are a historical caesura that imposes new problems on artists and composers with regard to representing trauma and terror. Contemporary opera is no exception to this as indicated by its increasing move towards antiheroic approaches to recent historical events in the context of civil wars, genocides, terrorism and states of terror.[1] Belonging to the processes of cultural mourning, these works contribute to the collective representation of traumatic past events. According to critical theorist Gene Ray, mourning, in this sense, is a collective process seeking to understand and work through shared trauma, so as to "accept the burden of change" (2005: 2, 12). Hence the importance of contemporary political operas is not only aesthetic, but also political since they often trigger a public discussion of socially repressed

[1] For example Anthony Davis's *X, The Life and Times of Malcolm X* (1986), John Adam's *The Death of Klinghoffer* (1991) and *Dr Atomic* (2005), Nicholas Maw's *Sophie's Choice* (2002), Keith Burstein's *Manifest Destiny* (2003) and Luis Enríquez Bacalov's *Estaba la Madre* (2007).

issues. Vassos Argyridis's chamber opera *Manoli...!*, commissioned by and performed at Pfalztheater, Kaiserslautern, in 1990, is such a work and constitutes the first opera with a Cypriot subject matter. Based on a play by George Neophytou—who also adapted the libretto—the opera tells the story of a Cypriot mother, Maria, who was an eye-witness to her son's murder during the July 1974 coup d'état in Cyprus.

Manoli...! deals with traumatic events of recent Cypriot history, and specifically with the absence of justice after the Greek coup d'état that led to the Turkish Invasion. In brief, on 15 July 1974 the Greek military junta launched a coup in Cyprus with the help of the paramilitary Greek-Cypriot group EOKA B. EOKA B was a later splinter group of EOKA, the anti-colonial Greek-Cypriot movement that fought against the British (1955-1959), aiming at the unification (*Enosis*) of Cyprus with Greece. As a result, the Republic of Cyprus was founded in 1960 under three protective powers (Greece, Turkey and England). Makarios III, the Archbishop of the Greek-Orthodox Church, became its first elected President. Soon, however, problems began between the two main communities[2]—Greek Cypriots and Turkish Cypriots—as well as within the Greek-Cypriot community. Feeling betrayed by President Makarios, many Greek-Cypriots regrouped in the armed far-right group EOKA B in order to continue the struggle for *Enosis*. Their actions were monitored by the military junta which had seized power in Greece in April 1967; the renewed struggle for *Enosis* became the justification given for the July 1974 coup in Cyprus. In fact, the coup backfired, for it provoked a two-phased invasion by Turkey (on 20 July and again later on 14 August), an intervention that allegedly aimed to protect the rights of the Turkish-Cypriot minority. Turkish forces never withdrew and continue to occupy 36% of the island. The consequences of the invasion were devastating: many dead and missing, and, from both sides together, roughly two-hundred thousand refugees. In the aftermath of the invasion, President Makarios was restored to power. He granted amnesty to those involved in the coup in an attempt to ensure national unity. The opera draws on the subjects of national conflict and the lack of justice in the Greek-Cypriot community. This paper explores the ways by which the opera *Manoli* expresses the trauma and anxiety of contemporary Greek-Cypriot society with regard to the events of July 1974. It will examine the mechanisms of memory and forgetting in post-1974 Cyprus in the context of a tenuously

[2] There are also Armenian, Maronite and Latin minorities on the island.

restored national unity, focusing on the opera's reception in the Greek-Cypriot press.

Twentieth-century opera is marked by a move away from Romanticism in general and from the aesthetics of the work of Richard Wagner in particular. Hence the turn toward shorter forms, including one-act operas, and the preference for themes that are no longer centred on the notion of redemption. By the early twentieth century, the fantasy of a world where love could fill the lack at the heart of subjectivity was long gone in opera, and stage works increasingly took on the themes of despair, loneliness and anxiety (e.g. Alban Berg's *Wozzeck* and *Lulu*, Arnold Schoenbergs's *Erwartung*, Béla Bartók's *The Miraculous Mandarin*). As the Italian composer Luigi Dallapiccola notes, twentieth-century opera no longer had the certainty that characterized nineteenth-century works, which were centred on love (1987: 102). On the contrary, as the love duet was replaced by monologue, loneliness was turned into an aesthetic, while most of these works ended in uncertainty. The ending of Dallapiccola's own opera *Il prigioniero*, a political opera written in direct response to the horrors of World War II, is a good example. In this work, the Prisoner begins to hope when the Gaoler calls him "fratello" ("brother") and leaves the door open. But when he is caught by the Holy Inquisition and realizes the Gaoler's betrayal, he calls hope the worst torture. The faded and open-ended closing musical phrase of the opera *La libertà* ("freedom") leaves the work inconclusive as to whether freedom is possible, an ambiguity much criticized by both the Italian Communist Party and the Catholic Church, which the composer repeatedly refused to clarify and resolve (1987: 126).

Vassos Argyrides's opera *Manoli...!* for a soprano and small orchestra[3] consists of the monologue of a mother whose life is marked by despair and anger for the unpunished murder of her son. Her sole interlocutor is her cat Manolis, who bears the name of her son Manos, underlining her loneliness and isolation. Freed from the Aristotelian notion of catharsis and empathy, *Manoli* is a thought-provoking work that does not aim to entertain, but rather hopes to provoke reflection on recent events of Cypriot history. The opera consists of one act and lasts approximately half an hour. Its brevity

[3] The orchestra consists of a double string quartet, double bass, flute, oboe, clarinet, bassoon, trombone, trumpet, horn and percussion (e.g. xylophone, vibraphone, timpani, cymbals, drum).

is not accidental, but vital for the musical unfolding of human suffering. As Adorno points out, "music, compressed into a moment, is valid as an eruptive revelation of negative experience" and it is "closely related to actual suffering" (2003: 37-38). *Manoli* is a brief, intense and direct work, freed from any decorative elements and characterized by silences. Silence and loneliness are reinforced by the use of spoken word, which is mostly heard without orchestra—a bare voice coming out of silence—and occasionally with orchestral accompaniment, like a recitative. The aesthetics of silence become even stronger with the alternations between sections of spoken word, and ones of rhythmic patterns and highly chromatic passages, which often appear fragmented and are associated with the Mother's trauma. Diatonicism is not absent from the work but it is used selectively, pointing to the lives of the Mother and Manos before the coup, thus turning the past into the Mother's main point of stability, both dramatically and tonally: e.g. the aria "Eines Tages" ponders the past, and "Mit siebzehn war mein Manos" speaks about her son's first love at the age of 17.

The composer effectively translates into music the mother's anxiety and melancholy. Chromatic and rhythmic *ostinati*[4] alternate with spoken word and silences, while her rather chromatic vocal line occasionally falls back into a nostalgic diatonicism and lyricism. The Mother's fragmented musical language evokes the nature of trauma as something raw and unyielding; as a knot which, when it is not processed by the subject and assimilated as experience, resorts to repetition.[5] The persistent repetition of chromatic phrases and semitones both by the mother and the orchestra undermines the diatonic character of the work and gives the music a weary character. A good example is the way the phrase "Ich weiss, dass sie wiederkommen" ("I know that they will come back") is set to music. The melodic and rhythmic motif, which dominates this passage, returns again in the work, mirroring in a sense the return of the trauma. Like Dallapiccola's *Il prigioniero*, *Manoli*'s end is rather inconclusive, leaving the question of the Mother, "so that they will not come back", hanging in the air. The opera ends with an imaginary trial, staged in the Mother's head, during which she testifies, somberly repeating three times the phrase "so they don't come back". Argyrides's uses timpani, drums as well as

[4] "Ostinato is a term used to refer to the repetition of a musical pattern many times in succession while other musical elements are generally changing." http://www.oxfordmusiconline.com/subscriber/article/grove/music/20547?q=ostin ato&_start=1&pos=1&search=quick
[5] On trauma and repetition, see Lacan 1998: 42–70.

winds and brass, successfully creating the atmosphere of a funeral march
but most importantly of a military band, thus musically conveying the
Mother's militant fixation on justice. The military tone of the music is
important yet not necessarily optimistic, since it underlines the fact that the
mother's decisiveness estranges her from the society she lives in. The
work, which starts with a shot, ends with the march-like sound of the
military drum, gradually fading away into silence.

Manoli...! deals with the issues of amnesty and forgetting in postwar
Cyprus. In the aftermath of the coup and of the Turkish invasion, the need
for national unity was a priority for President Makarios. Hence, upon his
return to the island Makarios announced that he was giving "an olive
branch" and amnesty to his political enemies, pleading for peace within
the Greek-Cypriot community, but also between Greek-Cypriots and
Turkish-Cypriots (cited in Papageorgiou 1976: 308-309).[6] In contrast to
the trials of the junta Colonels in Greece, the members of the armed group
EOKA B did not stand trial.[7] The only person to be tried was the President
during the coup, Nikos Samson, who was only persecuted much later
(Loizou 2000: 520-521). In August 1976 Samson was sentenced to 20
years imprisonment. Three years later he was released by presidential
decree due to health problems on the condition that he would seek
treatment abroad and live in exile.[8] Samson returned to Cyprus in 1990 to
complete his sentence, and was finally released in 1992 by a decree of
President George Vassiliou. Furthermore, the state's only gesture to deal
with the coup was the attempt to "cleanse" the civil service and security
forces. In 1977 the Council of Ministers of President Spyros Kyprianou
appointed two committees to investigate and bring to justice
misdemeanours by civil servants who took part in the coup (Loizou 2000:
546). A total of 1,122 complains were filed against 2,151 civil servants,
but only 303 complains made it to trial. In 1979, 62 people lost their jobs
by ministerial decree (548-550). The so-called "62" were restored
retrospectively in the 1990s by the Gafkos Clerides government. This
symbolic gesture, nevertheless, provoked strong reactions and confirmed

[6] All translations of Greek texts are my own.
[7] The Greek Colonels stood trial in 1975 and were sentenced to death. Their
sentence was later changed to life imprisonment after the intervention of Prime
Minister Konstantinos Karamanlis.
[8] Before he went abroad, his jail time had been significantly on the grounds of
good behaviour (Loizou 2000: 527-528).

that the events of 1974 remained raw for many. Indicative is the statement made by presidential candidate George Iakovou during the 1998 elections, that "by restoring the "62" [the Clerides government] tried to rewrite contemporary Cypriot history by absolving the coup".[9]

The way Greek-Cypriots dealt with the polarization that culminated into the coup is not very different to that followed by other countries such as Spain and Argentina in the aftermath of their lengthy civil wars. Despite the fact that the coup in Cyprus lasted only a week, it is important to briefly look into the latter's policies in order to contextualize the reaction of Cypriot authorities in 1974. In the case of Spain, the so-called "pact of forgetfulness" (*pacto del olvido*) was marked by the absence of a collective discussion of the violent past. After Franco's death both Republicans and Nationalists agreed to the so-called "never again" (*nunca más*), in an attempt to safeguard the transition from hostility to a mutual recognition of collective responsibility (Aguilar Fernández 2005: 163). For some, however, the general amnesty of 1977 was, in the words of one Socialist MP, "simply a forgetting... an amnesty for everyone, a forgetting for everyone, by everyone" (Tremlett 2006: 76). Similarly, the so-called Full-Stop Law (*Ley de Punto Final*) in Argentina in 1986 granted amnesty to everyone who took part in the seven-year military junta that took power in 1976.[10] It is obvious that the fear of ideological polarization that would reignite the conflict has been a significant factor behind the decision of political amnesty through forgiveness and forgetting. In the case of Cyprus, the government not only had to deal with the conflict within the Greek-Cypriot community and armed groups that had not disbanded, but also with the consequences of the Turkish invasion and the urgency of disarmament. However, the symbolic resolution of conflict through Makarios's gesture became problematic for many, who later saw the perpetrators continue their everyday lives without assuming responsibility or repenting. It is in this context that the Mother in *Manoli* repeatedly speaks of the need for accountability for those involved in the coup, "so that the case can be closed". The Mother's anger is constantly rekindled when she sees her son's murderer, who lives in her neighbourhood, and treats her like a crazy old lady. Each encounter makes her re-live the trauma of witnessing his death, for trauma, according to Jacques Lacan, "is that which always comes back to the same place" (1998: 42). Exclaims the Mother:

[9] www.hri.org/news/cyprus/kypegr/1998/98-01-24.kypegr.html
[10] It must be noted that this law, which was later considered unconstitutional, no longer exists in Argentina (Tremlett 2006: 83).

I see them coming! I know that they will come back. I can see it in their eyes, Manoli, when he steps out of his store and looks at me. He laughs full of mockery, Manoli. And I blush. I blush and am ashamed and walk away. I run away, Manoli, full of shame, as if I were the murderer and he the victim.[11]

The killer's lack of self-reflection is not accidental. The playwright/ librettist here refers to real events, and specifically to a group of people involved in the coup who did not keep low profile, but were deliberately provocative. It is precisely to this kind of behaviour that President Makarios refers in his speech a year after the coup, urging people to maintain the fragile unity, but at the same time underlying that:

Forgetting the past, peace and unity was and is my intention and my honest wish. However, the stance of those who participated in the coup so far has been unacceptable, they [...] have a provocative behaviour and present themselves as ultra-patriots, as leaders of the struggle. (cited in Papageorgiou 1976: 312)

The heroine's entrapment in the past makes her appear mentally unstable to those around her, who view her as a mother who could not deal with the fact that her son was murdered. The comments on the Mother's mental condition are contained in the opera (possibly for dramaturgical reasons), but appear more extensively in the play on which it is based:

[T]hey think I'm crazy. But they are the fools, Manoli. They have given me their own madness. But how come they think I'm deaf and they talk as if I cannot hear them? Yesterday, as I was walking outside the school, Eleni was standing outside her door with her neighbour Ioanna. "How are you, Mrs Maria, how are you doing, are you well, we don't see you anymore", small talk. As soon as I left... I had only made a step, Manoli, just a step, and they started. Poor her, since her son died she is not well. Her nerves. And the other one said, it's the war, dear Mrs Eleni. That's what happens in the war.
What can I say to them? Should I go back and tell them that it is your mind that's sick? Because you understand nothing. How many times should I say this to you? MY SON WAS NOT KILLED IN THE WAR. HE WASN'T IN THE WAR, MY SON. (Neophytou 5-6)

The Greek-Cypriot society is portrayed here as one that suppresses any voices which bring to the fore the traumatic events of national conflict, jeopardizing the fragile stability. The contrast between Mother and society

[11] With thanks to Kristian Krieger for translating the German libretto into English.

regarding memory is not simply a dramaturgical device but incorporates an ongoing criticism within the Greek-Cypriot community at the time. Indicative is an article published in the newspaper *Epikaere* (*Επίκαιρη*) with regard to the premiere of the opera in 1990, which in part reads:

> [T]he lie behind the official side, behind the slogans "I don't forget" or "All the refugees to their homes", when the same official side excludes the real expression of the desire for justice, looking condescendingly at those who wish it, shaking their head and calling them, full of "understanding", "poor people who did not manage to pull themselves together!" [...] Neophytou cuts into this schizophrenia that characterizes our official, political discourse, which, on the one hand, glorifies those sacrificed, the freedom-fighters and the mothers who lost their children for their country, while, on the other, it turns these very same people into clinical cases in our everyday social reality. (*Epikaere* 1990)

Cyprus is not unique in casting mentally ill those that hold firmly on to the past, failing to see that for the victims the event has no closure, no ending; hence, it is something very present that does not belong to the past. The story of the mothers of the "disappeared" during the dictatorship in Argentina presents us with a similar case. Specifically, the refusal of the so-called *Madres de Plaza de Mayo* (Mothers of Plaza de Mayo) to accept compensation offered by the democratic state for the disappearance of their children changed their status in Argentinian society. When they continued their quest for symbolic closure, the respected Mothers eventually angered some former supporters. Hence, from "mothers of the nation", they were later called *Las Locas de Plaza de Mayo* ("The crazy ones of Plaza de Mayo") both by the media and the government, since "they no longer embodied the state's vision of a reconciled nation" (Hamber and Wilson 2002: 45).

Memory as a ritual is very important in *Manoli*. Neophytou turns the Mother's need to tell her story into a focal point of the work: her testimony will unravel the knot of her trauma, enabling her to symbolize it. Thus, the trial of Manos's murderer will prove to be redemptive on many levels. On a political level, it will ensure the gathering of important experiences and information which will open up a public debate on the events of 1974. On a personal level, the Mother's testimony will function as a way of psychotherapy, since she will put into words what has been making her language stumble, what essentially has been censored by society itself. In a way, her testimony will reproduce the psychoanalytic procedure: Maria, the analysand, tells her story and by listening to her the judges, as psychoanalysts, become witnesses to her testimony. According to the

psychoanalyst and Holocaust survivor Dori Laub, the absence of a true listener to the victim's testimony may lead to "a re-experience of the event itself" (Felman and Laub 1992: 67-68). Testimony, for Laub, is not a monologue but presupposes a listener, through whom the survivor can reconstitute the internal "thou", an inner witness; in other words, through narration the survivor reclaims her position as a witness (70-71, 85). Laub's understanding of testimony is very close to Kelly Oliver's notion of subjectivity as an outcome of the "address-ability" and "response-ability" entailed in witnessing (Oliver 2001: 15–17). Taking as her starting point the ability to respond to the victim's testimony—to something that we cannot see but lies beyond recognition—Oliver frees witnessing from the Hegelian master/slave dialectic, that is, of the witness that narrates and of the other who, by listening, grants him recognition. Our obligation, according to Oliver, is "not only to respond but also respond in a way that opens up rather than closes off the possibility of response by others", thus creating the potential for a witnessing subjectivity beyond oppression (15).

In *Manoli* we are constantly confronted with the need for testimony. Although many survivors resort to silence, the Mother is obsessed with narrating the murder of her son. Nevertheless, her act of telling is not in any sense therapeutic, but a reliving of the trauma itself, since her sole listener is her cat Manolis. The refusal of society to respond to the Mother's testimony is effectively set into music in the passages for men's and women's chorus:

> *Women's Chorus*
> God, the poor woman, since she lost her son, she is totally confused. Her nerves!
>
> *Men's Chorus*
> Forget it, dear madam, forget about it! There was a war. We were invaded. We can not change this, unfortunately. There is no evidence.

The composer loosely uses the canon, a contrapuntal device, in these passages, which consist of short musical phrases. He systematically brings in the subject in all voices, one by one with very few, insignificant changes, since the subject is melodically rather static. It is the weaving of the rhythmic pattern that creates intensity through imitation of the subject in the different voices and their overlap. Through imitation Argyrides manages to create the sense of a blockage that is impossible to penetrate, suppressing any voice that wishes to say something different. Contrary to the musical passages of the choruses, which create the sense of a violent

blockage through rhythmic and melodic imitation and repetition, the mother's phrase "Mein Sohn ist nicht im Krieg umgekommen! Wie oft soll ich es Euch sagen" ("My son did not lose his life in the war. How often do I have to repeat myself?") is characterized by a chromatically descending line in semitones (G to A). This starts off fragmented but soon appears more composed and decisive in her next phrase, "Er war nicht im Krieg mein Sohn" ("My son wasn't in the war"), which is essentially a melodic augmentation of the previous one. It consists of a half-tone descent from G to B flat, in quarter and half notes, and is freed from any melodic ornaments or fragmentation, thus highlighting her determination and commitment to her cause. The Mother's statement is nevertheless crushed by the Men's Chorus which sings in homophony "Was vorher passiert, war das reinste durch einander. Wer kann sich noch zu recht finden" ("What happened before, that was pure chaos. Who can still find his way in this chaos?"). These passages are worth noting because they not only highlight the need to silence the voices that speak of the past, but also represent an acoustic testimony of the way the Mother perceives the response of society, that is, as voices that block her discourse and force her into the rhythmic and melodic repetition of the phrase "Ich habe nicht" ("Ich habe nicht den Verstand verloren" / "I haven't lost my mind"). Her despair is reflected in the rhythmic and melodic *ostinati* in the winds and strings (and the brass at the very end) that characterize her two phrases, and have a weary effect.

Neophytou is right in making the trial the focal point of the opera and the mother's sole reason d'être. In fact, the trial draws close to what theorist Slavoj Žižek calls "second death", highlighting the difference between real/biological death and symbolic death, that is the "settling of accounts" (1989: 135). Hamlet's father is a good example. His death suspends him in a space between life and death until his death is brought to a symbolic closure. It is in this space that we need to seek Manos, who is unable to "rest" until justice is served. In this context, the Mother's silence simply repeats his (real) death: "But I cannot just remain silent, Manoli. I would feel as if I bury him for a second time". Only the long-awaited trial can bring this affair to a close and complete Manos's symbolic destiny, allowing both mother and son to rest. However, the most important element is not the killer's punishment, but the mother's testimony, though which the witnessing of her son's death will finally come into existence. Through her narration the mother will be heard for the first time. She will address her environment and have the possibility of assuming a new form

a subjectivity beyond oppression through the dialectical process of witnessing.

Both the play and the opera aimed to trigger discussion on a subject that had been repeatedly repressed in postwar Cyprus. In that they have been successful not only through the performances the play and the opera *Manoli*, but also through the reactions caused by the cancellation of the televised rendition of the play starring actress Despina Bebedeli, scheduled to be aired at the 13th anniversary of the coup. The last-minute cancellation due to "technical reasons"[12] was only reported eight moths later by Bebedeli. This took place in an event on "Contemporary Greek Plays" with the Greek playwright Iakovos Kabanellis as the keynote speaker at the Nicosia Municipal Theatre. Specifically, when Kabanellis praised *Manoli* as an exemplary work of contemporary Greek theatre,[13] the actress stood up and informed everyone what had happened the previous July. The affair was widely reported in the press and was treated as a symptom of the politics of amnesia. The comments of the left-wing newspapers *Embros* (*Εμπρος*) and *Haravgi* (*Χαραυγή*) are characteristic:

> Was it postponed so that it could be shown at a day with no relevance and no pain, so that its directness and importance is diminished? […] The work must be shown on its day, even with a year's delay. We will be waiting for it. We know the answers, at least to some of our questions. (*Embros* 1988)

> The fact that it was filmed shows that someone read it and approved it. Also, the fact that it was shelved means that someone else saw it and rejected it. So the issue must be understood in light of the conflict of opinions within the bureaucracy of the CyBC [Cyprus Broadcasting Corporation] [....] We understand that the play's subject matter might have annoyed some conservative circles of the CyBC establishment. But which ones? (*Haravgi* 1988, 'The scandal')

It is worth noting the intensity of the language of the above articles as well as the conviction that the cancellation was a clear attempt to overshadow the anniversary so that the status quo would not be shaken. The play was aired a year later, on 15 July 1988, and was hailed by newspapers from across the political spectrum, while some journalists took the opportunity to speak extensively about the issue of historical memory and the dangers

[12] Personal statement of the writer George Neophytou in April 2006.
[13] According to Neophytou, he gave the play to Kabanellis at the beginning of 1988 during his visit to Athens.

of forgetting. In an article in *Haravgi* the notions of memory and forgetting are discussed, as well as the lack of justice that would ensure a less violent future (*Haravgi* 1988, 'Thought'). According to the journalist, the work forces us to see the link between past, present and future, and comes to awaken us from our lethargic sleep, acting as "an instigator of our conscious, our duty". Similar thoughts and emotions are also expressed more intensely in another article of *Haravgi* five days before the play was aired. The article draws specifically on the fact that there was no punishment for those involved in the coup: "the seven-day president Samson is cruising Europe", the perpetrators "have become politicians and try to give us lessons of patriotism" and "the victims of the coup and the Invasion have not found any justice, while the perpetrators live among us" (*Haravgi* 1988, 'Coup and television').

To conclude, the opera *Manoli...!* is an attempt to express musically and dramatically the trauma of the Greek coup d'état in the context of the Cypriot state's amnesty policy in the aftermath of the Turkish invasion. A monologue that oscillates between sound and silence, it is an attempt to express a personal and collective trauma of recent Cypriot history. As such, it contributes to the understanding and critical processing of the past. The Mother in *Manoli...!* asks us to listen closely to her story. Her call does not only refer to the event itself, but also to the what remains beyond recognition, what falls through the cracks of her testimony and hides in her silences. The opera manages to translate the element of silence and the elliptic nature of testimony, as well as the repetition of the trauma that blocks the Mother's language and fragments her music, thus turning the work into an effective negative presentation of the personal and collective trauma of the July 1974 coup in Cyprus.

Works cited

Adorno, Theodor W. 2003. *Philosophy of Modern Music*, trans Anne G. Mitchell and Wesley V. Blomster. New York and London: Continuum.
Aguilar Fernández, Paloma. 2005. *Μνήμη και Λήθη του Ισπανικού Εμφυλίου: Δικτατορία και Διαχείρηση του Παρελθόντος*, μεταφ. Σπύρος Κακουριώτης και Χάρης Παπαγεωργίου, επιμ. Στάθης Ν. Καλύβας. Heraclion: Crete University Press.
Dallapiccola, Luigi. 1987. *Dallapiccola on Opera: Selected Writings of Luigi Dallapiccola*, trans and ed. Rudy Shackelford. Exeter: Toccata Press.
Embros. 1988. 'A slap at the "high officials" of CYBC', 8 March.

Epikaere. 1990. 'George Neophytou's "Manoli...!": The "Madness" of this country', 2 June.

Felman, Shoshana and Dori Laub. 1992. *Testimony: Crises of Witnessing in Literature, Psychoanalysis, and History*. New Work and London: Routledge.

Hamber, Brandon and Richard A. Wilson. 2002. 'Symbolic closure through memory, reparation and revenge in post-conflict societies', *Journal of Human Rights* 1(1) March, pp. 35-53.

Haravgi. 1988. 'Thought on "Manoli...!"', 29 July.

—. 1988. 'Coup and television: The necessity of memory: The work "Manoli...!"', 10 July.

—. 1988. "The scandal of 'Manoli'", 18 March.

Lacan, Jacques. 1998. *The Seminar. Book XI. The Four Fundamental Concepts of Psychoanalysis, 1964*, trans A. Sheridan, ed. J. A. Miller. London: Vintage.

Loizou, Andreas N. [1981] 2000. 'Το Πραξικόπημα και το Δίκαιον', *Κύπρος: Ιστορία, Προβλήματα Και Αγώνες Του Λαού Της*, επιμέλεια Γιώργος Τενεκίδης, Γιάννος Κρανιδιώτης. Athens: Hestia.

Neophytou, George. *Manoli...!* Unpublished play.

Oliver, Kelly. 2001. *Witnessing: Beyond Recognition*. Minneapolis: University of Minnesota Press.

Papageorgiou, Sypros, 1976. *Μακάριος*. Athens.

Ray, Gene. 2005. *Terror and the Sublime in Art and Critical Theory. From Auschwitz to Hiroshima to September 11*. New York: Palgrave Macmillan.

Tremlett, Giles. 2006. *Ghosts of Spain: Travels Through a Country's Hidden Past*. London: Faber and Faber.

Žižek, Slavoj. 1989. *The Sublime Object of Ideology*. London and New York: Verso.

JOURNALISM, TRAUMA AND MENTAL HEALTH

NARRATING THE SILENCE OF TRAUMA

SUE JOSEPH

Introduction

Conception by racist pack rape kept secret for more than 30 years. Rape as war crime kept secret for more than 50 years. A doctor sexually abuses a five year old. Child abuse within a family. Silence is a ubiquitous by-product of traumatic crime but when the subjects of such crime finally decide to speak, the interview process itself can be a traumatising experience. Furthermore, the handling of information by the journalist, particularly in long narrative form, is integral to that experience. Contextualising these narratives within the genre of literary journalism, this essay is an exploration of professional practice when dealing with traumatic memory in subjects. The essay draws on interviews that form part of my unpublished manuscript of creative non-fiction, entitled *Speaking Secrets*. It calls for a greater academic discussion of empathy as a tool of journalism, rather than as a notion often regarded as anathema to the discipline. The essay argues that empathy should be taught and embraced within journalism education in Australia, particularly within the genre of long-form literary journalism.

There is a fleeting intimacy established between storyteller and story gatherer. An immediate relationship is formed when a journalist and subject come face-to-face (or even before, in negotiating agreement, time and place for an interview). It smacks of opportunistic potential at the time of interviewing but ends when the journalist walks out the door with what they came for: the story. The question that must be asked is: what is left behind? Is it an empowered subject who feels they have achieved what they set out to achieve? Or is it a damaged person—re-traumatised by remembering—who wonders whether they have said too much and how what they have said will be used? Interviewees may trust that the integrity of what has passed between them and the journalist will be maintained but really have no idea of the outcome until it is seen or heard. Janet Malcolm's

controversial book *The Journalist and the Murderer* highlighted the notion of false friendship. Malcolm takes one case history in her seminal text published in 1990, and does more to damage the already quite challenged name, reputation and profession of journalism than any text has done in the past. The opening lines of the book position her immediately: "Every journalist who is not too stupid or too full of himself to notice what is going on knows that what he does is morally indefensible" (Malcolm 1990: 3).

Malcolm's story 'Reflections: The Journalist and the Murderer', written in the form of an extended essay, first appeared as a two-part article in *The New Yorker* in 1989.[1] As an example of extreme writer/subject duplicity, Malcolm's dissection of literary journalist Joe McGinniss' coverage of the Jeffery MacDonald case was damning. Philip Weiss in *Newsday* wrote at the time: "If Janet Malcolm had blown up an ink factory, forcing the presses to shut down for a week, she couldn't have sparked greater outrage in the media kingdom" (Weiss 1990: 24). If Malcolm is guilty of one thing, it is hyperbole in those first few lines of her book. Perhaps it was intentional because it has certainly kept her in the forefront of mainstream journalism analysis and education, frequently cited in discussions surrounding journalistic ethics and practice, for the past 18 years. But most striking is what she eventually concludes: this *is* a relationship, and both parties have something to do with its dynamic and reality. Malcolm places heaviest responsibility on the journalist but also concedes that subjects play a part in the dance, albeit a mostly compromised part: "The subject's side of the equation is not without its moral problems, either" (Malcolm 1990: 143). This role is often overlooked by critics of journalism practice. She writes:

> Journalistic subjects know all too well what awaits them when the days of wine and roses – the days of the interviews – are over. And still they say yes when a journalist calls, and still they are astonished when they see the flash of the knife. (Malcolm 1990: 145)

Subjects of the journalistic interview are part of what is widely believed to be a clearly defined relationship. But in reality, it is not. The journalist, when sitting in front of his or her computer, ultimately has the final say, despite what has transpired throughout the interview process. American literary journalist Jon Krakauer warns: "I explain that if they decide to talk to me it will have to be for their own reasons, and they had better be good

[1] Issues of March 13 and 20.

reasons, because what I write could turn their lives inside out" (cited in Boynton 2005: 168).

Although both Malcolm and Krakauer argue that subjects have a certain agency in their choice to become involved as interviewees, journalists must make continuous ethical judgements about the capacity of their subjects, particularly subjects talking about deeply personal, traumatic, and/or sensitive topics, to continue with the interview. The mere fact the interviewee agrees to the interview is insufficient consent. Journalists must continuously question themselves and monitor the cues of the interview.

The manuscript *Speaking Secrets* delves into the lives of 10 people, asking questions about their most haunting and secret sexual traumas and memories, and how and when they finally spoke about them. And as such, is an evocative example of the tension between a writer and subject. The manuscript research sets out to establish an overt, visible relationship with each of the subjects and to hand that onto the reader in order to create an evocative and believable space for their voices to be heard and their stories to be told. Each story has been accompanied by rigorous research and fact checking, to allow a freer momentum for their voices. But, indeed, there is a perception of false friendship about this process. It doesn't matter that the interviewee has *agreed* to talk about deeply personal and often traumatic memories—the question is still: what right does the interviewer have to be there in the first place?

In the majority of the interviews conducted for *Speaking Secrets*, at some stage it was necessary to ask the subject if they wanted to halt the interview because of how distressed they became through the telling of their story. The stories were necessary for the research and somehow, the more upset or re-traumatised the subject became, the more evocative the storytelling became—very possibly a "morally indefensible" stance. But as Catharine Stimpson writes: "It offers little consolation to writers of some integrity ... such writers do what they must, but some blood will fleck the keyboards of even the wisest among them" (Stimpson 1990: 902).

The interviewed subjects of *Speaking Secrets* include: Uniting Church leader Dorothy McRae-McMahon, who speaks about her public coming out at the 1999 Church forum; former international casting agent Liz Mullinar, who recounts her near death illness and discovery of childhood sexual abuse at the age of five, memories she had expunged for decades;

the physically disabled NSW Greens Party convenor, David Cunningham, who speaks about his need and desire for some sort of fulfilling sex life; Arabella Joseph,[2] a young lawyer, brutally abused by a family member from the age of eleven to fifteen; Russel Sykes, son of black activist Dr Roberta Sykes, who relates his discovery at the age of 30 that he was the product of a gang rape of his then 18-year-old mother (it was a race crime and she was left for dead); Jenny Mendick, who reflects on her desire to claim a space for women who have had mastectomy but choose not to have prosthesis and her virtual gagging from the breast cancer community because of her stance; Rachael Wallbank, a sexually reassigned lawyer who took on the Australian Attorney-General against the Commonwealth and won the right for sexually reassigned people to marry; academic Jim Malcolm, who married at 20 even though he had been having sex with men for years—he regarded himself as bisexual, finally leaving his wife and three children, more than a decade later; Lyn Austin, the first Stolen Generation survivor to receive financial compensation for the systematic physical, sexual and emotional abuse she sustained once removed from her family as a ten year old; and war crime victim Jan Ruff O-Herne, brutally raped by hundreds of Japanese military in the last few months of WW2 in Indonesia.

Each interviewee has been constrained, some for decades. So, how did they finally manage to speak up, and then why did they agree to speak to me? Is this the impetus to confess that Michel Foucault wrote about?

> Truth, lodged in our most secret nature, demands only to surface; that if it fails to do so, this is because a constraint holds it in place, the violence of a power weighs it down, and it can only finally be articulated at the price of a kind of liberation. (Foucault 1976: 60)

What Foucault has identified is a human need to confess, even when societal norms may discourage it. Perhaps this innate tendency to confess answers the age-old question of why people talk to journalists and divulge, sometimes, their deepest, darkest thoughts, moments and memories for public consumption.

All interviewees were silenced or unable to tell their secret stories for various and varied reasons. But finally, each of them sought out the media to disclose their secrets. Their reasons are as diverse as they are personal. Sociologist Catherine Kohler Riessman writes:

[2] Not her real name.

> [S]ome experiences are extremely difficult to speak about. Political
> conditions constrain particular events from being narrated. The ordinary
> response to atrocities is to banish them from awareness. Survivors of
> political torture, war and sexual crimes silence themselves and are silenced
> because it is too difficult to tell and to listen. (Kohler Riessman 1993: 3)

These subjects were not solicited. Each subject was approached in the first
instance by phone or email. During this contact, the method and nature of
the research was explained. Namely, that they would be interviewed and
photographed for inclusion in a manuscript with the possibility of
publication. All but one person—and that particular circumstance will be
expanded upon later in this paper—agreed to this, each for varying
reasons. Ted Conover calls himself a 'nuts and bolts' writer when it comes
to literary journalism, and talks also of a contract he strikes, not so much
with his subjects but with his readers. He writes: "Either something
happened or it didn't. I have a contract with my readers according to
which they can expect my material to be true, and I honour that. I believe
in the literal truth of non-fiction" (Boynton 2005: 28).

This 'literal truth of non-fiction' is an imperative of literary journalism,
one I have adhered to rigidly in *Speaking Secrets*. But one of the main
aims of the manuscript was to give a voice to those who did not have
one—literal truth then becomes the subjects' truth or more simply, their
own story, in their own words.

Given the confronting nature of the subject interview, when interviewees
appeared distressed, they were offered the opportunity to terminate the
interview. Various theorists argue about the appropriateness of this—
indeed some proffer that it is preferable just to be silent and wait for a sign
from the subject. However this paper argues that it is incumbent on the
interviewer to monitor the verbal and non-verbal cues of the subject and—
where a subject is distressed—to remind them that they have a choice in
the process of being interviewed. None of the subjects in *Speaking Secrets*
elected to terminate the interview, despite probing questioning.

Raymond Schroth writes in the *Columbia Journalism Review*: "that is the
journalist's moral tension: one person's pain is another's stimulation, his
living. Suffering sells. Yet the journalist, insofar as he or she is a human
being, must strive to alleviate suffering" (Schroth 1995: 45). Schroth is
arguing for the integrity of the story as told to be reproduced, not a version
that makes for better reading. He is really calling for the highest integrity
of the reporter.

Pulitzer Prize winning columnist Jim Dwyer claims only one true justification for intruding on a victim's life: that the journalist will help:

> The journalist knows that ... his moral obligation is to help that foundry worker find the language, to be his scream, a scream that takes flesh in bold headlines, pictures, text, and layout that make the story jump off the page into the reader's heart. (Schroth 1995: 45)

<div align="center">***</div>

However, the mere fact the interviewee agrees to the interview is insufficient consent to an interview. Journalists must continuously question themselves and monitor the cues of the interview. They must adjust their "moral compass" (Kovach et al 2002: 181) continuously and reassess the ethical ramifications of continuing with the interview if there is clear distress.

Juxtaposed against this is the notion that if a victim or survivor has elected to speak to a journalist, respect must be given to how the subject tells the story. The journalist must not be deterred by a highly emotional subject. Some victims and survivors may even find it patronising if a journalist attempts to stop an interview because the subject becomes emotional, or the journalist themselves is upset. Psychiatrist Frank Ochberg suggests the journalist should come prepared, with tissues, like a therapist (Cote et al 2006: 108). He explains:

> When survivors cry during interviews, they are not necessarily reluctant to continue. They may have difficulty communicating, but they often want to tell their stories. Interrupting them may be experienced as patronising and denying an opportunity to testify. (108)

Ochberg asserts that asking the survivor or victim if they wish to terminate the interview may itself constitute a re-victimisation of the subject. My research does not support this position. Instead it shows that any re-victimisation or re-traumatising will present itself in the recalling of memories in answering a journalist's questions, not a suggestion to have a break or halt the process.

This also points to the crucial role of journalism education in helping young journalists develop an appropriate 'moral compass'. Working more explicitly with concepts of empathy and compassion may help position the journalist and allow him or her to make those voluntary ethical decisions about their subjects in a less detached fashion. Empathy, and its place

within journalism practice and education, is discussed rarely in Australia, except perhaps in the context of reporting on trauma and disaster. The critical and the practical value of the notion of empathy has been seriously underestimated in journalism. Empathy is antithetical to the image of the objective reporter who "remains emotionally detached even in the face of the most heart wrenching tragedy" (Fakazis 2003: 47) and it is a failure of journalism education that empathy is not taught (Fakazis 2003: 57). American academic Elizabeth Fakazis defines empathy as a "deep understanding of a subject's emotional and psychological perspective" and argues that it has concrete pay offs for enhancing journalistic practice because it "can help journalists deepen their understanding, allowing them to not only observe what their subjects do but also why they do it" (Fakazis 2003: 46).

In the long form non-fiction genre, transparent empathy is an effective and valid tool of the trade. It makes for better and more thorough, less detached and more honest, journalism and is particularly pertinent in dealing with stories of people who have suffered injustice meted out through violence, trauma or prejudice.

<div align="center">***</div>

During her interview for *Speaking Secrets*, Liz Mullinar became highly emotional and cried about the lack of bonding she formed with her two sons as a result of her childhood sexual abuse:

> When the conversation turns to the mothering of her sons her raw pain fills the room. I can almost taste it, mingling in with the Western Red Cedar scent. It is nearly overwhelming.
> She talks of relationships and how people who have been abused as children have very little trust in whatever remnant of emotion they have left – or anybody around them. She speaks of a deep loss regarding her sons, both of whom have been supportive of her journey.
> "Sadly I wasn't a very emotionally connected mother and therefore we wouldn't have as close a relationship as other mothers have with their children.
> "I think we do now. I work on it now. But if you don't when your child is small, you really can't – you've lost it ... you know..."
> Liz Mullinar cries. I think I hold my breath as she attempts to keep talking. "You can't get that back," she continues. "Any survivor of abuse who is honest will admit that they do not have a totally close relationship with their children. Because you can't have – it's got to have affected you. It must have affected you either emotionally or in some way so that you

over-compensate, under-compensate or whatever you do, you do it. You don't come from a functional base.

"I don't think I was capable of giving my children everything they needed ... because I think my childhood with my parents was, not consciously, but you know ... you have a good relationship but you can't emotionally give. They're lovely, nobody's saying anything else, but I'm saying because now I know how good a parent can be and that could be fantastic. One really appreciates the closeness of relationships.

"We very rarely talk on a really in-depth level to each other." (Joseph, *Speaking Secrets*)

Similarly, Russel Sykes appeared to dissociate several times whenever the topic of his mother's rape, and his very existence, came up. Sykes was asked many times—more than any other subject in the manuscript—if he wanted to halt the process. He declined every time and just seemed to want to talk, in his own way and at his own pace:

Talking to him is difficult. No, talking to him is not difficult at all. Talking to him on this subject is. He sits in my office on the fifth floor of the university's Bon Marche Building. He is tall and rangy and his legs seem to take up all the spare space. He has dark brown, almost liquid brown eyes and looks me square in the face when he speaks – except when we talk about what I have asked him here to talk about.

Sykes periodically zones off, staring out my window. Opposite are the chimneys from the old Carlton Brewery, and whenever a question gets too close, he just stares at them.

There are many protracted silences before I ask him, several times, if he wishes to continue the interview. He does. And we do. Although I wonder why he has agreed to it, in the first place.

I think the answer is a simple one. I asked. (Joseph, *Speaking Secrets*)

Jan Ruff-O'Herne was clearly shaken by my questions, and like Sykes, dissociated after she related her memory of returning to her mother's side in the Javanese internment camp, after being forced into a brothel for the Japanese military for three months:

"I had cut all my hair to make myself look ugly. We didn't need to speak. But I will never forget that wonderful feeling of what a mother means. I lay down on the floor on a mattress that was totally worn out and dirty and smelly with sweat, and I just lay in the hole of her arm, I can see it now, with her arm around me and she just stroked my head and we just laid there and I felt this safety to be back in my mother's arms. It was just such an amazing feeling. You know, we just lay there, we never spoke. She never asked any questions."

Jan Ruff-O'Herne closes her eyes tightly and I do not speak. She transports herself back to that night, to that moment, in her mother's arms. She strokes the air, as her mother stroked her hair, and I can almost see it and smell it. The moment is tangible. (Joseph, *Speaking Secrets*)

Lyn Austin just seemed as bewildered at the time of the interview as she must have been at the age of ten when recounting her removal from her mother:

The last Lyn Austin ever saw of her mother was as she was driven … hundreds of miles away, that day back in 1964.

"It just happened so quickly, you know one minute Mum's telling me you're going and then that weekend I was gone.

"And then there was this lady – I don't know if she was from the education department or welfare or where she was from. She just said we're taking you to this farm where there is other Aboriginal children and…Because they sort of felt that my mother wasn't equipped with looking after us.

"We went in this old FJ Holden actually. I can remember that, the old black FJ Holden."

Again, she stops talking and there is a quiet silence, saturated with meaning. When Austin answers my questions, she rarely looks me in the eye. She always looks a little away. But this time, putting her coffee cup down, she does look at me. She looks hard at me.

"I can still hear my mother's voice – it was in her voice I could tell, you know, the sadness. You know the anguish, and that."

Again, she stops, looking away. She seems to gather herself and takes a deep breath.

She remembers, but it is as if the memory is never far away. As if it has nestled there, just below the surface of her consciousness all these years.

"Yeah, yeah, they took me straight to the farm, and I always have that in me mind. I look back, I was looking out the window, like I was waving and you know Mum was crying and I always look back and I can see Mum standing on the roadside with her hands, you know, head in her hands crying.

"I just – I don't know, I never ever got back to ask Mum why, you know in the years as I remained with the family I never, because it was too late. She'd already gone. So, I was never able to go back and ask her why she let me go and that. So…". (Joseph, *Speaking Secrets*)

Child sexual abuse survivor Kate Richards clearly became so distressed throughout her interview with me that she could not even begin to eat the meal in front of her:

"For me, telling is really scary. But so far the people that have known have not reacted anything like I imagined. People actually get mad at him and don't get mad at me – or they don't think I'm disgusting. Or people will even respond by saying something similar happened to them. Apparently it's common but I just thought I was the only one.

"You can know something rationally but not believe. Like I know, I know in my rational lawyer head that it wasn't my fault; it is always an adult's fault if they do that to a child. A child does not have the capacity to want that or say no or get away. My intellectual head knows that but" She trails off.

I look at her plate and realise she is merely fiddling with her food. Moving it around the plate. And I know she is unable to swallow. I should have remembered this – she has explained to me that when she is made to talk of her uncle, her body relives copious oral rapes – and she cannot swallow.

I have a slight impression of trigger questions bombarding her brain with memories of her horror. Visual, bodily memories.

I push my plate aside. I should have remembered. I feel even colder and wrap my multicoloured beach towel more firmly around my shoulders. (Joseph, *Speaking Secrets*)

And psychologist and academic Jim Malcolm also cried throughout his interview when trying to talk about his father, and telling his own family of his sexual orientations:

"Then there was my Dad.

"We talked about it but it was extremely difficult – I was just choked – I felt like I was just letting him down but all I can really remember him saying is 'I love you'..."

There are tears streaming down Malcolm's face as he tries to speak. As he remembers. Jim Malcolm needs a cigarette, so we venture outside. I leave the tape recorder behind in his office and we just chat – about the weather, uni, smoking – anything that isn't personal. It is raining lightly and the path smells steamy. There are just a few students nearby. It is mid-semester break, and all universities notch down a gear or two at these times – there simply seems to be more minutes in each hour.

I wonder at the overwhelming emotions, nearly ten years after his father's death. There is no doubt about his love for this man, but it is deeper than that, linked imperceptibly to his sexuality.

"I had an enormous amount of love and respect for him," he says, almost in response to my unspoken questions. "It was clear to me that somehow, at some really deep level, I feared not being the person I should be in his eyes... and I was very emotionally repressed and I think doing that programme was one way of just bringing everything out.

He wonders out loud at his tears – wonders why he can't tell this story without them.

> "I suppose it says something about me and … the fact I told this story
> – I can't get it out without bursting into tears…it's just saying the
> words…"
> We go and make more coffee. Take another minute. He collects
> himself. I collect myself. We continue. (Joseph, *Speaking Secrets*)

All six insisted they wanted to continue, despite offers of terminating the
interview.

This partially confirms Frank Ochberg's assertion. However, unlike
Ochberg, I contend it is right to continue to give the subject the choice; to
always ask the question if they want to stop, or not, or have a break. Or to
simply halt the interview process entirely. But every one of the subjects in
the manuscript literally insisted on continuing, despite their reinvigorated
pain.

Of all the subjects interviewed, the biggest ethical dilemma arose in
relation to my interview with academic and clinical psychologist Jim
Malcolm, and it eventuated not during the interview but well after.

My research followed on from my first book *She's my Wife; He's just Sex*
(1997) which explored a certain type of sexual duality amongst married
and de facto men. That research focussed less on their sexual behaviour,
instead focussing on the lengths these men went to in order to maintain
their secret. It was during the publicity for this book that I met Jim
Malcolm. We were both interviewed by Kerri-Anne Kennerley for her
national Midday Show on Channel 9 in Sydney.

Her researcher asked me to invite one of the men in my book to attend the
interview. None of them agreed but suggested Jim Malcolm as he had had
extensive prior media experience. Malcolm agreed to the interview despite
his reservations about my book and its conclusions.

Unwittingly, I exposed Malcolm to a gruelling onslaught from Kennerley
about his personal sexual life despite his requests that he not be asked
about his own experience but rather focus on his work as a psychologist
and scholar, having just completed a PhD on the exact same topic as my
first book.

In light of this, Malcolm was not hostile but definitely not welcoming
when approached for *Speaking Secrets*. However, he did agree to the

interview; but at the time, not necessarily to publication. Perhaps arrogantly, I proceeded on the basis that he would ultimately be persuaded.

His chapter in *Speaking Secrets* is perhaps one of the most powerful in the manuscript because of his prior relationship with the media. Malcolm is a man who was exploited on the *ABC*'s Four Corners in the early 1990s; then agreed to come onto a national and live television chat show where he was ambushed and his character virtually destroyed by the host. Yet he still agreed to be interviewed for *Speaking Secrets*, with a potential for publication.

However, having read his chapter, Malcolm did not give his permission for it to be published.[3] I tried to persuade him; I cajoled him; I almost begged him but then I heard myself and realised, his refusing permission for publication is exactly what the research was about—integrity and trust and ethics and empathy, as an intrinsic part of journalism practice. I stopped trying to convince him and just listened to him.

He explained that reading my chapter on him truly taught him something about his prior choices to expose himself in the media, and he decided it had to stop. He had to educate the world in other, less public ways.

Effectively, Malcolm managed to take back some of his power which the media had taken from him. It was all about choice and control, and he demonstrates that while the story is of the utmost importance to a journalist, the person is more important.

Twenty years after Foucault wrote about the imperative to confess, already mentioned, University of Utah Professor Doug Birkhead appropriated this theory and inverted it, directly at the feet of journalists. He claims that journalism: "reflects an impulse to bring events into a forum so that they may be publicly accounted for. The press traditionally has sought to make itself – and us – bear responsibility of being witnesses rather than merely onlookers" (Sims et al 1995: 13).

[3] However, he did give me his permission to use his story in my final PhD submission and subsequent academic writings.

Birkhead places journalists and the practice of journalism as public confessor—a position of immense responsibility, in the name of the public's right to know. Interestingly, as a symbolic Fourth Estate, that is exactly the forum that each of the subjects in *Speaking Secrets* initially sought out to tell their untellable stories. This eagerness to tell reflects a collective impetus for righting wrongs and creating a space for social and political recognition. Many of them were intent on informing the public about mainly unspoken or taboo topics—this seemed to be the common imperative in the subjects. All the subjects of *Speaking Secrets* individually took on an almost advocacy role in agreeing to the interviews and the themes they were attempting to portray. Walter Lippmann likens the press to the beam of a searchlight, "bringing one episode and then another out of darkness into vision" (Cote et al 2006: 100). As Cote and Simpson state:

> Better reporting about trauma can help readers and viewers gain empathy for the suffering of victims and enrich everyone's awareness of the powerful role that trauma plays in people's collective lives ... if the ultimate benefit is greater awareness of how others suffer from trauma, the publics' renewed capacity to offer collective care and support will be the greatest public benefit. (Cote et al 2006: 8)

And this is what the subjects of *Speaking Secrets* collectively aspired to: educating the public and bringing taboo subjects 'out of the darkness'.

But possibly the most important issue in the current research is that each story is the victim's own story told in their own way. This does not mean that rigorous research and cross referencing is not necessary in order for the journalist to do their job properly. It just means that the subject needs to feel some control, at this stage. Empathy is of paramount importance not just during the interviewing process, but afterwards, at the computer screen, when that process is transposed onto the page. Cote and Simpson write:

> Trauma may leave a person feeling violated, angry, powerless. Many trauma victims feel their suffering had had some purpose if their story is told at the right time and in the right way. It can be a catharsis that releases some pain and gives their lives new dignity. (Cote et al 2006: 121)

They argue that this is a process that could help victims become survivors. Which is, at the end of the day, what I, as a journalist, need to believe.

Works cited

Boynton, R. 2005. *The New New Journalism*. USA: Vintage Books.
Cote, W. and R. Simpson. 2006. *Covering Violence*, 2nd edition. New York: Columbia University Press.
Fakazis, E. 2003. 'How close is too close? When journalists become their sources'. In Howard Good, ed. *Desperately Seeking Ethics*. USA: Scarecrow Press.
Foucault, M. 1976. *The History of Sexuality, Vol. 1: An Introduction*. London: Penguin Books.
Joseph, S. 1997. *She's My Wife: He's Just Sex*. Sydney: Australian Centre for Independent Journalism.
—. *Speaking Secrets*. Unpublished manuscript.
Kohler Riessman, C. 1993. *Narrative Analysis*. California: Sage.
Kovach, B. and T. Rosenstiel. 2001. *The Elements of Journalism: What Newspeople Should Know and the Public Should Expect*. New York: Three Rivers Press.
Malcolm, J. 1990. *The Journalist and the Murderer*. New York: Random House.
Mordue, M. 2007. 'The school for scandal', *Sydney Morning Herald*, March 3, http://www.smh.com.au/articles/2007/03/02/1172338885198.html
Ricketson, M. 1997. 'Helen Garner's *The First Stone*: Hitchhiking on the credibility of other writers'. In Jenna Mead, ed. *bodyjamming*. Australia: Random House, p.79-100.
Schroth, R. A. 1995. '... but it's really burning: Tragedy and the journalistic conscience, *Columbia Journalism Review* 43, New York September/October.
Sims, N. and M. Kramer, eds. 1995. *Literary Journalism*. New York: Ballantine Books.
Stimpson, C. 1990. 'The haunted house', *The Nation*, New York, June 25, p. 899.
Weiss, P. 1990. 'Reporting on reporters and their subjects', *Newsday*, New York, February 18, p. 24.

SILENCING OR VALIDATING TRAUMATIC TESTIMONY: FOOTBALLERS' NARRATIVE IMMUNITY AGAINST ALLEGATIONS OF SEXUAL ASSAULT

DEB WATERHOUSE-WATSON

Introduction

In 2004 several sets of sexual assault allegations were made against players from Australia's two principal football codes: the Australian Football League (also known as Australian Rules) and the National Rugby League. Two of these cases, in particular, which involved players from the Canterbury Bulldogs rugby league team and the St Kilda Australian Rules team, were the subject of intense media scrutiny, thus sparking an intense media debate around the culture of the leagues and the nature of relations between elite footballers and women. Other cases were also made public at the time, including one from 1998, in which at least two players and an official from the Hawthorn AFL club allegedly drugged and raped a woman in Hawaii (the alleged victim did not press charges). In none of these cases were charges laid, and no Australian footballer has been made to stand trial on a charge of sexual assault in any of the numerous cases before or since.[1]

[1] Allegations were also made against four Penrith NRL players in 1999, three West Coast AFL players in 2000, Cronulla Sharks NRL players in New Zealand in 2002, four Canterbury Bulldogs players in 2003, two Melbourne Storm NRL players in 2004, a Newcastle Knights NRL player in 2005, and former AFL player and assistant coach Darryn Cresswell in 2006, none of which resulted in charges being laid. In February 2005 the Ombudsman found that police 'bungled' an investigation into allegations that former AFL player Heath Culpitt raped a woman in 1999. Two women, one allegedly raped by two Hawthorn AFL players and a club official in Hawaii in 1999, and the other by an AFL player with local league associates in 2000, did not press charges. Charges were laid against AFL footballer

In this essay I contend that the representation of footballer rape cases in the Australian media has performed a de facto legal adjudication, which portrayed the complainants as liars, providing footballers with what I call a *narrative immunity* against being held accountable for alleged sexual assault. Thus, the essay will explore the role of narrative and grammar in both the media representations of the cases and in the different commentators' engagements with the complainants' traumatic testimony. Through comparison of different narrative constructions of the same events, I will show that even when commentators engage with a complainant's account, the techniques used to narrate it can evoke *cultural stories*, such as that of the Woman Scorned, the Party Girl, the Predatory Woman and the Gold Digger, which blame the complainant and discount her testimony. I will thus demonstrate that narrative and grammar were used to perform a de facto adjudication of the cases, deflecting blame away from footballers and providing them with a "narrative immunity" against allegations of sexual assault.

When newspaper journalists engage with traumatic testimony within the reporting genre they engage in the process of constructing a narrative that can either support or undermine the complainant's story. Although media texts relate to "real" people and events rather than imagined ones, they follow the same conventions of narrative and are therefore no less constructed than fictional texts. Through the author's choice of language, events are given meaning and, of particular importance for rape narratives, *character* is constructed. Studies have shown that, in rape trials, perceptions of the character of complainants—and the accused—are often a central influencing factor in jury decisions.[2] Therefore, the construction of character within a journalistic narrative is central to whether the complaint will be believed.

Further, no narrative stands alone, but rather intersects with and is informed by what I call *cultural stories*, that is, story patterns that have

Peter Burgoyone and ex-player Adam Heuskes and in 2000 (Michael O'Loughlin was also allegedly involved), and against NRL player Anthony Laffranchi in 2007; in both cases they were later dropped. Heuskes, Burgoyne and O'Loughlin subsequently made a payment of AUD$200,000 to the complainant, all parties signing a confidentiality agreement. Laffranchi's case went as far as a committal hearing before it was thrown out of court.

[2] See for example Natalie Taylor, who found that characteristics of both victims and defendants significantly affected jury decision-making. See also Christy Vishner.

currency within a particular cultural context. Some of the most popular cultural story figures in the context of sexual assault are the Party Girl, who goes out drinking and looking for sex; the Predatory Woman, who hunts down footballers for sex and is always sexually available to them; the Woman Scorned, who makes a false rape complaint out of revenge; and the Gold Digger, who makes a false complaint for money. These characters have a long history of being evoked in sexual assault discourse, in the legal system, popular literature and the media, and all of them featured prominently in the stories that circulated in Australia during the 2004 footballer sexual assault debate. The commentators who told these stories were quick to add that the behaviour of these women is not an excuse if a player does commit rape; however, narratives featuring the characters of the Predatory Woman, Party Girl, Gold Digger and Woman Scorned were nevertheless substituted for those featuring the raped woman, and thus used to demonstrate that rape had not occurred.

Stories abounded that women are "often forward with the players," (Gough, Lyon and Ryan) "target" them and "hunt in packs," (Lyon) clearly portraying women who meet footballers casually as sexual predators.[3] The *Footy Show* episode dedicated to the issue of sexual assault blamed all problems on predatory women, notably with then prominent St Kilda player Aaron Hamill warning about those women "who do hang around, they stick around and you've got to be careful … they are out there" (Porter). The stories portray women as the sexual aggressors and footballers as (potential) victims, and thus portraying a complainant as one who sought out footballers simultaneously portrays her as the sexual aggressor and the accused footballers as her victims.

The Woman Scorned, who, after consensual sex, makes a false rape complaint out of revenge, has been a prominent figure for centuries, notably evoked by the defence in criminal rape trials. In *A Woman Scorned: Acquaintance Rape on Trial*, Peggy Reeves Sanday traces this story back as far as the seventeenth century, where rape complainants were required to provide evidence of having resisted to the utmost to avoid being judged a scorned, vindictive woman who made the complaint to get

[3] Mike Sheahan also refers to "the provocative and often brazen interest of women" directed at footballers (93).

revenge.[4] Sanday cites numerous high profile rape cases from the late twentieth century where lawyers use a famous misquotation as part of the defence: "Hell hath no fury like a woman scorned," (23) demonstrating the currency that the Woman Scorned story retains. The Woman Scorned narrative was alluded to by commentators to explain why rape complaints have been made against footballers. For example, "life skills coach" to AFL players Damien Foster writes, "When the girl realises the total indifference with which she is being treated after intimacy, [meaning sex] bitterness sets in and it lingers." Similarly, "feminist" Germaine Greer claims that women today are "not embarrassed to say that they agreed to sex with one man they'd only just met, or even with two, but they hadn't agreed to being brutalised, insulted or humiliated, and they want redress."

Greer also evokes the Gold Digger, likewise an established figure in criminal rape trials whom Sanday also identifies in trials dating from the eighteenth century. The Gold Digger is evoked when a prominent and/or wealthy man—such as a noble in the eighteenth century, or a footballer in the twentieth/twenty-first—is accused of rape, whether or not the alleged victim seeks or receives a financial settlement.[5] Greer claims that women today "also seem quite interested in another factor in sex with footballers—namely, indecent amounts of money." She declares that rape allegations are made against footballers, and not other professional athletes, because only footballers have money. In his book *Bad Boys*, journalist and former rugby league coach Roy Masters also alludes to the Gold Digger in his explanation of why the alleged Canterbury Bulldogs rape victim made what he considers to be a false complaint: Masters claims that women in Coffs Harbour—where the alleged rape occurred—will "expose [themselves] to ... ignorance and ignominy" (80) by having group sex with footballers because there is a shortage of local men and unemployment there is double the national average. He thus implies that her motivations for making the complaint were to gain money, even though she never sought nor received a financial settlement.

[4] In a 1995 study of police officers' attitudes to rape complainants, Jan Jordan found that one in six police officers 'felt that many women who reported rape were lying and wanted revenge'.
[5] The woman who makes a rape complaint for money is also connected with the more general figure of the Gold Digger, who uses her sexuality to obtain money from wealthy men (frequently evoked in phrases such as 'she only married him for his money').

The Party Girl figure is the woman who is out to have a good time, consume large quantities of alcohol, and is therefore also out for sex. I base my analysis on Alison Young's discussion of perceptions of the intoxicated complainant. Young argues that the complainant's consumption of alcohol functions "to impugn her character and imply consent" (451) citing studies of rape trials by Edwards and Heenan in Victoria, who found that the complainant's alcohol consumption was a significant component of the defence's case, and La Free, Reskin and Visher in the United States which indicated that juries are more likely to acquit when the victim has consumed alcohol or drugs prior to the rape.[6] She argues that the association of alcohol consumption with immorality and consent to sex are linked to "our fascination with the speaking mouth [which] derives from its constitution as a border between the inner self and the outer other"; when alcohol or drugs are ingested, "the outer other is incorporated into the interior self." (454) Young, thus, concludes that "the woman who drinks from her glass or swallows the pill, while engaging in acts which may be entirely appropriate to their context, is never looked at as simply drinking from her glass or swallowing the pill, but as metonymically speaking her willingness to have sex." (455) If she is willing to incorporate one other—alcohol or drugs—she signals her willingness to incorporate "other" others: a penis, or penises. Thus, when a woman is portrayed having a good time, consuming alcohol the cultural story of the Party Girl means that she is simultaneously portrayed as inviting sex.

In a discursive climate like this, particularly when reports abounded of football representatives claiming the Director of Public Prosecution's decision not to lay charges as a "true vindication" and finding of innocence, (ABC) complainants' words held little weight in the eyes of many. I will therefore consider the role of journalists' retelling of traumatic testimony, and how it can either support or undermine the complainant's version of events. It is imperative that space be made for rape testimony to have truth value—to be believable—for two main

[6] A study of Victorian police responses to rape complaints conducted by Melanie Heenan and Suellen Murray found that victims/survivors who had not consumed alcohol or drugs were significantly more likely to have charges laid against the alleged perpetrator than those who had; Jan Jordan (98-99; 112-36) found police are more likely to disbelieve intoxicated complainants; in a study of juror attitudes and biases, Natalie Taylor cites a UK study which found that focus group participants tended to blame rape complainants when they drank alcohol; Diana Scully (123-25) demonstrates convicted rapists' knowledge of how intoxicated complainants are implicated and blamed.

reasons. Firstly, the impact of disbelief on an individual victim is immense, compounding the trauma of the rape and inhibiting recovery.[7] Secondly, and of importance to all victims and all people, rape is both the most underreported crime and the most difficult to obtain a guilty verdict for: it is the one crime whose victims are least likely to be believed. Therefore, every rape testimony presented as *in*credible reinforces the myth that women lie about rape, and affects the chances of every survivor being believed.

I will use two parallel newspaper articles to demonstrate the singular power of narrative in validating or invalidating a complainant's testimony, and the role of cultural stories in informing them. The narratives, made public in 2004 during the debate over the Canterbury and St Kilda cases, relate to a 1998 incident in which at least two players and an official from the Hawthorn Football Club allegedly raped a Californian woman whilst on tour in Hawaii. I selected this particular case rather than the more highly publicised ones because it generated two articles which, when juxtaposed, crystallise the potential problems of retelling a traumatic testimony within the newspaper reporting genre. The latter is the format that reaches the greatest number of people and therefore is likely to be the most influential. It also demonstrates the positive potential of media texts in validating a traumatic testimony and creating an audience receptive to the complainant's story. The first narrative, Michael McKenna's "I Didn't Say Yes to Anyone: Booze Cruise, Claims of Spiked Drinks and Allegations of Sexual Assault" appeared in Melbourne tabloid the *Herald Sun* in June 2004, and consistently undermines the credibility of the complaint and the complainant; the second, Padraic Murphy's "I Was Drugged, Says 'Gang Rape Victim'" appeared in national broadsheet *The Australian* one day later and portrays both complaint and complainant as credible. Both narratives are in the reporting genre, so the interjection of direct opinion is not permitted, and thus the construction of the narrative is the writers' only means of presenting their view of the complaint. Both narratives are based only on statements made by the alleged victim to Californian police, as official statements from the players involved were not taken. However, there are substantial differences and discrepancies between the two accounts: in the details included or omitted, sometimes direct contradictions in the nature of the details themselves, the structure of the narratives, the portrayal of the events and thus the portrayal of the complainant and alleged perpetrators as characters within the narrative.

[7] See, for example, rape survivor Susan Brison's *Aftermath*.

These parallel narratives illustrate the power that journalists have to either confirm or undermine rape-supporting, victim-disbelieving myths. If two such wildly differing accounts can be based on the same testimony, this demonstrates the fact that journalists can play a vital role in either upholding or disrupting the status quo, under which women's rape claims against footballers are disbelieved, simply by the narrative choices that they make.

Although the headline—or "title"[8]—of each narrative contains speech attributed to the complainant, Murphy's supports the complaint's validity whilst McKenna's undermines it: "I Was Drugged, Says AFL 'Gang Rape Victim'" (Murphy); "I Didn't Say Yes to Anyone: Booze Cruise, Claims of Spiked Drinks and Allegations of Three Rapes" (McKenna). Implicit in the statement "I was drugged" is the claim that the complainant could not consent to sex, and that someone set out to ensure this eventuality. McKenna's title contains an explicit denial of consent, but places this denial in a context that implicitly questions its validity. Each title refers to the woman's belief that a player or players added something to her drink; whilst "drugged" carries criminal overtones, "spiked drinks" suggests a joke, or something titillating, as does a "booze cruise." The complainant herself does not figure in McKenna's title; unlike the "gang rape victim" she is a disembodied voice placed in the context of a titillating booze cruise which suggests her claim of non-consent may be untruthful. McKenna's narrative is denied as narrative; whilst the title emphasises "claims" and "allegations," it is followed by "Michael McKenna reports," marking his account as "factual" reporting, not narrative construction, and (potentially) in opposition to what was "claimed" or "alleged." McKenna draws attention to the fact that only the alleged victim/survivor's version of events was presented in the police documents, declaring, "Police documents, released yesterday in Honolulu, tell only part of the story—the victim's version of events. The documents reveal nothing about what the players and official had to say in their defence." This implies bias on the part of the police, as they supposedly only released one side of the story, and thus presents the complainant's claim of rape as suspect from the outset.

McKenna continues his implicit claim to truth-telling employing a "neutral," reporting tone:

[8] I will use "title" rather than "headline" to emphasise the literary function of the articles.

In police documents released in Honolulu yesterday, a Californian woman
– who will not press charges – alleges she was raped in 1998 by three
members of a touring Hawthorn Football Club group.

Thus, at the beginning of McKenna's story, the woman as sole actant
"alleges she was raped," drawing focus away from whether or not men
raped a woman and placing it on the making of a rape allegation. This
tactic focuses attention on the alleged victim's actions rather than the
alleged perpetrators' behaviour. Drawing attention to the fact the woman
is not pressing charges also suggests the complaint is false as it implies
that it will not stand up in court and she is aware of this.

The above contrasts strongly with Murphy's opening:

Bruised, drugged and smeared with semen, a Californian mother of two
was forced to endure one final humiliation as she staggered from a
Hawaiian hotel *after allegedly being gang raped* by at least three –
probably more – members of the Hawthorn Football Club.[9]

Narrating the aftermath of the alleged rapes in this manner immediately
portrays the complainant in a positive light. Where McKenna's opening
foregrounds words such "claims," "allegations" and "alleges," Murphy
includes "allegedly" towards the end of the first paragraph, so that it marks
the actual rape alone and is thus effectively hidden. The description of the
victim's state, which occupies the first part of the sentence, is therefore not
presented as an allegation, but works to add truth value to the claim of
rape.

Through systematic foregrounding of particular events and de-emphasising
others, McKenna constructs the complainant's character as a Party Girl:
one who is out to have a good time, consume large quantities of alcohol,
and is therefore also out for sex. McKenna both emphasises and inflates
the complainant's use of alcohol and habitual "partying," whilst eliding or
erasing entirely the footballers' drinking. In the "title" the complainant is
directly linked with a "booze cruise," whereas in the opening paragraph
the Hawthorn team are described as "touring," with no mention of alcohol.
McKenna lists "swimming, driving a jeep around Oahu, and parties at
night" as the three things that made the holiday "wonderful" for the
complainant, following this directly with:

[9] Emphasis added.

On October 17, 1998, their last evening in Hawaii, they bought tickets for the Endless Summer Pub Crawl. It was billed as a "booze cruise." Cheap drinks flowed, first at a nightclub before the crowd of about 200 moved to the boat that sailed off the coast for several hours before returning to another club.

With no indication of a disjunction between the "parties at night" and the "booze cruise," the story which follows appears as simply another night of parties, implying that the first three nights were similar. McKenna lists the drinks the woman consumed, implying that they were consumed in quick succession: "She drank a cocktail, and a rum and Coke, before ordering another rum and Coke as she was called to the stage by 'the host' for a contest." After the description of the contest, McKenna writes, "the crowd was taken to the ship where the two women had a shot of tequila. 'And, um, and then it begun (sic) to get a little fuzzier, um, as far as the night goes,' the alleged victim told police." Following the consumption of tequila with "'and *then* it begun to get a little fuzzier"[10] strongly suggests that drinking the tequila caused the fuzziness, not the rum and coke being spiked at the club as the woman alleged.

Murphy, by contrast, portrays the woman's drinking as modest, particularly in comparison with the footballers, who were "already drinking heavily" when the women arrived, and makes it clear that her disorientation was not due to excess alcohol consumption: "Although she [had] had only four alcoholic drinks by the time she got on the boat, the woman said she was feeling dazed and confused, and was *corralled* by a group of the players who told her they were as famous as NFL stars [emphasis added]." The use of "only" indicates that her alcohol consumption had not been excessive, and "corralled" implies threatening behaviour on the players' part, treating the woman like an animal. He also refers to the cruise as a "sunset cruise," avoiding the sordid implications of "booze cruise" and the suggestion that the woman's confusion was due to excessive alcohol consumption.

The two accounts also diverge sharply when the Hawthorn official who allegedly set up the rape is figured, and the scene of the rape itself. Whilst Murphy portrays him as something of a predator, McKenna places him in a romance script with the alleged victim, therefore implying that she consented to sex. Murphy writes that:

[10] Emphasis added.

She also remembered being "hit on" by a club official aged in his mid-30s. After the cruise, on a bus that was taking the woman and the players to another nightclub, the club official groped and kissed the woman. "He was really ugly," the woman told police. "If I was anywhere near normal, I would have been like "OK, go away." He was just short and ugly and (had a) big nose."

Being "hit on" suggests that his overtures were unwanted; the fact that he "groped and kissed" her marks both acts as unwanted sexual touching (and therefore sexual assault). The assertion that he was ugly and that she would normally have told him to go away therefore supports the claim that his touching was unwanted, and undermines the counter-claim that she later had consensual sex with him.

McKenna's version is quite different. He writes "After the boat had docked (about 11.30pm), she alleged she boarded a bus and one of the team had *held her hand* and kissed her. 'He just started kissing me. I mean, he was really ugly," she said.'" (emphasis added) Describing the man's actions as "held her hand and kissed her" characterises him as the suitor in a romance script, rather than a sexual predator. Although McKenna also quotes the alleged victim here, the assertion of ugliness, rather than supporting the claim of non-consent, portrays the woman rejecting a romantic suitor on seemingly superficial grounds.

Both accounts agree that the woman vomited, the club official offered to buy her a toothbrush, and that they went up to his hotel room; however, once again McKenna chooses narrative events implying consent, whereas Murphy's account suggests non-consent and the woman's honesty. Whilst Murphy writes that they boarded "a bus that was taking the woman and the players to another nightclub," and that the woman vomited outside the nightclub, McKenna claims that "The bus dropped the crowd opposite the players' hotel" and she vomited outside the hotel. It seems likely that the bar and hotel were near each other, as McKenna also says elsewhere that the bus was going to another nightclub; however, while Murphy's narrative marks the nightclub as the bus's destination, McKenna claims that it is the hotel, further implying that the alleged victim was going to the players' hotel anyway (not her own), and was therefore interested in sex. Murphy's narrative portrays the complainant's stated actions and motivations as reasonable, and he writes:

> Although drunk, she told police she was not drunk enough to vomit. The club official then offered to buy her a toothbrush and took her to his hotel room upstairs, just after 11pm. She thought he was giving her a place to

clean up, and told police she would not have gone had she not been drugged.

Naming the man a "club official" marks him as an authority figure, supporting the woman's claim that she thought he was just giving her a place to clean up and making her actions appear reasonable rather than risky. He is figured as the agent and instigator, taking her upstairs to his room; reiterating the assertion that she had "been drugged" confirms the involuntary nature of her state of intoxication and provides an explicit explanation for her presence in the hotel room which does not suggest consensual sex.

By contrast, McKenna writes: "She said *the member of the Hawthorn party who had kissed her* had offered to buy her a toothbrush. They had gone to his room, where she cleaned her teeth."[11] The man in this narrative is the romantic suitor who "held her hand and kissed her" on the bus; they are co-agents in going to the hotel room, and what happens thereafter is set up as consensual. McKenna continues:

> "And, then, I don't know . . . I was in bed, somehow," she alleged. "My next recollection is (name, etc blacked out) *having sex with me*." She told police she had been naked, but she could not remember how she got that way. She had drifted in and out of consciousness.[12]

That she was at times unconscious is placed at the end of this sequence, minimising its impact, and the use of "drifted" implies a pleasant sensation; as the complainant has been portrayed throughout the narrative as a heavy drinker, it becomes possible for her uncertainty about what occurred to be attributed to the memory loss which sometimes happens after a night of drinking. McKenna continues:

> During the alleged rape, she said the room door kept opening and closing. Her next memory, she alleged, was waking up with the "*next person on me*" in the other bed of the room. "At the same time, I noticed there were other people in the room," she alleged. After waking during the second *alleged attack*, she told police she had blacked out again before waking up with a "*third person on me*." The woman said that *during this attack* he had asked her if she remembered that "I was the one in the contest with you?" "He started saying stuff like, 'Tell me you're an American slut. We,

[11] Emphasis added.
[12] Emphasis added.

I love American sluts,'" she alleged. *After the last alleged attack, she had dressed, but could not find her underwear.*[13]

In this section of the narrative McKenna uses the words "rape" and "attack" which of course suggest non-consent; however, in the context of this narrative, and at this point when the woman's consent to sex has already been confirmed, a likely conclusion is that the rape did not occur. The language used to describe the sexual contact is consistent with consensual sex: McKenna quotes the woman describing the first man as "having sex" with her and waking up with "the next person on me" and later with "a third person on me." This presents the three men "having sex" with the woman as a predicted sequence of events; that the woman's own words are used implies that she was aware of what was going to happen, and therefore consenting to it. By removing the complainant's words from their original context and cutting them off from their original "vouloir-dire," (meaning) as Derrida describes it, those words have been coopted and used to undermine her credibility, therefore supporting McKenna's portrayal of a false complaint. This is a danger that theorists Linda Alcoff and Laura Gray warn is relatively common for rape testimonies. Apart from the framing of "alleged attack" and "alleged rape," there is no suggestion that the contact was against the victim's will at the time. The last sentence of this section also appears incongruous, as after (allegedly) being raped by multiple perpetrators, the woman simply gets dressed. There is no indication of time delay, as in Murphy's account: "The single mother, whose children were aged 1 and 4, *woke about 4.30am.* She said the hotel room was a mess, with clothes and personal items spread across the room. She got dressed but could not find her underwear" (emphasis added). By contrast, according to McKenna's narrative, it is as if, after being raped by three men, the woman claims to have simply got up off the bed and put her clothes back on without any fuss, a ludicrous suggestion which strongly implies that consensual sex occurred.

Murphy's account of the rape scene is also far less consistent with the suggestion of consensual sex:

> Now lapsing in and out of consciousness, she next remembers waking to find the club official performing oral sex on her. She woke again and noticed the official putting on a condom before penetrating her. The woman next woke up on another bed in the room with a second man

[13] Emphasis added.

penetrating her. She described him as tall, with dark hair, muscular build and aged in his early 20s. "I remember realising he's on top of me ... and freaking out," she said. She woke later to find another player – aged 18-20 with dirty blond hair – penetrating her. She told police he "flipped her over" and penetrated her "doggy style" before ejaculating on her neck and face.

Murphy uses "lapsing in and out of consciousness," as opposed to McKenna's "drifting," and employs "penetrated" repetitively to describe what the footballers and official did to the woman. Including the woman's statement that she was "freaking out" underlines the claim that what occurred was not consensual sex. The description of the third man's behaviour more plainly marks his actions as abusive, degrading and therefore rape. That he "'flipped her over' and penetrated her 'doggy style'," ejaculating on her, places him outside a romance script, as he has treated her like an animal and performed actions that do not constitute a typical romance scenario. Also, the inclusion of the woman's descriptions of the perpetrators—for example "dark hair, muscular build and aged in his early 20s"—is reminiscent of a television or newspaper Crime Stoppers segment, in which it is clear that a crime has occurred and the only question is identifying suspects. The complainant is clearly portrayed as a raped woman, not a Party Girl, Predatory Woman, Gold Digger or Woman Scorned.

In McKenna's narrative, the complainant is portrayed as a Party Girl, who voluntarily got drunk, had sex with multiple men, filed a rape complaint for an unspecified reason, and declined to press charges. In the discursive context in which the article appeared, McKenna does not need to explain why the woman made a false complaint, because the cultural stories of Predatory Women, Women Scorned and Gold Diggers, which were in constant circulation, provides these explanations for him. Many, or even a majority, of the readers of McKenna's account may believe that the complainant fits one (or all) of these cultural archetypes rather than that of the raped woman. In Murphy's account, however, the complainant drank moderately, was drugged and raped, and reported the incident to police when "depression and trauma started to sink in": a Raped Woman.

Narratives such as McKenna's, which coopt the complainant's testimony to undermine her credibility, contribute to the popular perception that women

lie about rape[14]—those who allege rape by footballers in particular—and further contribute to a "narrative immunity", which protects footballers from being answerable for allegations of rape. There is a clear congruence between accounts such as these, which discredit the complainant, and the failure of any charges against Australian footballers to reach court. The cases were de facto adjudicated through the media.

By contrast, narratives such as Murphy's, which render a complaint believable, are vital in countering the many myths that serve to discredit complainants and ultimately deny them access to justice. Cultural stories gain their currency through constant repetition. When journalists engage with a rape testimony in a way that validates it, not only is the individual complainant more likely to be believed, but it goes towards making the story of the raped woman more widely believable, and may help to break down footballers' blanket immunity from allegations of sexual assault.

Works cited

The 7:30 Report. 2004. 'No rape charges but NRL fines Bulldogs'. Off-air videorecording. ABC-TV, Australia, 29 April.

Alcoff, Linda Martin and Laura Gray. 1993. 'Survivor discourse: Transgression or recuperation', *Signs* 18(2), 260-290.

Brison, Susan J. 2002. *Aftermath: Violence and the Remaking of a Self.* Princeton and Oxford: Princeton University Press.

Gough, Deborah, Karen Lyon and Melissa Ryan. 2004. 'The heady mix of women and football', *The Age,* Melbourne, 18 March, p. 4.

Greer, Germaine. 2004. 'Ugly sex has just got a lot louder', *The Age,* Melbourne, 23 March, p. 1.

Heenan, Melanie and Suellen Murray. 2006. *Study of Reported Rapes in Victoria 2000-2003,* Melbourne: Office of Women's Policy.

Jordan, Jan. 2004. *The Word of a Woman? Police, Rape and Belief.* Hampshire and New York: Palgrave Macmillan.

Lyon, Karen. 2004. 'They love their footy, but can they keep the faith?', *The Age,* Melbourne, 18 March, p. 1.

Masters, Roy. 2006. *Bad Boys: AFL, Rugby League, Rugby Union and Soccer.* Sydney: Random House.

[14] See for example Jan Jordan, who argues that 'a core of disbelief towards women reporting sexual assaults appears to lie at the heart of police culture', finding that officers who volunteered an estimate of the proportions of false claims in one 1995 study gave figures of 60% or higher.

McKenna, Michael. 2004. 'I didn't say yes to anyone: Booze cruise, claims of spiked drinks and allegations of three rapes', *Sunday Herald Sun*, Melbourne, 20 June, p. 84.

Murphy, Padraic. 2004. "I was drugged, says AFL 'gang rape victim'", *The Australian*, 21 June, p. 5.

Porter, Liz. 2004. 'Sex discussions feed footy's Whore-Madonna complex', *The Sunday Age Melbourne*, 28 March, p. 4.

Scully, Diana. 1990. *Understanding Sexual Violence: A Study of Convicted Rapists.* Boston: Unwin Hyman.

Sheahan, Mike. 2004. 'Saints duo take a massive risk', *Herald Sun*, Melbourne, March 17, p. 93.

Taylor, Natalie. 2007. 'Juror attitudes and biases in sexual assault cases', *Trends & Issues in Crime and Criminal Justice* 344, pp. 1-6.

Visher, Christy A. 1987. 'Juror decision making: The importance of evidence', *Law and Human Behaviour* 11(1), pp. 1-13.

Young, Alison. 1998. 'The waste land of the Law, the wordless song of the rape victim', *Melbourne University Law Review* 2, pp. 442-445.

MENTAL HEALTH TRAUMA NARRATIVES AND MISPLACED ASSUMPTIONS: TOWARDS AN ETHICS OF SELF-CARE AMONG (HUMANITIES-BASED) TRAUMA RESEARCHERS

KATRINA CLIFFORD

Introduction

Throughout the course of their careers, many mainstream media professionals will, at one time or another, face the prospect of having to cover a difficult, perhaps even traumatic, news story. For some, the most confronting element will be not so much in coping with the negative effects of covering *one* such story, but in healing the scars borne from reporting on *an accumulation* of disasters and traumatic incidents. At other times, the challenge will be in coping at all, but especially in the silence assumed by many journalists.[1]

The act of critically 'bearing witness' to the often insidious distress endured as a consequence of involvement in the coverage of traumatic incidents has centrally, and informatively, featured as part of my current research. This work explores the construction and contestation of discursive representations of what I term *fatal mental health crisis interventions*, or more specifically, the fatal police-involved shooting of persons in psychiatric crisis—the troubling and devastating outcome to a number of mental health crisis incidents in Australia over the past decade; several of which have resulted in controversy and public debate, high profile coronial proceedings and/or protracted news coverage. While still a work-in-progress, this research has been primarily conducted through the lens of one particularly *notorious*[2] case study involving the death, by

[1] See the Dart Centre for Journalism and Trauma's DVD *News Media & Trauma*.
[2] The word 'notorious' is used deliberately in describing this tragedy for two reasons: firstly, in grappling for language that best defines the incident and

police shooting, of a mentally ill man on the south coast of New South Wales, Australia, following a drug-induced psychosis.

With minimal barriers established around the perimeter of the incident, local news media were able to access the scene and capture to film a significant portion of the one and a half-hour long sequence of events that eventually led to and included the fatal shooting. One particularly graphic image of the man's bloodied body lying on the roadway moments after the shooting subsequently appeared in full colour print on the front page of the local newspaper the following morning, while edited footage of the incident was broadcast ad nauseum in the updates leading to the nightly news bulletin of one of the region's more prominent television stations. This footage was additionally aired on several of the network's affiliated programs; effectively taking the images to a national audience within 24 hours of the incident. Such was the trauma engendered by the graphic and repetitive nature of the media's coverage of the incident that the family of the deceased subsequently initiated an unsuccessful claim against New South Wales Police for psychological injury as a result of the fatal shooting.

Formal interviews with several of the media professionals directly responsible for the witnessing and/or reporting of this incident have revealed some striking commonalities between each one's experiences, testimonies and long-term memories of the event. First and foremost has been a shared sense of astonishment as to the clarity of detail with which each individual has been able to recollect the incident a number of years after the fact. This has been an observation quite often self-reflexively arrived at and voluntarily (often readily) articulated by the media professionals themselves during the research interviews. It is clear, however, that bearing witness to this particular fatal shooting has also left a number of other lasting impressions on the media professionals involved. In some cases, this has been evident through the volumes spoken in polite, albeit brief, written refusals to participate in the research. In the case of those willing to be interviewed, however, the act of bearing witness has unmistakably had a degree of (self-declared) influence on their subsequent professional practices and decision-making as news journalists.

captures the magnitude of the ongoing trauma induced by it, the word 'notorious' has been used several times by the family of the deceased man during informal conversations with them; and, secondly, because ultimately its use is descriptively fitting.

Of course, the traces of traumatic experiences do not leave their indelible imprints on media professionals alone. In the context of my own research, the effects extend even more patently to family and friends of the deceased, emergency services workers and the general duty police officers responsible for the fatal discharge of firearms. In short, such trauma potentially touches everyone exposed to it—including *researchers* whose work may bring them in constant contact with the painful images, documents, thoughts, feelings and personal interactions that often accompany sensitive research and engagement with (mental health) trauma narratives.[3]

Attempting to forge new ground in this area of research does not come without its own inherent challenges; not least of all being the "continuous process of renegotiating and maintaining proper boundaries" (Rager 26). In their own right, (mental health) trauma narratives significantly highlight the conflicts that recurrently occur in the nexus between institutional (e.g. news media, police, coronial, and medical) discourses and lay discourses. This discursive exchange is what has elsewhere been characterised as 'risk communication'—the interactions between various stakeholders in which "each stakeholder attempts to persuade others of the validity of their assessments and interpretations" (Blood, Pirkis & Francis 282). Mental health trauma narratives, therefore, act as exemplars of the ways in which the interplay of meaning frameworks, in the context of fatal mental health crisis interventions, bears *real social and political consequences*—for mental health and police training; for interpretations of 'risk' and 'dangerousness'; for the efficacy of resources developed to assist media professionals in the thoughtful and accurate reporting of mental health issues; for identity conceptions of persons experiencing mental illness and, more broadly, for mental health reform and response in Australia.

In this way, the public *articulation* of mental health trauma narratives (particularly by those participants often rendered voiceless and vulnerable in the aftermath of such incidents—especially operational police officers, their families, and the families and/or carers of the deceased) functions as a form of praxis, of embodiment, and of strategic intervention. For its part, trauma research that commits to the enterprise of 'bearing witness' to these narratives offers a corresponding and invaluable opportunity to facilitate and foster these acts of reclamation and empowerment.

[3] See Dunkley & Whelan

After all, by interrogating the power/knowledge relations constituted by discursive constructions and contestations of meaning frameworks, trauma research of this kind has the potential to bridge the subtle gap between acknowledgment of 'what is known' about mental illness and how this knowledge is *actively constructed*. In this respect, trauma research that embraces, articulates and examines the personal narratives of participants involved in fatal mental health crisis interventions has the very real potential to deliver benevolent results; to derive some good from what can only be described as terrible tragedies—if only by casting a necessary light on the painfully obvious (but equally valuable) moral lessons they embody as an impetus for change and prevention, and as an agent for mental health education and reform.

As a consequence, research of this kind walks a treacherous line between facilitating opportunities for traumatic recovery, redemption and endurance, and potentially causing further distress to participants already under duress. As Davison aptly explains: "When entering the research process any researcher may encounter unexpectedly problematic and uncomfortable territory. The capacity for harm is incumbent in any research"; although it is inexcusable for trauma researchers to embark on any line of inquiry "knowing that they are likely to leave their informants damaged by the experience" (381-382). However, "harm is the very last thing we want to happen, particularly where those we research are already socially excluded" (Barnard 13). Hence, this is the reason why it is obviously necessary, argues Peterson (1999), for any *responsible* trauma researcher, firstly, to obtain the requisite ethics approvals to conduct their work and, secondly, to commit to continuous individual ethical review as part of their ongoing research.

But while the ethical obligations incumbent upon researchers in their interactions with participants are considered *de rigueur* for principled qualitative trauma research, in comparison, there is very little critical discussion attributed to the potential harm that researchers of trauma (humanities-based trauma researchers, in particular) may themselves either encounter or endure as a consequence of the highly emotive and confronting nature of their work. Admittedly, while discussion of these experiences and the conflicts of identity that result has not been *deliberately discouraged*, in my experience, it has not been *actively encouraged* either. As Dickson-Swift and colleagues point out, there is a "growing awareness that undertaking qualitative research is an *embodied experience*" [emphasis added], but in spite of this, there remains "very

little empirical evidence about the researchers' experiences of undertaking qualitative research" (61).

The dynamics of trauma research based in the humanities

A search of the literature on trauma research and research of sensitive topics reveals a significant body of work relevant to the concepts of 'autoethnography' and 'reflexive orientation'; although, this literature tends to frame these concepts as emergent research methods for more clinically experienced researchers, such as mental health nurses and social workers (see, for example, Foster, McAllister, & O'Brien; Cutcliffe & Goward; and Davison). Literature on the emotional nature of research for qualitative researchers, it would appear, has yet to gain the same momentum. Notwithstanding this, the majority of the literature available remains limited in its scope; often focusing on the emotional impact of interviewing research participants in relation to sensitive topics, as opposed to exploring the emotional impact on researchers of working with distressing secondary resources, such as the study of coronial documents, victim impact statements and graphic media materials, as has largely been the case throughout my own research. There are, of course, notable exceptions to this—not least of all the work undertaken by Moran-Ellis (1996); Gregory, Russell, & Phillips (1997); and Fincham, Scourfield, & Langer (2008) in this area. Nonetheless, as Liamputtong suggests, the *compathetic response*—the pain or distress that researchers may feel as a consequence of contact with the distress of another (often a research participant)—need not result from face-to-face interviews alone, but "may arise from our direct observation, listening to or hearing the stories, reading stories about distressing experience, and remembering or thinking about the distressing stories" (82).

It would appear then that the difficult and, one imagines, confronting struggle fought by advocates within media circles and other professions to open up a critical space for both discussion and practical support of professionals touched by the secondary effects of being directly engaged with sensitive issues and/or traumatic and violent events is a journey that, by and large, has yet to be forged by (humanities-based) researchers of trauma. As Rager points out:

> Unlike qualitative researchers who conduct emotionally laden research, therapists would not be allowed to work in similar situations without proper preparation and without strategies in place for handling their own emotional reactions. (25)

Nonetheless, in comparison to the training and support initiatives that have increasingly emerged among professions that customarily encounter traumatic or violent incidents and narratives as part of their everyday work—trauma therapists being an obvious example; police another and, of course, the ongoing work of the Dart Centre for Journalism and Trauma and its resources, such as *News Media & Trauma*, a DVD produced "by news people for news people" in direct response to the kinds of complications and complexities mentioned—the personal struggles of (humanities-based) trauma researchers and the importance of self-care in this context are still largely neglected in both public and scholarly discussions of 'reflexivity' and the dynamics of 'emotionality' versus 'professionalism'. Writes Campbell:

> The emotions of researching emotionally difficult topics are often over-looked in academic discourse. Yet, the emotionally engaged researcher bears witness to the pain, suffering, humiliation, and indignity of others over and over again. (150)

Researching people's direct experiences of trauma and exploring the limits of traumatic recovery is, as Connolly and Reilly (536) point out, "difficult research". While there is, admittedly, little comparison between, for example, the experiences of people who knew the deceased and those of the (humanities-based) trauma researcher, given the former's reactions are of an entirely "different order" (Fincham, Scourfield, & Langer 860), the weight of responsibility that comes with bearing witness to the very personal, painful, heartfelt and sometimes truly *heartbreaking* stories shared by research participants, often encompassed in secondary source documents, is undeniable. Sullivan encapsulates this sense of responsibility in her reflections on her own sensitive research, stating: "At the forefront of my mind was always the thought that to be permitted a private view of another person's past, their pain, their sorrow, was a privilege" (4).

For a researcher, the effects of secondary trauma or "pain by proxy" (Moran-Ellis 181) can be broadly and variously characterised by emotional exhaustion and distress, guilt, outrage and anger, hyperemotionality, detachment and withdrawal, burnout and even intellectual paralysis—all of which can have a detrimental impact on relationships with partners and immediate family, as well as self, and the progress of one's research (McCosker, Barnard & Gerber; Perlesz; Laub; Liamputtong). The potential for a researcher to discover themselves the subject of resulting experiences of 'vicarious trauma' (see Hesse), 'vicarious traumatisation' (see McCann & Pearlman; Dunkley & Whelan), 'compathetic response'

(see Morse & Mitcham; Liamputtong) or 'compassion fatigue' (see Figley)—as it is interchangeably known—is therefore both undeniable and, in many ways, as reasonably significant as that encountered by their journalistic and other professional counterparts. Likewise, there are also notable parallels between the ethical obligations owed to trauma 'survivors'-as-interviewees by both media professionals and (humanities-based) trauma researchers; although, the formal requirements, practical applicability and enforcement of this ethics of care can vary significantly between the two.

This is not intended to undermine the tremendous inroads being made by other professions and organisations such as the Dart Centre for Journalism and Trauma. Nor is it intended to undermine the efforts of those practitioners who have sought to use qualitative research methods as a means by which to reconcile the authoritative pose of the professional self with that of the researcher's "vulnerable self" (Foster, McAllister, & O'Brien 47). Rather, what I want to highlight is the *equivalent need* for (humanities-based) trauma researchers to emerge from the borderlands of research—from that "intermediate space we can't quite define yet", somewhere between "passion and intellect, analysis and subjectivity, ethnography and autobiography, art and life" (Behar 177)—to similarly embrace the notion of giving themselves permission to publicly, and without fear of castigation or embarrassment, share these personal conflicts, as experienced throughout their own research and the inevitably intimate and precious, albeit challenging, process of 'bearing witness' to personal trauma narratives and potentially distressing secondary source documents and media materials.

This essay therefore aims to close this gap, if only by some small measure, by lending 'voice' to and locating my own attempts to reconcile such tensions within my work on fatal mental health crisis interventions, and as part of the turn away from a traditionally positivist paradigm to the adoption of an interpretivist (or what others, such as Grbich, would likely define as a postmodernist) approach to research. Moreover, this paper prompts a *call to action* for (humanities-based) trauma researchers to proactively address the question of how—in light of these very tensions— they might most appropriately 'declare their hand' within the ethical frameworks conventionally associated with trauma research while undertaking an ongoing ethics of self-care in their research activities and methods as a result of the potential impacts of this *embodied experience*.

Of course, it is important not to generalise or essentialise by profession; bearing in mind, as Dunkley and Whelan suggest, that "it is likely that not everyone will react the same way to what objectively may be labelled as a traumatic event" (111). There are obviously a number of factors, such as coping mechanisms, that contribute to an individual's response to (vicarious) trauma. Likewise, this response need not always be negative. It can, in fact, bring about positive identity changes in those working with individuals greatly touched by trauma and their (mental health) trauma narratives (Dunkley & Whelan 111).

In the conduct of trauma research in the humanities, navigating one's way through these accounts, and the sometimes disturbing nature of the (audio)visual and written materials that accompany and distinguish them, can be a highly complex, concentrated (even intimate) and enduring process. It is a process that is significantly complicated by the seemingly irreconcilable dynamics of retaining one's humanness in the face of such a trusted and generous act of gift-giving (as is the sharing of written and verbal personal trauma narratives by research participants), while also striving to preserve the detached and 'objective' manner typically associated with the positivist protocols of research and traditional, albeit rather erroneous, assumptions of what defines an ethical and proficient researcher.

Connolly (qtd. in Connolly & Reilly) refers to these very conflicts and the necessary intimacy that is infused into 'conversations' (be they face-to-face or through written expression) between research participants and the researcher in her own reflections on the experience of studying neighbourhood trauma. She writes:

> When researching my study participant's experience of trauma... I became the repository for the participant's emotions and feelings, and in some instances, I was the sole person to hear the narrative... I heard their experiences and then was left to hold or bear their stories... What I now know is that I cannot simply hear and then take away my participants' trauma narratives. There will be times when I engage in their lives beyond the interview process. (Connolly qtd. in Connolly & Reilly 531)

Reconciling traditional research demands with emotive response

What this demonstrates is that, in spite of any observations to the contrary, (humanities-based) trauma researchers *do not* exist outside the framework

of their own research (see Grbich), nor do they necessarily come to their work armed with the requisite skills, proclivity or capacity to meet the emotional demands of such research. This is especially so, one might add, for media and communications scholars, such as myself, or moreso, novice researchers who more than likely come to trauma research of the kind being conducted without a pre-existing familiarity of the mental health and health care environment, but with an understanding that they "must somehow make themselves familiar" (Nussbaum 36). This is while typically attempting to resolve or, at best, manage—quite often in isolation— "the personal and professional conflicts of collecting [and analysing] distressing material while struggling to maintain the assumed role of the 'neutral researcher'" (Davison 381).

As interdisciplinary scholars, we approach our research, more often than not, having been exposed to a long process of socialisation into academic life; often heavily reliant on a doctrine that privileges 'objectivity' and detached scrutiny above all else, and as paramount to the production of pre-eminent and authoritative research (Dickson-Swift et al 64; Finlay 543). In spite of recognising the practical and professional merits of this, one fundamental question remains in relation to my own research: how does a (humanities-based) trauma researcher effectively reconcile these demands for impartiality with the personal and emotive responses experienced as a consequence of rigorous and repetitive discursive engagement with media reports, coronial and court documents, photographs and audiovisual images depicting a person in psychiatric crisis during what are essentially the final moments of their life?

Faced with such personal conflict, surely a (humanities-based) trauma researcher must be enterprising enough to consider the challenge from a different viewpoint—possibly seeking to instead adopt something of a *reflexive orientation* that "positively embrace[s] subjectivity rather than habitually dismissing it" (Finlay 543)? As Frank (qtd. in Finlay 543) points out, such an approach has the potential to transpose what was once a problem into something of an opportunity, as the researcher looks "not to eliminate 'bias' to be more neutral, but to use it for more intense insight" by being self-conscious as to the active role they play in (co-)constructing meaning in their own research.

It could be argued that any disqualification of the subjective runs counter to the very principles of ethical and effectual (humanities-based) trauma research. As Foster, McAllister and O'Brien (47) explain, research of this

kind typically requires scholars to draw on genuine and personal expressions of "empathy, warmth, respect, patience, and trustworthiness" to cultivate a *dialogue*—rather than simply an *interrogation*—between the researcher and participant. This is part of the ethical responsibility assumed by the (humanities-based) trauma researcher in the course of 'bearing witness' to the mental health trauma narratives of participants.

To do away with this imperative—especially in the context of researching fatal mental health crisis interventions—could be seen, at best, to be insensitive and, at worst, opportunistic. It also bears the potential to destructively invite criticism that ridicules (humanities-based) trauma researchers as being so bold as to assume an inherent right "to 'parachute' into a group, treat people as the objects of research, form an omnipotent, omniscient position, and then leave to analyse the data" (Howarth, Foster, & Dorrer 240).

One might even argue, as Cohen, Manion, & Morrison (qtd. in Foster, McAllister, & O'Brien 46) do, that the "exclusive pursuit of objectivity, quantification, logic and reason", in and of itself, has the potential to promote these sorts of damagingly essentialist approaches to (humanities-based) trauma research. Although, such acts of "traumatic ventriloquism"— speaking *for* the traumatised—are, as Dawes (24) explains, both morally and ethically intricate; "bounded by two opposing questions" that generate a series of very personal and, perhaps, ultimately irreconcilable questions for the (humanities-based) trauma researcher: Do I have a right to talk about this? And, do I have a right *not* to talk about this? In other words, it is a dynamic bounded, writes Dawes, by the "poles of entitlement (What gives me the moral authority to tell this story? How can I prove my authenticity to my readers?) and obligation (How much of myself am I required to give to this story? What is my duty, and when am I free of it?)" (24).

While, ethically, it would therefore appear most appropriate to encourage (humanities-based) trauma researchers to continue to grapple with such complexities in the cultivation of a *dialogue* with research participants (in favour of otherwise adopting essentialist notions or techniques in their work), Bauer, Gaskell, & Allum (qtd. in Howarth, Foster, & Dorrer) caution that, at the same time, "accepting what is expressed by participants unquestioningly and without deeper analysis may be just as problematic as accepting the views of the researcher" (240). As Radstone further explains:

> Criticism and debate can easily appear callous, or even unethical, in a context where an audience is being asked to bear witness to unspeakable sufferings. This can lead, however, to a silencing of discussion which leaves hanging any number of questions about the continuingly problematic nature of academic discussion of trauma and the apparent acceptability of debate only of certain types of material [and I would add trauma testimonies] and not others. (22)

These dimensions have unquestionably generated certain conflicts within my own research. For example, on several occasions, I have had to willfully resist the urge to succumb to a simple 'memorialisation' of the deceased as an implicit form of overcompensation for fear of otherwise committing the sins of imprudent ethnographers before me or, equally, as a response to the 'debt' I feel I personally owe to the family as a consequence of their unconditional generosity in the provision of materials for analysis and the intrusion they have allowed my research to make on their lives and their path of traumatic recovery.

Researchers could undoubtedly appreciate the humbling experience derived from the privilege of engaging in a dialogue with those participants directly involved in and affected by the fatal police-involved shooting of persons in psychiatric crisis. In these situations, the last thing a *responsible* and *ethical* (humanities-based) trauma researcher wants to be, or be perceived as, is a marauder intent on pillaging the personal testimonies of participants for misuse, abuse or misguided self-interest. This is especially so when you consider that the notoriety fatal mental health crisis interventions typically attract—usually as a consequence of the media coverage afforded them (particularly in instances where there are visual images available of the incident)—more often than not results in the repeated exploitation of these narratives as 'public property', with flagrant disregard for the ongoing psychological and emotional costs to those involved. For its part, reflexive orientation therefore forces (humanities-based) researchers of trauma to consistently take stock of both their motivations and research techniques, and the possible ramifications of these; seeking a balance, for example, between being "too far in or too far out of the lives of the researched" (Dickson-Swift et al 855).

Towards a practice of self-preservation

In this respect, adopting a position of reflexive orientation can doubly be an individually liberating experience for the (humanities-based) trauma researcher, given that analysis of this kind carves out a space in which they

can assume an implicit permission to not only experience emotion and uncertainty towards their work, but to give voice to their individual research experiences and the concerns and conflicts that these may generate. These are admissions that, in many circumstances, trigger embarrassment for the average researcher, fearing that even expressing concerns over individual conflicts will be "viewed as personal weakness or professional incompetence" (Davison 381).

It is important to distinguish here between an *inability to cope* as opposed to what I am referencing, which is something altogether different—that is, an acknowledgment of one's own sense of compassion, which can, in turn, elicit other associated responses and subjective positions, and may ultimately influence a (humanities-based) trauma researcher's interpretations and analysis. This speaks to my earlier argument that, in the construction and contestation of discursive meaning frameworks related to fatal mental health crisis interventions, subjective positions and reflexive analysis are dynamic practices that, as Foster, McAllister, & O'Brien (46) argue, are not only *valid*, but should be *expected*.

More than simply making "visible the beliefs and values that the researcher uses [to] shape interpretations of data" (Foster, McAllister, & O'Brien 46), reflexive orientation retains the potential to *empower* (humanities-based) trauma researchers by doubly functioning as a mechanism for self-preservation—especially in the face of highly sensitive, confronting and emotionally charged research. Without reflexive analysis and, by correlation, the authority to express what might otherwise be perceived as personal weakness (in truth, the fact that while we may be researchers, we are also only human and "to be human is to be emotional", as Denzin (x) states) we start to factor ourselves out of the ethical equation—sometimes to the detriment of our own work (see Kleinman & Copp). This is precisely what Finlay pays tribute to when she refers to the fact that "to avoid reflexive analysis might even compromise the research itself" (543). More importantly, I would add, it might even compromise *the researcher*.

This is not to suggest that humanities trauma researchers should, by any means, recklessly abandon or disrupt their ethical obligations (including confidentiality—see McCosker, Barnard & Gerber) to ensure the wellbeing of research participants. Rather, my suggestion is that they should supplement this ethical responsibility with a similar commitment to developing the capacity to incorporate practices of *self-care* and *reflexivity*

into their research methodologies, activities, critical thinking and analysis. This is what Connolly and Reilly (534) refer to as the ability to *feel* the work, "to 'be with' the trauma, to respect the pain, but to let it go" through the cultivation of "reflexive alliances", which function as an "unloading zone" to allow the (humanities-based) researcher of trauma to externalise their felt experience and the emotionality that emerges in response to their research.

On one hand, this represents something of a call for 'community' among humanities trauma researchers. However, it also reflects a deeper need for formal recognition of the value that self-preservationist techniques lend to trauma research by allowing (humanities-based) trauma researchers to "blend the emotional insider experience back to a cognitive outsider role" to enable them to more effectively "reflect on the data, conduct the analysis, and resume [their]…role as a researcher in the research activities" (Connolly & Reilly 534). This is part of what Dickson-Swift et al. refer to as the "constant management of self" (69) in qualitative research, which lends itself appropriate for qualitative researchers to "see their emotional and cognitive functions as inseparable from each other and that emotions should be central to the research process" (64).

However, in many respects, this is easier said than done, given the emotional impacts of undertaking (humanities-based) trauma research are not always typically or proactively discussed by peer academics and members of postgraduate supervisory panels—even in regards to their own work. The danger of this lies in the notion of a cycle of negative self-fulfillment in that if supervisors, and other academics considered to be 'mentors' by postgraduate (humanities-based) trauma researchers, are unwilling to discuss their own experiences of *pain by proxy*—be it as a consequence of concerns for 'professional competency' or a general unwillingness or neglect of attention to the issue—then how else are other (humanities-based) trauma researchers expected to respond to their own personal and professional conflicts?

The likely outcome is that the novice or early-career qualitative researcher will be left under-prepared for the level of emotional engagement that (humanities-based) trauma research requires, without the requisite guidance on how best to address the "issues that may arise in conducting emotionally laden research" and without the confidence to articulate these concerns (Rager 23). Certainly, this is reflective of my own early experiences with/in my current research.

As Davison's studies suggest, all committed social work researchers—although, this is also analogous, I would suggest, to that of (humanities-based) trauma researchers—"who encourage informants to talk through painful topics are likely to encounter ethical dilemmas about the degree of responsibility they have for offering a counseling and advice function, if they possess such skills" (383). It was on this basis that I initially enrolled in a two-day Mental Health First Aid (MHFA) course to develop a better understanding of mental illness more generally, but to also seek out the professional advice, practical 'tools' and understanding that might better equip me to respond confidently, comfortably, appropriately and ethically towards my research participants, should they react adversely to the procedures undertaken or questions asked in the conduct of my research. Having been previously informed by the university's ethics committee that there were concerns as to my lack of clinical expertise or training, my enrolment doubly served, it must be said, as a potential means by which to address these concerns with regard to my qualifications and ability to deal with participants in distress.

Holland interestingly refers to similar ethics committee concerns being directed towards her own research of public voices of madness or mental illness in various media forums and among researchers in a paper titled, "The Epistemological Bias of Ethics Review". Here, she aptly draws attention to the way in which the committee's concerns about clinical expertise provide a clear, and I would suggest striking, example of "the privileged status of clinical knowledge over experiential knowledge" (Holland 907). They also reveal something of a predilection towards decision-making based on hypothetical worst-case scenarios, which assume, as a default position that, within mental health and trauma research, participants may likely pose some kind of risk to the researcher or that the researcher may likely pose some risk to them (Holland 898-899).

Holland's paper responds to such prejudgments with what is, to the majority of (humanities-based) trauma researchers, an otherwise obvious and pervasive point and to others a fitting reminder that safety to participants remains a primary ethical consideration in qualitative studies involving research with people, as does "the protection of participants' confidentiality, especially involving sensitive information" (Holland 898-899). Notwithstanding this ethical responsibility and conviction, it is worth reiterating that research participants typically take part in such research on

a "mutually agreed" and voluntary basis and, in doing so, retain the right
to withdraw from involvement in the research at any time. Writes Holland:

> [To] determine that this minimal risk [of harm] is a greater probability
> than the possible benefits of the research seems to reflect an overly
> pessimistic view and may also undermine the participatory efforts of those
> it is intended to protect. (899)

With such responsibility at the forefront of my mind leading into the
MHFA program, imagine my surprise when midway through the training,
I came to the unexpected and rather cathartic realisation that the course
was not only furnishing me with the knowledge and practical skills to
support *someone else* in mental health crisis or distress, but to also
confront *my own* possible distress and emotive responses to close
engagement with such a sensitive and emotionally charged area of
research and its associated personal trauma narratives and explicit media
materials. With the emphasis unwaveringly directed towards the ethical
responsibilities owed to my research participants, *I had not even
considered* the possibility of my own distress up until this point, despite—
in retrospect—there being an evident manifestation of its effects, albeit in
ways barely identifiable to me; especially without the rhetoric by which to
articulate it and reconcile myself with it.

This leads to an important point: if we are to advocate, as Dickson-Swift et
al. suggest, for "the acknowledgement of researchers undertaking emotion
work in research then we must also consider the types of support that may
need to be available to researchers" (73). This might include informal peer
support and mentoring, debriefing sessions with colleagues and/or formal
therapeutic supervision and counseling (Dickson-Swift et al 74). At the
very least, however, it should include an active and early discussion of the
issues related to conducting emotionally laden research, and the inclusion
of practices of self-care and self-preservation as part of the methodology
of the research project.

In spite of this, as Davison stresses, it is important to remember that there
is "no set of hard and fast rules for minimising researcher distress. There
are only guiding principles" (386). However, it would seem a significant
and crucial inroad to make to at least be able to, first and foremost,
acknowledge and accept that "[a]ll researchers experience intensities of
emotion" (Davison 389).

With this said, it is important to emphasise that reflexive orientation should never preclude the ethical obligations owed to participants by the (humanities-based) researcher of trauma. As Finlay rightfully points out:

> Taking the threatening path of personal disclosure, the researcher treads a cliff edge where it is all too easy to fall into an infinite regress of excessive self-analysis at the expense of focusing on the research participants. (531)

The extent to which a (humanities-based) trauma researcher commits to a reflexive orientation in their work therefore remains dependent on the decisive advantages of doing so. "Ultimately," says Finlay, "reflexivity should be "neither an opportunity to wallow in subjectivity nor permission to engage in legitimised emoting...Instead, with reflexive analysis, the self is exploited only while to do so remains purposeful" (542).

In the context of research relating to fatal mental health crisis interventions and the 'bearing witness' to personal trauma narratives, this argument extends even further to suggest that:

> [If] a researcher cannot give voice and validation to the kinds of emotions experienced during and in response to their research, their conceptual and critical analysis will be negatively affected. Debating this issue is crucial if we are to take such matters out from the level of theory into the reality of practice. (Davison 389)

Works Cited

Barnard, Marina. 2005. 'Discomforting research: Colliding moralities and looking for "truth" in a study of parental drug problems', *Sociology of Health & Illness* 27(1), pp. 1–19.

Behar, Ruth. 1996. *The Vulnerable Self: Anthropology that Breaks Your Heart*. Boston: Beacon.

Blood, R. Warwick, Jane Pirkis and Catherine Francis. 2004. 'News and social policy: Reporting of suicide and mental illness', *Agenda* 11(3), pp. 273–287.

Campbell, Rebecca. 2002. *Emotionally Involved: The Impact of Researching Rape*. New York: Routledge.

Connolly, Kate and Rosemary C. Reilly. 2007. 'Emergent issues when researching trauma: A confessional tale', *Qualitative Inquiry* 13(4), pp. 522–540.

Cutcliffe, John R. and Peter Goward. 2000. 'Mental health nurses and qualitative research methods: A mutual attraction?', *Journal of Advanced Nursing* 31(3), pp. 590–598.

Dart Centre for Journalism and Trauma. 2008. *News Media & Trauma* (DVD). Australasia.

Davison, Judy. 2004. 'Dilemmas in research: Issues of vulnerability and disempowerment for the social worker/researcher', *Journal of Social Work Practice* 18(3), pp. 379–393.

Dawes, James. 2007. *That the World May Know: Bearing Witness to Atrocity*. Cambridge, Mass.: Harvard University Press.

Denzin, Norman. 1984. *On Understanding Emotion*. San Francisco, CA: Jossey Bass.

Dickson-Swift, Virginia et al. 2009. 'Researching sensitive topics: Qualitative research as emotion work', *Qualitative Research* 9(1), pp. 61–79.

Dunkley, Jane and Thomas A. Whelan. 2006. 'Vicarious traumatisation: Current status and future directions', *British Journal of Guidance & Counselling* 34(1), pp. 107–116.

Figley, Charles. 1995. *Compassion Fatigue: Coping with Secondary Trauma Stress Disorder in Those Who Treat the Traumatized*. New York: Brunner/Mazel.

Fincham, Ben, Jonathan Scourfield and Susanne Langer. 2008. 'The impact of working with disturbing secondary data: Reading suicide files in a Coroner's office', *Qualitative Health Research* 18(6), pp. 853–862.

Finlay, Linda. 2002. '"Outing' the researcher: The provenance, process, and practice of reflexivity", *Qualitative Health Research* 12(4), pp. 531–545.

Foster, Kim, Margaret McAllister and Louise O'Brien. 2006. 'Extending the boundaries: Autoethnography as an emergent method in mental health nursing research', *International Journal of Mental Health Nursing* 15, pp. 44–53.

Grbich, Carol. 2004. *New Approaches in Social Research*. London: Sage Publications.

Gregory, David, Cynthia K. Russell and Linda R. Phillips. 1997. 'Beyond textual perfection: Transcribers as vulnerable persons', *Qualitative Health Research* 7(2), pp. 294–300.

Hesse, Amy. 2002. 'Secondary trauma: How working with trauma survivors affects therapists', *Clinical Social Work Journal* 30, pp. 293–309.

Holland, Kate. 2007. 'The epistemological bias of ethics review: Constraining mental health research', *Qualitative Inquiry* 13(6), pp. 895–913.

Howarth, Caroline, Juliet Foster and Nike Dorrer. 2004. 'Exploring the potential of the theory of social representations in community-based health research – and vice versa?', *Journal of Health Psychology* 9, pp. 229–243.

Kleinman, Sherryl and Martha A. Copp. 1993. *Emotions and Fieldwork.* Newbury Park, CA: Sage Publications.

Laub, Dori. 1992. 'Bearing witness or the vicissitudes of listening'. In Shoshana Felman and Dori Laub, eds. *Testimony: Crises of Witnessing in Literature, Psychoanalysis, and History.* London and New York: Routledge, pp. 57–74.

Liamputtong, Pranee. 2007. *Researching the Vulnerable: A Guide to Sensitive Research Methods.* London: Sage Publications.

McCann, I. Lisa and Laurie Anne Pearlman. 1990. 'Vicarious traumatization: A framework for understanding the psychological effects of working with victims', *Journal of Traumatic Stress* 3, pp. 131–149.

McCosker, Heather, Alan Barnard and Rod Gerber. 2001. 'Undertaking sensitive research: Issues and strategies for meeting the safety needs of all participants', *Forum: Qualitative Social Research* 2(1), http://www.qualitative-research.net/index.php/fqs /issue/view/26

Moran-Ellis, Jo. 1996. 'Close to home: The experience of researching child sexual abuse'. In Marianne Hester, Liz Kelly and Jill Radford, eds. *Women, Violence and Make Power: Feminist Activism, Research and Practice.* Philadelphia: Open University Press, pp. 176-197.

Morse, Janice M. and Carl Mitcham. 1997. 'Compathy: The contagion of physical distress', *Journal of Advanced Nursing* 26, pp. 649–657.

Nussbaum, Jon F. 1989. 'Directions for research within health communication', *Health Communication* 1(1), pp. 35–40.

Perlesz, Amaryll. 1999. 'Complex responses to trauma: Challenges in bearing witness', *Australian & New Zealand Journal of Family Therapy* 20(1), pp. 11–19.

Peterson, Debbie. 1999. *Encouraging Ethical and Non-Discriminatory Research with Mental Health Consumers: A Discussion Paper.* Wellington, New Zealand: Mental Health Commission.

Radstone, Susannah. 2007. 'Trauma theory: Contexts, politics, ethics', *Paragraph* 30(1), pp. 9–29.

Rager, Kathleen B. 2005. 'Self-care and the qualitative researcher: When collecting data can break your heart', *Educational Researcher* 34(4), pp. 23–27.

Sullivan, Kate. 1998. 'Managing the 'sensitive' interview: A personal account', *Nurse Researcher* 6(2), pp. 72–85.

REFUGEES, TRAUMA, GENDER AND RACISM

Professional and Ethical Issues in Reporting the Traumatic Testimony of Women Asylum Seekers

Pauline Diamond and Sallyanne Duncan

Introduction

Asylum seekers live on the margins of society, often with ambiguous legal status. Many are grieving, traumatised and otherwise distressed. As witnesses to war, torture and atrocity and having experienced loss and displacement, their exposure to trauma means they are likely to be among the most vulnerable people journalists encounter in their work. They may have reservations about speaking to the media for several reasons, which may include: language and cultural differences; previously experienced or perceived hostility from the host community (including negative portrayals of asylum seekers in the media); fear of jeopardising relationships with lawyers and immigration authorities by speaking out about their experiences; fear of repercussions for family and associates in their home countries; and the often painful nature of their personal reasons for seeking asylum. Additionally, refugees and asylum seekers are unlikely to have experience of dealing with the UK media and may not know what to expect from an encounter with a journalist.

The 1999 Immigration and Asylum Act introduced a system of dispersing asylum seekers to cities across the UK. As the only Scottish authority to sign up to the dispersal project, Glasgow agreed to host thousands of new refugees who began arriving in the city in 2000. The Scottish media, along with social services and support agencies, were un- or at least under-prepared for the new arrivals in terms of both resources and experience (Daghlian 2008).

An analysis of Scottish media coverage of asylum issues following the 2000 dispersal described the reporting as "increasingly negative, characterised by

stereotypes and a narrow focus on numbers and costs" (Irwin 2004). Researchers suggested a link between negative reporting and public hostility towards asylum seekers in Scotland—98% of the Scottish public rely on the media as their main source of information about asylum seekers and refugees (Oxfam Scotland 2007)—and stressed the impact of negative media coverage on asylum seekers' lives. The study shows the press tending to focus on the number of asylum seekers arriving in the city and the costs associated with hosting them. It concluded that a narrow set of themes recurred in Scottish press coverage of asylum, the most prominent of these being crime, cost to the taxpayer and the government's asylum policy (Oxfam Scotland 2007).

Asylum seekers' voices and personal experiences were 'lost' within the debate. Rather than using the refugees who had first-hand experience of fleeing their native country and of the UK asylum seeking process as primary sources the majority of sources quoted in articles were elite authority figures such as politicians, Government officials and police representatives who focused on policy announcements (Buchanan et al 2004; Irwin 2004; Smart et al 2005). Essentially, the effect was to "frame stories from a political perspective, thus presenting asylum as a social problem rather than as a human rights or humanitarian issue" (Irwin 2004: 5). Despite providing a balance to the more overtly negative representations of asylum seekers, these stories do not give space to the individual life stories of people seeking protection in the UK, thus failing to provide genuine insight into who asylum seekers are or any context as to why they have come to Scotland. Research into media coverage of asylum stresses the crucial role of these personal stories which detail the reasons why individuals flee their homes and seek asylum in the UK and are seen as "an important means of increasing understanding of how policies and attitudes affect real people" (Smart et al 2005). Indeed, only 22% of articles—across 50 UK newspapers monitored over a ten-week period in 2005—focused on individual refugees and asylum seekers. Such stories play an essential role in reframing asylum as a humanitarian issue and challenge media generated and media propagated myths about refugees and asylum seekers in the UK (Lewis 2006; Irwin 2004; Buchanan, Grillo & Threadgold 2004; Information Centre about Asylum Seekers and Refugees [ICAR] 2004).

Why women asylum seekers' voices matter

Women make up almost 40% of Glasgow's asylum seeker and refugee

population (COSLA 2007). Despite this ratio, which is fairly consistent across the UK, research suggests that women's experiences of asylum are under-represented in the UK media, being effectively "excluded from offering their testimony to reporters" (Buchanan, Grillo & Threadgold 2004: 34). Buchanan et al found an "almost exclusive reliance on male refugees as sources"—in 14 out of 182 print media articles—whereas female refugees were never the main source and were only quoted in two articles (Buchanan, Grillo & Threadgold 2004). As these figures reveal, it is rare for refugees of either sex to be given a voice in the UK press.

Refugee and asylum-seeking women often have different reasons from men for seeking sanctuary, for example gender-based persecution which may include sexual violence, forced marriage and honour crimes. The 1951 UN Convention on Refugees, established at a time when very few refugees were women, does not recognise gender-based persecution as a basis for seeking refugee status. For this reason, women often report a different experience of the asylum system as they may have particular needs based on their experience of gender-specific persecution in their home countries (ICAR 2008). ICAR stresses the importance of including refugee women in media coverage of asylum in the UK:

> The exclusion of women and children from articles about asylum seekers and refugees means that we are only hearing half the story of asylum... Yet the way in which women are treated in their countries of origin and the reasons behind their flight are incredibly important to our understanding of their needs once they arrive in Britain... It is therefore essential that their voice is heard in the public debate. (Buchanan, Grillo & Threadgold 2004: 35)

Having acknowledged the need to give women asylum seekers a voice it is important to recognise their specific vulnerability. In interviews with one of the authors of this article female refugees have testified to sexual violence, persecution, displacement, torture, shame, bereavement and trauma, making them highly exposed to routine reporting practices. Even where the journalist is consciously attempting to behave sensitively there are specific professional questions to address when interviewing survivors of such trauma. This article considers some of these ethical and practice issues by examining qualitative data gathered from a focus group consisting of refugee and asylum-seeking women in Glasgow, who had experience of being interviewed by the Scottish media. Thereafter, in-depth interviews were conducted with Scottish journalists, who have extensive experience of human rights reporting.

Communication issues in the interviewing process

> Unlike other relationships that have a purpose beyond themselves and are
> clearly delineated as such (dentist-patient, lawyer-client, teacher-student)
> the writer-subject relationship seems to depend for its life on a kind of
> fuzziness and murkiness, if not utter covertness of purpose. If everybody
> put his cards on the table, the game would be over. The journalist must do
> his work in a kind of deliberately induced state of moral anarchy.
> (Malcolm 2004: 142-143)

It would seem from Malcolm's statement that journalists are at an
advantage during the interview process, particularly when interviewing
members of the public with little media experience. While the journalist is
trained, skilled and practised at questioning, the interviewee generally has
far less experience of being questioned, lending the journalist the
advantage of control over the process. Moreover, the journalist seldom
discloses personal information while the subject in traumatic interviews
will be, to greater or lesser degrees, probed for intimate details of their
lives. Therefore, the interview can be deemed "an unequal transaction",
"an exploitative process", where journalists "pump people for information,
drain them emotionally and then discard them", and where the
"relationships which are invariably and inevitably lopsided" (Rafferty in
Smyth & Williamson 2004: 123; Malcolm 2004: 162).

Application of Western values and social norms by the journalist, even
sub-consciously, is likely to further undermine this unequal process,
leading to confused communication. For example, women from certain
cultures may have had infrequent opportunities to talk about themselves
and their lives and may feel uncomfortable doing so. It might be
unacceptable for women from some cultures to speak openly to a stranger,
as results from the focus group confirm. A Somalian woman explained:
"Third world women haven't had the chance to express themselves often.
Although some of us may be educated and speak and understand English,
we will often refer strangers to our husbands, as we are used to them
speaking on our behalf." She added that, as a Muslim, she has difficulties
talking to men she doesn't know and that she would be uncomfortable
with a male photographer. Several other women in the group agreed.

Indeed, for some refugee women, talking frankly about their personal
experiences may be foreign to their norms of communicating. They may
employ differing "levels of emotional openness" to the journalist, who
should attempt to appraise and value cultural differences in dealing with

emotion and distress (Richman 1998: 179-180). These cultural differences are evident from a statement by a Sudanese member of the focus group. "It is impolite for women from my culture to look a stranger directly in the eye. When talking to a journalist, I will often look down, away from the journalist's eyes. I do this to show respect and out of politeness but if the [Scottish] journalist doesn't know this then he might think I am telling lies because I'm not looking him in the eye."

Such cultural differences demonstrate the interpretative problems or misunderstandings that might arise if the journalist is under-prepared to meet a trauma survivor of a different culture to their own. The focus group was adamant that it is the journalist's responsibility to prepare for encounters where cultural and communication differences are likely to be present. One woman said: "Journalists need to educate themselves more about cultural differences." Another said: "Differences in cultural backgrounds should always be in the journalist's mind [when talking to refugees and asylum seekers] because this can make the journalist understand what is going on in the interview." Another said: "It is your role as a journalist to find out about other cultures and to be well prepared before doing the interview."

Language may also be an issue complicating the telling of an asylum seeker's story. On the part of the refugee, this is not just the challenge of speaking in a second language, but the inadequacy of words to describe the experience of persecution, suffering and loss. For the journalist, it is the test of fully comprehending the refugee's use of language and listening carefully enough to pick up on nuances. By adopting an engaged listening the journalist may be better able to discern the implicit meaning and emotion behind the words spoken. This raises complications for journalists, trained to report faithfully the words spoken by subjects and to avoid inferring meaning or attributing their own meaning to others' words. As Alia (2004) suggests, in traumatic reporting the superficial meaning of spoken words may not accurately convey an interviewee's story, thus the journalist should be alert to the poverty of language at this point in their interviewee's life. This is expected to be even more heightened where the journalist and the interviewee are from different cultures.

While a more sophisticated understanding of different cultures could enhance encounters between reporters and interviewees, it is unlikely that busy newsroom reporters will have the time for such research prior to each encounter. Nonetheless, the focus group results suggest that this preparation,

when possible, combined with an engaged, active listening to survivors of trauma may make the interviewee feel heard in a fresh way.

Being alert to and prepared for these differences is another element of an active, engaged listening, a skill that is particularly relevant to traumatic reporting. Trauma stories are neither straightforward narratives nor are they formed by an uncomplicated series of facts (Felman & Laub 1992). The story being told is one of deep pain and requires the journalist's attention. This was supported by the focus group who all agreed with one woman's assertion that "it is important to feel that the journalist is really listening". A disengaged listening or listening only for quotable statements may undermine the trust relationship necessary for effective reporting. Active listening that pays attention to the way the story is told, the sentence formation, the subtexts of gaps, silences and gestures, the shifts in meaning and tone, avoiding taking opening statements at face value, and not rushing the interview (Cote & Simpson 2000; Alia 2004) plus a cultural awareness would result in more effective and responsible reporting. However, one member of the focus group raised the worrying issue of professional indifference. "Journalists are not always enthusiastic about talking to us, some of them you feel are just doing their job and talking to us is not a part of it they enjoy very much."

This disengaged listening and professional indifference may also hinder the journalist's purpose, which is to get the story. Research suggests that trauma disrupts patterns of memory, complicating the interviewee's ability to answer questions and give a coherent account of events (Cubilie 2005; Ochberg 1998; Felman & Laub 1992). Interviewees may either be unable to suppress painful memories or may forget the original traumatic events, shutting down certain memories in an attempt to avoid being overwhelmed by the past. Equally, the re-telling of their experience can constitute a form of healing, with the interviewee piecing together their story as they tell it.

In fact, by describing, or testifying to, historic events, the interviewee effectively acts as a witness to those events, and this may alter the dynamic between the journalist and the interviewee. While recording the refugee's story or testimony, the journalist also becomes a witness; a witness to the witness. In this role, the ethical issues relating to engaged listening and potential harm to the interviewee and the ensuing duty of care the journalist may choose to assume towards the interview subject need to be considered.

Journalists should be aware of "hazards of listening", that in questioning and listening to the trauma survivor's testimony the interviewer acts as a vital "holding presence". In this respect, Laub states: "Bearing witness to a trauma is, in fact, a process that includes the listener. Testimonies are not monologues; they cannot take place in solitude" (Felman & Laub 1992: 70). Indeed, bearing witness demands listening well, so as not to re-traumatise the testifier, as well as the ability of the listener – or journalist – to cope with what's being said. As Laub notes the listener/journalist "through his very listening" comes to "partially experience the trauma in himself" (57).

But is it ethical for journalists to use personal narratives of suffering, trauma and loss to illustrate global conflicts, even if they partially experience the trauma? When asked about this, members of the focus group reasserted their belief in the importance of reporting the truth of their experiences. One said: "I want people to know what we feel about asylum and racism in Scotland." Another added: "Even if the journalist does not seem genuine, asylum seekers should think, I'm not doing this [telling my story] for this journalist, I'm doing it for everyone else that's out there seeking asylum in Scotland. You have to get the message out there any way you can."

For these women, testifying publicly seems to be in part a political act, motivated by a sense of responsibility to the wider refugee and asylum community. This may be the journalist's purpose too but they may also wish to bring a human face to a complex issue or to use a personal tragedy as a form of entertainment or for the purposes of commercial productivity. Each has different motivations. Asylum seekers seem to be concerned with broadcasting the 'truth' of their experience and countering the negative, hostile and inaccurate media coverage of asylum seekers which, they report, impacts directly on their everyday lives in Scotland. Journalists are likely to be more concerned with getting a good story that will increase their publication's circulation or audience figures.

One refugee from the focus group said: "Some people say journalists are using us to tell stories and sell newspapers but in a way we used them. We couldn't have raised awareness [about asylum] and got our message out without the press. I'm really grateful to journalists for doing this for us. It's important to get different messages about asylum out there."

Revisiting trauma with vulnerable interviewees

Refugees' and asylum seekers' exposure to trauma in the form of war, torture, displacement and loss, heightens their vulnerability during the media interview. Therefore, journalists need to take care. Felman notes:

> The fear that fate will strike again is crucial to the memory of trauma, and to the inability to talk about it. On breaking the internal silence, the holocaust from which one has been hiding may come to life once more and be re-lived; only this time around, one might not be spared nor have the power to endure. The act of retelling might itself become severely re-traumatising if the price of speaking is re-living: not relief, but further re-traumatisation. Moreover, if one talks about the trauma without being truly heard or truly listened to, the telling might itself be lived as a return of the trauma – a re-experiencing of the event itself. (Felman & Laub, 1992: 67)

The fear of re-living the original trauma in interviews with journalists is a very real concern for the refugee women consulted in the focus group. As one Somali said: "It's not an easy thing to talk to the press. It's not easy to tell our stories because every time we tell them we remember them. We go back to that memory and back to how it felt. That's the worst thing—what happened to us will never go away. It is scarred on our hearts forever."

Interviewees may be suffering from post traumatic stress disorder (PTSD), a condition that is particularly common among the adult refugee and asylum-seeking population in western countries (Fazel et al 2005). Symptoms include flashbacks to the traumatic event, nightmares, extreme anxiety as well as identity disorders, guilt, low self esteem and—especially relevant to journalists—a reluctance to talk about the original traumatic event (Gorman 2003). When interviewing refugees and asylum seekers, particularly women, for whom rape and sexual violence is often a factor in the trauma experienced, journalists should be aware that PTSD might be present. However, it is unlikely that journalists generally would have the requisite knowledge to recognise the signs and respond to them. Also, not all refugees may be suffering from PTSD but they may still be vulnerable. Consequently, there is a danger that in looking for such signs and failing to find them the journalist assumes the interviewee is more emotionally robust than they actually are. Thus, while they may be attempting to avoid harming the interviewee they could inadvertently do just that. However, one journalist, who has interviewed refugee women in the Goma camp in the Republic of Congo, was conscious of such sensitivities and recognised

a duty of care towards interviewees, despite being "quite hard line" in her pursuit of a story. "People wouldn't open up if it wasn't obvious that you care."

Refugees and asylum seekers may have been subject to torture in their home countries and during flight. As a result, interviewees who have survived torture may be particularly disinclined to discuss their personal story and reasons for seeking asylum. One member of the focus group said that discussing her personal experience with a stranger was too painful because "it hurts too much to talk about it". This "silencing" of survivors is one of the most invidious consequences of torture (Stevenson & Rall 2007) and one which journalists are unlikely to have experienced elsewhere in their careers, unless they specialise in conflict reporting. Again, there is potential for the journalist to do harm because of their lack of understanding. One journalist, who has interviewed refugee women in the Republic of Congo, noted the need for consideration of vulnerable interviewees' emotional and physical wellbeing: "You need to be sensitive but many of the women I interviewed said that talking about their experiences is cathartic." For example, several members of the focus group reported a strong desire to speak out publicly about the personal injustices and humiliations they had endured in the process of seeking asylum. As one woman from the Ivory Coast said: "I want people to know what we've been through. I want to shout it out everywhere." While the group agreed on the importance of making personal stories of seeking asylum public, most said they preferred to discuss the issues that affect them rather than the details of their personal stories. "I don't like to talk about my own experience but as an [asylum] activist I can talk about issues that affect refugees and asylum seekers, for example racism, housing, gender issues and the asylum system."

However, a reluctance to talk about the parts of their story that the journalist wishes to pursue i.e. their personal traumatic experience, could mean that any attempts by the journalist to persuade the interviewee could be seen as intrusive. Because of the intimate nature of suffering and pain, reporting suffering is necessarily intrusive (Sanders 2003). Therefore, negotiating the ground between encouraging an interviewee to discuss traumatic events while respecting their reluctance to revisit the original trauma is a key ethical dilemma for journalists reporting refugee and asylum seekers' stories. One journalist said she would not shy away from asking difficult and probing questions but would not traumatise an interviewee to get a good story. "I would never force someone to talk

about something that they don't want to talk about. I might tell them why I think it would be valuable for that experience to be shared with people, but that's a different thing." Data collected from the focus group reveals an agreement among the refugee women that personal stories of asylum do need to be told publicly, however the group was uncomfortable with journalists persuading women to talk when they had shown reluctance to open up or had already declined to discuss an issue. "Journalists can always ask women to talk because some stories have to be told. But journalists have to know when to stop, when to accept no for an answer." However, determining the point when encouragement becomes coercion is a tricky ethical assessment for a journalist in the midst of a traumatic interview, particularly if they are unfamiliar with indicators of trauma-induced stress other than generally recognised signs of distress and therefore may have difficulty ascertaining whether they are traumatising the interviewee or not.

Equally though, journalists need to be aware of "good taste censorship" and be willing to "show and disturb" or they could be accused of being indifferent rather than considerate (Bell in Kieran 1998). One journalist interviewed for this study said she is unlikely to refrain from asking questions that could be painful for traumatised interviewees, believing that sometimes journalists "protect themselves when they think they are protecting others [by avoiding asking difficult questions]".

Once the interview is over the vulnerable interviewee is left alone to deal with any potential psychological and emotional consequences of discussing the original trauma. In this situation journalists have a duty to minimise harm but should be wary of developing a therapeutic relationship with their interviewees even though as Rafferty notes, the interviewee can be left with "unmanageable feelings when the journalist walks away" (Rafferty in Smyth & Williamson 2004: 135).

Refugees and asylum seekers are unusual among trauma survivors in that they have often had to tell their stories repeatedly in the process of seeking sanctuary. They will have been asked by lawyers, immigration officials and social services caseworkers many times for details of their 'story': the particulars of torture survived, the intimacies of losses sustained. To be asked once more for details by a journalist may be seen as an unnecessary and unwanted occasion to revisit the site of their suffering. The journalist may also be seen as another member of a hostile establishment, and therefore, someone they are unlikely to trust initially, and the interview

process a continuation of the humiliation of having to repeatedly detail one's losses. A concern raised by the focus group was the fear that revealing personal details to the media may jeopardise their claim for asylum in the UK or that the information may reach back to their country of origin. "Talking to the media is a big risk for asylum seekers as it could affect your case [claim for asylum]. When I first started talking to journalists my mum said don't do it. She said it will affect your claim; they might send you back. I said fine, let them send me back. This is too important. When we started doing this [talking to the media] more and more people did it too. They saw us doing it and saw that nothing bad happened to us. But I think it is harder for older people, especially women. My mum would never tell you her story even if you paid her a million pounds." This recognition of the journalist's inability to control the consequences of their reporting after publication, no matter how unrealistic that expectation is, will have an adverse effect on the trust relationship between the interviewee and the journalist.

A psychological study of refugees in western countries notes that although some may have attained a degree of security in the host country, their suffering and vulnerability is ongoing. According to Richman:

> Most refugees are not in a 'post traumatic' situation, since they continue to endure a variety of distressing experiences. Nor can assumptions be made about which factors are most painful for them to deal with: the experiences of detention and torture may have less salience for individuals than other experiences such as loss and bereavement, inability to be at their parents' funerals, separation from children or other relatives, deaths of comrades, the political situation in their country of origin and the impunity of their oppressors. (1998: 179)

This was confirmed by comments from the focus group. One woman said: "Refugees are generally very vulnerable people. I'm still frightened after being here legally for three years. The future feels very insecure and I often experience racism. Without full integration refugees and asylum seekers will never feel safe in Scotland."

Responsibility and compassion

The journalist interviewing the vulnerable and traumatised subject has a different relationship to that person than the viewer or reader: journalists and their subjects are connected by "intimate communication" and differing and often conflicting responsibilities (Cote & Simpson 2000: 86).

By adding in the emotive nature of reporting on traumatised individuals like refugees the process emerges as complex and volatile. Further complication is added for the journalist in deciding on a hierarchy of moral claimants, who has the greater claim and which responsibility should the journalist prioritise over others. For one of the journalists interviewed for this study the primary responsibility is to the story, and thus to her readers. She said: "I'm a writer, not a social worker. I'm quite hard line. I write for my readers, not the people I am interviewing." She believes interviewees understand this. Perhaps, but where journalists are dealing with interviewees whose fluency in English, and indeed in the methods of Western media, may be limited surely there must be a more pressing moral responsibility to clarify this with the subjects of the story.

This view does not appear to sit well with compassion. Compassion necessitates emotional involvement with another's pain and is a notion that many journalists try to avoid, fearing that it will compromise their objectivity, despite, as Smith notes, "widespread doubts as to whether it [objectivity] is achievable or even desirable" (2008: 214). From the evidence gathered in this study it would seem that it is possible for the journalist and interviewee to be connected emotionally by intimate communication and still present an account that, as Kieran asserts, encourages "the audience's understanding of an event via truth-promoting methods" (1998: 34).

The journalists admitted feelings of compassion towards their vulnerable and traumatised interviewees. For example, one said: "You have to feel a degree of empathy to portray their story well, and to remain human." Another said: "I'm not sure I could do a good interview unless I felt empathy and that applies to ordinary people, celebrities and vulnerable people. That doesn't mean that I always agree with or believe everything that they tell me, but for the kind of interviews I tend to write [reasonably in-depth and personal] it's vital that I make some kind of effort to connect with my interviewee. I think my mission as a journalist would be infinitely more complicated if I didn't ever feel either of those things." Another said: "Objectivity is not a higher form. It is much more difficult to empathise and to understand the emotional impact of what's being said."

If we accept that journalism's purpose is to inform, truthfully, then the question for ethically concerned reporters may be whether compassion will interfere with the achievement of this goal. To successfully combine empathy for vulnerable subjects with scrupulous attention to the facts the

responsible journalist must make an ethical commitment to both the means and the ends of the project; to both the people whose stories are being told and the public to whom journalists owe the truth.

Empowering the interviewee through consent and sharing control

Journalism can be a high-pressure profession and the demands of 'getting the story' may conflict with the time and attention required to ascertain whether an interviewee fully understands the implications of discussing their personal life with a reporter. When interviewing traumatised individuals there is an ethical imperative on the journalist to seek informed consent from the interviewee and to ensure that they understand what contact with a journalist means, if harm is to be avoided. In practice, this can range from declaring their status as journalists as part of their preamble to seeking an interview through to having an interviewee sign a written consent form. However, by making clear the potential consequences of the interview prior to its taking place, the journalist exposes himself to the risk that the interviewee withholds consent. But if the journalist working on a traumatic story is to adhere to a key tenet of sensitive reporting—respect for their interviewee's humanity—then this is a necessary risk. They must be aware of the impact they have on the moral claimants in their stories.

One journalist interviewed for this study said: "When interviewing particularly vulnerable women it is even more important than normal to ensure they understand what they are consenting to. It's also important that they understand their details could be published online [to a wider audience and potentially available in their country of origin]. Where there is any concern, err on the side of caution, for example, by anonymising quotes." Another said: "I think it's vital that you make sure that whoever it is that you're interviewing understands that what they say is going to appear in print. This is true for anyone who isn't in the public eye and doing interviews for publicity but it's particularly true for people who are vulnerable and who are perhaps involved in ongoing legal negotiations or housing wrangles. What might make a good story might also put them in a very difficult situation and for me I always want to be aware that they know what the impact might be of what they're telling me".

Entering into this type of negotiation with an interviewee subverts the traditional paradigm of journalistic power and the interviewee's

corresponding acquiescence. Explaining the journalistic objective in terms of outlining, before the interview, the areas to be discussed and the intended focus of the eventual article, is especially important for refugee and asylum-seeking interviewees who are unlikely to be familiar with the UK press and who do not share the same cultural references as the journalist. This openness is a form of sharing control with the interview subject. It reinstates an element of control to the interviewee, who through their trauma has lost control of other aspects of their lives. This is especially true for asylum seekers for whom forced exile, displacement and alienation in a foreign country are by definition disempowering experiences.

Conclusion

Reporting individual refugee and asylum seekers' stories is an important though often absent element of fair and accurate coverage of asylum issues. However, reporting the testimony of individuals who have experienced trauma, loss and displacement raises several ethical issues for journalists.

An unreflective interview technique may cause anguish to survivors of trauma and persecution, while language and cultural differences may present additional complications. These issues demand awareness on the part of the journalist of the individual's vulnerability and raise the question of whether journalists have a duty of care towards their interviewees. This study suggests that journalists do in fact recognise this duty and that they employ specific strategies in its execution. The research also suggests that journalists feel able to recognise an ethical imperative to avoid inflicting harm on their interview subjects and to treat them with compassion, while simultaneously recognising and fulfilling their duty to their readers and to the story itself.

The research identified several professional and ethical issues involved in recording the testimony of refugee and asylum-seeking women, including:

- An ethical imperative to secure informed consent from the vulnerable interviewee prior to the commencement of the interview;
- A responsibility to minimise the hazards and risk of harm to the vulnerable interviewee when asking for details of particularly traumatic events and memories;

- A willingness to negotiate with sensitivity the complex ground between seeking information from vulnerable interviewees and intrusion into grief and suffering;
- An acceptance by the journalist that it is their responsibility to prepare for encounters where cultural and communication differences are likely to be present;
- An acknowledgement that disengaged listening or listening only for quotable statements may be ethically dubious when dealing with vulnerable interviewees;
- A recognition of the interviewee's humanity and particular needs as a trauma survivor, in particular the need to be listened to as a human being who has experienced great suffering and not just as a 'subject' for a newspaper story;
- An awareness of the potential for the interviewee to suffer from PTSD or related conditions such that they may be emotionally fragile;
- A commitment to accuracy in recording the details of the testimony in the understanding that through the interview, the individual may be in the process of reconstructing their identity and moving through the devastation of trauma.

The research also suggested a willingness on the part of refugee and asylum-seeking women to discuss their personal stories with journalists who show an awareness of the ethical issues noted above. Broadcasting their reasons for seeking asylum and attempting to engender a greater and more nuanced understanding of asylum among the UK public was a prime motivator for these women in the focus group.

A concern that personalised news stories may invite voyeurism and passivity on the part of the reader raises an ethical issue about the presentation of details of personal suffering as 'entertainment'. While reporting the asylum seeker's story, the journalist may choose to locate the personal narrative clearly within the political and social context that has given rise to the individual's pursuit of protection from persecution. The presentation of the asylum seeker's story in this manner may avoid the spectatorship associated with personal narratives in the press and may enable a more ethical presentation of the intimate details of an individual's distress.

By considering some of these ethical issues involved in reporting the testimony of refugee and asylum-seeking women, journalists may be able to contribute more fully to the knowledge-enabling project of journalism

and to a more fair and accurate representation of asylum issues in the media.

Works cited

Alia, Valerie. 2004. *Media Ethics and Social Change*. Edinburgh: Edinburgh University Press.

Bell, Martin. 1998. 'The journalism of attachment'. In Matthew Kieran, ed. *Media Ethics*. London and New York: Routledge, pp. 12-22.

Buchanan, Sarah, Bethan Grillo and Terry Threadgold. 2003. 'What's the story? Media coverage of refugees and asylum seekers in the UK, 2003', *Article 19*,
www.article19.org/search-
results/index.html?freetext=What's+the+story%3F+Media+coverage+
of+refugees+and+asylum+seekers+in+the+UK%2C+2003

COSLA Strategic Migration Partnership. 2007. 'Asylum and Migration Statistics', http://www.asylumscotland.org.uk/asylumstatistics.php

Cote, William and Roger Simpson. 2000. *Covering Violence: An Ethical Guide to Reporting about Victims and Trauma*. New York: Columbia University Press.

Cubilie, Anne. 2005. *Women Witnessing Terror: Testimony and the Cultural Politics of Human Rights*. New York: Fordham University Press.

Dahlgren, P. and C. Sparks, eds. 1992. *Journalism and Popular Culture*. London: Sage Publications.

Fazel et al. 2005. 'Prevalence of serious mental disorders in 7000 refugees resettled in western countries: A systematic review', *The Lancet* 365.9467, pp. 1309-1314.

Felman, Shoshana and Dori Laub. 1992. *Testimony: Crises of Witnessing in Literature, Psychoanalysis and History*. London and New York: Routledge.

Gorman, Jane. 2003. *Understanding Post-Traumatic Stress Disorder*. London: Mind.

Information Centre about Asylum and Refugees (ICAR). 2004. 'Media image, community impact: Assessing the impact of media and political images of refugees and asylum seekers on community relations in London, 2004.'
www.london.gov.uk/major/refugees /docs/mici_exec_summary.pdf

—. 2008. 'Women refugees and asylum seekers in the UK, 2008.' http://www.icar.org.uk/briefings_womens

Irwin, Andrea. 2004. *Asylum and the Media in Scotland: A Report on the*

Portrayal of Asylum in the Scottish Media. Oxfam, Scotland and Glasgow: Caledonian University.

Kieran, Matthew, ed. 1998. *Media Ethics.* London and New York: Routledge.

Lewis, Miranda. 2006. 'Warm welcome? Understanding public attitudes to asylum seekers in Scotland', Institute for Public Policy Research, www.ippr.org

Malcolm, Janet. 2004. *The Journalist and the Murderer.* London: Granta.

Ochberg, Frank. 1998. *Post-Traumatic Therapy and Victims of Violence.* New York: Brunner/Mazel.

Oxfam Scotland. 2007. 'Fair play: Refugees and asylum seekers in Scotland: A guide for journalists', *Forced Migration Online: A World of Information on Human Displacement,*
http://repository.forcedmigration.org/show_metadata.jsp?pid=fmo:5447

Rafferty, Jean. 2004. 'Interviewing: The unspoken compact'. In Maria Smyth and Emma Williamson, eds. *Researchers and Their Subjects: Ethics, Power, Knowledge and Consent.* Bristol: Policy Press, pp 123-135.

Richman, N. 1998. 'Looking before and after: Refugees and asylum seekers in the West'. In P. Bracken and C. Petty, eds. *Rethinking the Trauma of War.* London: Free Association Books, pp 179-180.

Sanders, Karen. 2003. *Ethics and Journalism.* London: Sage.

Smart, Kate et al. 2005. *Reporting Asylum: The UK Press and the Effectiveness of PCC Guidelines,* Information Centre about Asylum and Refugees (ICAR).

Smith, Anthony, ed. 1980. *Newspapers and Democracy: International Essays on a Changing Form.* London: MIT Press.

Smith, Ron F. 2008. *Ethics in Journalism,* Oxford: Blackwell.

Stevenson, K. and J. Rall. 2007. 'Transforming the trauma of torture, flight and resettlement'. In M. Bussey and J. Wise, *Trauma Transformed: An Empowerment Response.* New York: Columbia University Press, pp 240-241.

TOO DARK, TOO TALL, TOO SOMETHING: NEW RACISM IN AUSTRALIAN SCHOOLS

ANNE HARRIS

Introduction

Australian schools are failing our Sudanese students from refugee backgrounds. Not just linguistically, but academically and socially as well. This essay examines some experiences of Sudanese young women in schools, and is drawn from my doctoral research entitled *Cross-Marked: Sudanese Young Women Talk Education*, which suggests documentary film as an effective arts-based educational tool for both research and the classroom. The participants recount past and present traumas associated with their refugee journeys, foregrounding experiences of racism, and their commentaries show unequivocally that Australian schools, despite sometimes noble efforts to support them, are largely re-traumatising these newest young Australians. In this essay I will highlight the experiences of two of my co-participants: Nyadol Nyuon and Achol Baroch.

From one extreme to another

Nyadol Nyuon is a 21-year old Sudanese woman enrolled in a Bachelor of Arts degree at Victoria University. Despite arriving in Australia mid-year-eleven, Nyadol went on to graduate with a 67 ENTER score, higher than most of her Sudanese peers—indeed, higher than many of her Australian counterparts. She has successfully navigated the second year of her degree, but her overwhelming feeling about high school is one of failure. She was told by her teachers, despite English language skills which exceeded many of her Australian classmates, that she could not enrol in mainstream English, and therefore she completed the ESL stream. Her dream is to study Law, but she was fervently discouraged from this by her teachers. Her presence in the BA program is to her a compromise, but she will complete it and then attempt to transfer into Law. She is acutely aware of time going by, but she works hard and remains ambitious. Despite this, she

wanted to repeat her VCE primarily to 'prove her teachers wrong', but her mother's advice compelled her to go on to university and let the past go.

> I was very upset when I went to school sometimes, because I was constantly being put into categories that I did not think I fit in. They would think I'm traumatised, I'm a refugee, I'm a victim. And with all the best intentions that they had, it was almost as though I was being vilified for something – of course I'm a refugee, of course I've gone through these experiences. But one thing they failed to recognise in me is that I'm here in Australia now, and what you should be noticing now is not so much what I've suffered and what I've gone through and that I'm a refugee and I'm traumatised, it's the strength and the resilience that a lot of refugee people have. You can feel sympathy for me, but I really don't need that, and I think a lot of refugee people don't need that.

On the other end of the spectrum, Achol Baroch had only one dream when she arrived in this country 3 years ago: to attend an Australian high school. She attended language school for one year. All of her friends and relatives then moved on to high school, but Achol was assessed by her teachers as having insufficient language skills to enrol, and was therefore streamed into a TAFE language class, where she has floundered for 2 years. She feels that the other students at TAFE are older, know where they are headed, and that they have little in common. Achol believes the ESL class she attends has not been helpful with language acquisition, and she often doesn't go. She wants to be an actress, and would rather focus on trying to get auditions now instead of going to school. In December 2008, she gave birth to her first child, and hopes one day to go back to school but doesn't know when.

> If I say I want to go to high school they be like, 'If you go to high school what you gonna do? You can't read. If you can't read, why you going to high school?' I was like, 'Why you guys telling me I can't read? If I go there I can find help.' They're like, 'Nah, your chances are not good, you can't go to high school.' They never gave me a chance to go to high school in Australia and that really hurt, you know ... I was like 'okay' because I don't have a chance anyway.

These two young women—both vibrant, ambitious and eager to fit into Australian society—represent the diversity of Sudanese former refugees in Australian schools. They have both been let down by the education system, and have both in different ways been largely left to their own devices. Someone like Nyadol—with consistent prior education, good English skills, and strong family support—will succeed despite the school's underestimation of her potential. For Achol—with almost no

prior schooling, poor English skills and few family or financial resources—the school's underestimation of her *social* needs of school have been devastating. Both stories highlight the desperate need of former refugees in schools far beyond language. Each has made the point that no one took the time to talk to them, to assess them properly, or to assist them in making lasting and supportive relationships within the school system. The challenges facing students from refugee backgrounds are multitude, and cannot be reduced to a need for language, although they often are in funding and educational circles. While language acquisition is crucial to any integration process, this is not the only—or even the most daunting—obstacle the young women in my study have identified. Both young women have identified ways in which film and other arts-based tools can be used to their advantage in educational contexts.

Calling it like it is: When words are not enough

My research consists of six short ethnographic documentary films, co-created with twenty one Sudanese-Australian young women from Melbourne. The films are intended to give them an alternative space to discuss what they have experienced, what could be improved in schools, and what advice they can pass on to other young women from refugee backgrounds. While the films have an education focus, the participants have talked about a multitude of related topics, including: work, gender, the media, and the alternative places where much of their language acquisition has occurred: informally with friends and relatives, in the community, from movies, music and the internet. Clearly, education goes far beyond what happens in classrooms and in the schoolyard.

This essay asserts that, while language needs are identified by state and federal funding bodies, other tools for integration remain largely overlooked and underfunded. In addition to my research, I work part time in an all-girls Catholic secondary school in Melbourne's multicultural western suburbs, where I have worked for the past five years. Our school is not unique in its struggle to meet the needs of our African students, and where our African students struggle to meet the needs of the school. Over the past three years we have battled to find more funding for language assistance, but we have also begun to realise that these students need more than just language. As a researcher, I have met secondary school educators and administrators who are, likewise, struggling to come to terms with these students. Teachers and principals speak of difficulties with attendance, behaviour management, homework, and segregation or conflict

in the schoolyard. Teachers are overwhelmed with the demands of assisting struggling students in capacity classrooms, of insufficient time, of lack of ESL knowledge, of the students' academic conceptual deficits. There is simply not enough time to give *enough* support. As a result, these students are sometimes streamed *out of,* (or into!) mainstream classes inappropriately, are inadequately advised about pathways for further study, and as a result feel alienated at school. But perhaps most importantly, racism—both overt and covert—adds to their disconnection.

Students in this study have reported experiencing verbal and psychological racism on a regular basis, but it is hard for them to prove. We know that 'verbal and psychological abuse as a devastating form of racism' (Ambler, 8-11; Peacock and Albert, 11-16) is alive and well in schools not only in Australia but internationally. Achol, Nyadol and the other 19 co-participants *all* reported experiencing verbal and psychological abuse including subjugation to the terms or phrases 'monkey', 'nigger', 'go back to the jungle', 'go home', and 'black bitch.' All participants expressed the negative effects of these experiences, which were exacerbated by school staff who regularly denied, ignored, or avoided dealing with the attacks. In some instances the victims were punished instead. Kumashiro (2000) tells us that "educators and others need to examine not only how some groups and identities are Othered, that is, marginalised, denigrated, violated in society, but also how some groups are favoured, normalised, privileged, as well as how this dual process is legitimised and maintained by social structures and competing ideologies" (Kumashiro, 35-36). Navigating classmates' racism is one matter, but unresponsive teachers and administrators has had a greater negative impact according to participants' commentaries. With their involvement in creating short documentaries about their experiences, the participants in *Cross-Marked* report feeling 'stronger' and 'happier' to have someone listen to their stories, and it has provoked advice from them concerning improvements in schools. Achol's most important suggestion involves the use of film or audio recordings of lessons, which may be played back by new students from non-English-speaking backgrounds struggling in Australian schools.

However, racism is not the only obstacle confronting students from refugee backgrounds. These young people sometimes have inadequate support at home for either the demands of homework or the circuitous Australian school system; their parents often have little schooling in a vastly different cultural context, and these students can be confused about where to look for assistance. At times they experience conflict between

home duties versus school requirements. If they are to invest sufficient time in studying as their teachers demand, they sometimes risk being perceived as threatening the home culture, rejecting traditional obligations, or becoming 'too Australian'. Simultaneously, students like Nyadol can be framed at school by a deficit model simply by virtue of their refugee backgrounds, and feel—as they repeatedly say in their films— underestimated by their teachers and peers.

Underestimating and overestimating: The double bind

On the one hand, students newly-arriving from refugee experiences are under-funded by the Department of Education ESL guidelines, which has remained relatively 'unchanged since 1983, and was not designed for' students with severely interrupted schooling (ACTA, 3). 'Students are entitled to stay up to 12 months in the ESL New Arrivals Program (NAP), although further Commonwealth funding is not provided after the initial six months' (Couch & Olliff, 1). Even twelve months is grossly inadequate for many former refugees beginning English-language learning for the first time.

The most needy of these students—like Achol—are floundering as they struggle to remain engaged with the school system at all; insufficient English language support means they are unequipped to thrive in the same courses of their Australian-born peers, which is well-documented in recent research (Cassity and Gow 2005; CMY 2006). Achol is aware of her severe language needs, but identifies school as a place of social connectedness. But government funding and schools are all severely overstretched, and while they often share Achol's view of the role of school, they are at pains to be able to respond to the need. Increasingly, young people like Achol are dropping through educational—and social— cracks, suggesting long term concerns for successful integration in Australian society. Achol feels that her dream has ended, and she is still just 18. As she describes it:

> If you know me, and I can't read, you're supposed to help me. Hardest thing is…teacher not listening to me. If I'm asking a question, nobody gonna come there…and if every month they gonna try to tell me 'pick your level up', that really piss me off! How (am) I gonna pick my level up? I just been here three years, you know, and I never learn English before in my life. And how I gonna pick it up? It's not like a paper or books or … it's not that easy!

Achol's story highlights a number of problems for former refugees and their teachers. Was the language centre remiss in streaming Achol to TAFE? Should they have given her the chance she so badly wanted? If she had been allowed to enrol in a local high school, where *would* she have found the language help she insists she could have found?

The fact is that Achol wasn't given the chance, and this bitter disappointment—along with her poor English skills—holds her back more than anything. Ambler (1997), Delpit (1995) and Tirabo (2001), in researching Canadian Aboriginal students' academic performance, have documented the powerful impact of low expectations of marginalised students, creating a 'self-fulfilling prophecy' in students' failure rates. For Achol, the language centre's lack of confidence in her abilities ignores other non-language based needs: to fit in, to have a chance—even if that chance ends in what we might consider academic failure. Achol never mentioned graduating from high school, or getting high marks; she simply dreamt of attending like everybody else. By denying her this possibility, the education system has deprived her of the opportunity to 'construct her identity' like her peers. It ignores the socialisation function of school, the community-building that occurs here, and the cultural performance space that offers rehearsal for 'the outside world'.

Achol's disengagement from her language centre peers is perhaps a more damaging blow than slow language acquisition, and for Sudanese young women, the isolation appears to be more severe than for their male counterparts. Achol began with a ready-made peer group which offered support and informal participatory mutual learning. Once that was removed, Achol has struggled to find 'her place' here. Powerfully, Achol has named her new baby Loner because, as she says, "she will always know what it's like to be alone."

> I was alone all this time. I'm doing everything by myself you know, nobody was there for me up to now. But I think it's a good name for her, you know. She'll understand what it means to be lonely. All the time to be alone without nobody's help and no support. I came to Australia. Other people dream to come here, and some people they don't appreciate it, but I do. All these dramas going on, but here is more safe, you get whatever you're looking for, opportunities, everything.

Achol's story also represents both the resilient optimism of many in the former refugee community, but also the burden on schools of trying to integrate students with unprecedented low levels of literacy. The challenges to schools of this kind of service delivery are well-known, and

widely discussed in educationalist circles. Solutions are few, but schools are trying. I suggest, however, that we are not trying hard enough, quickly enough, in schools where a combination of low literacy and stark cultural divides are creating what some believe is a new face of racism. We must tackle the problem of racism 'head on' (Brough et al, 193), and we must begin to recognise the many necessary reasons why even academically severely challenged young people need to be in school. I urge teachers to renew their commitment to their new arrival students, and more than anything to take the time to dialogue with their students—the best way to assess each child's individual abilities and obstacles. Freire told us over 30 years ago that dialogue is the key to creating education that is 'the practice of freedom' and not the practice of 'domination' (Freire, 81), and it is the key to recognising the individuality of former refugee students and of meeting the diversity of those needs.

There is a second side to the invisible segregation that is occurring in Australian secondary schools. Nyadol Nyuon and others like her—those who are excelling academically—talk about an emerging 'glass ceiling' for former refugees, not only in schools but in the workplace as well. When Nyadol arrived her mother brought with them meticulous records from her school in the Kakuma refugee camp in Kenya. Both Nyadol's spoken and written English is articulate and was – even at that time – up to the standard of her peers. Even her ESL teacher admitted that Nyadol should not be in the ESL class. And, yet, when she enrolled school administrators would not allow her to attend the mainstream English class. She had taken no aptitude test, nor interviewed with members of the English department faculty. Based on her recent arrival in the country, Nyadol was refused entry into the mainstream class. So when she graduated, a great dream for many of her Sudanese peers, she still believed she had failed:

> A teacher's duty is to kindle your interest to want to do more, not to want to do less. Or even not to do anything at all!... every time I'd look at (the teacher) I'd think, 'What does she think of me?' You know, 'What are the other categories in her head that she's placed me in that I can't escape?' And one of my teachers told me, 'If you fail, you can always repeat year 12.' And I think he meant it in a good way, but I ask, 'What tells him that I'm going to fail?' Because I was doing as well as most of the young people in class … they were seeing the refugee, and I think they were seeing too much of that refugee and not enough Nyadol.

The story highlights Nyadol's frustration. Being underestimated by those who are meant to help you achieve is demoralising and can in itself end in

despair and disengagement. Even when motivated by the best of intentions, the students are damaged by this lack of faith: I see it often from teachers who claim it's their professional duty to *prevent* students from enrolling when they believe they will not succeed in a given course, that advising the student otherwise would be setting them up to fail. Still, other low-achieving students are most often *advised* what to take and not take, based on their academic histories, but not refused access to classes. So why are former refugees? As Nyadol puts it:

> Restricting someone's perception of how high they can reach, its killing people's dream. And I think some teachers make the assumption that because of the experiences that we've had we would not necessarily be able to cope with a lot of things but you came through war, and lived being a refugee person. Literally, you ask yourself: what can I not overcome? And someone else telling you what you can or cannot be, or what you cannot do, it's unacceptable.

Clearly many teachers are struggling to meet the needs of their students, but their resources are limited. Arts-based tools can provide simple, flexible and student-centred alternatives to text-based literacy acquisition and socialisation. Many teachers and administrators are trying to do the best for these students, but are drowning in confusion and fear. The considerable body of resources (many online) is growing every day, but the students themselves are each teacher's best advocate and adviser. Organisations like Foundation House (VFST) offer freely available curriculum support and ready-made integration programs such as their "Klassroom Kaleidoscope" resource, available free of charge via the internet. Community organisations like the SAIL (Sudanese Australian Integrated Learning) Program, the Sudanese Lost Boys Association of Australia [there is currently no Lost Girls Association], and SORA (Sudanese Online Research Association) are eager and available to advise from within the community. It is an arrogance to assume that non-African, non-refugee educators should automatically know what's best for these young people. That's why my research holds at its centre the belief that asking the young people themselves is one crucial missing step: they do know why they need to succeed here. They may not know everything, but they hold crucial knowledges about themselves, their histories, and their desired futures that will make their success possible—and dialogue does not require funding. Inviting these young people to present their perspectives on film, in dance, music, visual art and drama is a simple and effective beginning for engagement in the new world of western education. It requires however a reversal of the 'deficit model' view that

Sudanese young people arrive with nothing to offer, and everything to learn.

Unintentional racism

According to my co-participants, some racism in schools is dismissed and minimised by teachers and administrators as baseless and we can call this 'unintentional racism' in schools, or, as does St Denis, 'the problem of denial' (St Denis, 4). Subtle racism is invisible to many non-Africans and indeed is a source of shock and denial by teachers when African students identify encounters which hurt them including: peers avoidance on the schoolyard, being asked what it was like to live in huts in Africa (even when they come from urban centres), racial stereotyping, or the ubiquitous 'she scares me'. St Denis reminds us that naming racism in schools takes courage, and that 'there are many reasons and ways in which the problems of racism and white supremacy are relegated beyond acknowledgement, beyond naming and therefore, beyond problematising and re-dress' (St Denis, 5).

I have been struck as a researcher and teacher by how often Sudanese people are referenced according to their skin darkness and height by teachers, community workers, and Sudanese young people themselves. Height—a marker of beauty in traditional Sudanese culture—and skin colour have become recurrent symbols of their difference, and representative of an inability to hide, to blend, to fit in. Sudanese young people, like all adolescents, want to fit in. And while their backgrounds present unique challenges to them and to the education system, we must not forget that they are still just young people who more than anything want to belong. Even language acquisition for many is seen primarily as a tool not of future (academic or workplace) success, but as a means of becoming 'Australian'. Many Sudanese Australians are finding that even as they become proficient in English, racism continues to hinder their efforts to integrate. Nyadol experiences it regularly, but now she is seeing her younger brother encounter the same troubles:

> The racist chants that some people would say, even to my little brothers, you know, 'You are so out of place, there is no place where you fit in.' Being African it's even tougher because your skin colour stands out so much! I could just never get lost among people, or be short enough. I'm always too dark, too tall, too something, you know, to be Australian. Sometimes it's sad because ...it's not so much that you don't want to be

an Australian, it's that you would never be *seen* as an Australian. You will always be Sudanese-Australian, but always Sudanese more.

The unintentional racism present in most schools creates what I call 'refugeity': a sense of Otherness, or not belonging, which many students face, not only former refugees. Bullying can establish in its victims a sense of 'refugeity', another uncomfortable topic for school administrators. Schools must begin to recognise that segregation or alienation happens in countless informal ways in schools, and which sets the pattern for children's integration and experience of wider society. When refugee students are left in classrooms of thirty students, with teachers rushing headlong through unfamiliar curricula, sometimes as the only black student in the class, those students are not going to seek help. When teachers introduce a unit on poverty in Africa, or AIDS, their Sudanese students are not often going to interrupt to correct the sometimes inaccurate or stereotyped information, but will often remain silently resentful of the inaccuracies and stereotypes. As the constituency of our classrooms change, so must our teaching styles and topics.

Anecdotal evidence shows that African-Australian students will often not raise their hands for fear of appearing stupid, being laughed at, or drawing unwanted attention to themselves. Their poor English skills mean that they often doubt themselves, linguistically and also conceptually. Nyadol tells us that students from refugee backgrounds may find it difficult to directly question authority, even when their futures are at stake:

> We don't understand that you can say no to authority. Because where we
> come from it's very hard to say no to authority, so when the teacher says
> 'you can't do English,' you just know you can't do English.... and if they
> tell you you can't do English, that has a lot of impact, a lot of influence on
> not only your perception of yourself, but sometimes the perception of your
> community.

Teachers and administrators need to develop greater understanding for this cultural difference and develop proactive habits for initiating dialogue with former refugees in their classes in order to continually assess their progress. Ignoring this trend adds to the kinds of disruptive behaviours that some principals and teachers are coming to associate with Sudanese students. I urge you to resist media stereotypes and consider the fact that *some*—not all—refugee students act out because they are being victimised, ignored, and other attempts to rectify the situation have failed. These students need committed and long-term assistance to adapt to their new contexts (and for their new contexts to adapt to them!), and dialogue *must*

be part of that assistance. To imagine that *all* refugee students are the same, with the same needs, is as re-traumatising and stereotyping as ignoring them altogether. As Achol describes it, this kind of invisibility can be crippling:

> The hardest thing is: you didn't understand the teacher what they say. You didn't understand the class what they're talking about. You look like you're a deaf person in the middle of millions of people. You can't talk to anybody: not your teacher, not your friends in the class, because they're speaking English. You wish you can talk to somebody next to you speaking English but you can't speak it. That's like a nightmare to me.

Intentional racism

Some teachers and administrators inadvertently encourage segregation between cultural groups to avoid what they fear will be confrontation, or their general inability to effectively manage the repercussions when they occur. Nyadol has experienced it:

> My brother recently got beaten by three boys, and they poured milk on him and I went to the teachers, and the response of the teachers was very disheartening because he's the only black kid in the school and …what (the teacher) told me was, 'Maybe he doesn't deserve some of the things they do to him.' And I asked him, 'so he deserves some of the things they do to him?' My mom went to them the day my brother got beaten because he came home crying. And when I went one week later, on the next Friday, they had done nothing. They had not even enquired who the boys were, or what they did. After I went they just gave them a warning.

It is also unreasonable to assume that if there is fear of people with dark skin, there will not be race-based segregation or antagonisms in classrooms and on schoolyards. Anecdotal evidence in most schools suggests that there *is*, and yet many principals and school staff deny this, or talk about the 'African problem' instead. Without exception, all of the young people who have participated in my film series have identified racism as a negative factor in their experiences in Australian schools. Both from teachers and their peers, on the streets but also in the classrooms and school yards, African former refugees are confronting a new trauma they never dreamt of back home. Nyadol has identified it as only the next obstacle in a series of traumatic events resulting from fleeing the war in Sudan:

> Does racism exist in schools? I definitely think so. Some teachers might be racist, and I think some students too might be racist.

The media vilification of the Sudanese community in Australia after the bashing death of Liep Gony in 2007 proved what many Sudanese young people knew to be true: even when they are victims, they are seen as perpetrators. Although Gony was bashed to death by non-Sudanese perpetrators, then-Immigration Minister Kevin Andrews used it as a reason to say Sudanese immigrants were not fitting into Australian society, and African intakes were reduced by thirty percent. The effects of the media coverage of the affair have been long-lasting, and can be felt in schools. In a recent focus-group assessment I conducted at my high school, students discussed their fear of their African classmates, which they attributed only to 'skin colour' and things they'd 'heard' in the media. When pressed, they admitted they'd had no negative encounters with their African peers, but that perhaps negative media reports had contributed to their apprehension.

Nyadol states in her film: "No matter what we do, we're seen as criminals." These perceptions filter into schools, and often the new students feel they have nowhere to hide. Nyadol articulates the double bind in what follows:

> You go to school and that's where you're supposed to be given the chance of constructing your future life, and you have this whole negative environment surrounding you. And you come out of school, and you still feel it on the street. I keep asking myself: if (Liep Gony) had been a white kid, beaten by Sudanese boys to death, what would have been the reaction? It would have been ugly.

The truth is it *was* ugly, and the Sudanese community is still feeling the effects. But many outside of the Sudanese community have forgotten the tragedy, and schools are reluctant to admit that racism remains a problem in schools. From teachers who are frightened of their African students, to administrators who worry that their schools are being seen as "African schools", to students who feel 'threatened' by their African peers but can't say why, it seems just by their very presence, African students are intimidating someone. Critical pedagogy compels us to consider the perspectives of the African students, and I suggest that, compounded by slow English language learning, African students too frequently remain absent from discussions about their own learning. Giroux (64) states: "Any pedagogy of critical thinking that ignores the social relations of the classroom runs the risk of being mystifying and incomplete," and this includes silencing of the marginalised and racist practices.

If *Cross-Marked* can be taken as an indicator of Sudanese-Australian young women's perspectives, racism must be dealt with before schools can truly be safe and supportive learning environments. There is ample evidence in my study that most African-Australian students have experienced both intentional and unintentional racism from their peers—verbal assaults that escalate until the African student sometimes reacts with physical assaults—for which they (and not their peers) are punished. Peacock and Albert (2000) offer research on students who 'fight back' against racism in the school, and the schools' inability to support them. They suggest that when conflicts do arise, responsibility is often attributed to the refugee students, a view supported by Achol and Nyadol's experiences:

> When an African kid does something it's because they are 'traumatised', but when a white kid does something it's because they are 'naughty.'...the biggest response I've had since I came to Australia that a lot of Sudanese young people have been told, by teachers, is 'ignore it'. Ignore what they say, don't respond. But I realise it's not even the kids that are ignoring it, it's the teachers that are ignoring it! Maybe because they are ignoring it, they want the kids to ignore it also, but if you are the victim, it's hard to ignore. You know it's hard to ignore being called a monkey, or going to school and finding it written on the wall. It's just hard, you know, and it shouldn't be happening. (Nyuon, 2008)

As these young people come to schools with additional educational challenges, they feel that teachers are by and large ignoring them – allowing them to enrol and then leaving them to fend for themselves. When the pressure mounts and there is a conflict, in a 'her word against mine' standoff, schools are not coming down on the side of their black students. This perception, whether true or false, is leading some young African students to feel hopeless, disengage, and drop out in increasing numbers. The research of St Denis and others (2002) shows that often "the denial of racism is justified on the basis that openly addressing racism will only make matters worse" (St Denis, 31). But "worse" for whom? Many African-Australian students feel that speaking about racism in schools is validating and empowering, and assists them in taking positive action toward countering the damage to self-esteem from covert racist encounters.

Better ways forward

There is a growing body of research that offers alternative means of support for these students. Parallel programs which feature small-group

language tutoring help. Achol's advice to tape record or videotape lessons and units of work to be replayed at home, is practical and inexpensive. Parent and community engagement programs form a necessary three-way partnership with schools to support former refugee young people to remain in school and to strive to achieve. However, community organisation research shows that schools often seem confused in how to create home and community links, and try to do it all themselves. 'Schools often do not have strong connections with ethnic communities and other organisations that may be able to assist to make links with CALD parents' (O'Sullivan, 20). Students can help: most of the young people with whom I've worked as a teacher and researcher are enthusiastic about bringing their worlds together. As Achol reminds us, optimism and persistence are the keys:

> I think I can do better than this you know. I can read, write, do a lot of stuff. I know I'll struggle maybe three or four or five (years), but then one day maybe I'll be better than today.

African-Australian students need optimism and persistence, but so too do their schools. Homework clubs and arts-based learning and socialisation programs like Foundation House's 'Beaut Buddies' effectively draw marginalised students (and importantly their families) back into the life of the school, and provide informal opportunities for language acquisition and socialisation along the way. But, as Achol's story reminds us, the students have to be in the schools in the first place. Critical pedagogy interrogates the economic rationalism seeping into education by asking "What kind of models for identity construction does this new and powerful teaching machine offer? What kind of a better tomorrow does it imply?" (Suoranta et al, 195). In Australia, a better tomorrow is an educational outcome we all desperately need.

Works cited

Ambler, Marjane. 1997. 'Without racism: Indian students could be both Indian and students', *Tribal College Journal*, 8(4), pp 8-11, http://www.tribalcollegejournal.org/themag/backissues/spring97/spring 97ee.html

Australian Council of TESOL Associations. 2006. 'An ACTA overview of the issues around the settlement and provision of services for new arrivals from Africa', http://www.tesol.org.au/files/files/15_refugee_report_final.doc

Brough, Mark, Don Gorman, Elvira Ramirez and Peter Westoby. 2003. 'Young refugees talk about well-being: A qualitative analysis of

refugee youth mental health from three states', *Australian Journal of Social Issues* 38(2), pp. 193-208.

Clifford, James. 1988. *The Predicament of Culture: Twentieth Century Ethnography, Literature, and Art.* Cambridge: Harvard University Press.

Couch, Jen and Louise Olliff. 2005. 'Pathways and pitfalls: The journey of refugee young people in and around the education system in Greater Dandenong, Victoria', *Youth Studies Australia*, http://findarticles.com/p/articles/mi_hb353/is_/ai_n29214345

Delpit, Lisa. 1995. *Educating Other People's Children: Cultural Conflict in the Classroom.* New York: The New Press.

Freire, Paulo. 1970. *Pedagogy of the Oppressed.* New York: Continuum.

Foundation House (VFST). 2007. 'Klassroom Kaleidoscope: A program to facilitate connectedness and well-being in the culturally diverse classroom', http://www.survivorsvic.org.au/resources/publications_and_resources.htm

Giroux, Henry. 1988. *Teachers as Intellectuals: Toward a Critical Pedagogy of Learning.* Massachusetts: Bergin and Garvey.

Harris, Anne. 2010. Cross-Marked: Sudanese-Australian Young Women Talk Education. Unpublished thesis. Melbourne, Australia: Victoria University.

Kumashiro, Kevin K. 2000. 'Toward a theory of anti-oppressive education', *Review of Educational Research* 70(1), pp. 25-53.

Lauglo, Jon. 2000. 'Social capital trumping class and cultural capital? Engagement with school among immigrant youth'. In Stephen Baron, John Field and Tom Schuller, eds. *Social Capital: Critical Perspectives.* Oxford: Oxford University Press, pp. 142-167.

MacIntosh, Peggy. 1998. 'White privilege: Unpacking the invisible knapsack'. In Paula Rothenberg, ed. *Race, Class and Gender in The United States: An Integrated Study.* New York: St Martins Press, pp. 165-169.

O'Sullivan, Kate. 2006. 'A three-way partnership? Exploring the experiences of CALD families in schools', *Centre for Multicultural Youth Issues*, pp. 1-23. http://www.cmy.net.au/ResearchandPolicy

Peacock, Tom and Betsy Albert. 2000. "Our children's songs: American Indian students and the schools', *CURA Reporter* 30(1), pp. 11-16.

St Denis, Verna. 2002. 'Literature review on racism and the effects on Aboriginal education'. In *Minister's National Working Group on Education, Indian and Northern Affairs.* Ottawa, Ontario; Canada, pp. 4-34.

http://www.sfu.ca/mpp/aboriginal/colloquium/pdf/Racism_and_Abo_E ducation.pdf.

Sudanese Online Research Assocation. 2008, http://sora.akm.net.au/

Suoranta, Juha, Tuukka Tomperi and Robert FitzSimmons. 2004. 'Revolutionary pedagogy in media culture: Reading the techno-capitalist order of education'. In Gustavo Fischman, Peter McLaren, Heinz Sünker and Colin Lankshear, eds. *Critical Theories, Radical Pedagogies, and Global Conflicts*. MD: Rowman and Littlefield, pp. 185-206.

Sudanese Australian Integrated Learning (SAIL) Program Inc. 2008, http://home.vicnet.net.au/~sail/

Sudanese Lost Boys Association of Australia Inc. 2008, http://www.lostboys.org.au/index.php

TRAUMA, CINEMA AND THE MASS MEDIA

GENRE CINEMA AS TRAUMA CINEMA: POST 9/11 TRAUMA AND THE RISE OF 'TORTURE PORN' IN RECENT HORROR FILMS

LINDSAY HALLAM

Introduction

When first approaching research into the area of trauma theory, my initial thought was that my main research interest, which is the genre of horror cinema, would be completely at odds with the aims of this theoretical field. For even though horror cinema revolves around the experiences of fear, terror and trauma, these experiences are aroused for the purposes of pleasure and entertainment. This genre does not exist in order to heal past wounds, it exists in order to create them, and to then parade these wounds in extreme close-up.

Furthermore, horror films are not often included in this area of film analysis, with the focus being primarily on films outside of typical genre conventions, mainly documentaries and dramas that recreate past events. Janet Walker, in her book *Trauma Cinema: Documenting Incest and the Holocaust*, introduces the concept of "trauma cinema", which is defined as "a group of films that deal with a world-shattering event or events, whether public or personal" (2005: 19). Walker goes on to state that these films can be "ranged across a continuum", starting from documentary, across to dramatic re-enactments and then to "abstract sequences" and the "representation of dreams, hallucinations, stories, and fantasies" (2005: 24). It is stated clearly, however, that "[w]holly imagined genres such as science fiction would range beyond the ... edge of this study" (2005: 24).

While the majority of trauma cinema theory examines films that also fall into this range, some headway has been made into the analysis of genre films within this area. For example, one of the foremost writers in this

field, E. Ann Kaplan, devotes a chapter in her book *Trauma Culture: The Politics of Terror and Loss in Media and Literature* to the study of the melodrama genre, taking Alfred Hitchcock's *Spellbound* as its primary example. Kaplan investigates "the degree to which a pervasive popular genre, the melodrama, might have served the function of registering *while negotiating* the cultural traumas of modernity, including those of war, race, and gender" (2005: 69). Kaplan finds that the melodrama is able to address cultural traumas that are otherwise suppressed or forgotten. Specifically, the melodramas of the post-World War 2 period deal with war trauma in a way that the prevailing dominant culture was largely ignoring. For example, the central theme of Hitchcock's *Spellbound* just happens to be that of traumatic amnesia—the very symptom that the culture was manifesting at the time it was made (1945).

Therefore, it is within the realm of genre cinema that events that are "too dangerous for the culture … to acknowledge or recall" (Kaplan, 2005: 74) can be examined and worked through. This is done through the use of displacement and allegory. These films do not recreate an event directly, but use narrative in order to deal with the effects, namely, the resulting trauma, of a certain event. In his article 'Allegorizing Hiroshima: Shindo Kaneto's *Onibaba* as trauma text', Adam Lowenstein argues that although there is a tendency "to favour 'realist' representations over 'allegorical' ones" (2004 146), it is within allegorical representations of traumatic events that questions are asked about how history is constructed and how the event itself is being remembered. It is Lowenstein's book, *Shocking Representations: Historical Trauma, National Cinema and the Modern Horror Film*, that begins to open up the field of trauma theory to the discussion of horror cinema. A very recent publication, Linnie Blake's *The Wounds of Nations: Horror Cinema, Historical Trauma and National Identity*, also contributes the study of horror cinema within trauma theory.

Looking across the history of horror cinema, each decade is defined by certain cycles or sub-genres which emerge, from the Universal studios monster films of the 1930s, to the low-budget horror of the 1970s, the slasher films of the 1980s, and the ironic horror of the 1990s. Looking at the times we live in now, within the history of horror the first decade of the twenty first century is most likely to be remembered for the creation of a sub-genre that has come to be known as 'torture porn.' This term was coined in 2006, in an article by David Edelstein, written for *New York Magazine*, in response to a slew of horror films that have been released in

the past few years, for example, the *Saw* and *Hostel* franchises, *Wolf Creek*, *Captivity*, *Turistas*, and *The Devil's Rejects*. Edelstein notes how:

> Explicit scenes of torture and mutilation were once confined to the old 42nd Street ... in gutbucket Italian cannibal pictures like *Make Them Die Slowly*, whereas now they have terrific production values and a place of honour in your local multiplex. (Edelstein 2006)

Once a form of horror that catered only to a small, niche audience, graphic depictions of gore and sadism have become a mainstream norm.

These films have achieved an unprecedented popularity, typified by the phenomenal success of the *Saw* franchise that has grossed more than $500 million worldwide; while critically they are almost universally scorned. The term torture porn was meant by Edelstein to be derisive, as he finds these films to be "viciously nihilistic" (2006). Another critic, James Poulos, has gone as far as saying that torture porn "invades the human soul and allows evil to triumph over the dignity of the human" (2006). Even some horror film directors have expressed concern and disdain: George Romero, director of the *Night of the Living Dead* and its sequels, stated: "I don't get the torture porn films" and "they're lacking metaphor" (Onstad, 2008), while Joe Dante, director of *Gremlins* and *The Howling*, has called them "Abu Ghraib movies" (Nelson 2007).

This remark by Dante, again meant as an insult, is a telling one. For more often than not, discussions about the emergence of torture porn inevitably make reference to 9/11 and the subsequent War on Terror. The events of September 11, 2001 left a deep and indelible mark not just on the US, but on the whole world. Later events, such as the bombings in Bali, London and Madrid, have contributed to a feeling that nowhere is totally safe and secure. In retaliation, the US, along with its allies such as Australia and Britain, has waged a so-called War on Terror. As well as fighting a war on two fronts, in Iraq and Afghanistan, there is of course the possibility of terrorist networks existing anywhere in the world. And as long as the war wages on, atrocities will be committed on both sides.

In 2004 images were released of US military personnel torturing and humiliating prisoners at Abu Ghraib. One of the most shocking aspects of these pictures was the fact the soldiers had taken these photographs themselves, and are often shown in the photos, smiling and laughing. The soldiers were then swapping the photos amongst themselves and emailing them to friends. Although the response to these images the world over was

primarily that of disgust and disbelief, the US government refused to acknowledge that what was depicted was actually torture. Secretary of Defence Donald Rumsfeld stated: "My impression is that what has been charged thus far is abuse, which I believe technically is different from torture." He went to state: "therefore I'm not going to address the 'torture' word." Yet despite the US government's avoidance of not only the issue of torture, but even the word itself, torture has become a central issue in the news media and, as torture porn horror cinema shows, in the popular media.

In her article 'Regarding the Torture of Others', Susan Sontag examines the Abu Ghraib photographs and notes the "confluence of torture and pornography" (Sontag 2004). The prisoners were often forced to perform or simulate certain sexual acts and positions, and later when the photographs were distributed, they were mixed in with other photographs of the soldiers having sex with each other. Thus, these photographs are in fact real examples of 'torture porn'. What is most disparaging is that the nature of these images has subsequently been denied and suppressed by those in authority. Rather than dealing with the images, the decision was to downplay them.

But these images did not go away. Instead, they have returned again and again, on the big screen at the local multiplex. As Adam Lowenstein states: "Horror's dark gift is to remind us that the tragic events we think we've gotten over and understood always come back to haunt us" (cited in Nelson 2007). Just as Kaplan brought to light how the post World War 2 melodrama dealt with war trauma in a way that was being avoided by the culture at large, so, too, can it be argued that the torture porn horror film deals with cultural fears and traumas resulting from 9/11 and the subsequent incident at Abu Ghraib.

By looking closer at these films, it is possible to appreciate that certain themes and images continually recur, in a way that demonstrates a definite connection between what is presented onscreen and what is happening in the world outside. What becomes most apparent is that the majority of these films involve characters who are travelling to other countries or going on road trips across country, for example, *Hostel, Turistas, Borderland, Frontier(s),The Devil's Rejects* and *Wolf Creek*. While in the slasher film of the 1980s, made just as the AIDS epidemic was beginning, having sex is a sure fire way to get yourself killed, it seems that in a torture porn film, the worst thing you can do is go travelling.

For Americans, one of the most shocking realisations after 9/11 was the awareness that outside of their own borders they were hated. For decades American audiences had bought into the myth, which was continually perpetuated by Hollywood, that their way, the American way, was being held as a beacon of truth and justice. It was now apparent, though, that the way they saw themselves, and the way the international community perceived them, had diverged completely. They were not the strongest and the most powerful; they were vulnerable. And it is this newfound vulnerability and insecurity, and the trauma resulting from this realisation, which is expressed in these new horror films.

This fear and vulnerability is masked, however, by a veneer of ignorance and arrogance. In these films we can see a stereotype emerge: that of the Ugly American. In *Turistas*, *Borderland* and *Hostel*, characters travel to other lands not for the purposes of learning and cultural exchange, but for cheap thrills and easy sex. They go to their destinations in order to exploit the people (women especially), and their resources (usually drugs and alcohol).

In turn, however, the ignorance of these Americans is exploited by the natives in order to lure them into danger. In *Hostel*, the boys are enticed to a town in Slovakia by the prospect of being able to have any woman they want. They are told: "There's so much pussy and because of the war there are no guys. They go crazy for any foreigner. You just *take them*." It is not until *Hostel Part 2* that the new set of characters, girls this time, are informed that in fact there has not been a war in Slovakia for 50 years. *Hostel* director Eli Roth has maintained that his films are about: "American ignorance … Americans really don't know anything and they don't really care about other cultures" (Stratton, 2007). It is this ignorance that leads them into danger.

In reference to Eli Roth's previous film *Cabin Fever*, Linnie Blake writes: "Significantly for a post-9/11 film, a sense of spoiled and helpless children getting everything that's coming to them abounds." Blake goes on to state that the film:

> can also be viewed as an extremely forceful indictment of the ignorance and complacency of a generation that has managed to graduate college without learning a single thing about the world, their country, or themselves. (Blake 2008: 141)

Such a statement can actually be applied to the characters of any torture porn film. The young people in peril in these films are often not that sympathetic. In fact, the killer in *Saw*, who calls himself Jigsaw, picks his victims precisely because they 'deserve' it. His victims mostly include junkies and criminals, who are put in elaborate traps and forced to perform sickeningly painful acts in order to survive. The idea is to have them face death so they can then learn how to live. Of course, most of the time the victims do not succeed, and they are killed in elaborately horrific ways.

Although it is the *Saw* series of films that demonstrate torture porn's popularity, it must be noted that torture porn is not limited to mainstream Hollywood. There are examples of this sub-genre that have been made outside of America, for example: *Wolf Creek* is from Australia, *High Tension, Martyrs, Inside* and *Frontier(s)* are from France, *Ordeal* is from Belgium, *WΔZ* is from England, and several films made by Takashi Miike, such as *Audition* and *Ichi The Killer*, are from Japan. Torture porn is closely linked to streams of new 'extreme' cinema which has been coming out of Asia and France. Surprisingly, it is France, a country that refused to follow Bush's War on Terror, which has contributed quite a few films to this new trend. Like the films from the US, these films deal with real events that have scarred and traumatised the nation.

Frontier(s) opens with what appears to be actual footage of recent riots which have erupted due to the election of a right-wing official. These scenes reference recent race riots and the rise of neo-fascism. A group of young people get caught up in the riots after having just committed a robbery, and so flee Paris in order to get to Holland (again, we have characters who go travelling). Once in the countryside they stop at a motel that just so happens to be run by a family of Nazi cannibals. The family are given obviously German names such as Karl, Hans and Goetz, while the four young people are an ethnic mix; one of the group, Farid, refuses a meal of "fried pork" because he is a Muslim. The one girl in the group, Yasmin, has her hair cut off because it is black, and the Father complains that her complexion is "too dark". Thus, we have a family of Nazis in France, torturing and killing young Arabs, in a (highly problematic) juxtaposition of recent and past examples of French racism. Throughout the film concentration camp imagery is used, such as Yasmin's enforced haircut, and the scene where a character is killed in a gas chamber.

Certainly, this description highlights the most problematic aspects of this sub-genre. This use of real atrocity and real trauma as a means to deliver

thrills to the audience can be seen as bordering on exploitation. But what these films do is remove any trace of fantasy from horror. Graphic violence is used in order to heighten the engagement with reality and with the experience of trauma. In fact, many of the films within this sub-genre trade on the fact that they are based on supposedly 'true' events: Eli Roth states that inspiration for *Hostel* came after reading about a service in Thailand where people could pay to kill someone (*Time Out* 2006). Similarly, *Borderland* is based on a cult that practiced human sacrifice (Massacre n.d.), whilst *Wolf Creek* combines elements from two recent Australian crimes: the serial killings committed by Ivan Milat and the disappearance of Peter Falconio (Britton 2008). In "Free speech and the concept of 'torture porn': Why are critics so hostile to *Hostel II*?" Julie Hilden defends the use of graphic violence in these films. She claims that:

> it seems strange to fault *Hostel* for its very realism about violence suffered by innocents – while, at the same time paying no mind to the endless, often bloodless and supposedly well-deserved violence of summer movies. Such violence passes so quickly we often barely register a particular shooting... In contrast, *Hostel* and *Hostel II* dwell on the horrors they depict, and condemn them. What kind of presentation really desensitises us to violence? I think the answer is clear (Hilden, 2007).

According to Hilden, this violence is justified by the very fact that is shown in such graphic detail, demonstrating to the audience the pain and suffering that violence causes.

Yet, what can be said about the audience's response to this violence? As Dominick LaCapra attests, in trauma theory there is a "process of acting out, working over, and to some extent, working through" (2001: 187). By applying trauma theory to the analysis of torture porn, we can begin to see this process coming into play. When asked why young audiences respond to his films, Eli Roth replied:

> There's a whole generation now that was 10 years old when 9/11 happened and now they're 16 and 17 and they have grown up with being told, 'You're going to be blown up. Terror alert orange.'...the type of violence they need to see in a movie to stimulate them, that they react to, is what...they've seen in their lives. They want to be shocked that way so they can scream about it (Stratton 2007).

What Roth is referring to here is the long held notion that horror can have a cathartic effect. Having grown up in a nation that is traumatised and in a state of constant fear, young audience members are using torture porn as a

form of release, of acting out. These films go even further, though, and ask questions about American culpability, about the use of violence and torture as a form of retaliation and revenge, about the damage that is done to a culture when it is told to live in constant fear.

In contrast to other films that have dealt directly with the Iraq war and the War on Terror, such as *Rendition, Home of the Brave, Stop-Loss* and *In the Valley of Elah*, these horror films have used allegory in order to ask these questions, and in so doing have been able to find and engage an audience, primarily young people. For it is this audience who has had to grow up with trauma, who has felt powerless to do anything about it, but yet it is this audience who is asked by those in the government to travel away from home and fight the war that resulted from these events.

Thus, we can find some merit in these critically derided and scorned films. Through the application of trauma theory we can see that the trauma resulting from recent events is being played out, but in a way that is also asking questions about how we came to this point, and the responsibilities that come with working through it.

Works cited

Blake, Linnie. 2008. *The Wounds of Nations: Horror Cinema, Historical Trauma and National Identity*. Manchester: Manchester University Press.

Britton, Vickie. 2008. 'The truth behind the film *Wolf Creek*: Wolf Creek, the backpacker murders, and the Peter Falconio case', *Suite101.com*, http://horrorfilms.suite101.com/article.cfm/the_truth_behind _the_film_wolf_creek

Edelstein, David. 2006. 'Now playing at your local multiplex: Torture porn', *New York Magazine*, http://nymag.com/movies/features/15622/

Hilden, Julie. 2007. 'Free speech and the concept of 'torture porn': Why are critics so hostile to *Hostel II*?', *FindLaw*, http://writ.lp.findlaw.com/scripts/printer_friendly.pl?page=/hilden/200 70716.html

Kaplan, E. Ann. 2005. *Trauma Culture: The Politics of Terror and Loss in Media and Literature*. New Brunswick, NJ: Rutgers University Press.

LaCapra, Dominick. 2001. *Writing History, Writing Trauma*. Baltimore: Johns Hopkins University Press.

Lowenstein, Adam. 2004. 'Allegorizing Hiroshima: Shindo Kaneto's

Onibaba as trauma text'. In E. Ann Kaplan and Ban Wang, eds. *Trauma and Cinema: Cross-Cultural Explorations*. Hong Kong: Hong Kong University Press, pp. 145-162.

Massacre, Tex. n.d. 'Borderland: Director Zev Berman', www.bloody-disgusting.com/interview/428

Nelson, Rob. 2007. 'The zeitgeist made 'em do it', *Village Voice*, www.villagevoice.com/2007-06-05/film/the-zeitgeist-made-em-do-it/

Onstad, Katrina. 2008. 'Horror auteur is unfinished with the undead', *New* www.nytimes.com/2008/02/10/movies/10 onst.html?_r=1&oref=slogin

Poulos, James G. 2006. 'Tortured souls', *The Weekly Standard*, www.weeklystandard.com/Content/Public/Articles/000/000/013/044 tpbrj.asp?pg=2

Sontag, Susan. 2004. 'Regarding the torture of others', *The New York Times*, http://www.nytimes.com/2004/05/23/magazine/23PRISONS.html?ex=1400644800&en=a2cb6ea6bd297c8f&ei=5007&partner=USERLAN

Stratton, David. 2007. '*Hostel Part II* interview', *At the Movies*, www.abc.net.au/atthemovies/txt/s1941380.htm

Walker, Janet. 2005. *Trauma Cinema: Documenting Incest and the Holocaust*. Berkeley: University of California Press.

Time Out. 2006. '*Hostel* – Eli Roth Q&A', www.timeout.com/film/news/1007/

LEVINAS AND THE FACE:
HELPING NEWS CONSUMERS WITNESS,
RECOGNISE AND RECOVER TRAUMA VICTIMS

GLEN DONNAR

Introduction

> Let the atrocious images haunt us. Even if they are only tokens, and cannot possibly encompass most of the reality to which they refer, they still perform a vital function. (Sontag 2003: 115)

In our consumption of mediated terrorism, we are hauntingly confronted with an irresolvable dilemma; as Susan Sontag writes: "the gruesome invites us to be either spectators or cowards, unable to look" (2003: 43). Often, we choose to look away, or not look at all. But to not look is to ignore the suffering of those (distant) others, victims of terrorism. It is to refuse recognition of them as individuals with whom we share the world. And it is to avoid and deny our own responsibility, in their death *and* their mediation. In a modern life it may seem "normal to turn away from images that simply make us feel bad" (Sontag 2003: 116); it may even be easy to accommodate, but it need not be so.

As contemporary news consumers, our understanding of atrocity principally a product of the impact of televisual images—constructed, selective, decontextualised—we understandably feel helpless, overwhelmed by daily images of terror and suffering. However, adopting a Levinasian approach to what we see can afford a way for us to respond ethically and meaningfully to the (often anonymous) victims we see, as well as those we do not. Although appropriating Levinas as an applied ethics could be regarded as an example of the 'totalising' tendencies he critiques, this essay is intended to stimulate discussion on the possibilities of contemporary news consumption. Indeed, perhaps Levinas' own response to watching the suffering of children on French television opens a way for such an extension of his ethics: "Nothing is nobler than exposing man's misery"

(cited in Lewis 2007: 83-84). I also note that the argument may also be transferable, even more pertinent, to the practise of journalism or journalist education. That said, I am solely focused at present on positing a way for news consumers to respond ethically to news as it *is* presented, rather than with how it *could be* presented.

Affect and effacement in mediation and death

Terrorism seeks to efface its victims with the express aim of communicating to other parties. Its 'success' depends on its victims being witnessed, for atrocity "must be made visible to terrorise"; such atrocity selects, or rather targets, victims and "reduces them to de-humanised objects" (Humphrey 2002: 91). It "objectifies and codes the victim's body... made to signify a category and no longer an individual subject" (Humphrey 2002: 94). Yet effacement through (violent) death is mirrored by that through mediation. The camera, and by extension the media, objectifies those it seeks to represent; what is represented becomes "something that can be possessed" (Sontag 2003: 81). The individual is appropriated, and they and their suffering can thus be diminished, even denied.

Contemporary news consumers continue to be exposed to ever more (distant) violence, yet while the camera allows us to witness it also serves to alienate or separate us from what—indeed *who*—we witness. When we see atrocity and death "on (the other side of) the screen we watch it passively as a spectacle, we don't react to what we see in the same way as if it were actually happening to us" (Humphrey 2002: 96). Further, Sontag argues the surfeit of images "keeps attention light [and] relatively indifferent to content" (2003: 106). Watching the innumerable victims of atrocity, presented to us as distant and anonymous, "protects but also prevents [us] from comprehending the Other's experience of pain and suffering" and serves "to collectivise the Other's death as if it belonged to them as a category" (Humphrey 2002: 99, 101). Their victim status can be presented as inevitable and we as news consumers become alienated, inattentive, disinterested.

Yet is it necessarily any better to be moved, affected by the suffering we watch? Humphrey argues that affectivity "is the primary mode of connection between victim and witness" and that "the priority of affect over cognition in the media" restates its importance in establishing meaning (2002: 91). On the other hand, Sontag expresses increasing concern with media "exploitation of sentiment ... and of rote ways of

provoking feeling"; for in so far as "we feel sympathy, we feel we are not accomplices to what caused the suffering" (2003: 80, 102). Sentimentality and sympathy are simple, facile responses, even 'impertinent' and 'inappropriate'. In sympathy, just as in indifference, we as news consumers abrogate our responsibility. Despairingly, it seems, given the objectifying and annihilating effects of mediated terrorism, that alienation and indifference or facile sympathy are the lot of news consumers. Nonetheless, I believe that a renewed ethical space for the recovery of news subjects *as* individuals is possible via a Levinasian approach, but it requires a shift from *what* is shown to *how* we view. Or, more precisely, from *what* we see to *who* we witness.

Witnessing the face of the other

For Emmanuel Levinas, ethics as first philosophy concerns our relations with others and originates before the foundation of philosophical principles, rules or codes, when the face (*le visage*) of the Other discloses itself to me—'face to face'. The face "is simply there, present to me in an originary and irreducible relation" (Davis 1996: 46). It is disclosed as absolute Other and 'breaks into' my lived experience, implying that it was *already* and *always* there; absolutely beyond my comprehension—ultimately unknowable, mysterious. It "comes to [me] unexpectedly, and calls [me] out of [myself] and into an ethical confrontation" (Davidson 2008: 43). It cannot be assimilated, nor is it an object for my cognition or manipulation, since anything we can 'know' becomes the Same.[1] Significantly, the face "is *expression*, a source of meanings coming from elsewhere rather than the product of meanings given by me" (Davis 1996: 46); it is a revelation.

The encounter with the face shows me the existence of a whole world outside myself. This encounter both precedes and exceeds my experience; ethics precedes ontology.[2] It may, as a real part of the human body, be available to be encountered but "it is before all else the channel through which alterity presents itself to me, and as such lies outside and beyond what can be seen and experienced" (Davis 1996: 135). For Levinas, and we as news consumers, it is both the reality of the encounter *and* the elusiveness of the face that are crucial. For "[w]ithout the possibility of real encounters, the Other would be a senseless abstraction; but if the

[1] See Critchley 1996.
[2] See Bergo 2007.

encounter were only phenomenal this could easily become an object of perception or knowledge" (Davis 1996: 135).

Thus, for Levinas morality is a *response* to what is out there already; it originates from without. The Other's 'regard' *of* me constitutes me as self, "an 'I' discovers its own particularity when it is singled out by the gaze of the other" (Bergo 2007), and challenges me to respond. In provoking recognition, the Other in turn commands respect and humility. The face of the Other *elicits* my responsibility. I can neither accept nor reject this responsibility because my existence is entirely bound up in my relation with the Other (Davis 1996). We are therefore "ethical in [our] very foundations, involved in ethical relations whether [we like] it or not" (Davis 1996: 53). This does not mean that we will respond in an ethical way, only that we *must* respond.

For news consumers, to witness is no longer to be able to feign ignorance of suffering and is to assume a measure of responsibility. In witnessing suffering, "social connections [can be] created between victim and witness, establishing a basis for moral responsibility" (Humphrey 2002: 91). And as Sontag observes, although "[i]mages have been reproached for being a way of watching suffering at a distance ... watching up close – without the mediation of an image – is still just watching" (2003: 117). *All* witnessing "involves an epistemological gap whose bridging is always fraught with difficulty"—a difficulty compounded by distance—but "[t]o judge from appearances is the fate of all who have to rely on communication for access to others' experiences" (Peters 2001: 713). Paradoxically, just as atrocity must be made visible to terrorise, witnessing —whether in person or through a text—is likewise essential for the recognition of its victims.

However, according to Davis (1996: 133) to witness or look, is also "associated with perception and knowledge, therefore it annihilates the face ... by bringing it within the sphere of the Same". Since we cannot even comprehend the Other, the only "way of suppressing it is to seek its annihilation" (Davis 1996: 50). So mediation, like death, can be argued as the attempted destruction of the face, its mystery and infinity. Yet Levinas argues ultimately that the Other cannot be annihilated. Individual 'faces' can be—this cannot be dismissed nor its tragedy diminished—but the face of the Other never can be. It "remains inviolate and inviolable. The face appears in my world but does not belong to it; I can do it no harm" (Davis 1996: 50-1). The face transcends individuals (*and* their representation) but,

paradoxically again, also facilitates their recovery after loss. Although death and mediation seek to efface the individual, this effacement is never total, never complete. Admittedly utopian, Levinas demonstrates the futility and ultimate failure of violence, "that it can never succeed in its true aims" (Davis 1996: 51). The face exceeds and survives the obliteration of any individual face. The frailty and strength of the Other is thus mirrored in death and mediation. In both it is always available for appropriation, but despite this, can never be fully grasped, ensuring "the survival of alterity" (Davis 1996: 141). The Other is not just someone who can be seen, but is someone who also sees, who also regards (us). Respecting otherness lies in our resisting the Other's annihilation and makes recovering victims possible.

The face and recovering victims

Sontag's discussion of the photos taken at Tuol Sleng prison by the Khmer Rouge of victims poignantly illustrates this. Thousands of men, women and children were held at the prison, located in a former school in Phnomh Penh, in the latter half of the 1970s. Photographed, forced to produce false confessions and tortured before execution, of an estimated seventeen thousand only twelve detainees survived. In Sontag's view, those photographed "remain an aggregate: anonymous victims" (2003: 60); demoted to representative instances of their impending plights. However, the face—*their* faces—must not be confused with or reduced to "anything we might see, thematize and appropriate" (Davis 1996: 133), for this would "make of [each] an intentional object of the perceiving consciousness" (Davis 1996: 46). As Levinas writes in *Totality and Infinity*, "[t]he face of the Other at each moment destroys and overflows the plastic image it leaves me" (1979: 43). These victims-to-be, their singularity denied, only their plights known to us, silently and defiantly stare out at the camera. They stare out *and* through the camera/photograph, at those that seek to objectify them, murderer and viewer alike. The photos are undoubted visions of terror and trauma yet the faces therein cannot be confined to mere representation, they exceed their representation in their stare, in their regard. We the viewer, even now, are included in this regard and implored/compelled to assume responsibility, to acknowledge them and their suffering. Their faces call on us to respond, to recognise them as Other, and to recover them as individuals.

Another more contemporary example further supports this line. Following the Madrid train bombings of March 2004, in which 191 were killed and

over 1500 injured, the *Metro* newspaper ran a series on the victims.[3] A person close to each victim was asked to relay their personality, life and hopes. Accompanying each piece was a portrait of the victim. In this way, each was effectively and poignantly memorialised "through a portrait, not as a picture of a corpse ... biographically and subjectively recovered for their readers" (Humphrey 2002: 104). In this way we also recover the face of the victims of Tuol Sleng. We may not have their biographical information or personal stories, but we see them as they were—not as they were to become—alive, like us; terrorised certainly, but *their* face extant. They are (ever more) memorialised, and they and the trauma they suffered acknowledged and witnessed. For if we attend to their faces *as* faces we cannot be indifferent. Their 'bodily' face may have been erased, but as exhibitors of *the* face, they can never be erased while we acknowledge them and respond to their call upon us. They transcend their representation, transcend their violators, transcend their effacement.

The third party and recovering the 'faceless'

Yet what of those we do not see clearly, or who are absent (from view) entirely, perhaps even annihilated? In lived experience, we are readily open to the face of the Other. Yet, dependent upon the particular social relationship and context, we do not attend equally, or with equivalent intensity, at all times to all people. While my responsibility for the Other is absolute, each exhibitor of the face is not always or equally present to my lived experience. Likewise, in consuming mediated terrorism it is not always easy to discern and respond to the face of mediated others. Victims will not always so evidently slip or transcend their representation. Something more therefore seems to be required if we as news consumers are to be able to witness and engage with *all* mediated suffering.

According to Levinas, in the encounter in which I discover the Other "the potential presence of innumerable others is also revealed to me" (Davis 1996: 52). The simultaneous disclosure of this third party (*le tiers*) shows, not only that a world exists outside of myself, but that one exists outside my relationship with the Other, that I share the world with a multiplicity of others (Davis 1996). For as Levinas writes in *Otherwise than Being*, the third party "is always potentially present in the proximity of the Other, because the Other is never simply *my* Other; the Other implies the

[3] *Metro* was a free daily newspaper available across Spain (the edition folded in early 2009). Ironically, it was distributed outside the underground rail system.

possibility of others, for whom I myself am an Other" (1991: 83). Davis argues that with the entrance of the third party the ethical relation can become a concern for social justice because it prevents my relationship with the Other from becoming self-enclosed and the world becomes "a multiplicity of others, in which each subject is unique" and each responsible for all (1996: 83-84).

This is pertinent to our many encounters with the 'faceless' third party in the coverage of terrorism, and a BBC documentary on the Madrid attacks again serves to illustrate this.[4] While the images and testimony of bloodied survivors readily disclose the face to us, it is those we cannot see clearly—those in body bags, those strewn across the tracks and those in the wreckage of the trains—that are now my focus. For their existence as the third party—*potential* rather than *disclosed* faces to and for me—does admit that in our experiences of mediation, just as in lived experience, we *feel* varying intensities of 'faceness'. However, as Moran observes, "[o]ne does not actually have to see someone to face the ethical demand of their 'face'" (2000: 349). We are compelled and, more importantly, able to open ourselves to these innumerable potential Others, with whom we also share the world. The victims and many survivors, as exemplars of the third party, may not directly disclose their face to us; we may not even encounter their (mediated) existence. Yet it is nevertheless possible for us to extend or grant the face to them. Like the Other, they too are deserving of our response, our recognition and our responsibility.

Responsiveness as a passive engagement

Sontag suggests that news consumers do not become inured "because of the quantity of images dumped on them. [...] It is passivity that dulls feeling" (2003: 102). Yet Levinas argues that it is not agency but responsiveness—a *fundamental* passivity—that matters in our relations with others. Agency suggests that the Other is manipulable and can be grasped, whereas responsiveness is an openness to the Other and a readiness to respond to their call upon us. Such responsiveness, such a *passive* engagement, is admittedly difficult but, as Sontag recognises, "images cannot be more than an invitation to pay attention, to reflect, to learn" (2003: 117).

[4] The documentary was part of a three-part series entitled, *The New al*-Qaeda, and was aired in Australia on the SBS program, *Cutting Edge: Terrorism Special*, in December 2005.

According to Levinas, my absolute responsibility for the Other is necessarily one-sided, and "not mirrored by the Other's reciprocal responsibility towards me", for this too "would imply that I was empowered to speak for the Other" (Davis 1996: 51-52).[5] As such, the relationship cannot be universalised and we must accept morality "as aporetic, never resolved, without recourse to comforting principles which help to simplify difficult choices" (Davis 1996: 53). Our goal then as news consumers is to bridge the inevitable epistemological gap accompanying our relations with the Other *and* representation, while accepting that it can never be fully bridged. This requires laying ourselves open to the Other and 'going beyond' images to discern the face. It also requires 'going beyond' images in *looking for* and granting the face, facilitating an ethical response to the third party, just as to the face of the Other. It requires all this, accepting that since my responsibility and obligation are absolute, "they exceed my ability to fulfil them, always demand more, are never satisfied" (Davis 1996: 54).

Levinas' ethics of the face and the third party does not and cannot tell us how to witness the (distant) suffering of Others; rather, it represents "a challenge" (Davis 1996: 144). But, more than this, it presents an opening or a possibility for news consumers. Since suffering must be witnessed in order to recognise its injustice and recover its victims, by adopting a 'Levinasian' approach to the consumption of mediated terror the (mediated) Other can be regarded not just as someone to be seen, but as someone who also sees, as someone who also *regards* us. Images may only be 'tokens' but they can and do perform a vital function. As Sontag observes, photos of suffering and death—of the victims of Tuol Sleng, of Madrid, of anywhere—"are more than reminders of death ... [and] victimization. They invoke the miracle of survival" in their continual perpetuation and renewal of memories (2003: 87). The effacement of victims in death (or mediation) cannot be reversed but, in our response and recognition as news consumers—in *how* we view and *who* we witness—it can be exceeded, transcended and they, ultimately, recovered.

Works cited

Bergo, B. 2007. 'Emmanuel Levinas'. In *Stanford Encyclopedia of Philosophy,* http://plato.stanford.edu/entries/levinas/.
Critchley, S. 1996. 'Obituaries: Emmanuel Levinas (1906-1995)', *Radical*

[5] See also Bergo 2007.



Philosophy 78, July/August, http://www.radicalphilosophy.com/default.asp?channel_id=2191&editorial_id=9839.

Davidson, R. 2008. 'Face to Face', *New Humanist* 123, May/June, pp. 42-43.

Davis, C. 1996, *Levinas: An Introduction*. University of Notre Dame Press: Notre Dame.

Hand, S., ed. 1989. *The Levinas Reader*. Oxford: Basil Blackwell.

Humphrey, M. 2002. *The Politics of Atrocity and Reconciliation: From Terror to Trauma*. London and New York: Routledge.

Levinas, E. 1979. *Totality and Infinity: An Essay on Exteriority*, trans Alphonso Lingis. The Hague, Boston: M. Nijhoff Publishers.

—. 1991. *Otherwise than Being; Or, Beyond Essence*, trans Alphonso Lingis, The Hague, Boston: M. Nijhoff Publishers.

—. 1996. *Basic Philosophical Writings*, eds. Adrian T. Peperzak, Simon Critchley and Robert Bernasconi. Bloomington: Indiana University Press.

Lewis, R. 2007. [no title], *The Velvet Light Trap* 60, Fall, pp. 83-84.

Moran, D. 2000. 'Emmanuel Levinas: The phenomenology of alterity'. In *Introduction to Phenomenology*. London and New York: Routledge, pp. 320-353.

Peters, J. D. 2001. 'Witnessing', *Media, Culture & Society* 23, pp. 707-723.

Sontag, S. 2003. *Regarding the Pain of Others*. Farrar, Straus and Giroux: New York.

Taylor, J. 1998. *Body Horror*, Manchester: Manchester University Press.

Taylor, P. 2005. 'The drug dealer, the estate agent and the telephone man', *The New al-Qaeda*, England: BBC.

Tuol Sleng: Photographs from Pol Pot's Secret Prison, http//:www.tuolsleng.com/.

Zylinska, J. 2005. *The Ethics of Cultural Studies*. London and New York: Continuum.

Appendix A

Film Screenings

An American in Aberfan

Running time: 60 minutes
Director: Christopher Morris
Production year: 2006
Production country: UK

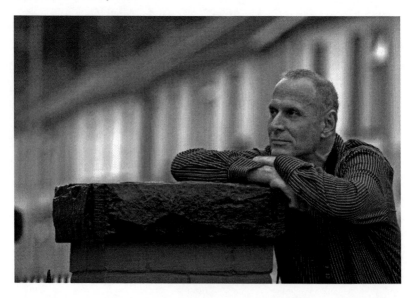

Internationally acclaimed installation artist/photographer Shimon Attie was approached to create an artwork commemorating the 40th anniversary of the Aberfan disaster. The disaster was the slippage of a slag heap in the pit village of Aberfan, South Wales, in 1966, which engulfed the primary school and killed most of one generation. Shimon's artistic work is built around memory, place, and in particular working with communities and

their collective memories. Having spent time in the village with survivors and bereaved parents, Shimon Attie has created artwork that reflects the hopes and aspirations of the people of Aberfan. Christopher Morris's documentary *An American in Aberfan*, produced by the BBC Wales, draws a portrait of the artist at work and opens windows into the lives of the community of Aberfan.

CHRISTOPHER MORRIS is Head of the International Film School, University of Wales, Newport, Wales. He has devoted his career to documentary filmmaking and over the past two decades he has also worked in radio and television documentary productions. A recurring theme in his work has been the changing nature of childhood and in 2000 he made *The Hallelujah Kids* for the BBC. He has won the Premios Ondas, RTS and BAFTA awards and prizes at the Celtic, Berlin and Chicago film festivals. In 2009 he won the Gold Award for Best Current Affairs Radio Documentary of the Association for International Broadcasting's Global Media Excellence Awards.

Behind This Convent (Inyuma y'ababikira)

Running time: 127 minutes
Director: Gilbert Ndahayo
Production year: 2007-2008
Production country: Rwanda

'In Rwanda, it is said "if one wants to be healed from the sickness, he must talk about it to the world". For twelve years, I lived with the remains of about two hundred unpeaceful dead in my parents' backyard. I wanted to tell the story of their death in the 1994 tutsi's genocide ... a story that has not been shown on film until now' (Gilbert Ndahayo). April 10th, 1994. Killers storm a convent in one of the small hill towns of Rwanda. They ransack the village and force people to march along the roadside where they select about 200 Tutsis from the group and proceed to execute them in a courtyard behind a convent. November 13th, 2007. Rwandan film actor and director, Gilbert Ndahayo, receives a letter. His father's killer is in a "gacaca" court to face charges of genocide. The screams from the backyard echo in his memory and Ndahayo's camera captures a hellish pit of death. This debut feature documentary is a profoundly intense and emotional journey into the Africa's first and the world's most intensive killing campaign in recorded history. This story is Ndahayo's testimony to the power of film and forgiveness.

GILBERT NDAHAYO was born in Rwanda to a lawyer-politician father and a teacher mother, and moved with his family to Kigali city when he had just turned seven. A decade after the genocide, Ndahayo finds himself as one of the emerging talents of Rwandan filmmaking, or "Hillywood". After intensive film training through the Swedish Institute in Rwanda and the Hollywoodian Mira Nair's film lab, his debut short drama *Scars of My Days* (2006) won the inaugural Rwandan film award. Other prize-winning films have subsequently toured at international festivals, including the prestigious Tribeca Film Festival in New York. Now, part of the large international Tutsi diaspora, Ndahayo currently resides in New Jersey, completing a novel and looking for an inspirational educational institution to further hone his digital filmmaking skills. He often speaks internationally to raise awareness about the horrors of genocide. Ndahayo's first feature *Behind this Convent* is regarded as landmark film about Rwanda's genocide. His compassionate and moving memoir both haunts the soul and inspires new hope. His new fiction film *If God was A Woman*, filmed on location in Rwanda, is in post-production and scheduled to be released in the United States in 2009.

The Day the Sun Was Lost

Running time: 20 minutes
Director: Minoru Maeda
Production year: 2002
Production country: Japan

This is an animated film made by the son of a Hibakusha, which deals with his father's experiences before and during the bombing of Hiroshima. Unlike many films made about the bombing, this film does not dwell on the bombing itself and its aftermath, but rather focuses on the daily life of the filmmaker's father as a child at play with his friends, in celebration of the last days his father was to know normal childhood. There was great conflict in the family as Maeda-san produced the film since his father wanted it to focus on the horror of the bomb. To the son, however, it is a film about his father as a child, which gives him back a few moments of the innocent childhood he was about to lose.

MINORU MAEDA is an artist, teacher and animator living in Hiroshima.

Detailing: Wrecking and Rubber Necking

Running time: 10 minutes
Director: Lezli-An Barrett
Production year: 2008
Production country: Australia

In 2007 I was invited to document the remains of a fatal road traffic accident. I had 24 hours to access the car wreck. My curiosity was aroused as I looked at the mangled metal; I was struck by my intense emotional response to this 'object of evidence'. I did not know the victims. I struggled with a sense of morbid fascination. I thought this must be the 'drive' for drivers to rubber neck an accident. I was drawn to look in detail at the remains of the car. I was reminded of Andy Warhol's 'death and disaster' paintings, especially his 'car crash' series. I returned the next morning with a small film crew and we explored every inch of the wreck. The experience differed from every other film shoot I had done before: this was death and the wreck described the fate of the two victims. The violence inscribed in the still metal wreck evoked again and again the speed and trauma of the impact and containing the map and narrative of events. We filmed in reverence in whispered tones. Unexpectedly, the sister of the driver visited the site as we filmed and the traumatic ramifications rippled out beyond the physical into the personal. This film consciously works in opposition to the desensitised saturation of 'car crash' representations in film, television and visual culture. The title refers both to the meticulous 'detailing' that occurs when a car is being valet

cleaned and to the film's production strategy.

LEZLI-AN BARRETT is a senior lecturer in Film and Television at Curtin University, Perth, Australia, and a PhD candidate at the University of Western Australia. Barrett is also an experienced film director and producer. A selected list of her film productions includes: *An Epic Poem* (drama/documentary, Channel 4 TV, UK), *Teamsters Rebellion, 1934* (documentary, Workers Education Association), *Miners' Strike* (documentary, Workers Education Association), *Madams* (drama, BBC, UK), *Business as Usual* (drama feature film, Warner Bros. and Channel 4 TV), *Understory: A Journey Through the Styx* (documentary, in postproduction).

Fascist Propaganda

Running time: 5 minutes
Director: Pablo Leighton
Production year: 2002
Production country: Chile

Experimental music video that visualises the song 'Adolfo, Benito, Augusto and Toribio' by the Chilean group *Fulano*. The video presents a portrait of the four dictators through a montage structure.

PABLO LEIGHTON was born in Santiago, Chile, in 1972. He has a BA in Journalism from Universidad Católica de Chile, and a MFA in Filmmaking from The Massachusetts College of Art, Boston. He is currently researching a doctoral thesis entitled 'A Culture of Audio-Visual Propaganda under Dictatorship and Democracy in Chile' at Universidad de Santiago, Chile. As part of his studies, Pablo was awarded an Endeavour Research Fellowship by the Australian government and a Chilean grant to spend a semester participating in conferences and

receiving supervision at various Australian universities. He has directed, written and edited several documentary and short fiction films.

The Forgotten

Running time: 40 minutes
Director: Glen Stasiuk
Production year: 2002

Production country: Australia

The Forgotten is a documentary film that tells the story of the Aboriginal & Torres Strait Islander men and women soldiers who fought and died for Australia during the wars of the twentieth century. The film focuses on the honour they felt representing their nation despite facing racial prejudices and not being classed as citizens of the country. The film also contains a personal story about four Nyungar brothers from the South-West of Western Australia, one of whom is acknowledged as the first Aboriginal Soldier to receive a military medal in the First World War. *The Forgotten* features war veterans and family members' personal memories of their experiences in both World Wars, as well as the wars in Korea, Vietnam, the Persian Gulf and East Timor. Writer, producer and director Glen Stasiuk was inspired by his Aboriginal family's history and the respect he feels for the ANZAC "black diggers". *The Forgotten* was honoured with the award for Best Documentary at the 2003 Western Australian Screen Awards.

GLEN STASIUK is a maternal descendent of the Minang Wadjari Nyungars (Aboriginal peoples) of the South-West of Western Australia, while his paternal family are emigrates from post-war Russia. His family's rich cultural background has allowed him, through his filmmaking with Black Russian Productions, to explore a diversity of cultures, knowledges and narratives. Stasiuk holds a Business degree from Edith Cowan University and a BA (Honours) from Murdoch University, Perth, Western Australia. Currently, Stasiuk is a media and cultural studies lecturer and the Director of the Kulbardi Aboriginal Centre at Murdoch University. Stasiuk is also the Managing Director of Kulbardi Productions, which is a media production house designed to document and archive Noongar culture, language and histories from an Indigenous perspective. "Ngulluk Wangkiny Koora, Yeye, Boorda" (We speak of yesterday, today and tomorrow).

Haunting Presences

Running time: 30 minutes
Director: Florencia Marchetti
Production year: 2007
Production country: Argentina/USA

Haunting Presences is a documentary that explores the silenced memories of families living in the margins of a big industrial city in Argentina. Under the worst environmental and economic conditions, they live in intimate coexistence with two sites of state-sponsored terrorism used by the military dictatorship: a clandestine detention and torture center, whose buildings now serve as a public school for the children of the nearby slums, and the city's largest public cemetery, where the bodies of murdered political detainees were illegally buried in mass graves. *Haunting Presences* deals with the visible and invisible traces of violent past experiences, through the eyes of a younger generation trying to make sense of the fear and silence they still encounter around them. A group of young high school students drive the story, trying to find out what happened to their own families, formulating questions that teachers and elders find hard to answer. Through the film's journey of discovery, we meet older folks telling ghost stories, while narrating the everyday aspects of state sponsored terror and its dire consequences. Florencia Marchetti, the film director, is herself part of this younger generation and thus her own story is threaded through a personal and meditative voice-over narration that offers both historical context and interprets the workings of social memory. Collaborating with highly marginalized communities, Marchetti puts her own political, cultural and technical capitals at work, striving to redistribute the power to exercise, produce and spread different versions of the past under military rule. *Haunting Presences* complicates prevailing public memories of that period and invites the involvement of a wider community in the interpretation of past traumatic events.

FLORENCIA MARCHETTI completed a degree in Social Communications and postgraduate studies in Anthropology at the University of Córdoba, Argentina. She finished an MA in Social Documentation at the University of California, Santa Cruz, in 2007. Additionally, Marchetti has worked as a photographer and ethnographer for many years, carrying out participatory research in Córdoba. *Haunting Presences* is the culmination of a series of collaborative enterprises using audiovisual tools, which started in 2001.

Hope

Running time: 104 minutes
Director: Steve Thomas
Production year: 2007
Production country: Australia

Hope began as a survivor's account of the SIEV X disaster in 2001, when a people smuggling boat sank on its way from Indonesia to Australia and 353 people perished. Amal Basry clung to a floating corpse as she watched women and children drown all around her. The film became a collaboration with Amal, who by this time was fighting for her life once again. *Hope*'s website: http://www.hopedocumentary.com.au/

STEVE THOMAS has been making independent documentaries for nearly 20 years. He lectures in documentary making at The Victorian College of the Arts, University of Melbourne (http://www.vca.unimelb.edu.au). His film work has received numerous awards, including an AFI Award and a United Nations Association Media Peace award. Some of his film titles include: *Black Man's Houses, Harold, Errands of Mercy, Least Said Soonest Mended, Welcome to Woomera*, and most recently *Hope*. For Steve Thomas's CV go to: www.hopedocumentary.com.au

Inside Stories: Memories from the Maze and Long Kesh Prison

Running time: 4 x 30 minutes
Director: Cahal McLaughlin
Production year: 2005
Production country: Northern Ireland

Inside Stories: Memories from the Maze and Long Kesh Prison is a 4-part documentary that explores how traumatic memory finds a narrative, how this is informed by location, how participants perform while being recorded, and how ownership of the material influences authorship. The film documents the memories of three ex-occupants of the political prison-complex in the North of Ireland during the Troubles—a republican ex-prisoner, a loyalist ex-prisoner, and a prison officer—who return to the now empty prison. The film also depicts the reminiscences of two Open University teachers who retrace their car journey to the prison, where they had taught Art History and Women's Studies. The interviews are open-ended and the physical characteristics of the prison are used to stimulate memories and guide the narratives of the three participants. The film was shown as a four-screen installation at Catalyst Arts, Belfast, in April 2005, and London South Bank Digital Gallery, in December 2005. It was screened as a single film at the Imperial War Museum, London, in

September 2005, and at Constitution Hill Gallery, Johannesburg, in February 2006. *Inside Stories* was also broadcast as four separate programmes by Northern Visions Television, Belfast, in September 2005.

CAHAL MCLAUGHLIN is a senior lecturer at the School of Media, Film and Journalism at the University of Ulster. A documentary filmmaker with almost 20 years of broadcast and community production experience, he has most recently directed *Inside Stories: Memories of the Maze and Long Kesh Prison* (Catalyst Arts 2005) and *We Never Give Up* (2002) for the Human Rights Media Centre, Cape Town, on Apartheid reparations in South Africa. McLaughlin's writings include: 'Telling Our Story: Recording Audio Visual Testimonies from Political Conflict' in R. Barton and H. O'Brien, eds. 2004. *Keeping It Real: Irish Film and Television*, London: Wallflower Press, and 'Touchstone and Tinderbox: documenting memories inside the North of Ireland's Long Kesh and Maze Prison' in J. Schofield, A. Klausmeier and L. Purbrick, eds. *Re-mapping the Field: New Approaches in Conflict Archaeology*. McLaughlin is director of the Prisons Memories Archive (http://www.prisonsmemoryarchive.com), which is a record of over 200 interviews from the North of Ireland's political prisons, and he is the Chair of the Editorial Board of the *Journal of Media Practice*.

"I" PTSD

Running time: 20 minutes
Director: Randall Burton
Production year: 2006
Production country: USA

"I" PTSD explores Intergenerational Post Traumatic Stress Disorder from the personal and clinical perspectives of two survivors and three clinicians. The film includes a text/musical prologue that provides a socio-economic overview and introduces the key issues. This is followed by participant insights about a neglected aspect of what is termed Complex PTSD. Visual imagery is juxtaposed to the *tellstory* as a meta-narrative to suggest historical and psychological elements. Finally, there is a brief epilogue about the participants' current and future plans. This work was developed as a study film rather than a finished program for public distribution. The clinicians and organizations involved with its development do, however, plan to produce a long-form presentation when certain medical/treatment modalities that are now in trials have been approved for clinical use.

RANDALL BURTON's parents were both World War II survivors, who died prematurely from complications of trauma-spectrum mental illness by the time he was 12 years old. After his mother's death in 1968, Burton was placed in a California "boys home," where he was beaten, tortured, raped and psychologically terrorized by mentally ill Vietnam Veterans for two years. At age 15, Burton was a runaway with a "dissociative" disorder. He joined the U.S. Navy at age 17. After a series of extreme events in Vietnam during the 1975 evacuation effort, Burton was medically discharged from the U.S. Navy. Thereafter, he pursued several failed careers in journalism, radio, television and writing. During those troubled years, he also produced several "street" documentaries about social change, some of which were exhibited on American Public Television and academic venues. Despite modest gains as a media maker, Burton experienced a severe physical and psychiatric crisis in 1999. After lengthy hospitalizations, Burton was medically "retired" by the U.S. Veteran's Administration due to chronic spinal, head and psychiatric distress. In 2003, after being diagnosed with what has been termed Complex PTSD, he began an exploration of his condition as part of his efforts to recover and help others who similarly suffer. These efforts resulted in the *IPTSD* film, which premiered at the 2006 Annual Conference of the International Society for Traumatic Stress Studies in Los Angeles. Since then, Burton has returned to documentary production, including his current project about a 90 year-old Quaker peace activist named Pauline Hare of Salem, Oregon.

Least Said, Soonest Mended

Running time: 52 minutes
Director: Steve Thomas
Production year: 2000
Production country: Australia

Least Said, Soonest Mended is the story of my twin sister, Val, who in the 1960s became an 'unmarried mother' and was coerced to give up her baby for adoption. Val has suffered ever since. At the time of filming resolution appeared possible, when her adopted daughter contacted her after 33 years.

STEVE THOMAS has been making independent documentaries for nearly 20 years. He lectures in documentary making at The Victorian College of the Arts, University of Melbourne. His film work has received numerous festival awards, including an AFI Award and a United Nations Association Media Peace award. Some of his film titles include: *Black Man's Houses, Harold, Errands of Mercy, Least Said Soonest Mended, Welcome to Woomera*, and most recently *Hope*. For Steve Thomas's CV go to: www.hopedocumentary.com.au

Liyarn Ngarn (The Spirit of Coming Together)

Running time: 67 minutes
Director: Martin Mhando
Production year: 2007
Production country: Australia

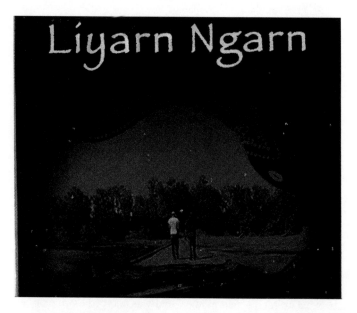

Oscar nominee Pete Postlethwaite (*In the Name of the Father, The Constant Gardener*) has been coming to Australia since 2003 and is again on his way but this time he is trying to understand why this country keeps drawing him back. In this documentary, Postlethwaite's quest to comprehend the contradictory relations he finds amongst people who love Australia so dearly, and yet are so frustrated by its politics, is facilitated by singer-writer Archie Roach and Pat Dodson, the "father of Aboriginal reconciliation".

MARTIN MHANDO, born in Tanzania, has lived in Australia for over 20 years. He has directed 3 feature-length, award-winning fiction films: *Yombayomba* (1985), *Mama Tumaini* (1986), and *Maangamizi* (2000). *Liyarn Ngarn* is his first major documentary. Mhando received the Paul Robeson Award at the Newark Film Festival in 2004 and *Maangamizi* was Tanzania's nomination to the Academy Awards in 2001. He completed his PhD with a dissertation on African cinema and is currently an academic with Murdoch University, Western Australia, as well as a researcher in African cinema.

Memory Cages

Running time: 9 minutes
Director: Rachel Wilson
Production year: 2002
Production country: Australia

Aesthetically referencing the 1960s avant-garde, *Memory Cages* is a personal art film that portrays memory, trauma and psychological compartmentalisation. In three scenes set in a single room, the film visually illustrates the emotional landscapes of unrequited love, sibling rivalry and frustrated anger.

RACHEL WILSON lectures in media production at the School of Media and Communication at RMIT University, Melbourne, Australia. As a screen practitioner, Wilson has worked on several documentaries, features, shorts and TVCs. In addition, she is actively involved in screen culture in Melbourne, sitting on public boards, such as the selection panel for short documentaries for the Melbourne International Film Festival. In 2010 Wilson is the national President of ASPERA (Australian Screen Production Education and Research Association).

Neir Chi Puj (Educated Girls)

Running time: 10 minutes
Director: Anne Harris
Production year: 2008
Production country: Australia

Neir Chi Puj (Dinka for "Educated Girls") is a short documentary that features Lina Deng, a 21-year old Sudanese-Australian young woman living in Melbourne, who talks about education in Australia: what is working, what is not, and what could make it better. Having finished her VCE in 2007, Lina reflects on her life and educational experiences since arriving in Australia in 2004, and where she is heading in the future. *Neir Chi Puj* was filmed collaboratively by Anne Harris and Lina Deng.

ANNE HARRIS holds a PhD from Victoria University, Melbourne, Australia, where she is also a Lecturer in Creativity and the Arts in the School of Education, focusing in the areas of arts in education, performativity of identity, and critical pedagogy, about which she has published extensively. Her creative doctoral thesis, *Cross-Marked: Sudanese Australian Young Women Talk Education*, is a series of seven short ethnocinematic films co-created with and about Sudanese young women and their educational experiences in Australia. Harris is also a

playwright, videographer and musician and is currently an artistic associate of the Pumphouse Theatre (Melbourne). She received her MFA at New York University, where she studied with Tony Kushner and Arthur Miller, among others. She has been active in theatre and community arts for over 25 years, and has been a teacher for over fifteen.

News Media & Trauma: Stories from Australian Media Professionals about Reporting Trauma

Running time: 20 minutes
Director/Producer: Cait McMahon & Brett McLeod
Production year: 2008
Production country: Australia

Evidence shows that news gatherers, such as journalists, photographers, and sound and production crew, who are exposed to potentially traumatic events can experience significant emotional effects. What is also known is that media professionals are very resilient. This educational documentary, produced by the Dart Centre for Journalism and Trauma, Australasia, seeks to facilitate discussion about issues pertaining to work-related trauma exposure for media workers. The film is part of a training program to enhance the resilience of journalists by helping them become trauma literate. Trauma literacy contributes to understanding the importance of self care, but also potentially enables more ethically sensitive interviews, thus ultimately creating better news stories. The film contains a series of interviews with working news professionals who share candidly their personal reactions when covering traumatic incidents.

CAIT MCMAHON is a psychologist, specialising in trauma response in news media personnel, and the Managing Director of the Dart Centre for Journalism and Trauma, Australasia (www.dartcentre.org). McMahon has presented both nationally and internationally on this topic and has undertaken extensive research with journalists, editors, film, and sound and camera crews to assess the impact of trauma effects within the industry. McMahon has a special interest in examining outcomes of trauma that contribute to wellness as well as psychological injury, utilising the concept of 'post-traumatic growth'.

BRETT MCLEOD joined Melbourne's leading talk station 3AW as a cadet in 1984, and within a few years took on the role of News Director. Since joining *National Nine News* in 2000, McLeod has covered stories

taking him from the war in Iraq to the Asian tsunami. In 2002 Brett was posted to *Nine*'s European bureau. His major stories reflected the main theme of this era, terrorism, and included reporting on the spot for attacks in Israel, Madrid and Istanbul. He was in Baghdad shortly after the arrival of US forces in 2003. After returning to Melbourne at the end of 2004, McLeod was sent to an event of unprecedented scale: the Boxing Day Tsunami. He spent two weeks covering the appalling devastation. Since then his stories have ranged from the Kerang train crash to the 2006 war in Beirut. McLeod continues to combine reporting with news reading for *Nine*.

Oranges

Running time: 20 minutes
Director/Producer: Sivamohan Sumathy
Production year: 2006
Production country: Sri Lanka

Bombs go off and news of the war pours in. There has been a civil war in Sri Lanka between the state and minority Tamil militants, the LTTE, for the past 20 years. *Oranges* explores the relationship between a middle class Tamil woman and a Sinhala man, set in the city of Colombo, in the backdrop of the war and the ethnic conflict.

SIVAMOHAN SUMATHY is attached to the Department of English, University of Peradeniya, Sri Lanka. She has an interest in critical theory, including Marxism and Feminism, performance studies and film theory. She is also a theatre activist, script writer and film director. Her theoretical and creative work focuses on the nation state and militarism, women's expression of displacement, survival and resistance, as well as film, media and theatre practice. Sumathy has also been involved in bringing different ethnic communities together in dialogue in Sri Lanka.

The Outer Limits of Read-ability

Dirk de Bruyn's 20-minute performative screening involves 3 simultaneous 16mm film projections and a live performance of sound poetry that addresses issues of traumatic effect and affect. *The Outer Limits of Read-ability* extends the concerns of my earlier film, entitled *Traum A Dream* (Australia, 2003), into the immediacy of the performance situation. *Traum A Dream* has been described as "a representation of traumatised space, depicting a person who is consumed by a body of pain in which slowly something is remembered." *The Outer Limits of Read-ability* enlists the strategies of experimental film, direct cinema, and punk, while invoking Artaud's notion of "cruel performance". *The Outer Limits of Read-ability* extends a series of presentations including: *Audiopollen*, Brisbane, July 2007; *Undue Noise*, Bendigo, October 2007; *Intermission* at GreySpace, Melbourne, November 2007; *OtherFilm Festival*, Brisbane, November 2007; and *Horse Bazaar*, Melbourne, February 2008. Further thoughts on the placement of my performance work is available in: Dirk de Bruyn (2008) 'Fractured Urban Memories' in T. Mehigan, ed. *Frameworks, Artworks, Place: The Space of Perception in the Modern World*, Amsterdam; New York: Rodopi; and in S. McIntyre (2008) 'Theoretical Perspectives on Expanded Cinema and the "Cruel" Performance Practice of Dirk de Bruyn' in *Senses of Cinema*, Issue 48, January-March 2008 (http://www.sensesofcinema.com/contents/08/46/dirk-de-bruyn.html)

DIRK DE BRUYN is a lecturer at the School of Communication and Creative Arts, Deakin University, Melbourne, Australia

Pareliya

Running time: 66 minutes
Director: Priyantha Kaluarachchi
Production year: 2006
Production country: Sri Lanka

This film was made on a shoe-string budget with one hand-held digital camera operated by self-taught documentary filmmaker Priyantha Kaluarachchi. Using the backdrop of the Commission of Inquiry held into the train disaster that killed 1,500 persons at Pareliya, Sri Lanka, during the 2004 tsunami, this documentary explores the complex emotions and political vision of a young man who, having survived the over-turning of the train and lost his wife of a few months, went on to form a dynamic protest group that succeeded in lobbying the state to appoint a Commission of Inquiry.

PRIYANTHA KALUARACHCHI is a member of the South Asia Documentary & Film Net in Sri Lanka. He has directed fiction films and documentaries both independently and as freelance. Previously he worked at Young Asia Television in Sri Lanka and was a member of the Sirisa TV production team, winning the Best Television Documentary and the Best

South Asian Television Program awards. Since 2005, Priyantha has
directed two documentaries: *Sri Lankan Women in Buddhism* and
Pareliya. The latter has screened in international film festivals, such as
Talent Campus in India, Talent Campus in Berlin and Cinerail in Paris.

Piralayam (Upheaval)

Running time: 18 minutes
Director/Producer: Sivamohan Sumathy
Production year: 2006
Production country: Sri Lanka

In the war-torn East of Sri Lanka a mother is caught between warring
parties as she tries to retain her only daughter. In the meantime, the
goddess of the sea waits in the wings. The drama is played out in the
backdrop of the tsunami that hit the coast of Sri Lanka on the 26th of
December, 2004.

SIVAMOHAN SUMATHY is attached to the Department of English,
University of Peradeniya, Sri Lanka. She has an interest in critical theory,
including Marxism and Feminism, performance studies and film theory.
She is also a theatre activist, script writer and film director. Her theoretical

and creative work focuses on the nation state and militarism, women's expression of displacement, survival and resistance, as well as film, media and theatre practice. Sumathy has also been involved in bringing different ethnic communities together in dialogue in Sri Lanka.

A Silence Full of Things

Running time: 7 minutes
Director: Alejandra Canales
Production year: 2005
Production country: Australia

A Silence full of Things is a short and stylised documentary that travels through a woman's sensorial memories of political torture. Political torture continues to be practiced by states around the world. As spectators, most people can look away or turn off its images. Others live with marked bodies and memories triggered by everyday smells, sights, and sounds.

ALEJANDRA CANALES is a Chilean-Australian artist who has lived in Sydney since 1998 after practicing theatre in Chile for over 8 years. Canales's work is predominantly concerned with the social and political dimensions of artistic practice. In 2004 Canales received a scholarship to complete the MA Honours Documentary Directing course at the Australian

Film, Television and Radio school (AFTRS), where she directed two documentaries: *Switch On the Night*, which has received awards nationally and internationally, and *A Silence Full of Things*, which received a special mention for best documentary at the 4th Australia-Japan Student Film Forum. Currently, Canales is a recipient of a scholarship at the University of Western Sydney as a Doctorate of Creative Arts candidate and she is developing a feature length documentary.

Stacking

Running time: 7 minutes
Director: Vicky Smith
Production year: 2006
Production country: UK

Stacking is a 16mm film in which I use the technique of direct liquid animation as a means of stacking up images of bodies. Psychological states are expressed through the body's distortion as themes of damage, conflict and tension are worked through the material. Additionally, I perform my voice and make audible the sounds of the body in the physical process of painting, filming and struggling with matter. The atmosphere of dirt and decay is emphasised by the heightened use of film 'noise', while 'found' sound extends the language of inseparability between individual

and environment. *Stacking* investigates the immediate physical registration of expression offered by camera-less film, whereby the somatic veracity of the film strip as a physical object allows Smith to explore a discourse close to the body and the emotions.

VICKY SMITH is an artist active in research into experimental animation. She currently teaches Film Studies at the University of West England. Recent exhibition of her work includes: camera-less animation performance in *The Act of Drawing on Screen* at Vivid Media Arts, Birmingham (2009); *Kino Pixel: Exploding the Image*, Herbert Gallery, Coventry (2008); *Interrogating Trauma* Conference, Curtin University, Perth, Australia (2008); *Retrospective of Wilhelm Reich*, Jewish Museum, Vienna (2008). Recent academic activities include: principal convener of *Animation Deviation*, a UWE symposium for artists researching into theories of animation motion (2010). Recent publications include: 'A Report on the Act of Drawing on Film' in *Journal of Media Practice* (2010); 'Stopping Motion in *Stages of Mourning*' www.luxonline.org.uk/ articles/stopping_motion_in_stages_of_mourning(1).html (2007); 'Moving Parts' in *Experiments in the Moving Image*, ed. J. Hatfield (2006).

Stages of Mourning

Running time: 17 minutes
Director: Sarah Pucill
Production year: 2004
Production country: UK

Ritualised through performance to camera, *Stages of Mourning* is Pucill's film journey of bereavement, in which the artist orders image fragments of her late lover and collaborator Sandra Lahire. As a meditation on coming to terms with loss, the film explores how our relationship with the dead is made different through film. By trying to physically immerse herself into photographs and film footage and by restaging these, Pucill forms a continuous stream of the life of two lovers. Through this doubling and layering, illusions accumulate as if these were the product of a machine that doesn't stop. The film was shot on 16mm and is distributed by Lux (London), Canyon Cinema (San Francisco), and CFMDC (Toronto).

SARAH PUCILL lives and works in London and has been a senior lecturer at the University of Westminster since 2000. Her film work is distributed through Lux, The British Film Institute (BFI), British Council, New York Film-Makers' Cooperative, Canyon Cinema, the Canadian Filmmakers Distribution Centre (CFMDC) and Light Cone Paris. Pucill's films and photographs explore the mirroring and merging we seek in the Other and are concerned with the idea that as subjects we are not separate. Pucill's works have been shown at major international film festivals, including: London Film Festival, Oberhausen Short Film Festival, Ann Arbor Film Festival, Osnabruck Media Arts Festival and Montreal Festival of New Cinema. Television broadcasts include: SBS TV Australia (*Mirrored Measure*, 1996), Carlton Television (*Backcomb*, 1995), Granada

TV (*You Be Mother*, 1990). *Taking My Skin* was recipient of the *Marion McMahon Award* at the Images Festival in Toronto 2007 and, together with *Stages of Mourning*, received a Director's Citation from the Black Maria Film Festival. *Taking My Skin* was also shown as part of 'Mother Cuts: Experiments in Film, Video & Photography' at New Jersey University Gallery in 2008. *You Be Mother*, Pucill's award winning film (Best Innovation, Atlanta, 1995; Best Experimental Film, Oberhausen, 1991) was exhibited in 'A Century of Film and Video Artists' (2004) at Tate Britain, where her work has also enjoyed retrospective screenings, and in 'A History of Artists Film and Video' (2007) at BFI, Southbank. Her recent film *Blind Light*, premiered at Millennium Film, New York in 2007, screened at the Star and Shadow in Newcastle and at the European Media Art Festival in 2008. Pucill's essay 'The Autoethnographic' was published in *An Anthology of Experimental Film and Video*, edited by Jackie Hatfield (London: John Libbey, 2006).

Tales from the South

Running time: 21 minutes
Director: Antonio Traverso
Production year: 1997
Production country: Australia

Tales from the South is a fragmented, visual and poetic film representation of an exiled Chilean woman's memory of her ordeal at the hands of the torturers of the military dictatorship. As she writes an allegory of self-discovery against a mythical landscape, her flashbacks are layered with elements of both her story and her self-reflexive thoughts about her current condition. *Tales from the South* received financial support from the Australian Film Commission and won the Second Place in the experimental category in the 1997 *Nextframe* International Film Festival, Philadelphia, USA. It has been screened in Australia, Chile, UK, and USA.

ANTONIO TRAVERSO is a Senior Lecturer in Film and Television studies with the School of Media, Culture and Creative Arts at Curtin University, Western Australia. As a film practitioner, he has written, directed and produced several short experimental and documentary films. He was born in Santiago, Chile, where he also studied a university degree in philosophy in the early 1980s. He has lived in Australia since 1987. Traverso was co-convenor of the *Interrogating Trauma* conference.

APPENDIX B

VISUAL ART EXHIBITION

After the London Incidents/Protests at Plaza de Mayo (Panizza Allmark)

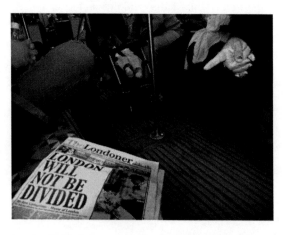

This collection is divided into two photographic series that explore sites, scenes and sensations of trauma in two cities and the reconstruction of public space under terror and fear. The first photographic series, *After the London Incidents*, highlights the 'culture of fear' in Britain, in the wake of the London bombings of 7/7. The photographic exploration documents the sense of unease and tension within the first few weeks after the terrorist attacks and after the brutal shooting of an alleged suspect in the London underground. The photographs are a subjective response to media reports. They explore the vicarious trauma related to the constant sensational media coverage and the litany of alarmist evocations. The second photographic series, *Protests at Plaza de Mayo*, draws attention to Plaza de Mayo, Buenos Aires, Argentina, making visible the signs of protest of a group of mothers and grandmothers and their supporters who have gathered in the square every Thursday since 1977. As an urban public

space, Plaza de Mayo is central to the cultural history of the city, being the site of a long history of demonstrations since the Peronist era. The civic heart is haunted by the cultural memory of violent death, trauma and terror. The mothers and grandmothers of Plaza de Mayo have been staging marches around the square for over thirty years in a solemn protest, asking for answers about their missing children, who were kidnapped by the military. The extent of the state-run terrorist campaign was vast, with over 30,000 victims, including a few of the defiant women of Plaza de Mayo.

PANIZZA ALLMARK holds a PhD in Media Studies from Edith Cowan University, Western Australia, and has been a documentary photographer for over 10 years. She has had seven solo exhibitions and numerous group exhibitions both locally and internationally, including New York (2007) and Urbino, Italy (2006). Concerned with media depictions of the body, gender and the city space, her visual work is represented in the art collections of Parliament House in Western Australia.

Exhale
(Mick Broderick)

This digital video installation combines video projections with text and ambient sound in response to the filmmaker's visit to Rwanda in 2007. What comes to mind when we contemplate genocide? Is it ever possible to represent mass trauma? What are the limitations to artistic presentation, mediation and meditation? *Exhale* is an attempt to approach and evoke the 'unrepresentable'. The (mostly) static digital video camera used here records stillness and tranquillity at places that 'paradoxically' endured sustained violence and atrocity. A series of vignettes, either as multi-

screen or linear looped after 35 minutes, captures both human interaction and nonhuman indifference at urban and rural trauma sites in Rwanda's capital city Nyamata Catholic Church, Bugesera, and the Kigali Memorial Centre. Yet these spaces somehow remain outside time with a distinct ambience and aura. Pilgrims and curious tourists come and go. Seemingly oblivious to the catastrophic milieu, life goes on. At tropical dusk, amid places of unimaginable slaughter and brutality, the ochre brickwork diffuses and absorbs the haemorrhaging signs of assault. In the brief twilight of evensong, African birds warble and cackle, schoolchildren play their street games, disembodied voices trail off, far away noises and incongruous sounds of motorbikes, cars and trucks erupt, disrupting the lilting cadence of birdsong, squeals of joy and peels of laughter, while roosters crow, and daily life ebbs and flows, with all its ambivalence and antipathy. Be patient. Take your time. Bare witness.

MICK BRODERICK is Associate Professor in the School of Media, Communication & Culture at Murdoch University. He has written extensively on the cultural and media representation of the nuclear era and the apocalyptic. He was co-convenor of the *Interrogating Trauma* conference.

Never Again
(Thomas Delohery)

In the past I have dealt with such subjects as The Killing Fields in Cambodia and the war in the former Yugoslavia in the early 1990s. Since 1997 my work has mostly been about the Holocaust. In this exhibition I include pieces that firstly deal with the Holocaust in Europe before and during WWII. After the war, the United Nation's words were, "Never Again". Yet, it did happen again in the *killing fields* of Cambodia, where the Kymer Rouge learned from the Nazis by using the very same SS Torture Manual and even photographing many of their victims before execution. I also show pieces related to the former Yugoslavia, where it was deemed that there was a lot of unfinished business to do in the 1990s that stemmed back from the Second World War. A lot of bloody, unfinished business, I might add. Here again we saw internment and killing camps, just like in the Holocaust. The only difference was that the victims were Muslim rather than Jewish. We don't see these camps in black and white anymore, now we see them in full colour. The emaciated figures behind the barbed wire now don't have blue and white striped clothes, they have jeans like you and I. Thus, the work in this exhibition is three-fold: the horrors of the Nazi Concentration Camps in full colour; the black and white and grey images of similar scenes in camps in the former Yugoslavia; and finally black and white ink drawings of men, women and children, numbered and photographed, just before they are executed in Cambodia's infamous Torture Centre in this county's capital city. I include images of child soldiers recruited by the Kymer Rouge and brainwashed into doing unspeakable things. I also show images of refugees, which is a common fallout and sad fact of life caused by these horrific conflicts.

THOMAS DELOHERY (B.A., M.F.A. and Clare Artist) was born on the 2nd June 1971. He studied both at The National College of Art and Design in Dublin and at The University of Ulster in Belfast. He has a First Class Honours B.A. Degree in Fine Art Painting, received in 1993, and a Masters in Fine Art, received in 1997, both from the University of Ulster in Belfast. In 2004 he successfully completed 140 hours in Holocaust Studies for Educators at Yad Vashem, the International School for Holocaust Studies, Jerusalem. In 2005 he completed a 2-week seminar in Poland and Lithuania in Holocaust Studies for Educators run by Yad Vashem, Jerusalem. There is a growing file on Delohery's work in the Holocaust Art Research Centre in Yad Vashem. Delohery has visited most of the infamous Concentration, Killing and Slave Labour camps of Europe: Auschwitz I, Birkenau, Dachau, Flossenbürg, Belzec, Majdanek, Treblinka, Sobibor, Terezin, and Stutthof, as well as sites of massacres, partisan hideouts, former Ghetto areas and Schindler's Emalia Factory. In

2004 he travelled to Israel to do a series of one-on-one interviews with Holocaust Survivors. Delohery's trip to exhibit and participate in the Conference "Interrogating Trauma" was supported by The Arts Council of Ireland (www.artscouncil.ie). His proposal was kindly supported by Suzanne Bardgett O.B.E., Director, Permanent Holocaust Exhibition, Imperial War Museum,London (www.iwm.org.uk); Ben Barkow, Director, The Wiener Library, Institute of Contempory History, London (www.wienerlibrary.co.uk); and Holocaust Suvivor Judy Cohen, Toronto, Canada (http://wowenandtheholocaust.com). Delohery's personal website is www.thomasdelohery.com.

Rosario Rettig
(Paula Cristoffanini)

This installation (2005-2008) is Cristoffanini's attempt to understand the tragedy that befell her country of origin, Chile, and render the human right abuses perpetrated there during the 17-year military rule of Augusto Pinochet more visible. The piece is inspired by the work of British sculptor and installation artist Cornelia Parker, who seeks to elucidate

difficult matters and events through the manipulation of objects that trigger cultural metaphors and personal associations, which allow the viewer to transform ordinary objects into something both compelling and eloquent. *Rosario Rettig* consists of a "rosary" made of blood red crystal beads, in the shape of blood drops, one for each of the 2279 persons who died or disappeared as a result of human rights abuses between 1973 and 1990, as recognised by Chile's National Commission for Reconciliation's Rettig Report. The rosary is gathered on a slab, referencing a mortuary slab, in the shape of a blood stain. It is a sculptural piece with a continuous video projection of the names of the dead and disappeared.

PAULA CRISTOFFANINI was born and raised in Chile. She has lived in Australia since 1970, mostly in Perth. Among the influences in her work are her mixed Chilean and Italian heritage, her experiences as an immigrant, and as a woman in changing times. Paula has had a long-standing interest in the visual arts having had her first training in the area as a young university student in Chile. Paula brings a wealth of experience to her practice. After completing a university degree in Psychology in Australia, Paula joined the public service where she worked in immigration, multicultural affairs and refugee assessment and in the area of women's interests. She recently completed an Advanced Diploma in Visual Arts (Perth Central TAFE), majoring in sculpture.

When Places Have Agency: Traumascapes, Temporality, Memory, and Memorializing (Alexandra Opie)

Using material accumulated through joint research with Catherine Collins, *When Places Have Agency* is a multi-channel video installation artwork that meditates on the theme of vernacular memorials. Image and sound collected are mined for elements to create atmosphere. Experimental sound artist Bob Ostertag explored the potent use of re-editing sound recorded at the site of a burial in his 1991 work *Sooner or Later*. This installation pursues a similar exploration that in this case extends into image as well as sound. The installation allows viewers to confront tragedy and healing as evident in private memorials in public spaces. In my work I am interested in creating for viewers a feeling of actual time and space, an experience of artwork as presence rather than representation. Through large-scale video installation, I work with time-based media to create a direct physical experience for an audience through an unfolding set of images and sounds. Themes I explore in my artwork include

tragedy, memory, sense of place, and surveillance.

ALEXANDRA OPIE is Assistant Professor of Art at Willamette University. She teaches video art, installation and photography. She received her Masters in Fine Arts in video art from the School of the Museum of Fine Arts, Boston, in 2000. Her artwork has been exhibited at museums and galleries in the United States: Boston, Chicago, New York, Portland, Salem, and San Francisco. To see examples of Opie's earlier artwork, such as the 1999 series of digital photographs entitled *Burn*, please visit www.alexandraopie.com

Deconstructing Barriers
(Elena Stöhr)

Stöhr's photographs focus on the personal and aesthetic effects of breast surgery upon the body. By documenting one of her tumor surgeries, Stöhr seeks to explore the relationship with her own body and to find an outlet

for healing in art. *Deconstructing Barriers* approaches illness as a silenced, unspeakable topic that needs to be talked about.

ELENA STÖHR lives in Berlin, Germany. She received her MA in English, Scandinavian and Finnish Language and Literature Studies from the University of Cologne in 2008. During the past ten years, Stöhr has edited and published a number of *zines* and has been involved in art projects, including the DIY shop collective *Craftista*. Her future plans include a dissertation about *(grrrl)zines* in the United States, trauma and life writing, as well as small press publications and photography exhibitions across the globe.

CONTRIBUTORS

Mick Broderick is Associate Professor and Research Coordinator in the School of Media, Communication & Culture at Murdoch University, where he is Deputy Director of the National Academy of Screen & Sound (NASS). His major publications include editions of the reference work *Nuclear Movies* (1988, 1991) and, as editor, *Hibakusha Cinema* (1996, 1999). *Recent co-edited collections with Antonio Traverso include Interrogating Trauma: Arts & Media Responses to Collective Suffering (Routledge, 2010) and the special issue* 'Arts and Media Responses to The Traumatic Effects of War on Japan', *Intersections: Gender and Sexuality in Asia and the Pacific*, No. 24, June 2010. A screen producer and curator, Broderick's new media installation on the Rwandan genocide, *Exhale*, was selected for the Perth International Film Festival in 2007 and his curated exhibition of cold war material culture artefacts, *Atomicalia*, was on show at museums in Hiroshima during 2009. As writer, co-editor and co-producer, his documentary *Messages of Hope* screened before over 20,000 genocide survivors at the Rwanda National Stadium during the 16th anniversary commemorations in April 2010.

Dirk de Bruyn has made numerous experimental, documentary and animation films and new media interactive work over the last 30 years and has continued to maintain a no-budget, independent, self-funded focus for much of this work. He has written about and curated various programs of film and video art internationally and written extensively about this area of arts practice. In the early 1990s de Bruyn lived in Canada and taught Animation at Emily Carr College of Art and Design in Vancouver. He currently teaches Animation and Digital Culture at Deakin University, Burwood, Australia.

Katrina Clifford is a freelance journalist and editor, currently completing a PhD at the University of Canberra, Australia. Her research interests include the representation of mental illness by the media; the politics of police use of force; media ethics and visual framing; and collective memory and trauma recovery. She holds a Masters of Research (Media and Communications) from Goldsmiths College, University of London.

Pauline Diamond is a freelance journalist specialising in social issues and human rights reporting. She writes for a number of UK newspapers and magazines.

Dr Giorgia Doná is Reader at the University of East London, where she teaches Refugee Studies and Anthropology and also researches trauma, culture and wellbeing; conflict and post-conflict; and children and displacement. She Guest Edited the Special Issue "Refugee Research Methodologies", *Journal of Refugee Studies* (2007, with Voutira) and the Themed Issue "Child and Youth Migration: Changing Trends and Responses", *International Journal of Migration, Health and Social Care* (2006).

Glen Donnar teaches in the School of Media & Communication at RMIT University, Melbourne, Australia. Glen is also a doctoral candidate, exploring representations of masculinity in contemporary American cinema. He has published work on the mediation of terror in *Media International Australia* and *ACCESS: Critical Perspectives on Communication, Cultural & Policy Studies.*

Dr Sallyanne Duncan is programme director of the MLitt degree in Journalism at the University of Strathclyde, Glasgow, Scotland. She worked for many years as a journalist in the Scottish local press before becoming an academic. Her research focuses the reporting of events involving trauma, bereavement or anxiety.

Dr Stephen Goddard lectures in the School of Communication and Creative Arts at Deakin University, Melbourne, Australia. His research interests include historical and contemporary documentary, experimental and auto/biographical screen practices.

Dr Lindsay Hallam teaches film studies at Curtin University, Western Australia. Her work has appeared in *Senses of Cinema, Asian Cinema* and the *Bright Lights Film Journal.* She is currently working on a book that applies the philosophy of the Marquis de Sade to transgressive cinema.

Anne Harris is currently a Lecturer in Creativity and the ARts in the School of Education at Victoria University, Melbourne, Australia. Her research focuses on the areas of transnationalism, performativity of identity, and ethnocinema. She has worked as a playwright, dramaturg and composer in Australia and the USA, and as a script assessor and workshop

leader for several companies in New York and Australia. She was co-founder and artistic director of LEND Theatre in New York, and teaching artist for the American and Central Australian Young Playwrights' Festivals. She holds an MFA in Dramatic Writing from New York University.

Dr Jennifer Harris is Head of Cultural Heritage at Curtin University in Western Australia. She is an executive member of the Australian National Committee for the International Council of Museums (ICOM) and is an active member of ICOFOM, the International Museology committee of ICOM. Her research interests include popular culture, heritage and museology.

Dr Sue Joseph is has been a journalist for thirty years. She currently teaches in the journalism and writing programs at the University of Technology, Sydney. Joseph has written two books: She's my wife, He's just sex and; The Literary Journalist and Degrees of Detachment: An Ethical Investigation. She is working on her third about Australian Creative Non-fiction writers.

Lee-Von Kim is a doctoral candidate in English and Cultural Studies at the University of Western Australia. Her thesis examines the legacies of historical trauma in visual cultural productions by Kara Walker, Clara Law, Tracey Moffatt and William Kentridge. Her research interests include postcolonial literature, critical theory, trauma studies and film studies.

Sarah Leggott is Associate Professor of Spanish at Victoria University of Wellington, New Zealand. Her research interests focus on twentieth-century Spanish literature and culture, with a particular interest in women writers and autobiographical narratives. She is the author of *History and Autobiography in Contemporary Spanish Women's Testimonial Writings* (Edwin Mellen Press, 2001) and *The Workings of Memory: Life-Writing by Women in Early Twentieth-Century Spain* (Bucknell University Press, 2008), and has also published articles on twentieth-century Spanish women writers.

Anna Papaeti holds a PhD from King's College London. She has published on nineteenth- and twentieth-century opera, Lacanian psychoanalysis and political music. She worked at Royal Opera House, London, and as Associate Dramaturg at Greek National Opera. In 2010 Papaeiti is a

DAAD post-doctoral fellow, researching the postwar works of Hanns Eisler at the Universität der Künste, Berlin.

Antonio Traverso is Senior Lecturer in Film Studies in the School of Media, Culture and Creative Arts at Curtin University, Perth, Australia. He was born in Santiago, Chile, where he studied philosophy in the early 1980s and has lived in Australia since 1987. Traverso has published essays on political world cinema and in 2009 he was co-editor (with Suvendrini Perera) of a special issue of *Social Identities: Journal for the Study of Nation, Race and Culture*, titled 'Living Through Terror: (Post)Conflict, (Post)Trauma and the South'. In 2010 he co-edited (with Mick Broderick) a book anthology, *Interrogating Trauma: Arts & Media Responses to Collective Suffering* (Routledge), and a special issue of *Intersections: Gender and Sexuality in Asia and the Pacific*, No. 24, titled 'Arts and Media Responses to the Traumatic Effects of War on Japan'. Currently, he is working on a monograph about post-dictatorship Chilean cinema. As a film practitioner, he has written, directed and produced short experimental and documentary films. Traverso was co-convenor of the *Interrogating Trauma: Arts & Media Responses to Collective Suffering* conference, held in Perth in 2008.

Deb Waterhouse-Watson (BA [Hons], BMus, A.Mus.A. [violin]) completed her PhD in English at Monash University on the representation of football and sexual assault in the media. The author of both critical and creative works, she teaches English, Literature and Communications Studies at Monash and Deakin universities, Victoria, Australia. Her current research interests include: gender and sexualities; sport; law and literature; popular fiction, including romance, fantasy and science fiction; and children's literature and film.

Dr Magdalena Zolkos is Research Fellow in Political Theory at the Centre for Citizenship and Public Policy, University of Western Sydney, Australia. Her research interests include radical democratic theory, transitional justice, political community in post-conflict contexts, and the concept of trauma in political theory. She has published academic articles in *International Journal of Transitional Justice*, *European Legacy*, and *Journal of Contemporary European Studies*. Zolkos is the author of *Reconciling Community and Subjective Life: Trauma Testimony as Political Theorizing in the Work of Jean Améry and Imre Kertész* (Continuum, 2010).